Van Buren District Library
De
D1358802

PAINTING OF THE

ROMANTIC ERA

Van Buren District Library
De

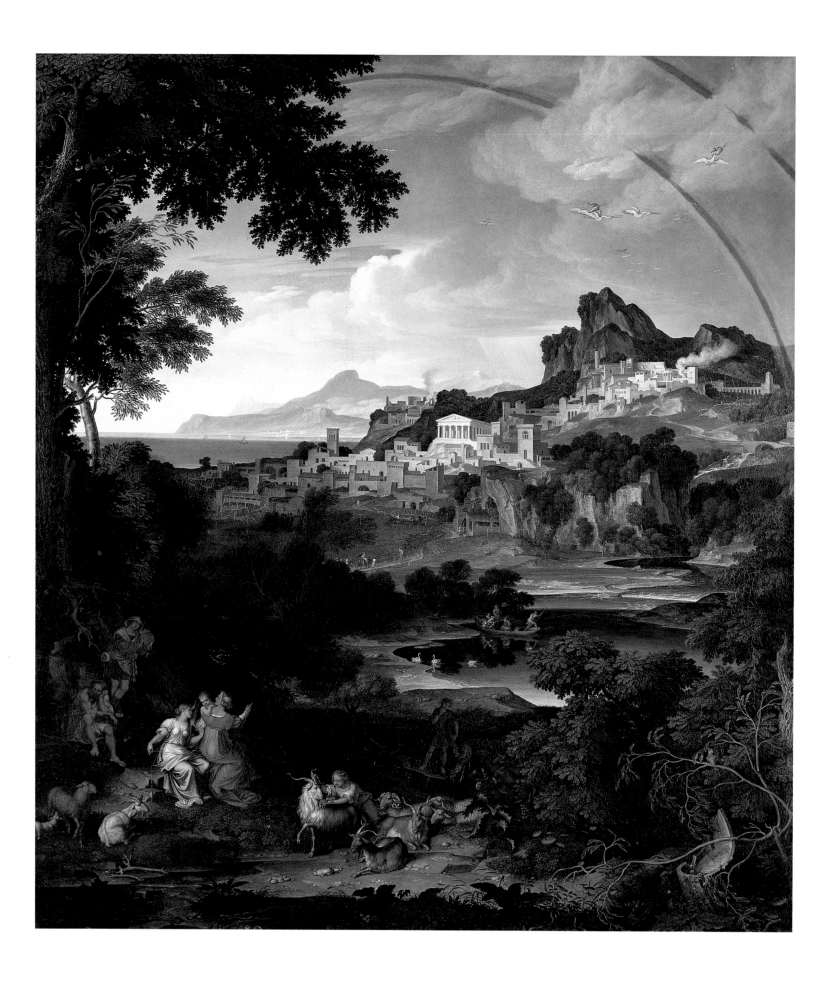

PAINTING OF THE
ROMANTIC ERA

Edited by
Ingo F. Walther

by Norbert Wolf

TASCHEN

KÖLN LONDON MADRID NEW YORK PARIS TOKYO

O.S.
759.6
Wol

Illustration page 2:

Joseph Anton Koch

Heroic Landscape with Rainbow, 1815

Oil on canvas, 188 x 171.2 cm

Munich, Bayerische Staatsgemäldesammlungen, Neue Pinakothek

"The mysterious way leads inward. Within us,
or nowhere, is eternity with its worlds, past and present."

Novalis

1999 Benedikt Taschen Verlag GmbH
Hohenzollernring 53, D-50672 Köln
Editing and production: Juliane Steinbrecher, Cologne
Translation: John William Gabriel, Worpswede
Cover design: Angelika Taschen, Cologne

Printed in Portugal
ISBN 3-8228-7061-7
GB

Table of Contents

GREAT BRITAIN

PAINTING OF
THE ROMANTIC ERA

Ideals in Nineteenth-Century Painting

Around the year 1800, philosophers, writers and artists in Germany began to propagate a new vision of the world they described as "romantic." The term covered a range of ideas: that nature was informed with the divine spirit and that the individual human imagination could immerse itself in the universal fabric; but also that the creative mind, being profoundly solitary, would yearn for harmony between man and nature.

Romantic ideals developed largely in opposition to a neoclassicism that had become entrenched in the traditions of Greco-Roman antiquity, and advocated an open-ended and progressive – that is, a modern – view of the age. Yet Romantic artists also turned back to the late medieval and Renaissance periods, for themes from the Judeo-Christian heritage, because only with its aid, they believed, could the utopia of a politically and intellectually enlightened European future be achieved.

The openness and highly subjective character of such ideals suggest why the Romantic Movement could not, nor wished to, produce any normed artistic style, and why painting in the various European countries, and by extension in the United States, employed a great gamut of subjects and treatments extending from tranquil contemplative scene to spectacularly staged event. It is precisely this diversity that lends Romantic art its fascination, a fascination from which many subsequent art movements of the nineteenth and twentieth centuries would not remain immune.

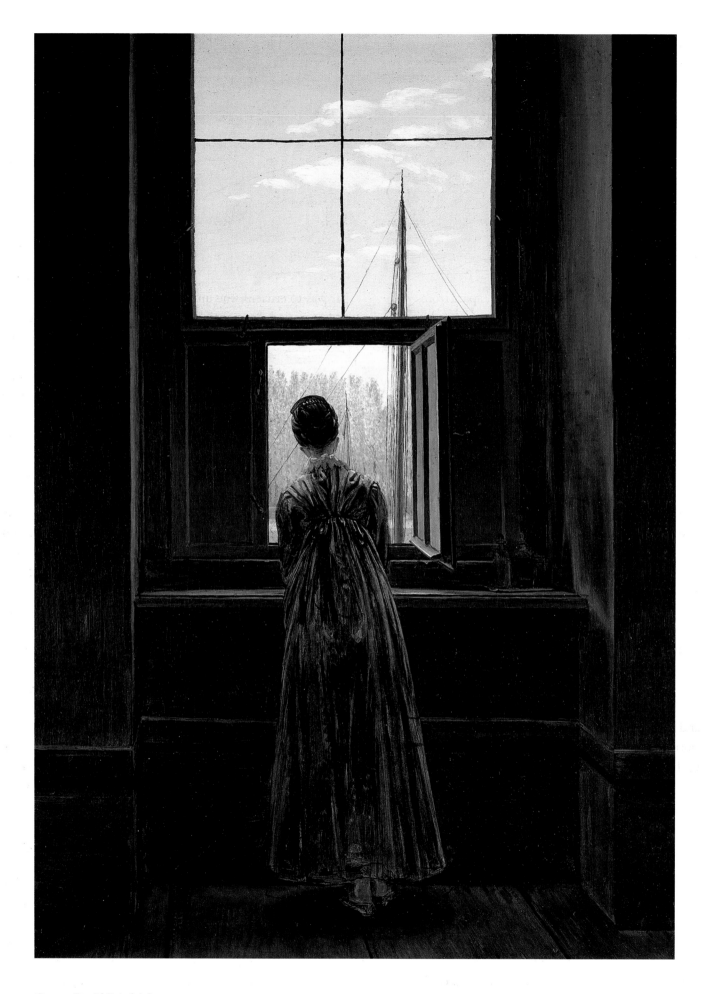

Caspar David Friedrich
Woman at a Window, 1822
Oil on canvas, 44 x 37 cm
Berlin, Nationalgalerie, Staatliche Museen
zu Berlin – Preussischer Kulturbesitz

Clarity and Vagueness of the Stylistic Category

"Oh Dear Friend, I wish Romanticism had never been invented in the first place," sighed Fortunat, the hero of an 1834 novel by the Romantic author Joseph von Eichendorff. That sigh has since been repeated many times over by modern historians of the era, in grappling with a term that so persistently eludes precise definition and yet, despite its irritating vagueness, has long since become indispensable.

In contemporary usage, the adjective "romantic" carries an enormous range of connotations, being applied to the scenic roads of Europe and the hotels that dot them, to "romantic love" in the movies and television soap operas, to sunsets behind palm trees and cozy garden nooks, apart from standing for certain aspects of literature, music and visual art. When we say something is romantic, we think of sentiment and sentimentality, a poetic, nostalgic, or dreamy mood, but one that might also verge on the irrational, even the insane. The term invariably has an undertone of the imaginative and fantastic, and of a remoteness from reality paired with longing. As antonyms, we think of mundane, banal, pedantic.

Not even the scholarly disciplines concerned with Romanticism have been able to do more than arrive at an approximate definition, because the content and substance of the movement, by their very nature, invite controversial interpretations and speculations. The only point on which everyone seems to agree is that Romanticism was an intellectual and artistic transition that occurred at the turn of the eighteenth to the nineteenth century. Yet problems arise as soon as we try to date its beginning and end. While in the field of music, most composers from Beethoven to Richard Strauss are considered Romantics, literary history concentrates on two or three decades around the year 1800. Art history either restricts itself to the period between about 1790 and 1840, or, on the other hand, extends the research field enormously, seeing the Romantic attitude at work in painting from the eighteenth to the twentieth century, which inevitably leads to an overlapping with other stylistic categories.

Then again, due to the tendency of Romantic art to the fantastic and irrational, it is often treated as a substream of Symbolism, which, after many fits and starts, blossomed in the Sturm und Drang of the late eighteenth century and bore its finest fruit in the latter half of the nineteenth. On the other hand, the sentimental and, as it were, cozy aspects of Romanticism make it difficult to distinguish from the style known in German as Biedermeier, which is usually dated from about 1815 to 1850. And finally, since Romantic art includes not only an escape from reality but a fearless confrontation with it, such terms as "romantic naturalism" and "idealistic naturalism" have been coined in an attempt to bridge the gap. Basically all of these names reflect scholars'

embarrassment in face of a range of artistic expressions which, unlike earlier styles such as Renaissance and Baroque, resist being pressed into a hard and fast system.

The word "romance" itself goes back to the Old French word "romanz", which characterized the vernacular Romance dialects as opposed to church Latin. Soon, verse and prose narratives about chivalrous knights and their adventures came to be called "romances," which developed into the medieval "roman," a term still used in many European languages today to designate the novel.

In the seventeenth century, we find the word employed in two different senses. When the Englishman Thomas Baily used the adjective "romantick" for the first time in 1650, it was to criticize the untruth of fictional writings. At the same period, "romantic" was applied in a positive sense to the landscape paintings of Claude Lorrain (1600–1682), Nicolas Poussin (1594–1665), and Salvator Rosa (1615–1673). So in parallel to the motley untamed inventiveness of the fictional world we have the "picturesqueness" of depictions of nature informed with emotion.

In the eighteenth century, when tales of horror set in the Gothic past came into fashion, the aspect of the eerie and spine-tingling phantasmagoria came into play. In France, the Shakespeare translators Letourneur and Girardin used the term "romantique" in 1776 to characterize the emotional qualities of a scene. And in 1777, in his Musings of a Lonely Vagabond, the philosopher Jean Jacques Rousseau (1712–1778) firmly established the Romantic ideal in French thought.

For a long period the concept remained synonymous with the content of popular novels, with medieval chivalry and adventures in remote times and lands. Novalis (Friedrich von Hardenberg, 1772–1801), who was the first to speak of "the Romantic", meant nothing other than a writer of novels. Novalis belonged to a young generation of German authors who, around 1800, gave the term an entirely new twist, and who himself provided what may be the best-known definition of Romanticism: "By giving the commonplace a high meaning, the ordinary a mysterious aspect, the known the dignity of the unknown, the finite an aura of infinity, I romanticize it."

Jean Paul (1763–1825), explaining why everything that fed only on longing and memory, everything remote, dead, unknown, had the charm of transfiguration, said that these things triggered the magic power of the imagination and helped it soar into infinity. And it was Novalis, again, who formulated a rule that was taken to heart by many painters and well as writers: "Everything seen from a distance becomes poetry: distant mountains, distant people, distant events. Everything becomes romantic."

In reaction, the English painter Joshua Reynolds (1723–1792), in an academy lecture of 1778, attacked pictures that expressed nothing but vague ideas and ignored all rules of

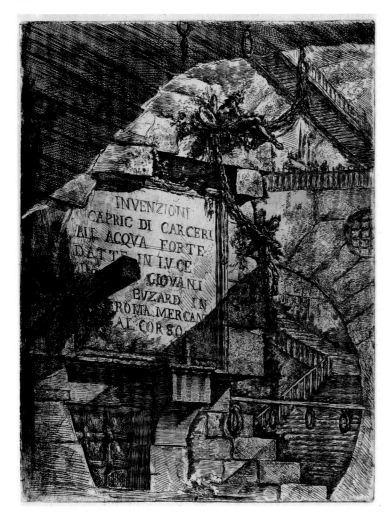

Giovanni Battista Piranesi
Carceri, 1761
Title page (second version)
Etching, 54.6 x 41.8 cm
London, The British Architectural Library

science and scholarship as established by the classical art of antiquity. This was a slap at precursor forms of Romanticism and an argument in favor of classical clarity, which, according to academic doctrine, was even capable of morally improving mankind. Ever since Reynolds, Romanticism has borne the onus of representing anti-classicism per se. Even its subjects, derived from the medieval world and European Christianity, were said to run counter to the repertoire of Greco-Roman art.

In 1820, Johann Wolfgang von Goethe (1749–1832) reported on "classicists and romanticists in Italy, violently battling one another." One could not simply jettison the classical education if one wished to be modern, Goethe concluded, yet neither could one belie the thought that stemmed from the Bible. For the great mass of people, he said, it was enough to attach the label "romantic" to "everything that is dark, absurd, confused, incomprehensible." Nor was all "patriotic and home-grown" art necessarily romantic, either.

It was Goethe, celebrated by the Germans as their quintessential classical writer, but elsewhere usually considered a

Romantic, who supplied the prime example of that often-sought blend of classical theme with medievalist setting, of clarity with phantasmagoria. This was his Faust, the first French translation of which, published in 1827, not coincidentally fueled the fire of French Romanticism. Eugène Delacroix' (1798–1863) illustrations to this edition struck Goethe as being "devilishly good stuff."

The earliest, most cogent and comprehensive theories of Romantic art were developed in the German-speaking countries around the year 1800. This circumstance has led many commentators to state that the Germans invented the style, whose intellectual and aesthetic attitudes were supposedly particularly attuned to the "German character." One such author was the historian Gordon Craig. In his highly praised 1982 book, *The Germans,* Craig saw a certain melancholy wistfulness, an undefined longing, an alienation from reality, sentimentality, a tendency to introversion, an unpolitical attitude, an immersion of the self in "the mysterious forces of nature and God," and finally, a pervasive pessimism and obsession with death as symptoms that led to this potentially pathological alliance. Though much of this argument is correct, many aspects of it are placed in historically incorrect contexts.

There can be no doubt that Romanticism, though it had an enormous resonance in Germany, was a phenomenon that pervaded all of Europe during the late years of the eighteenth century and the transition period to an industrialized society in the nineteenth. It even occasionally overleapt the borders of Europe, for instance stimulating American painters of the late nineteenth century to develop a unique version of the style, above all in the field of landscape painting. As far as the unreal and eerie, the dark and evil ingredients of the Romantic mood are concerned, sufficient examples are found in English and French literature and art, where they were indeed often carried to extremes, giving rise to the concept of "black Romanticism."

An indicative example is the interpretation placed on the work of the Italian engraver Giovanni Battista Piranesi (1720–1778). Piranesi was an extravagant artist. His penchant for the fantastic culminated in the dungeon imagery of the *Carceri* (ill. left), depicting interiors that ran counter to all spatial logic, fitted with instruments of torture that called orgies of violence to mind. The demoniacal character of these prints inspired the English writer Thomas De Quincey (1785–1859) to his *Confessions of an English Opium-Eater,* which, on its publication in 1822, caused a furore throughout Europe and had a profound influence on on French Romanticism in particular. Alfred de Musset (1810–1857) translated the book in 1828, and stimulated later terror fantasies, including an "aesthetics of evil," among such writers as Charles Nodier (1780–1844), Victor Hugo (1802–1885), Théophile Gautier (1811–1872), and Charles Baudelaire (1821–1867).

Impulses from the Eighteenth Century

The example of Piranesi in itself suggests the enormous influence exerted by eighteenth-century art on the emergence of Romanticism. Many of the ideas developed back then were revived at the turn of the nineteenth century, and incorporated into a new philosophical and artistic view of the world.

From the late seventeenth century until well into the following decades, for example, artists and intellectuals in France and elsewhere struggled with the question of the extent to which the dominant classical model should be retained. Advocates of "modernity" doubted the continuing validity of its norms. This reservation not only led to a reevaluation of Judeo-Christian culture, it subsequently raised the issue of what artistic standards could take the place of the classical codex. Instead of an aesthetics based on ineluctable values, there developed in England and France a doctrine of the beautiful based on individual taste and sensibility. The feeling and "sentiment" of the individual artist and viewer of art now became the key factor. Ultimately this implied a turn to a psychological approach to art, which by the middle of the nineteenth century had begun to concentrate on its more sensational aspects.

Divergencies from the normal and mundane led writers and artists into the realm of the "romanesque", as the French philosopher Charles de Montesquieu (1689–1755) put it, the realm of the exciting, alarming, and the range of qualities which at the time were subsumed under the notion of "the interesting." Artistic spontaneity that ignored all borderlines, strokes of genius and creative intoxication which spirited the artist into exotic, archaic, and barbaric realms, were praised as the new means of aesthetic experimentation.

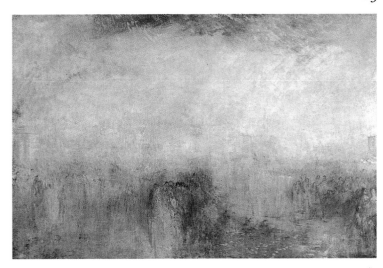

William Turner
Venetian Festival, c. 1845
Oil on canvas, 72.5 x 113.5 cm
London, Tate Gallery

In the book *A Philosophical Enquiry into the Origins of Our Ideas of the Sublime and Beautiful,* published in 1757, Edmund Burke (1729–1797) paved the road to an aesthetics of awesome and pleasurable terrors. After Burke's attempt to base the visual arts on a theory of human passions, the categories of the grand and sublime, the archaically rugged, the mental stimuli provoked by the bizarre, obscure, chaotic, even the shock effects which exposed the depths and abysses of the human soul, came increasingly to figure in European thinking as the motive forces behind truly compelling works of art.

Around the time of Burke's treatise, the concept of the "picturesque" became a key term of the epoch. As in "romanesque" landscapes à la Claude Lorrain, Nicolas Poussin and Salvator Rosa, the word connoted psychological moods triggered by certain themes, but also by certain modes of formal depiction. The year 1795 saw the publication of Uvedale Price's *Essays on the Picturesque,* followed around the turn of the century by several publications by Richard Payne Knight, who maintained that picturesqueness was based above all on values of light and color. This amounted to a theoretical anticipation of the dissolution of concrete subject matter into pure coloristic effects, which a short time later would be put into practice most superbly by William Turner (1775–1851) in watercolors and oils of a decidedly Romantic flavor.

As we can see, much of what moved Romantic artists around and after 1800 had already been prepared in theory years before. This also holds for artistic practice. A good example is the English Garden, which emerged around 1720 and whose apparently untamed, natural tree groupings burst the geometric constrictions of the French Baroque garden, had from the start been looked upon as a reservoir of picturesque and atmospheric moods. It was no coincidence that

John Constable
The White Horse, 1819
Oil on canvas, 131.4 x 188.3 cm
New York, The Frick Collection

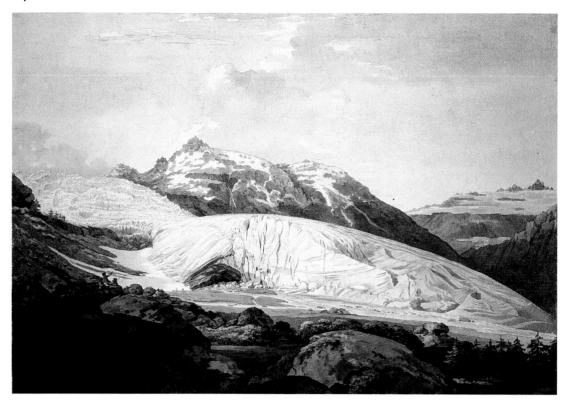

William Pars
The Rhône Glacier and the Source
of the Rhône, c. 1770/71
Watercolor and India ink, 33 x 48.4 cm
London, The Trustees of the British
Museum

the diverse views and vistas of the English Garden were often based on the romantic pictures of Claude Lorrain. After the appearance of Burke's treatise on the sublime, gardens were increasingly fitted out with artificial ruins, Gothic chapels, Chinese pagodas, and Moorish kiosks. Their layouts were suffused with the same sublime longing for distant places and times, a penchant for the exotic and medieval, and an aesthetics of decline and decay, which would come to characterize later Romantic painting.

Even more: The landscape gardener William Chambers (1726–1786) planned (though never executed) landscapes of "terror" and "melancholy" that would have fit seamlessly into pre- and early Romantic Gothic novels. He envisaged burned out and inundated ruins populated by half-starved wild animals, instruments of torture strewn about the grounds, subterranean dungeons from which the screams of the martyred could be heard, artificial volcanoes spewing fiery red clouds of smoke. In gloomy caves visitors to the park would come across wax corpses of famous kings and the most heinous criminals of all time, as eerie celestial music from water organs played in the background. Not only would the pedestrian be visually and acoustically assaulted but physically as well, by artificial earthquakes, electric shocks, mechanical rainshowers, and sudden explosions. A walk through the park was to be transformed into a theatrical spectacle, a spine-chilling experience.

The English Neo-Gothic style that arose in close conjunction with the gardens in the eighteenth century, soon became a means of romantic self-expression on the part of its first contractors. Strawberry Hill, for instance, was based on the ideas of Horace Walpole (1717–1797), an aristocratic art collector who in addition, with *The Castle of Otranto* (1764), penned one of the earliest horror novels in literary history. The interior decoration of Walpole's house was derived from Gothic cathedrals and funerary chapels, an extravagant suffusion of the private sphere with the enigmatic sacred aura of the Middle Ages.

The medieval chivalrous romance had, as it were, found its concrete setting in preindustrial England. This was even more strikingly the case with Fonthill Abbey (built 1796–1807). Once again its builder, William Beckford (1759–1844), was the author of an "oriental" novel, *Vathek,* of 1786. Initially conceived as a church, painting gallery and sepulcher, the huge complex of buildings in the Neo-Gothic style was soon converted into a residence. Those who lived there must have felt lost in the overwhelmingly dimensioned, cavernous rooms and staircases descending into abysmal depths.

Another eighteenth-century phenomenon that fits into the prehistory of Romanticism is the change in people's experience of distant and foreign places. This change initially took place with respect to that traditional land of European dreams, Italy. For about two centuries well-placed young men had been travelling to Italy to expand their knowledge of antique sites and Renaissance art. In addition to this educational interest, in the eighteenth century ever more travellers felt the desire to cultivate moods, feelings, and sensations, especially those inspired by the beauties of the Italian landscape.

At the same time, the English in particular took watercolorists along with them on their journey in order to record the atmosphere they so enjoyed. Ever since Burke and that

magic word, the sublime, their interest had been increasingly attracted by areas seen on the way south which were especially picturesque or thrilling.

While the Swiss Alps, the quintessence of sublime landscape, had already been painted in the 1760s by William Pars (1742–1782; ill. p. 14), Lord Byron (1788–1824) subsequently raised the Rhine Valley and Venice to embodiments of romantic scenery, and soon streams of tourists were following in his footsteps. For young intellectuals and artists, the poet Byron became a symbolic figure of Romantic melancholy. In addition, with his travels in Albania and Greece, where he fought in the war of independence against the Turks, Byron embodied that striving for ever more distant and exotic climes which, likewise, had its roots far back in the eighteenth century.

In Germany in the 1770s, Johann Gottfried Herder (1744–1803) attempted to make the Orient popular, an attempt continued by Friedrich Schlegel (1772–1829), who in 1800 declared that "the supremely romantic" must be sought "in the Orient" – which for him encompassed North Africa and all of Asia. Schlegel also waxed enthusiastic about the travel reports of Georg Forster (1754–1794), who had accompanied Captain Cook on a South Seas expedition in 1772–1775. In France, the heroes of the novels of Abbé Prevost (*Manon Lescaut,* 1797) and Bernardin de Saint-Pierre (*Paul et Virginie,* 1788), surfeited with civilization, experienced their adventures in the New World, as later did François René Chateaubriand's (1768–1848) "romantic" hero René (*René,* 1802), in French America.

Finally, mention must certainly be made of the new role that landscape painting had begun to play. Art theory in earlier eras had denigrated this genre, since it could not fulfil the classical demands which were met above all by history painting. In academic instruction this judgement was largely to retain its validity far into the nineteenth century. Yet already in the eighteenth, when such thinkers as Henri Rousseau, Denis Diderot (1713–1784), and Friedrich Schiller (1759–1805) had lamented the alienation of man from nature, a fundamental change in attitude had begun to emerge. The subjectively felt moods of landscape, impossible to capture in rules, now came to be valued as qualities in their own right.

Burke had viewed landscape as the arena of the sublime, and accordingly, wild, untamed nature, the Scottish highlands or the Alpine ranges – dramatic scenery in general, as a setting for thrilling occurrences – increasingly attracted artists' attention. The French painter Claude-Joseph Vernet (1714–1789) depicted storms at sea and foundering ships (ill. below); Philippe Jacques de Loutherbourg of Strasbourg (1740–1812) took up Vernet's themes before eventually, in England, applying their sensational effects principally to depictions of industrial landscapes (ill. p. 16). Portions of German and English Romanticism after 1800, and American Romanticism during the nineteenth century, then exalted the landscape to a favorite, and often enough symbolically charged subject.

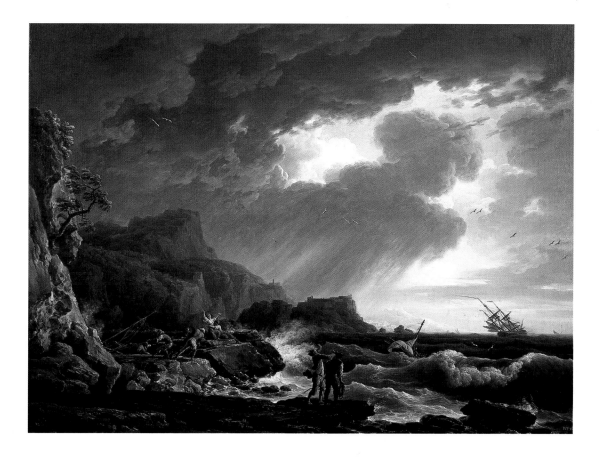

Claude-Joseph Vernet
A Seastorm, 1752
Oil on canvas, 99 x 137 cm
Private collection

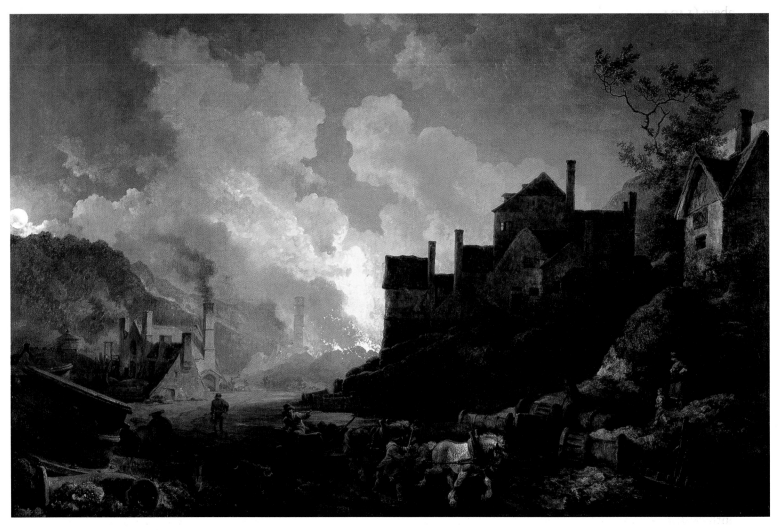

Philippe Jacques de Loutherbourg
Coalbrookdale by Night, 1801
Oil on canvas, 67.9 x 106.7 cm
London, Science Museum

Literature and Philosophy Set the Tone

The Romantic Movement was able to recur to the rich stores
of material provided by the eighteenth century in many
respects. But rather than merely developing this material,
it reshaped it into an entirely new view of the world. The
first signs of this became apparent in German literature and
philosophy around the year 1800.

At the beginning stood such works as Goethe's epic,
Torquato Tasso (1790), or Wilhelm Heinse's (1746–1803)
Ardinghello (1787), Italian fantasies suffused with early
Romantic nostalgia. Wilhelm Heinrich Wackenroder's
(1773–1798) *Effusions of an Art-Loving Friar* (1797) and
Ludwig Tieck's (1773–1853) *Franz Sternbald's Peregrinations*
(1798) followed suit, but now describing Italy not as
the land of classical art but as that of churches, palaces,
museums, seat of the papacy, center of the Christian world.
Especially important for the formation of Romantic thought
was the novel *Heinrich von Ofterdingen* (published 1802) and
the lyric cycle *Hymns to the Night* (1800), both from the pen
of the young Novalis. Further, the tradition of Gothic tales
of terror found a continuation not only in trivial literature

but in the genius and divided reality of an E. T. A. Hoffmann
(1776–1822).

Tieck worked from 1799 to 1801 on his German transla-
tion of Cervantes's *Don Quixote,* "the perfect masterpiece of
higher Romantic art," as August Wilhelm Schlegel (1767–
1845) called it a short time later. Schlegel's interest also con-
centrated on Italian literature of the fourteenth to sixteenth
centuries. But above all, from 1797 he translated the works
of Shakespeare, and firmly implanted the great "anticlassical"
English author in the German Romantic canon.

Another British contribution eagerly accepted throughout
Europe, but especially in Germany, was the *Ossian,* a literary
sensation of the latter half of the eighteenth century which,
though purported to be the poem of an Old Gaelic bard,
turned out to be largely a new imitation, written by a Scots-
man by the name of James Macpherson. *Ossian* accorded per-
fectly with that Romantic enthusiasm for the remote past
which also expressed itself in the rediscovery of the German
Middle Ages, the *Nibelungenlied,* and the minnesongs, or love
lyrics, of the Hohenstauffen period. After the minnesingers
came the mastersingers, as embodied by Hans Sachs of

Nuremberg (1494–1576). With Tieck and Wackenroder, an enthusiasm for the "Germanic" character of the Dürer period entered a harmonious marriage with that for things Italian, the Renaissance, Italian poetry, and the painting of Michelangelo (1475–1564) and Raphael (1483–1520).

Seen as a whole, this literature, whether newly written or adapted, emphasized the emotions felt and the atmosphere sensed in face of landscapes seen or imagined, as well as sub-jectively negating classical rules. Its broad-based recurrence to the most diverse eras and cultures reflected an urge to create universal links and bonds; yet its parallel emphasis on Christian values was intended to have current relevance, and its revival of the local past was aimed at strengthening national consciousness. The latter was particularly evident in the case of the fairy-tales written by Romantic authors, and the collections of folktales and songs of the period. Both fields were veritably predestined to serve as repositories of Romantic fantasy. They opened up a realm of the miraculous, not to mention the horrifying and cruel. But above all the fairy-tale anthologies, foremost that of the Brothers Grimm (1812), hoped to discover the buried wellsprings of the German popular soul.

In the other European countries as well, the role of litera-ture as a catalyst for Romanticism cannot be emphasized strongly enough. In England, the tradition of the Gothic novel continued unbroken from the eighteenth to far into the nineteenth century, culminating in the works of Jane Austen (1775–1817) and Mary Shelley (*Frankenstein,* 1818), and finally in those of the American Edgar Allen Poe (1809–1849). Also unbroken since the eighteenth century were the influence of *Ossian,* of John Milton's (1608–1674) *Paradise Lost* and *Paradise Regained,* and of Edward Young's *Night Thoughts* (1742–1745). The preface written in 1798 by William Wordsworth (1770–1850) to Coleridge's *Lyrical Ballads,* in its emphasis on nature as a counterworld to society, is considered to mark the inception of the English Romantic Movement.

In France, in the wake of the Revolution around 1800, the Napoleonic Era had seen the emergence of first, quite idio-syncratic versions of Romanticism. An approach comparable to German developments was reflected in Chateaubriand's publication of 1802, *The Spirit of Christianity, or The Beauties of the Christian Religion,* in which the novels *Atala* and *René* were included. Here Christianity was reinterpreted on an aes-thetic basis. In a typically Romantic ambivalence, faith was tempered by doubt, hope by melancholy, enthusiasm for a universal life by fear of what lurked in the depths of the hu-man soul. The book on Germany by Madame Germaine de Staël (1766–1817), published in London in 1813 and, after Napoleon's fall, in Paris in 1814, popularized the Romantic philosophy and literature of Germany and recom-mended that the French overcome moribund neoclassicism with its aid.

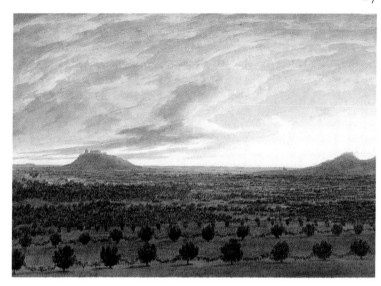

John Robert Cozens
View of Mirbella, c. 1782
Watercolor, 24.7 x 36.8 cm
London, Victoria and Albert Museum

In the Jena Circle mentioned above, not only writers but philosophers, such as the Schlegel brothers, Johann Gottlieb Fichte (1762–1814), Friedrich Wilhelm Schelling (1775–1854), and also the Protestant theologian Friedrich Schleier-macher (1768–1834), contributed to the journal *Athenäum,* which appeared from 1789 to 1800 and may justifiably be called the first and clearest manifesto of Romanticism.

Its main purpose was to supplant the scientific, empirical view of the world by a "poetical" one. Contemporary society, these authors believed, lacked a binding mythology whose contents and symbols would be capable of expressing what eluded rational thought, and which could come into being only through idealism. Were this to be achieved, modern history would lead to a truly divine realm on earth. This would entail a shift of the external, confessional forms of religion into the consciousness of the individual. Only the creative self was capable of measuring the infinite. An important mediatory role in this process would be played by nature.

August Wilhelm Schlegel compared the silent dialogue between spectator and nature to Holy Communion, and many a Protestant theologian placed the experience of nature on the same plane as the experience of the sacrament. Art, too, came to be seen in an ever more religious light. All fields of human thought and creativity were to contribute to a revolution of existence, were to proclaim the liberty of the individual with all of its consequences, from triumphant omnipotence to despairing loneliness.

It was precisely this split in the human character, thought the Romantics, that would enable man to rise above himself. Change and transformation, a liberation from norms, and a blurring of borderlines became the program of the move-ment. Contradictions and existential crises were considered

not a negative but a positive, creative factor, encouraging what Schlegel called "the progressive," an incessant process of becoming. Despite the positive tenor of the program, however, its high claims contained the seed of despair, of an absolute weariness with life. Jean Paul gave this the name "Weltschmerz", but even before him, Chateaubriand and Byron had raised comparable feelings and literary characters to icons of the modern, Romantic myth.

The Romantic Movement saw itself as embodying the new mythology of modern Europe, as a kind of summing up and "progressive" continuation of European thought and achievement since the Christian Middle Ages, aimed at emancipating the human individual from his role of subject and giving him a meaningful place in a contemporary age whose political and industrial revolutions had lent all the more urgency to the question of meaning.

Seen in this light, Romanticism, for all its suffering at the state of the world, was at least initially and in its best works something quite different from a pathetic self-abnegation. Rather, it was borne by the optimism of new beginnings, by an idealism that envisioned the whole of religion, philosophy, politics, art, psychology, and individual destinies raised to a new, meaningful, and forward-looking plane. This universal goal explains why the Romantics made continual borrowings from earlier epochs and yet reached quite different intellectual conclusions and artistic results. It was only when their ideals foundered on the rocks of political and economic reality that many proponents of Romanticism retreated into a domestic and non-committal "inwardness."

Principles of Romantic Painting

Change as a program – this phrase alone makes it understandable why, in Romantic art, there were literature, music, painting and drawing, but no Romantic architecture or sculpture. It was Novalis who, in his *Heinrich von Ofterdingen* of 1802, created the erotic myth of the "blue flower," which soon burgeoned into a myth of longing and yearning for the faraway: The color blue as a symbol of the nocturnal, of tender, longing sensations. Painting might be called the medium of the unlimited; ever since Goethe's treatise on color, painters became preoccupied with the symbolic potentials of light and color, Philipp Otto Runge (1777–1810) and Turner foremost.

Lending color and light a dominant role enabled Romantic painters to abandon the rational scheme of perspective in favor of an indeterminate space, suitable for conveying universal ideas. Caspar David Friedrich (1774–1840) created the exemplary specimen in his *Monk by the Sea* (ill. p. 39), and Turner, again, took the principle to an extreme that almost recalls modern abstraction.

This explains why in many countries, especially England and Germany, landscape became the principal motif of Romantic painting. In the landscape, nature as the arena of higher powers was to be revealed. The infinite expanse of the ocean, the sublime Alpine realm, the panorama view to the far horizon, but also "Waldeseinsamkeit", or sylvan solitude – a key term of German Romanticism coined in 1797 by Ludwig Tieck – could evoke the divine presence in elemental nature and make the observer feel it; yet they might equally express human isolation in the face of the limitless universe. Ultimately the natural environment was not depicted for its own sake, but as a mirror of internal mental and emotional processes.

Carl Gustav Carus (1789–1869; ill. pp. 48, 49), significant painter and theoretician, saw the goal of landscape pictures in rendering states of mind transparent through corresponding moods in natural life. In this sense, Runge ranked landscape as the central subject of the art of the future. Yet some Romantic landscape artists concentrated on natural history and the processes of growth and decay. This explains the key role played by landscape cycles illustrating the times of day or seasons of the year, symbols of the natural cycle. It also explains the signs of the historical past so frequently seen in Romantic landscapes: Gothic cathedrals, monasteries and castles, ruins, cairns, populated by monks, eremites and knights; and in many cases the evidence of geological study in the landscapes, which revealed the natural forces of formation and erosion – factors that could lead beyond Romanticism to a more objective and prosaic approach to landscape.

Another characteristic motif of Romantic painting was the framed view, a landscape seen from an interior through an open window or door. Carus introduced two of his Nine Missives on Landscape Painting of 1831 with a suggestive description of an interior, making reference to Goethe's *Faust* (II, Act 2): "Enclosed space suits the artificial best. The universe can hardly hold the natural rest." The tension between the landscape expanse outside and the intimacy of the enclosed room conforms perfectly with Novalis's dictum of evoking an "aura of the infinite" in the finite.

In Caspar David Friedrich's *Woman at a Window* of 1822 (ill. p. 10), the dark interior has been interpreted as standing for the constricted, earthly world which receives its light only from the window, symbolizing the supernatural world. The opposite bank of the river below the window has been said to represent the Beyond in the religious sense, while the ships' masts rising into the frame stand for a Christian recasting of the classical motif of the underground river across which Charon ferries dead souls.

Though weighty objections have been made to this strictly theological interpretation, the isolation of man from nature in the picture remains indisputable. The figure seen from the back, leaning against the window – the artist's wife – seems imprisoned in the small, sparsely furnished room and the linear gridwork of the composition. Only the middle pane of

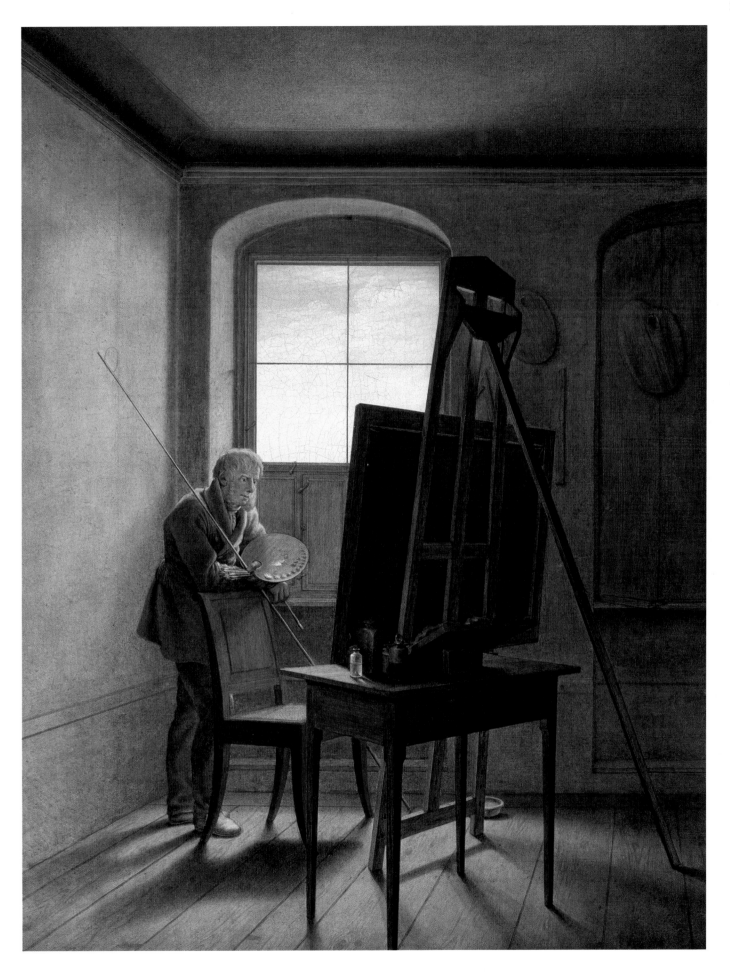

Georg Friedrich Kersting
Caspar David Friedrich in his Studio, 1812
Oil on canvas, 51 x 40 cm
Berlin, Nationalgalerie, Staatliche Museen
zu Berlin – Preussischer Kulturbesitz

the window is open, underscoring by contrast the glazed upper aperture that separates the brilliant expanse of sky and landscape from the somber room.

In *Caspar David Friedrich in his Studio* (ill. p. 19), Georg Friedrich Kersting (1785–1847) shows the artist leaning on a chair, musing before his easel. The painted canvas is hidden from view. What goes through Friedrich's mind in the process of painting can only be surmised from his absent gaze. The single window of the bare room is entirely closed, the lower part shuttered; only at the top is a section of grey-blue sky visible. "A painter who sees no world within himself should desist painting," Friedrich once declared. Here a painter who recreated the world out of inward vision is shown at work in a darkened room, into which a tiny excerpt of the exterior world reflects what he struggles to evoke, the glory of a higher existence as a refuge for the troubled soul.

In the case of any movement in art which emblazons continual change on its banner, which sets out to explore unknown and uncharted territory, a common denominator from artist to artist and country to country will be difficult to find. This makes it all the more important to look at individual nations and painters, with an eye to discerning further characteristic traits of Romanticism.

German Painting

Romantic artists in Germany found little in eighteenth-century painting that inspired them or could be adapted to their purposes. In Southern Germany and the Alpine provinces, the reign of Rococo and its brilliant final culmination in ecclesiastical art, lasted into the 1770s. In other regions, toward the end of the century a French-influenced neoclassicism with a certain idyllic mood and atmosphere began to spread. An example is the work of Asmus Jacob Carstens (1754–1798), who waived color to produce compositions reminiscent of Michelangelo, the themes of which occasionally had a sentimental tendency. Yet it would be mistaken to call them Romantic, since there had always been streams within European neoclassicism that avoided all academic pedantry and infused the classical vocabulary with emotion.

For similar reasons it is likewise problematical to associate the "heroic" or "ideal" landscapes of the Tyrolean Joseph Anton Koch (1768–1839) with Romanticism. Problematical, but not impossible, for as the artist himself said, in good Romantic manner, "Let the creative soul take the separate part, the tiniest detail into itself and shape out of itself the whole, as if at one fell swoop, under a lightning flash of the idealizing imagination."

In *Heroic Landscape with Rainbow* (ill. p. 2), the 1815 version of which was acquired by the Munich Academy as an outstanding example of a genre usually scorned by such institutions, Koch showed that neoclassicism could seamlessly blend into Romanticism. The picture spirits the viewer into a distant, byegone realm populated by shepherds and shepherdesses. From the foreground, the eye is led by clear compositional lines over copses and lush river valleys to sunny plateaus and rugged mountains, over whose slopes spread classical and medieval towns as idyllic symbols of communal life. The rainbow, symbol of God's grace, links heaven and earth, classical and Christian forms of existence, into a harmonious, cosmic unity. Melancholy and sweet, the sense of the past binds itself to the present, as Friedrich Schiller once wrote. In contrast, Koch's *Schmadribach Falls* (ill. p. 22) exhibits a sharp-focus verisimilitude that would bear fruit less for Romantic art than for the naturalistic streams of the nineteenth century.

The most promising point of departure for the Romantic painters was eighteenth-century art into which aspects of the sublime had already entered, especially depictions of terrifyingly beautiful mountain vastnesses. Such pictures of a visionary and quite Romantic cast were painted by the

Eugen Napoleon Neureuther
Cinderella, 1861
India ink, graphite, watercolor and tempera
heightened with silver, 66 x 49.5 cm
Munich, Städtische Galerie im Lenbachhaus

Philipp Otto Runge
St. Peter on the Sea, 1806/07
Oil on canvas, 116 x 157 cm
Hamburg, Hamburger Kunsthalle

Swiss artist Caspar Wolf (1735–1798), who had worked for a period with Loutherbourg in Paris.

Fichte's philosophy, which raised the self-conscious ego to the measure of all things; Goethe's *Wilhelm Meister*, a "Bildungsroman" with its voyages of discovery into the human soul; and the French Revolution – these three were declared the greatest tendencies of the age by Friedrich Schlegel in 1798. The intellectuals of Germany, a land hobbled by particularism that still bore the pompous title of Holy Roman Empire, a feudal country without capital or cultural center, without a politically responsible middle class or industry, initially saw in the French Revolution of 1789 a chance not only for political but for spiritual renewal. The emancipated citizen, they thought, would join ranks with the people of other nations to form a cosmopolitan society, throwing down all intellectual and emotional frontiers. Schlegel, again, stated that it was a revolutionary mission to establish the Kingdom of God, which would be identical with the beginning of progressive development and modern history.

Yet disappointment soon set in as the consequences of the revolution became ever clearer. The subsequent wars of liberation against Napoleon demanded thinking in terms not of universal but of national politics. Still, with the early Romantics the idea of the nation-state remained bound up with the desire for bourgeois emancipation and for a new, progressive attitude to life, as when Schleiermacher, in 1807, linked the neo-Protestant movement with the emergence of the German nation.

The usual distinction made in German Romanticism between a Protestant northern and a Catholic southern stream is superfically correct; it is true to say that much of southern German painting was strongly determined by Catholic subject matter and aims, and therefore was relatively conservative in orientation. Still, painters in northern Germany saw themselves beholding not so much to Protestantism as a confessional dogma as to a religiosity that was universal in the sense described above – that is, humane and cosmopolitan. A revealing example in this regard is Friedrich's *Tetschen Altarpiece* of 1807/08 (ill. p. 38), which after many alterations of plan was finally installed in the palace chapel of a Catholic prince, without artist or liberal-minded buyer seeing any obstacle in the sacred content of the painting.

Friedrich's mind was not beclouded by mysticism to nearly the extent that some of his contemporaries and many of his modern commentators maintain. Certainly he was a Romantic – but one who kept his eyes open to his environment and era. Nor was it simply Teutomania that made Friedrich a Francophobe. It was the conviction that Napoleon had betrayed the French Revolution (which admittedly many Romantics initially idealized) and had humbled Germany. At this point, such motifs as cliffs, boulders, oak, fir, and pine trees began to take on a new prominence in Friedrich's art. These were allusions to things German, if very covert ones, since French censorship had continually to be reckoned with. The call to arms ardently followed by his artist and poet friends Kersting, Theodor Körner (1791–1813), Friedrich de la Motte Fouqué (1777–1843), Philipp Veit (1793–1877) and Ferdinand Olivier (1784–1841), was not for Friedrich,

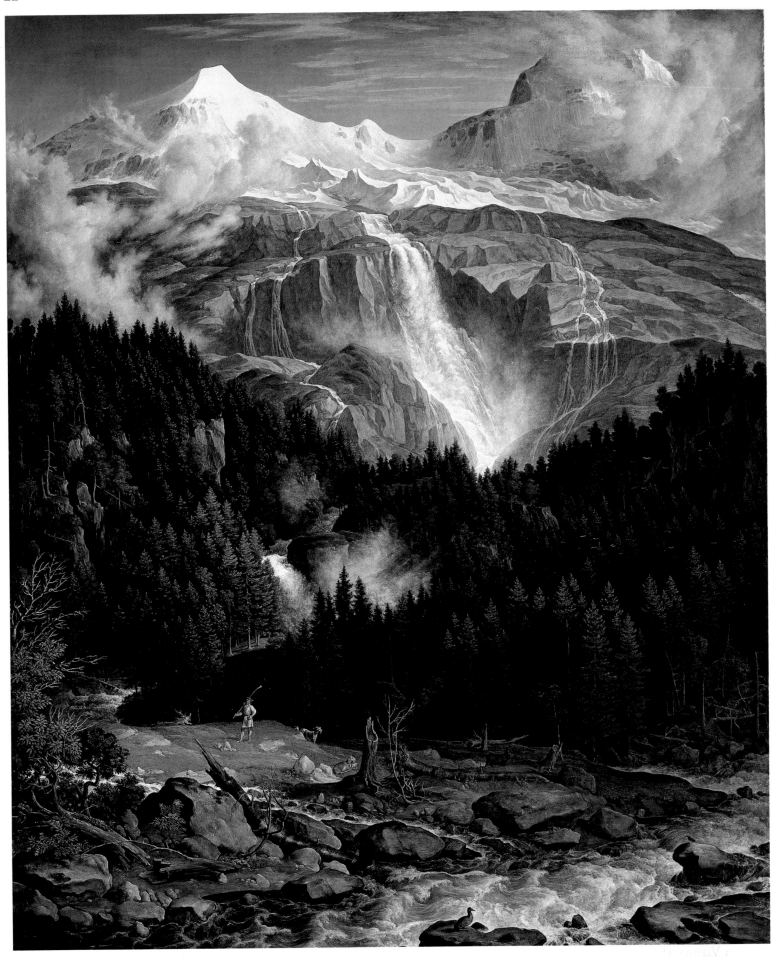

Joseph Anton Koch
Schmadribach Falls, 1821/22
Oil on canvas, 131.8 x 110 cm
Munich, Bayerische Staatsgemäldesammlungen,
Neue Pinakothek

however, who considered himself too old to fight. But he did sponsor a portion of the equipment for the Voluntary Corps formed to oust Napoleon.

Friedrich's example made Dresden one of the key centers of Romantic art. For Johan Christian Clausen Dahl (1788–1857), Carus, Kersting, Ernst Ferdinand Oehme (1797–1855) and many others, the landscape of the region was the prime theme, in which individual mental powers, a divine, cosmic omnipotence, and the utopia of a harmonious future coverged. Most of these artists were initially receptive to the ideal of a progressive human and political development, as propagated at the start of the century by the Jena circle of philosophers and writers.

It was Philipp Otto Runge, who lived in Hamburg, who provided the most detailed theoretical underpinning for the new, Romantic painting, declaring landscape to be its foremost mission. Landscape, Runge said in effect, was not simply the visual compilation of a natural scenery, but revelation through sensation or sentience. By the same token, even a human face or a scene with figures could become a "sentient landscape."

This perhaps explains why he considered the pure colors to be symbols of a limitless, divine illumination of the universe, which unfurled itself between the poles of light and darkness. Runge developed visual allegories whose pantheism, the belief that God was inherent in every element of the self-existing universe, was most clearly expressed in his cycle of *Four Seasons* (ill. p. 37), conceived in 1802/03. The planned cycle united Christian and classical mythological motifs, plants and landscape in ornamental compositions intended as metaphors for human existence. For obvious reasons, Runge's cerebral and frequently mystical art would not find successors to nearly the same extent as did Friedrich's more cogent symbolism.

The Nazarenes, the Catholic branch of the German Romantic Movement, envisioned a national art based on medieval Christian traditions. For the generally sentimental treatment of their nostalgic and politically conservative themes, they preferred, unlike their northern German colleagues, the linearly contoured, closed form. The story of the Nazarenes began in 1809, when a few students in Vienna, disaffected with the neoclassicism taught at the academy, formed an "order," the first artists' group in the Romantic era to be inspired by the cult of friendship. They called themselves the St. Luke's Brotherhood, after the Evangelist and patron saint of painters. Conditions for membership were a rejection of academic norms and an adherence to certain ethical and religious principles.

From Vienna, the group moved in 1810 to Rome, where they settled in the secularized monastery S. Isidoro. The founding members, who included Johann Friedrich Overbeck (1789–1869) and Franz Pforr (1788–1812), were joined over the following years by others, such as Peter von Cornelius (1783–1867), Wilhelm von Schadow (1788–1862), Johann and Philipp Veit, Julius Schnorr von Carolsfeld (1794–1872), and Ferdinand and Friedrich Olivier (1791–1859). Due to their long hair parted in the middle, the Romans mocked them as "Nazarenes."

Their appearance and dress amounted to a programmatic statement, for it was not classical antiquity but the "holy" Middle Ages they sought in Rome. The contemporaries of Albrecht Dürer (1471–1528) and the Italian painters before Raphael, especially Fra Angelico (c. 1387–1455) and Perugino (c. 1445–1523), became the models for the Nazarenes' attempt to revitalize painting by infusing it with profound sacred feeling and a Catholicism accessible to the people. This religious emotion was accompanied by a "neo-German" patriotism supposedly rooted in the people. Thus until about 1830 the Nazarenes embodied a form of Romanticism that, its eyes turned back to the utopian ideal of the medieval caste society, fought the republican ideas introduced by the Enlightenment and French Revolution. Their subjects, biblical, symbolic, or taken from ancient German history and legends, were treated in a naive, popular, gracefully linear, narrative style.

The Nazarene's prime aim was to exalt mural painting in this style to a new, grand and national art. They were able to put it into practice to only a modest extent, in projects such as the frescoes for the Palazzo Zuccaro, residence of the Prussian Consul General, Bartholdy, in Rome (1816–1817), and thereafter frescoes in the Casino Massimo. Cornelius was the only member of the group to work on a monumental scale, from 1818 in Munich and then in Berlin.

Still, in pursuit of their ideal of a revitalized religious mural painting, for a few decades the Nazarenes received greater international attention than any other movement in German Romantic art. Their significance for cultural history lies not least in their contribution to a rediscovery of German medieval and early Renaissance painting, which, for example, was given a prominent place in the museum by Philipp Veit, director of the Städelsches Kunstinstitut in Frankfurt from 1830.

Apart from the two key movements mentioned, there were many other German artists who pursued Romantic or partially Romantic aims on their own. The two most significant were Karl Blechen (1798–1840) and Carl Anton Joseph Rottmann (1797–1840). Blechen, after an early influence from Friedrich, gradually developed a more realistic and daring plein air approach to landscape (ill. pp. 62, 63). Rottmann's idealistic landscapes (ill. pp. 60, 61) developed from Romantic beginnings into a monumental picturesqueness, a dramatic, painterly approach that ultimately eludes stylistic classification.

After the fall of Napoleon, Metternich marshalled the forces of restoration at the 1815 Congress of Vienna, and the "Carlsbad Edicts" led to a "persecution of demagogues," that

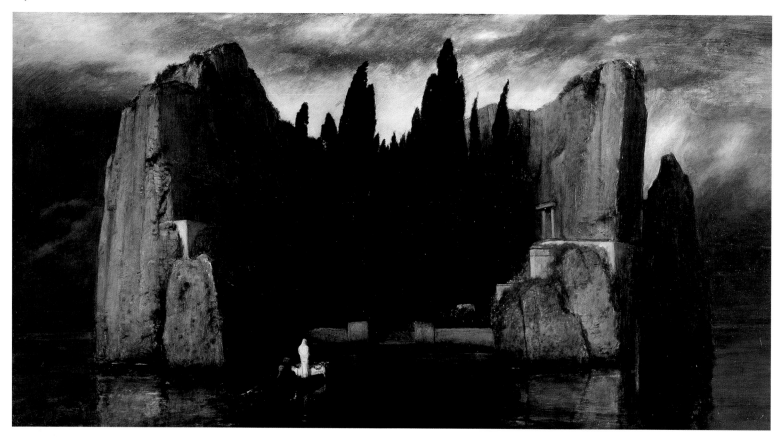

Arnold Böcklin
The Island of the Dead, 1883
Oil on wood, 80 x 150 cm
Berlin, Nationalgalerie, Staatliche Museen
zu Berlin – Preussischer Kulturbesitz

is, of university staff and journalists suspected of fomenting revolution. The two great German powers – the Austrian empire and the Prussian monarchy – maintained the old feudal and clerical prerogatives, as the congeries of small and miniscule states cultivated a mind set of submissive parochialism. Not until the German Uprising of March 1848 – the same year as Marx and Engels published their Communist Manifesto – would the parliamentary idea enjoy a brief heyday.

However, the preceding "Vormärz" period had seen the defeat of the great national and democratic tendencies, as the bourgeoisie ensconced itself in submissive humility and forsook the public sphere for the private. In 1848, Victor von Scheffel (1826–1886) published two poems in the Munich satirical magazine *Fliegende Blätter* whose titles translate as "Biedermann's Cozy Evenings" and "Bummelmaier's Lament." A few years later some other author telescoped these into "Biedermaier," a pseudonym under which he launched a vitriolic attack upon the petty bourgeois complacency of the pre-1848 period. This philistine "new inwardness" also suffused the painting of the time, which can be characterized not so much in terms of a definite style as in terms of its underlying attitude. It was humble and unambitious, expressing itself in small-format compositions for sitting rooms, featuring tightly framed portrayals of local landscapes or towns with figurative staffage, or in individual and group portraits infused with reserved if somewhat prosaic dignity. It was in such work that Biedermeier painters gave their best.

Romanticism blended seamlessly into Biedermeier. This is just as true of the genre scenes in constricted interiors painted by Kersting as it is of the landscapes and fairy-tale subjects done by Adrian Ludwig Richter (1803–1884) and Moritz von Schwind (1804–1871). In paintings that have lost none of their general appeal even today, Richter transformed the early Romantic, cosmically evocative landscape of the soul into the "garden arbour idyll," a genre named after the then popular household journal, *Die Gartenlaube.* In Richter's pictures, nature enfolds people like a charming ornament, a domesticated nature in which they feel just as at home as within their own four walls. Peace and quiet is the prime civil right; and where better to find it than out of doors, though not so far out of doors that one loses sight of home. Too much strangeness or unfamiliarity would have disturbed one's recuperation after a long day at the mills. Two of Richter's print sequences were indicatively titled *Beschauliches und Erbauliches* and *Fürs Haus,* or *Things Tranquil and Edifying* and *For the Home.*

Even greater popularity was attained by Schwind, be it through his frescoes in the Munich Residence (begun 1832) and a series of watercolor designs for Hohenschwangau Castle, for the Wartburg in Thuringia (begun 1853) or for

the Vienna Opera House (begun 1866), or be it through his fairy-tale cycles and paintings such as *Rübezahl* of 1851–1859. The most popular and beloved Biedermeier artist of all, however, was Carl Spitzweg (1808–1859), whose whimsical visual anecdotes, for all their idyllic character, tacitly caricatured the narrow-mindedness of his fellow citizens. His humorously ironic themes should not blind us to the free, well-nigh impressionist paint handling that came to the fore especially in Spitzweg's late period.

The Romantic vision of a continual progress from the finite to the infinite entailed a rejection of every self-contained, classical view of the world, in favor of both formally and substantially open compositions. Many of the artists' contemporaries dismissed this openness as being tantamount to mere indulgence in mysticism. A number of Romantic artists in fact became tragic outsiders. The failure of their utopian goals plunged them into melancholy, into a cult of friendship with a handful of kindred spirits, into a retreat to solitude in nature. At such existential extremes, these attitudes remained limited to the "pure" Romanticism of the first two or three decades of the century. Still, Romantic traits continued to suffuse a large part of German painting throughout the nineteenth century, being present in the Biedermeier, but above all in the more naturalistic landscape tendencies to follow.

The final third of the century, however, witnessed a true burgeoning of the Romantic attitude. Examples are the paintings of Arnold Böcklin (1827–1901; ill. p. 24)), shot through with melancholy, a mood of death, and mythological symbolism, as well as and especially the artistic program of the Bavarian "fairy-tale king," Ludwig II. In the spirit of Richard Wagner's musical dramas, Ludwig began in 1868 to have his neoromantic Neuschwanstein Castle decorated with scenes from *Tristan and Isolde, Lohengrin, Tannhäuser,* and *Parsifal.* Though the Romantic attitude does not fully explain Ludwig's palaces, it does explain his immersion in a built dreamworld, as well as his wish that it be demolished after his death.

But there can be no doubt that all this was a far cry from early German Romanticism around 1800 and its political and prophetic aspects. Now Romanticism merely served as a means of escape from a disenchanted reality, and into the magic realm of distant times and climes, an escape in which the nouveau riche bourgeoisie increasingly began to participate from 1850 onwards. Sitting rooms were plunged in dimness by pseudo-oriental curtains that kept banality at bay; knick-knacks and travel souvenirs embodied middle-class visions of escape and meaning, or reminiscences of a medieval era of leaded-glass and knight's manors. Home was a place for reverie, while real life took place outside, in the counting-houses and mills, the barracks and government offices.

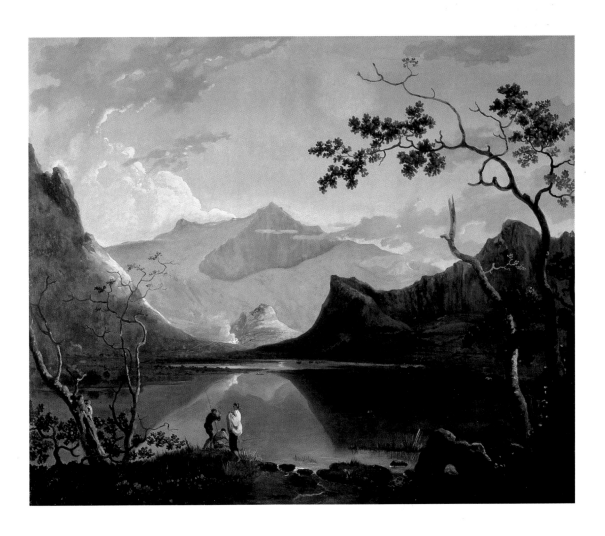

Richard Wilson
Snowdon, c. 1770
Oil on canvas, 101 x 127 cm
Nottingham, Castle Museum and
Art Gallery

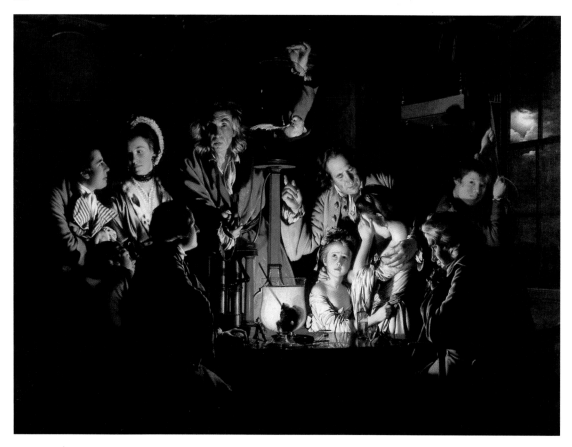

Joseph Wright of Derby
The Experiment with the Airpump,
1768
Oil on canvas, 183 x 244 cm
London, National Gallery

Great Britain

The nineteenth-century English Romantics, as I noted above, were able to recur to an incomparably rich heritage of romantic tendencies in the art of the foregoing period. The landscaped garden was a repository of picturesqueness and sentiment, and its exotic accoutrements conveyed a longing for the charm of the faraway and byegone. The neo-Gothic structures or ruins with which the gardens were fitted out were often associated with the settings of those tales of terror whose Gothic Romance tradition continued without interruption into the industrial century.

In the Ossian epic, in Milton's *Paradise Lost,* and in Young's *Night Thoughts,* Britain had produced literary works whose mythicizing and demonizing of Christian themes and exploration of the depths of the human psyche were to make them unfailing sources for all of Continental Romanticism. The highly regarded Shakespeare belonged inalienably to the cultural heritage of a nation which, in Burke, could also boast the foremost propagator of the sublime. With the doctrine of sensualism, English philosophy at the start of the eighteenth century had paved the way for the psychological penetration of human art and culture.

Like no other nation, England forced the transition from manual craftsmanship to mass production based on a division of labor. Despite Adam Smith's (1723–1790) complaint, in 1763, that this caused what we today would call a dumbing down of workers, the Industrial Revolution was inexorably underway. It led to an enormous growth of cities, complete with slum housing for the equally rapidly growing prole-tariat. The more brutal working life and the conditions of existence became, the more writers and artists reacted to the prosaic and impoverished industrial world by celebrating the power of the imagination and individual creativity. When the Frenchman Philippe Jacques de Loutherbourg, a painter of dramatic natural sceneries who settled in London in 1771, began to lend the new industrial plants a grandiosely sinister effect, he both demonized and romanticized them, a reaction to the new situation shared by many artists in England.

In a picture like *The Experiment with the Airpump* of 1768 (ill. above), Joseph Wright of Derby (1734–1797) summed up the intentions behind the art of the era in an exemplary way. The well-nigh demoniacally emphasized experimentor in the center has just created a vacuum in a glass receptacle. To him falls the godlike decision whether or not to revive the laboratory animal, a pigeon that has already collapsed. In the faces of the spectators of this nocturnal spectacle are reflected, depending on age and degree of sensibility, a range of feelings extending from curiosity and fascination to sadness and concern, from an acceptance of the new possibilities of science to their rejection.

A broad current of imaginative, fantastic – in a word, pre-Romantic – paintings flows through English art of the eighteenth century. A few examples will have to suffice for many: the landscapes of Richard Wilson (1714–1782; ill. p. 25), the pictures of John Runciman (1744–1768), and those of an American artist working in England, Benjamin West (1738–1820).

Johann Heinrich Füssli (1741–1825), a Swiss who as Henry Fuseli lived in England from 1778 until his death in 1825, illustrated Dante, Milton, and Shakespeare, and, after 1800, the Nordic saga of the *Edda,* the *Nibelungenlied* (ill. below), and Friedrich de la Motte Fouqué's fairy-tale *Undine*. But he was best known for his various versions of the Nightmare (ill. p. 69), in which the unreal and eerie were given compelling form. Figments and outgrowths of the imagination determined Fuseli's œuvre and led, in his paintings, to distortions of the classical canon and an abandonment of familiar spatial logic.

The transition to a demoniacal Romanticism took place in his work almost to the extent that it did in that of William Blake (1757–1827). Blake was both poet and painter, providing superb and idiosyncratic illustrations to his own writings, to editions of the Bible, and to the works of Dante, Milton, and Young (ill. p. 70). He has justifiably been called the great myth-creator and visionary of English Romanticism. The creative and destructive passions of the human soul, capable of throwing open the doors to Heaven and Hell, were the forces underlying Blake's compositions, which burst through formal conventions even more strongly than Fuseli's.

In the field of landscape painting the transition from the eighteenth century to Romanticism took place more gradually, and initially in a concentration on much more peaceful moods. With landscape views in oil or watercolor, artists projected another type of counterworld to the Industrial Revolution, a world in which the schism between man and nature seemed to have been overcome.

The point of departure for this development was the eighteenth-century fashion of rounding off the education of young aristocrats by a journey to Italy. Often they were accompanied on this Grand Tour by watercolorists, whose series of pictures served a purpose not unlike the tourist snapshots of today. Travels to picturesque attractions, as well as a new interest in the moods of local sites and sceneries, led to an unprecedented upswing in English landscape painting from about 1800 to 1840.

Among the artists involved, such as Thomas Girtin (1775–1802), followed by John Crome (1768–1821), Richard Parkes Bonington (1802–1828), and John Sell Cotman (1782–1842), the outstanding figure was John Constable (1776–1821), whose atmospheric depictions of the natural scene, rendered in loose, unconventional brushwork, excited Delacroix and Théodore Géricault (1791–1824), and later influenced the masters of Barbizon and even the Impressionists.

Yet greater than them all was William Turner, whose motifs dissolved in sheer color and light were passionately defended against their detractors by John Ruskin (1819–1900), the leading theoretician of Romanticism in England, in his 1843 book *Modern Painters.* Turner, member and professor of the Royal Academy, initially oriented himself to the classical

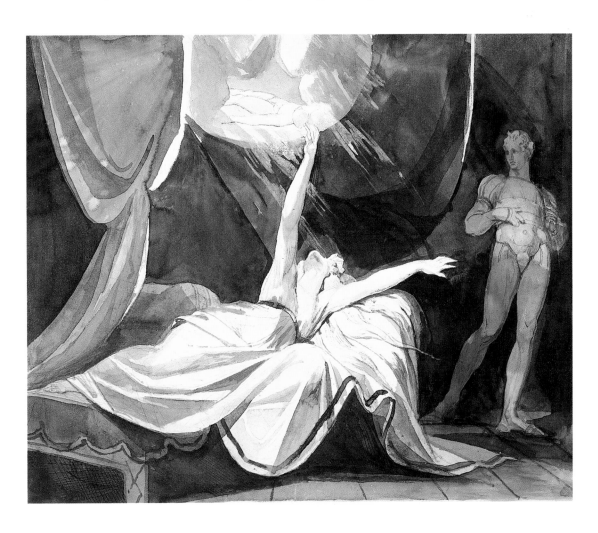

Henry Fuseli
Kriemhilde Sees the Dead Siegfried
in a Dream, 1805
Pencil and watercolor, 38.5 x 48.5 cm
Zurich, Kunsthaus Zürich

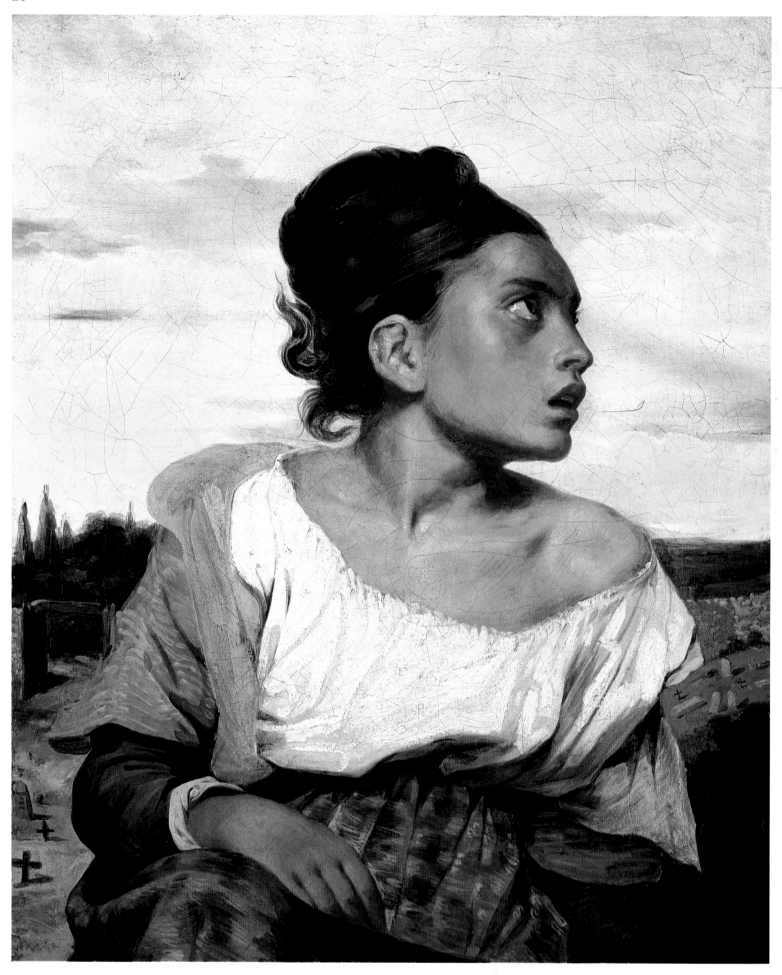

Eugène Delacroix
Orphan Girl at the Cemetery, 1824
Oil on canvas, 66 x 54 cm
Paris, Musée du Louvre

landscape style of Claude Lorrain, as well as to Burke's reflections on the beautiful and the sublime. In 1802 he took his first journey to the Continent, to Switzerland. Two years thereafter Turner opened his own gallery, and began to make ever more daring experiments in watercolor and drawing that culminated in the virtuoso sophistication of his late work. In the course of his career, based on Goethe's color theory, Turner developed a revolutionary handling of light and color, producing textures and structures that had an impressionistic, sometimes practically abstract effect, as seen particularly in the Venice paintings of the 1840s. Turner looked upon unbounded nature as an insoluble mystery, which he envisioned in a series of mythical landscape scenes in terms of cosmic destiny. Seeing the universe as extending between the poles of light and darkness, he found visual correspondences to the processes of creation and destruction, birth and decay, of a visionary power that far surpassed the poetic landscapes of other Romantic artists.

As in Germany and other countries, later Romantic painting in England tended to drift into the uncommittal, or attempted to make up for a dearth of profundity by theatricality or melodrama. A case in point are the compositions of John Martin (1789–1854), which often seem forced and occasionally recall the pomp of Hollywood technicolor movie epics (ill. p. 71).

Yet with the Pre-Raphaelites, England experienced a belated but impressive culmination of the Romantic approach. In the 1820s, under the leadership of Benjamin Robert Haydon (1786–1846), a few admirers of Blake founded a secluded artists' society. Like the German Nazarenes, of whom they were aware, these artists rejected modern materialism and, recurring to Italian Early Renaissance painting before Raphael, they emulated the religious fervor of the Middle Ages.

These were the premises on which the Pre-Raphaelite Brotherhood was founded in London in 1848. An anti-academic protest united artists such as John Everett Millais (1829–1896), William Holman Hunt (1827–1910), and the brothers William and Dante Gabriel Rossetti (1828–1882) into a group that lasted until 1853, and whose aims were shared, though they were not official members, by William Dyce (1806–1864), Edward Burne-Jones (1833–1898) and Ford Madox Brown (1821–1893).

All of these artists adopted themes of deep symbolic and socially relevant meaning, which they found preformulated in medieval legends and literature, in the Bible, and in Shakespeare. Their ideals, however, were not exhausted in a retrospective view, for they grew out of an earnest moral involvement with the conditions of the contemporary age. In an antiquarian and allegorical guise the Pre-Raphaelites addressed, for instance, morbid psychological and sexual themes that to Victorian moralism were taboo. This lent their pictures a unique tenor, a blend of evocative symbolism

with intense color combinations recalling Gothic stained glass, and an incredible fidelity to detail in the drawing. Such an unconventional combination of social message with realistically observed objects and lighting effects was also propagaged by John Ruskin, the most influential English critic of the nineteenth century, who defended the Pre-Raphaelites in these terms against their many critical detractors.

The works of the Pre-Raphaelites are located between romantically escapist musing, idealistic ethics, and a realistic interpretation tending almost to the surreal. Their fidelity of detail combined with intense palette and ornamental composition found application in the latter half of the nineteenth century in the decorative arts of England. Brown, Burne-Jones, Rossetti and others supplied product designs to the firm established in 1861 by the social reformer William Morris (1834–1896). The founder of the Arts and Crafts Movement envisioned a revival of solid, handmade home furnishings to supplant the shoddy, mechanically mass-produced merchandise of the day, and with his associate artists developed an ornamental approach that would become a forerunner of Art Nouveau.

France

France, too, produced artists and works in the eighteenth century that seemed to anticipate Romanticism proper, for instance the dramatic seascapes of a Vernet, several of the history paintings of François-André Vincent (1746–1816), or a few of the depictions of ruins by Hubert Robert (1733–1808).

The writings and novels of the philosopher Jean-Jacques Rousseau exerted an enormous influence on European thought. Rousseau argued that with the advance of civilization, humanity had let itself in for continually worsening symptoms of decay and degeneration. His famous cry, "Back to Nature," did not mean returning to man's primitive beginnings, but it did draw fresh attention to everything primitive and archaic. And it basically implied the same thing as the widespread appeal to overcome the alienation of man from nature, an alienation described and decried by Denis Diderot, Enlightenment philosopher and co-editor of the *Encyclopedia.* It was precisely its emphasis on reason that enabled the French Enlightenment to arrive at new insights into individual psychology on the one hand and nature on the other. Besides advances in empirical science, it helped paved the way for new sensibilities in the arts.

This development in the direction of Romantic attitudes, however, was interrupted in 1789 by the French Revolution. The artists who served it could not, or would not, countenance any journey into the mysterious depths of the individual mind, for it was more important to champion the victorious republican ideals and supply visual propaganda for

Jean-Pierre Franque
Bonaparte in Egypt, Urged to Return by a Vision
of Conditions in France, 1810
Oil on canvas, 261 x 326 cm
Paris, Musée du Louvre

collective political goals. In terms of content, this painting adopted the ancient Roman catalogue of virtues, and conveyed these in formal terms by means of a rigorously composed neoclassicism and in the medium of history painting. When Napoleon launched into his campaign to vanquish all Europe, teeming history works or allegories continued to be employed to celebrate the triumphs of the commander, and subsequent emperor, and his armies. Although this celebratory intent occasionally led to a sort of romanticizing of the image of Napoleon, the beginnings of French Romanticism shortly after 1800 developed in opposition to the emperor and to the neoclassical, Empire style officially propagated by him.

Chateaubriand and Germaine de Staël were among Napoleon's most outspoken critics. Madame de Staël advocated taking German Romanticism as the model of a universalism that transcended all petty power politics and, in the artistic field, as a way to overcome "anemic" neoclassicism. How difficult this proved to be, however, is shown by the long and successful career of the foremost neoclassicist, Jean Auguste Dominique Ingres (1780–1867). On first view, his 1862 painting The *Turkish Bath* (ill. p. 102) may appear to bear traces of exotic, oriental romance. Yet the extreme precision of its graceful lineatures, the smoothness of the cool surfaces of color, and the formal purism of the whole, would seem to exclude any deeply felt emotion, any tendency to Romanticism in the narrower sense.

The Salon exhibition of 1827 was extolled in France as marking the victory of true Romanticism over neoclassicism. Yet the extent to which the French version differed from those of Germany or England may be seen from the work of

its two main protagonists, Géricault and Delacroix. Both were profoundly painterly painters, and both were brilliant geniuses who, like all greats in art history, are by nature difficult to categorize in terms of any one style. And both bypassed the landscape genre so preferred throughout the rest of Europe, and turned instead to the history painting. The pathos of their compositions built on color and light, but unlike early history paintings, theirs often focussed on the nameless hero, the individual involved in fateful events or disastrous circumstances. Especially Delacroix, with his liberated, sensitive paint application, with coloristic pictorial symphonies which largely baffled contemporary audiences, achieved an intensity whose effects were still felt among the Impressionists, and ultimately by Vincent van Gogh, Paul Gauguin, and Paul Cézanne. Even in his highly dramatic subjects, set in the distant past, Delacroix was not concerned with mere fantasy or theatricality, but solely with human passions, which he believed were the catalyst behind historical developments.

The accusation of empty posing, sentimentality, and pathetic national pride can be aimed with more justification at the history paintings of Eugène Devéria (1805–1865) or Paul Delaroche (1797–1856; ill. p. 108), which well served the taste of the petty bourgeois masses for "the interesting," for an escape from the drudgery of everyday life. The orientalism which was concurrently the fad in France, as well as the genre of Italian folk scenes, produced in their finest examples a new, painterly transformation of subject matter which bore a certain affinity to the discoveries made in English landscape painting, though the weaker examples did not go beyond a superficial sentimentalism.

Jean-François Millet
The Angelus (Evening Prayer), c. 1858/59
Oil on canvas, 55.5 x 66 cm
Paris, Musée du Louvre

Gustave Courbet
The Painter's Studio, 1855
Oil on canvas, 359 x 598 cm
Paris, Musée d'Orsay

Landscape became a central concern of nineteenth-century French painters only belatedly, but with all the more impact. The School of Barbizon, led by Camille Corot (1796–1875), often populated their gauzily rendered slices of the natural scene with mythological figures, intended to embody both an archaic and a utopianly envisaged unity of man and nature. These were counterimages to touristically accessible, more or less fleetingly viewed scenic attractions, as well as standing in opposition to nature ravaged by economic exploitation and development. Employing the means of plein air, open air or outdoor, painting, the Barbizon landscapes represented more an overture to Impressionism than a form of Romanticism, despite their evocation of the moods and atmospheric changes in nature.

At the same time, French painting was dominated by a sociopolitically oriented Realism in which a distant echo of Romanticism could occasionally be heard, as in Jean-François Millet's (1814–1875) *Angelus* (ill. p. 30), which struck contemporary critics as the quintessence of sentimental melodrama. In fact, if a comparison be sought, one finds closer parallels to this peasant family at its evening prayers in the Biedermeier work of Ludwig Richter than in the universalism of early Romanticism around 1800. The great Gustave Courbet (1819–1877) cannot be accused of sentimentality,

but perhaps it was something of the late Romantic heritage that led him to place at the very center of his grand allegory on his political, cultural, and artistic environment, *The Painter's Studio* (ill. above), a moody landscape on which he is just working, watched by a small boy and a nude model, personifications of unspoiled natural life.

Romantic Painting in other European Countries

As the previous review has shown, Romantic painting was doubtless centered in Germany and England, where, in the field of landscape painting especially, theoreticians' advocacy of the liberation of the individual from social constraints and his becoming one with the universe found clearest expression. France, on the other hand, evinced a quite unique development in which genre and history pictures predominated and to which stylistic classifications are very difficult to apply. This difficulty also often confronts us when we look further, to the painting of other European countries.

Scandinavia, however, poses no problem in this regard. The source of Romanticism there was the Copenhagen Academy. Although Nicolai Abraham Abildgaard (1743–1809) was a friend of Fuseli and Alexander Runciman in Rome, and adopted many of their subjective traits and formal distortions

to increase the expressiveness of his motifs, he nevertheless ran his academy classes along largely neoclassical lines. The academy's director, Jens Juel (1745–1802), was likewise beholding to this tradition, yet in small landscapes done around 1800 (ill. p. 117) he anticipated the naturalism that would soon come to the fore in Germany, in the work, for instance, of Wilhelm von Kobell (1766–1856). The Copenhagen Academy was able to provide key German Romantics, Friedrich and Runge, with a training the excellence of which they continually emphasized. Also, it was there that their first contacts were made with the indubitable master of Scandinavian Romantic painting, the Norwegian Johan Christian Clausen Dahl, who in 1818 settled in the immediate neighborhood of his friend, Friedrich, in Dresden and frankly admitted that Friedrich was his ideal.

Belgian Romanticism, as far as one can speak of such, was limited entirely to the field of history painting. Its leader, Gustave Wappers (1803–1874), whose works caused waves of enthusiasm not only in his homeland, was content with a patriotic concentration on the history of Flanders, unlike, say, the painters of early German Romanticism, who attempted to combine national consciousness with universalistic aims. Accordingly, Wappers had no qualms about imitating Rubens. He was surpassed in this by Antoine Wiertz (1806–1865), whose admiration for the great Flemish master took on veritably pathological character. In the Netherlands, too, the work of Wijnand Jaan Joseph Nuyen (1813–1839), to name only one, documented the extent to which Romantic tendencies in the Lowlands were linked with a recurrence to national painting of the Baroque.

It is a strange phenomenon that Spain and Italy remained largely unsusceptible to the Romantic attitude, which would seem to support the argument that the movement was largely a "Nordic" one after all. At the turn of the eighteenth to the nineteenth century, Spain possessed, with Francisco de Goya (1746–1828), one of the most outstanding figures in the history of European art (ill. p. 33). Only in its Rococo beginnings is Goya's work classifiable in stylistic terms, for its later phases are marked by sovereign originality. Nor can Goya be called a Romantic by any stretch of the term. Still, the way in which, in paintings and prints, he pilloried human stupidity and superstition, the clerical narrow-mindedness of his countrymen, the degeneracy of the Spanish royal family, the barbarian depths to which both individuals and fanatic masses sank in the war against Napoleon's troops, and the visions and nightmares with which Goya filled his Madrid house around 1820 – all of these exist in an orbit not unfamiliar to Romanticism. Yet obviously Goya's views about the world and humankind were too merciless, too harsh, to trigger any merely pleasurable sense of horror. By comparison to his attitude, Romantic "Weltschmerz" has the look of superficial cant.

Spanish artists such as Leonardo Alenza (1807–1845) and Eugenio Lucas y Padilla (1824–1870) subsequently exploited Goya and romanticized him, whereas Francisco Lameyer (1825–1854) and Jenaro Pérez Villaamil (1807–1854) took their cues from the landscape painting of English Romanticism.

Italy, the prime land of Romantic yearnings, was like Spain in only very gradually opening itself to the movement. In the first place, the classical heritage, including poets like Dante and Tasso, who were elsewhere considered "anti-classical," still carried too much weight there. And second, Italian painting had long lost its international rank by around 1800. Nevertheless it had still had artists like Tommaso Minardi (1787–1871), whose brilliant early work combined harsh realism with empathy, and Francesco Hayez (1791–1881), whose accomplished neoclassical figure paintings were suffused with restrained emotion. Those were roughly the poles between which Italian Romanticism, including an artist like Giovanni Migliara (1785–1837), moved. Then there were the "Purists," with Luigi Mussini (1815–1888) at the helm. Orienting themselves among other models to the German Nazarenes, this group published a manifesto in Rome in 1843 in which they advocated a return to quattrocento painting. Another indication that in Italy, as throughout Europe in the nineteenth-century, Romantic tendencies surfaced again and again and suffused a great variety of other developments.

A link between Russia and the pacesetting centers of European history painting was formed by Karl Pavlovic Brüllow (1799–1852). With *The Last Day of Pompeii* (ill. p. 115) Brüllow created a melodramatic, apocalyptic vision that was enthusiastically described by Alexander Pushkin (1799–1837) and Nikolai Gogol (1809–1852), who, like many of their countrymen, saw the painting as at long last bringing Russian art up to international standards. While Romantic reverberations were felt in the work of Alexei Venezianov (1780–1847) and Alexandr Ivanov (1806–1852), Russian painting as a whole, apart from historical themes, soon turned to a naturalistic depiction of everyday life, which occasionally had emotional and sometimes even sentimental traits without really striving for a Romantic liberation of individual feeling. Similarly to developments in Russia, the tentative emergence of Romantic painting in Poland – Piotr Michałovski (1800–1855) deserves mention here – was increasingly overborne by realism from the 1830s onwards.

Raden Saleh Ben Jaggia (c. 1801–c. 1880/81), a Javanese prince, studied painting in Holland and travelled through Europe from 1841 to 1846. Initially influenced by Delacroix, he was deeply impressed, when he came to Dresden, with Dahl, and with him the Friedrich school. With Ben Jaggia's return to Batavia the spirit of German Romanticism was wafted to a distant, exotic land of the kind to which it had always felt attracted – and that not only theoretically.

Francisco de Goya
El Gigante, c. 1808/09
Oil on canvas, 116 x 105 cm
Madrid, Museo Nacional del Prado

Romantic Painting in the United States

When the Pilgrim Fathers left England for America to escape religious persecution in the early seventeenth century, they not only brought their settlements to the New World but also their doctrine of salvation. They envisioned creating a Nation of God in New England, or New Canaan, as they called it. Their emigration, their passage through the wilderness, the foundation of a Kingdom of God on earth, bore parallels in the Puritans' minds with the Exodus of the Jews to the Promised Land. New England was part and parcel of the Christian history foreordained by the Lord; the settlers claimed the privilege of being a chosen people, and their belief in a possible earthly paradise determined their vision of America's destiny. In consequence they propagated the American present as the point of departure for an unlimited secular progress.

Ideas of this kind retained their underlying validity in many subsequent guises. Wild and unspoiled nature, in particular, figured in America as a sublime manifestation of divinity. It was revered with well-nigh religious fervor and at the same time raised to a patriotic symbol.

This perhaps explains why, around 1800, landscape became the preferred medium of Romantic painting in the United States, as well as an emblem of America as an earthly paradise. Painters there frequently took as their model Claude Lorrain, with his prospects leading the eye to an idealized and hazy horizon, and his moods of color and light that evoked a paradise in the here and now.

Claude's arcadias were transformed into a vision of America. It was in this vein that Thomas Cole (1801–1848), an emigrant from England who founded the Hudson River School, extolled the New World wilderness as a divine creation in his 1836 "Study on the American Landscape." In the same vein, Cole's pupil Frederic Edwin Church (1826–1900), in his 1857 painting *Niagara Falls* (ill. pp. 130/131), raised the natural wonder to a symbol of the political energy of "God's own" people and their country. In parallel, Cole's pictures of the South American tropics presented the spectacle of an exotic paradise. At the same period, the German-born Albert Bierstadt (1830–1902) discovered the American West for painting in romantically visionary compositions.

Yet the artistic appropriation of the frontier West or the tropics also had an escapist aspect, because the more unspoiled regions in the United States were overrun by civilization, the more artists had to turn to exotic landscape preserves if they wished to continue dreaming the dream of a "promised land," to continue to believe in the Romantic utopia of a reconciliation between elemental nature and modern man.

PHILIPP OTTO RUNGE

1777–1810

The Lesson of the Nightingale is the major work of Runge's Dresden period. Its theme goes back to Klopstock's ode, *Die Lehrstunde*, verses from which are inscribed in the oval frame of the central field.

The work employs the age-old device of the "picture within a picture." The central, colored medallion field is encompassed by a wide rectangular frame imitating a reddish-brown wood relief. At the top, surrounded by oak leaves, a symbol of hope and revival, Amor plays his lyre. On the left rise lily stems from which a winged putto emerges, as does another on the right from a rose bush. At the center of the lower edge of the frame, a dragonfly rests with outspread wings. Depicted in a forest clearing in the medallion is a figure, Psyche and nightingale, whose facial features are those of Runge's bride, Pauline. Before her is the boy Amor with flutes in his hands, and behind her a child is asleep in the dark forest.

The musical harmony between figures and nature is intended to attune the heart to love. The ancient myth of Amor and Psyche merges into a communion with nature, and at the same time becomes an allegory of Runge's own love for Pauline.

When the prospect of an altarpiece for Greifswald opened for him in the early summer of 1805, Runge chose *The Rest on the Flight into Egypt*, that traditional motif of Christian art, and completely reinterpreted it to convey his personal myth of a dawn of humanity. The perfect purity embodied here reflected a desire, felt by so many Romantic artists, to visually recreate the whole world, as it were from a *tabula rasa*.

As in no other picture by Runge, the atmospheric landscape with its mountain chains receding into the background plays a key role in the overall composition. It has a Mediterranean character, and yet also bears traits of the Baltic Sea island of Rügen, a favorite goal of Northern German Romantic artists.

Joseph and the donkey are seen from a relatively low vantage point, darkly silhouetted against the empty sky – an allusion on Runge's part to a declining, "unenlightened" age. The baby Jesus, lying on Mary's shawl, seems himself to radiate light as the first rays of the sun converge on his raised hand. The scene symbolizes the paradise of a world in the freshness of dawn, a world in which, though already civilized with gardens, pyramids and palaces, is promised a new beginning with flowering magnolias and a tree of life, just as the luminous red of Mary's dress alludes to the color-engendering power of light. A boy angel in the flowering tree greets the rising sun with strains of his harp, as a second presents to the Christ Child a white lily as symbol of innocence and of bringing light to the world. As night passes, the campfire in front of Joseph dies down. The man, embodying the moribund era of the Old Covenant, turns his back on the sun, but the woman, Mary, turns toward it and hence toward the New Covenant, centered in the radiant being of the Redeemer.

Philipp Otto Runge
The Lesson of the Nightingale (second version), 1804/05
Oil on canvas, 104.7 x 85.5 cm
Hamburg, Hamburger Kunsthalle

Philipp Otto Runge
Rest on the Flight into Egypt, c. 1805/06
Oil on canvas, 196 x 131 cm
Hamburg, Hamburger Kunsthalle

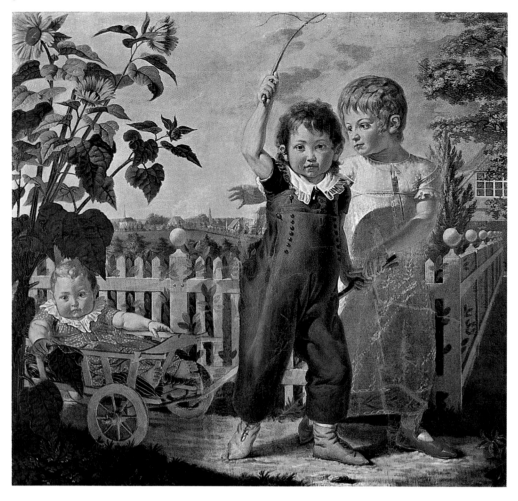

Philipp Otto Runge
The Hülsenbeck Children, 1805/06
Oil on canvas, 131.5 x 143.5 cm
Hamburg, Hamburger Kunsthalle

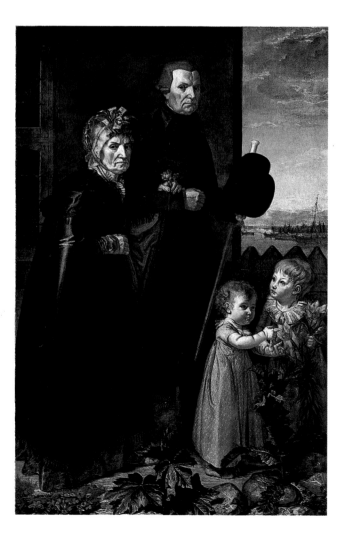

Philipp Otto Runge
The Artist's Parents, 1806
Oil on canvas, 196 x 131 cm
Hamburg, Hamburger Kunsthalle

PHILIPP OTTO RUNGE
1777–1810

Friedrich August Hülsenbeck was the business partner in Hamburg of Runge's brother, Daniel. Runge painted three of Hülsenbeck's children at play in front of their summer house in Elmsbüttel, outside Hamburg. The picture shows Hülsenbeck's son, Friedrich, seated in a wagon, being pulled by Hülsenbeck's only daughter, Maria, as their brother, August, brandishes a whip. The children move in parallel to the picture plane towards the edge of the garden fence, which suddenly recedes into the background towards the summer house. In terms of adult scale, the fence appears much too low by comparison to the looming figures of the children. Herein lies the great achievement of this children's portrait, which avoids cuteness and the conventional adult perspective of this genre. Instead, the spectator is placed on a level with the children, whose activity takes on the character of a physical, nature-given force.

This painting was done when Runge's parents were sixty-nine years of age. They are depicted together with their grandchildren. The children appear on the lighter side of the composition, with a view over a river valley and proliferating plants. Their grandparents, whose features have grown similar in the course of a long, shared life, are shown in front of a dark house wall, a bit weary, their time on earth nearing its end. The salient feature of the group portrait, however, is its character of an allegory of life, associating its end with its beginning, night with dawn.

Morning was originally intended as part of a painting sequence on the times of day, as evidenced by a series of preparatory drawings and etchings. The four planned paintings were to encompass, moreover, the themes of the seasons, the ages of life, and the human temperaments, and were envisioned as monumental decorations for a central building whose design would be based on plant forms.
 In the central field of the small version of *Morning*, which was followed a short time later by a larger version in oil (fragment; Kunsthalle, Hamburg), a nude female figure rises above the sea, which extends beyond a plain dotted with flowers and bushes. This figure, alluding to Venus and Aurora as well as to the Virgin, ultimately embodies the forces of nature striving toward the sunlight. From her right hand, directly over her head, a lily with pairs of embracing children seems to grow. Above this appears a star with three cherub's heads. The child lying on the ground – Eros and Christ Child in one – may be interpreted as representing a pure incarnation of light. The painted frame bears more depictions of children and plants, which, with the interior image, Runge said represented "the limitless illumination of the universe".

Philipp Otto Runge
Morning (first version), 1808
Oil on canvas, 109 x 85.5 cm
Hamburg, Hamburger Kunsthalle

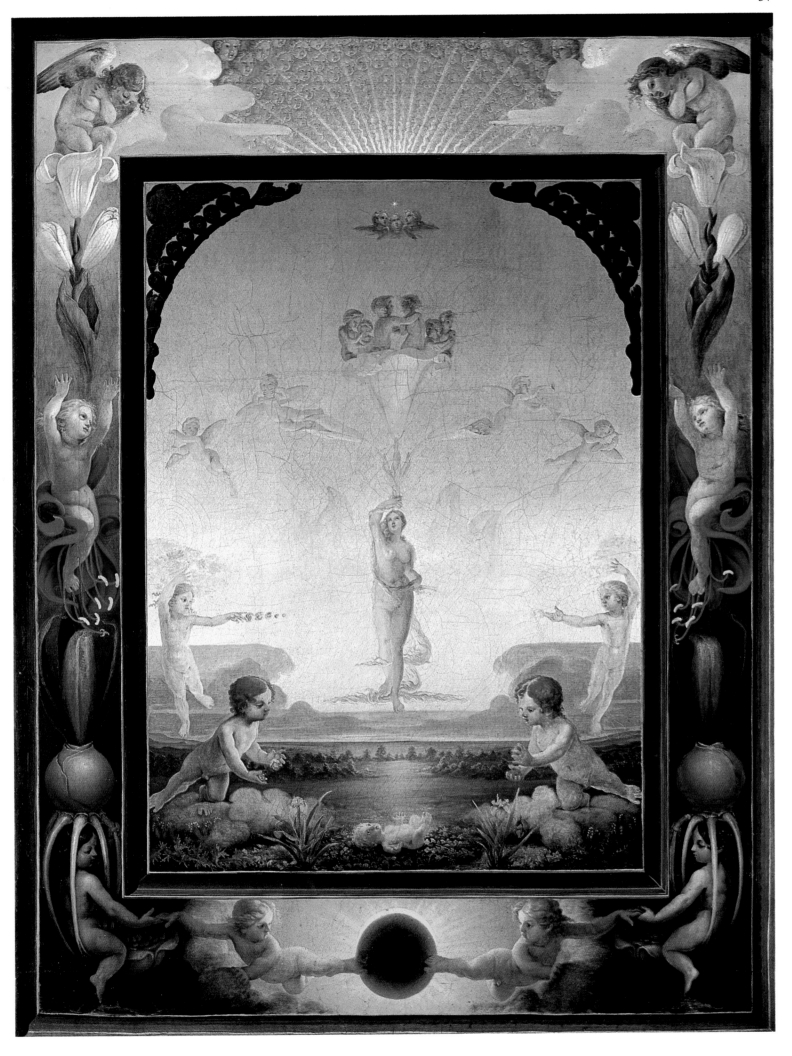

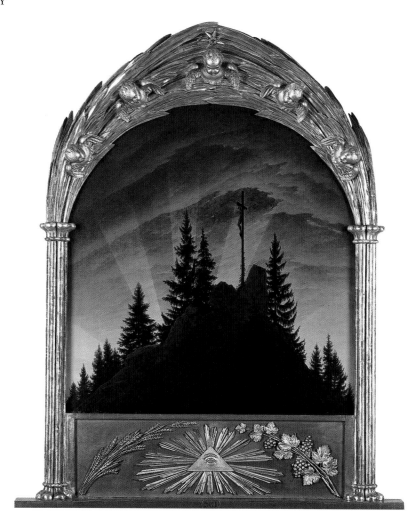

Caspar David Friedrich
The Cross in the Mountains (Tetschen Altarpiece), 1807/08
Oil on canvas, 115 x 110.5 cm
Dresden, Gemäldegalerie Neue Meister, Staatliche
Kunstsammlungen Dresden

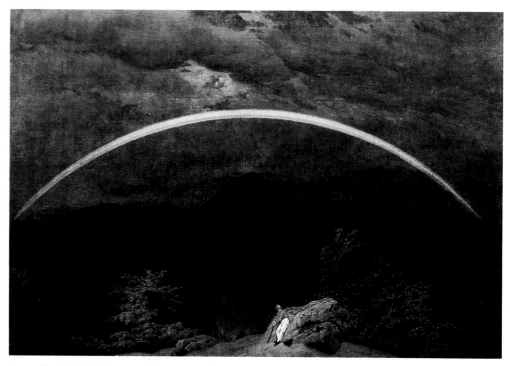

Caspar David Friedrich
Mountain Landscape with Rainbow, c. 1809/10
Oil on canvas, 70 x 102 cm
Essen, Museum Folkwang

CASPAR DAVID FRIEDRICH
1774–1840

The *Tetschen Altarpiece* was the first oil painting
Friedrich publicly exhibited. Prepared by a few
drawings, the composition emphasizes flatness
and lucid frontality. Friedrich's eschewal of al-
most all effect of depth, his indifference to
classical perspective as to nearly every other
rule of traditional landscape painting, drew
acerbic criticism at the time, which was
summed up in a now famous polemic written
by the classically trained Freiherr von Ram-
dohr. Yet Friedrich had no intention of paint-
ing a conventional landscape.

Contrary to the often-repeated statement
that the painting was intended as an altarpiece
for the chapel of the castle in Tetschen, Bo-
hemia, Friedrich originally wished to dedicate
it to King Gustav IV Adolf of Sweden. At the
time Gustav Adolf ruled over the region in-
cluding Greifswald, the artist's birthplace, and
was one of the leading protagonists in the bat-
tles of independence against Napoleon. Ac-
cordingly, the pictorial elements can be inter-
preted not only as religious but as national
symbols. A monumental cross on a mountain
peak, for instance, was envisioned by the poet
Ernst Moritz Arendt as a monument to the
Germans. It was only when Gustav Adolf's po-
litical importance declined that Friedrich de-
cided to sell the picture – now reinterpreted in
exclusively religious terms – to Tetschen. It
was then that it received the carved wooden
frame, with the Trinity symbol of a triangle
around the eye of God, sheaves and grapes as
symbols of the Eucharist, palm fronds and an-
gels' heads, to underscore the picture's new
role as altarpiece (a function it actually never
served, being ultimately hung in the castle
bedroom). While Friedrich originally had spo-
ken of the sun as rising, and thus symbolizing
a new political beginning, now it was said to
be setting, marking a change of era from Old
to New Testament. What was once an early
Romantic secular vision of hope was recast into
an atmospheric image of melancholy.

On a brightly illuminated rise in the fore-
ground, a hiker in city clothes leans on a rock
in the midst of an otherwise unpopulated ex-
panse. Behind him yawns a gorge obscured by
rising fog, and a panorama view of distant
mountains with a dominant central peak, the
whole range plunged in darkness. A rainbow
appears in the heavily clouded, gloomy sky,
spanning the entire picture from edge to edge.
This has occasionally been interpreted as a noc-
turnal rainbow, which would imply that the –
physically unlikely – light source in the clouds
was the moon. Probably Friedrich initially
planned the picture to be a night scene, and
added the rainbow at some later point.

At any rate, it is likely correct to say that
the artist identified himself with the figure,
and intended the painting as a personal reli-
gious confession, with the emerging moon
symbolizing the illumination of the world by
Christ, and the rainbow, in conformance with
old symbolic tradition, expressing a reconcilia-
tion between humanity and God.

Immediately after its completion following three revisions, *The Monk by the Sea* was shown at the Berlin Academy exhibition, where it was purchased by the Prussian Royal House. That same year, Heinrich von Kleist published his famous description, in which he spoke of monotony and boundlessness and an apocalyptic impression, as if the picture had been inspired by Young's *Night Thoughts*. It had no foreground except the frame, said Kleist, and viewing it was "as if one's eyelids had been cut away."

Characteristically for Friedrich, the composition relies principally on its structural draftsmanship while the colors themselves, though wonderfully nuanced in a range of delicate glazes, play little more than a secondary role. The aim was to express a new sense of boundless space, in which several separate tiers are ranged one behind the other.

Friedrich ignored almost all of the established rules of landscape painting, relinquishing every accessory except for the tiny figure of the monk, and not attempting a systematic rendering of depth. The sailing boats that originally flanked the figure were deleted, and an expanse of empty sky was left to fill five-sixths of the picture plane.

Up to the horizon, our eye feels quite comfortable with the size relationships, especially as the monk's figure gives a certain sense of scale. But the background can no longer be comprehended in terms of dimension. Since every line in the painting seems to lead out of it, it evokes an infinite expanse, the true subject of the picture.

The monk, with whom Friedrich identified and into whom he expected us as spectators to project ourselves, feels infinitely small as he contemplates the immensity of the universe, the "sole spark of life in the great realm of death," as Kleist put it. Thus Friedrich's monk can be seen as an exemplary embodiment of that tragic, melancholy sense of life which was one of the essential ingredients of early German Romanticism.

Abbey under Oak Trees served as a companion piece to *Monk by the Sea*. The oak trees and the Gothic ruins – based on the actual ruins of the Cistercian monastery at Eldena in Pomerania – were presumably intended as allusions to the pre-Christian period of nature religion and the Christian Middle Ages. The funeral procession of monks leads past an open grave and toward the church portal, in which a crucifix flanked by two torches appears. The ultimate destination of the procession, however, would appear to be the light-flooded heavens beyond the horizon, which seem to promise at least the possibility of a better world beyond history and death.

The painting with its noble symmetry was purchased, like *Monk by the Sea*, by the Prussian king at a time of grave political unrest, which nonetheless promised a new beginning and led to Germany's liberation from the Napoleonic yoke. It was later described by Friedrich's friend, Carl Gustav Carus (ill. pp. 48 and 49), as perhaps "the most profound, poetical work of art in all recent landscape painting."

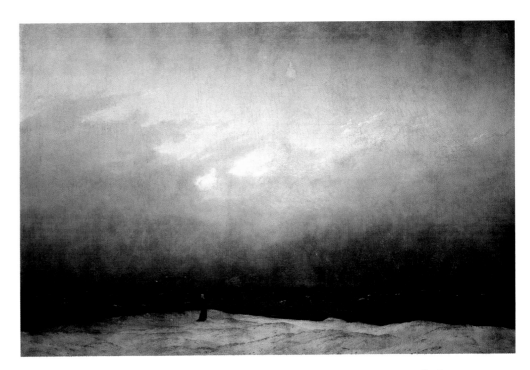

Caspar David Friedrich
The Monk by the Sea, 1809/10
Oil on canvas, 110 x 171.5 cm
Berlin, Nationalgalerie, Staatliche Museen
zu Berlin – Preussischer Kulturbesitz

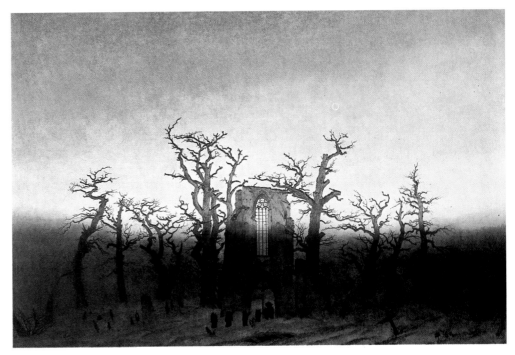

Caspar David Friedrich
Abbey under Oak Trees, 1809/10
Oil on canvas, 110.4 x 171 cm
Berlin, Nationalgalerie, Staatliche Museen
zu Berlin – Preussischer Kulturbesitz

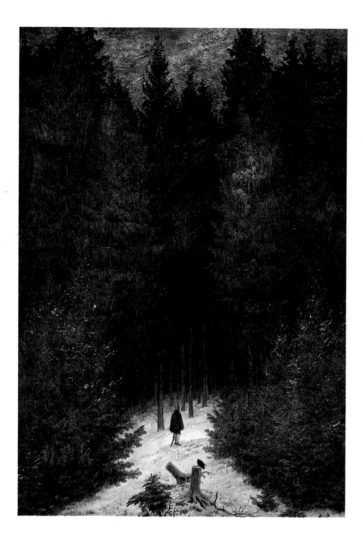

Caspar David Friedrich
The Chasseur in the Forest,
c. 1813/14
Oil on canvas, 65.7 x 46.7 cm
Private collection

CASPAR DAVID FRIEDRICH
1774–1840

The first owner of *The Chasseur in the Forest*,
Prince Malte von Putbus, described its content
thus: "It is a winter landscape; the rider, who
has already lost his horse, rushes into the arms
of Death, as a raven caws the death dirge after
him." This is doubtless one of Friedrich's most
deeply patriotic pictures, whether it was in-
tended to recall the demise of Napoleon's
armies in the wintry steppes of Russia, or
whether the fir wood was an allusion to the
closed ranks of German patriots in the War of
Independence, the snow a reference to preced-
ing conditions in Germany, and the young firs
next to the tree stumps in the foreground a
symbol of the new generation rising above
those who lost their lives in the war.

At the center of the picture rises *The Lone Tree*,
a giant oak some of whose branches bear fo-
liage while others have died. Beneath it stands
a shepherd, watching his flock. The water-
filled hollow at its base, like the small pond
and the sweeping landscape extending to dis-
tant mountains, set a horizontal contrast to the
vertical of the trees.
 Like hardly another composition of
Friedrich's, this one seems to rest solely on vi-
sual observation. Yet here, too, we can detect
many symbolic references and allusions to
transience, which interpret the connection be-
tween man and nature in both historical and
existential terms. The tree itself seems to take
on veritably human traits, as if it were a sen-
tient individual presence.

Chalk Cliffs on Rügen, painted during
Friedrich's honeymoon trip to Greifswald in
the summer of 1818. In the foreground, a
grassy strip of ground arcs from the tree-grown
rocks at the edges to converge at the center.
Beyond it we sense a precipitous drop, down
into a gorge between the chalk cliffs. We look
as through a window between the framing
rocks and past the bizarre shapes of freestand-
ing needles to the distant sea below, a seem-
ingly endless expanse of water whose surface.
 Of the many interpretations of this picture,
the most convincing is that which considers it
an allegory of Friedrich's love for his wife, and
places it in the tradition of the Romantic
friendship picture. Concomitantly, the stand-
ing male figure at the right, clad in medieval
revival attire, would represent an idealized,
youthful version of the artist himself, gazing
out over the expanse of water toward the two
sailboats, which presumably represent the cou-
ple's "ships of life." The elderly man in the
middle might be a second self-portrait, this
time as a skeptic who gingerly and anxiously
tries to see whether there is really something
interesting down there, where the woman
points.

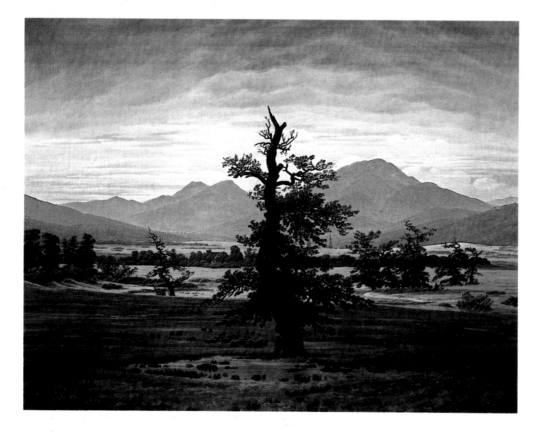

Caspar David Friedrich
The Lone Tree (Village Landscape in
Morning Light), 1822
Oil on canvas, 55 x 71 cm
Berlin, Nationalgalerie, Staatliche Museen
zu Berlin – Preussischer Kulturbesitz

Caspar David Friedrich
Chalk Cliffs on Rügen, 1818
Oil on canvas, 90 x 70 cm
Winterthur, Stiftung Oskar Reinhart

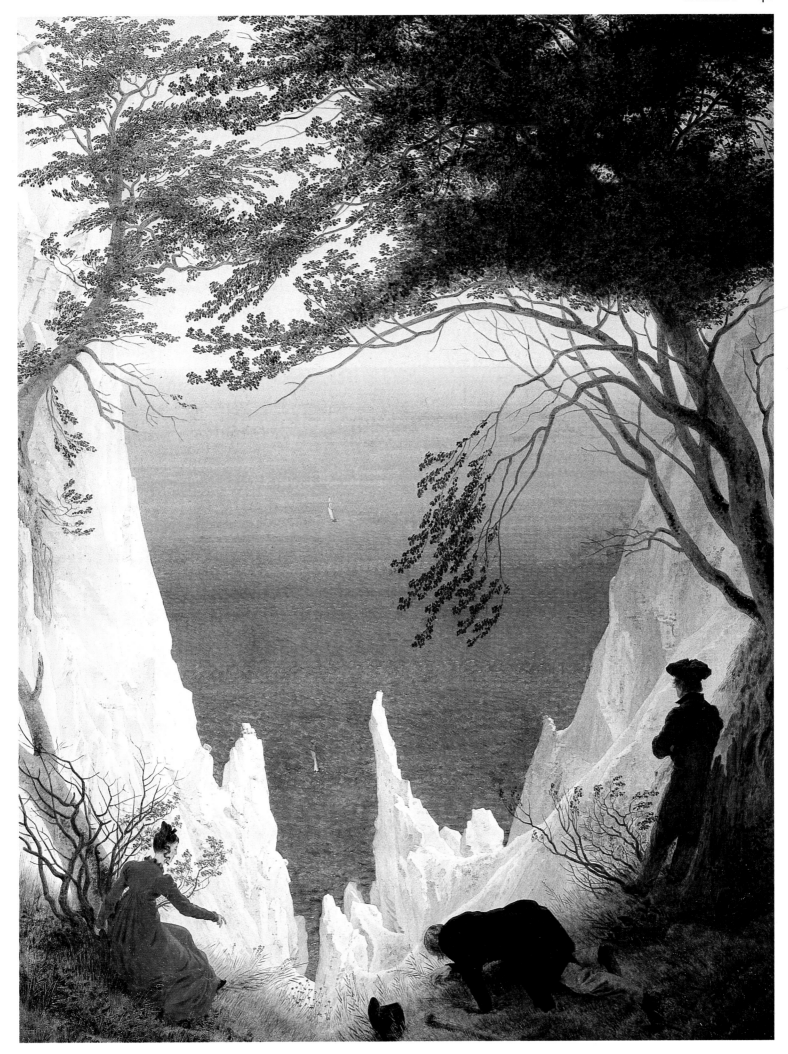

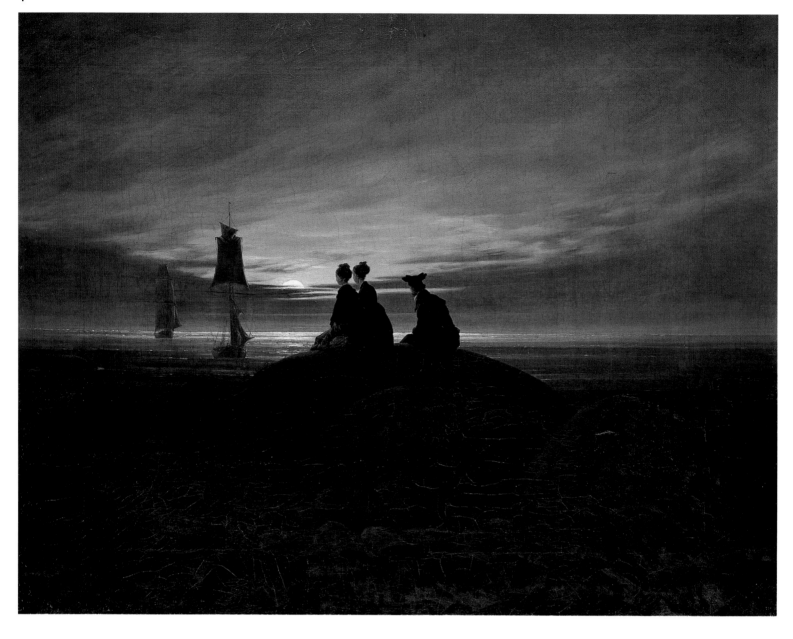

Caspar David Friedrich
Moonrise over the Sea, 1822
Oil on canvas, 55 x 71 cm
Berlin, Nationalgalerie, Staatliche Museen
zu Berlin – Preussischer Kulturbesitz

CASPAR DAVID FRIEDRICH

1774–1840

Moonrise over the Sea was conceived as a companion piece and compositional contrast to *The Lone Tree* and, like it, was finished towards the end of 1822. It was executed for Consul Joachim Heinrich Wilhelm Wagener, whose collection of paintings would later form the basis of the Nationalgalerie in Berlin.

Friedrich depicts tourists from town watching the sight of the moon rising over the sea. Seated on a rock, their silhouettes extend above the horizon. The two women, snuggled closely together, and the man dressed in medieval revival costume watch sailing ships returning home, a possible metaphor for life nearing its end. The sails on the foremost ship are being reefed; the journey is about to reach its destination.

The center of interest, both for us as viewers and for the people gazing into the distance, is doubtless the rising moon and the way it illuminates the cloudy sky. Considering Friedrich's spiritual views, it would surely not be amiss to interpret both phenomena as symbols of the supernatural, even of Jesus Christ himself. According to the Friedrich expert Helmut Börsch-Supan, the huge boulders on the shore can be read as symbols of the rock of Christian faith. He goes on to say that it is no coincidence that the rounded contour of the largest of these sea-eroded boulders, where the figures sit, extends towards the lower margin of the lighted area, as it were setting a vertical counterpoint to the horizontal axis of the horizon. At this point in the composition, light and dark, near and far come together.

A more prosaic interpretation was prompted by a thematically and compositionally related work of 1821, now in The Hermitage, St. Petersburg. To a critic of the period, the large rocks on the beach in the foreground merely indicated the presence of "shallow inflowing sea tides."

The picture is dominated by a strange violet hue, a color that, according to Ludwig Richter, Friedrich thought of as expressing sadness. Yet this mood is counteracted by the glow of the moon and its silvery reflection on the water, a sign of hope.

In the foreground, on a dark, craggy, sharply silhouetted outcrop, a wanderer in medieval-style German costume stands with his back to the spectator. He gazes out over clouds of fog rising from the depths and the bare sharp rocks emerging here and there, toward distant peaks and mountain ridges. High above them lies a bank of clouds.

The composition reflects a tendency seen in Friedrich's work after 1816 to create continuous transitions between near and distant spaces, between the finite and the infinite. Also, it perfectly illustrates the principles of the Sublime as formulated, for instance, by the English poet, Lord Byron, who once asked whether mountains, hills, and clouds were not part of himself and his soul, just as he was a part of them. Or by the German painter Carl Gustav Carus, who in 1835 exclaimed, "Just climb to the top of the mountains, look over the long ranks of hills... and what emotion grips you? There is a silent reverence within you, you lose yourself in unbounded spaces, your entire being experiences a silent purification, your ego vanishes, you are nothing, God is all."

The figure seen from the back was probably intended as a patriotic memorial to a man killed in the war. Yet he also stands proxy for the spectator and leads the eye over the distant fog banks, which here evoke the cyclical processes of nature. In this way, precisely rendered natural phenomena become objects of religious meditation.

The Polar Sea is one of Friedrich's major works. The sailing ship crushed by ice floes in a desolate polar landscape can be understood as a symbol of epochal disaster, encompassing both the futility of human effort and the human capacity to hope against all odds.

The image conveys a symbolic protest against the oppression of the Restoration and the political "winter" that prevailed in Germany under Metternich. One of its immediate sources may well have been an account of Edward William Parry's polar expedition of 1819–1820, in search of the Northwest Passage. In addition, the image would appear to reflect a tragic experience of the artist's youth, for which he partially blamed himself – the death of his younger brother, who drowned after breaking through ice during a winter outing.

Though the sea has frozen to ice and organic nature seems as doomed as the ship, the light-flooded sky and unbounded horizon stand, as so often in Friedrich's work, for faith in redemption. The sharp-edged ice floes piled into a jagged pyramid are replied to by the seeming weightlessness and translucency of the calm and peaceful background. Once again it is the character of the terrifyingly sublime that transforms the polar environment into a vessel to convey human feelings.

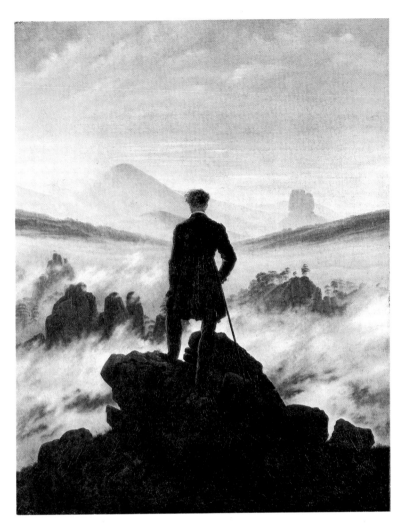

Caspar David Friedrich
Wanderer Watching a
Sea of Fog, c. 1817/18
Oil on canvas,
98.4 x 74.8 cm
Hamburg, Hamburger
Kunsthalle

Caspar David Friedrich
The Polar Sea (formerly The Wreck of the Hope), c. 1823/24
Oil on canvas, 96.7 x 126.9 cm
Hamburg, Hamburger Kunsthalle

Caspar David Friedrich
Mountainous River Landscape (Day Version),
c. 1830–1835
Mixed techniques on tracing paper, 76.8 x 127 cm
Kassel, Staatliche Museen Kassel

Caspar David Friedrich
Mountainous River Landscape (Night Version),
c. 1830–1835
Mixed techniques on tracing paper, 76.8 x 127 cm
Kassel, Staatliche Museen Kassel

CASPAR DAVID FRIEDRICH
1774–1840

In 1830, Friedrich was commissioned by the successor to the Russian throne, Alexander, to execute four transparent pictures. These must be intended for a "young, childlike heart," noted Friedrich in a letter to the prince's tutor, the Russian poet and state councillor Shukovski.

In addition to complicated lighting arrangements, the artist envisaged the pictures being accompanied by music. His Gesamtkunstwerk, as he explained, would represent the transformation of the demonic state of the world, from a secular to a spiritual and finally transcendental state. Evidently Friedrich set out to do his best to refute the opinion earlier expressed by August Wilhelm and Caroline Schlegel, who declared that transparent pictures were not fine art but "pretty trickery."

Underscored by the allegorically intended musical accompaniment, the pictures, painted on translucent paper and illuminated from behind in a darkened room, were to evoke the continual transformation of nature during the times of day, as well as in the transcendental sense. It was a Gesamtkunstwerk whose synaesthetic appeal was intended to move the heart and mind. Friedrich was not able to finish the project until 1835, when he sent the four transparencies and the projection apparatus to St. Petersburg. Their present whereabouts is unknown, and they are considered lost.

Friedrich executed other works of this type, one of which has survived and is now in the Gemäldegalerie, Kassel, a *Mountainous River Landscape* of the late period that comes from the artist's estate. The translucent paper is painted on both sides in a mixture of watercolor and tempera, and represents, with the aid of different light sources, a day and a night version.

The day version is dominated by delicate pastel gradations of rose and lilac, olive and greyish-green, and the wide, mighty river with its islands is flanked by gently rolling hills. Visible in the foreground is a skiff with young lovers and a boatman. When lit from behind by artificial light, the daylight scene is transformed into a nocturnal one, and the dark river valley is suffused by the brilliant rays and reflections of the moon. Only now does the silhouette of a town accentuated by Gothic church spires become visible.

The "wonder lamp" behind the picture, wrote E. Waldmann, "caused the mountains to gradually appear in the moonglow of the magical night and made the universe deeper, and depending on how one moved the lamp, it became evening or night, and the world took on more fullness of detail, and the overall impression, now melancholy and gloomy, now mildly illuminated, and all the moods of light, now weaker, now stronger, seemed to take effect in infinity."

ERNST FERDINAND OEHME
1797–1855

When Oehme entered the Dresden Academy in 1819, he was accepted for private instruction by the highly influential Johan Christian Clausen Dahl. A much greater impression on him, however, was made by the works of Caspar David Friedrich.

Oehme's *Cathedral in Wintertime* of 1821, for instance, clearly reflects the influence of Friedrich's *Abbey under Oak Trees* (ill. p. 39). As if with a telescopic lens, Oehme enlarges the open Gothic portal of the church to reveal the altar and monks in dark cowls moving towards it. He largely omits natural elements, like the gnarled oaks Friedrich used so eloquently, instead relying on the crystalline forms of Gothic architecture to convey his message. The church's attenuated structure and exaggerated height, and the filigree delicacy of its walls, do not correspond to any actual building; they give the impression of a vision seen in a dream.

Unlike Friedrich's abbey, this church is undamaged. Though it does recall past ages, it is no symbol of decay and transience but a solid bulwark that defies winter storms. The candles burning on the high altar radiate a reddish light which illuminates the two tracery windows from within. Rendered in an exquisite range of hues, this phenomenon of light and color replies in a spiritual metaphor to the cold, gloomy mood of the surrounding material world.

After his early period in Dresden, Oehme began in the 1830s to shake off the influence of Friedrich and turn to landscape views of a more naturalistic kind, which, despite their objectivity, still continued to exhibit sophisticated painterly effects and the moods these were capable of conveying.

His *Greifensteine in the Saxon Erzgebirge* is a good example of this "Romantic realism." The focus of interest here is on the geological features of the topography with its towering cliffs and typical local vegetation. This approach was based on intentions much like those outlined by Carl Gustav Carus in his theory of landscape painting, namely, to create a scientifically accurate portrait of the cliffs that would reflect the geological processes that led to their formation. While the landscape already lies in evening shadow, the sky is still shot through with a play of light, soft blues, greens, and yellows.

Two lone buzzards in the foreground are the only living creatures visible, yet a plume of smoke rising from the woods in the middle ground signals human presence. Thus the straightforward observation of the picture is poetically heightened after all: The great unspoiled outdoors is contrasted with an allusion to human settlement, and the encroachment this entails.

Ernst Ferdinand Oehme
Cathedral in Wintertime, 1821
Oil on canvas,
127 x 100 cm
Dresden, Gemäldegalerie
Neue Meister, Staatliche
Kunstsammlungen
Dresden

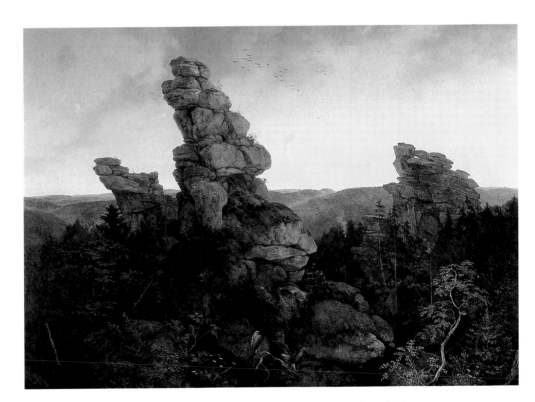

Ernst Ferdinand Oehme
The Greifensteine in the Saxon Erzgebirge, 1840
Oil on canvas, 100.5 x 142.2 cm
Gotha, Museen der Stadt Gotha, Schlossmuseum

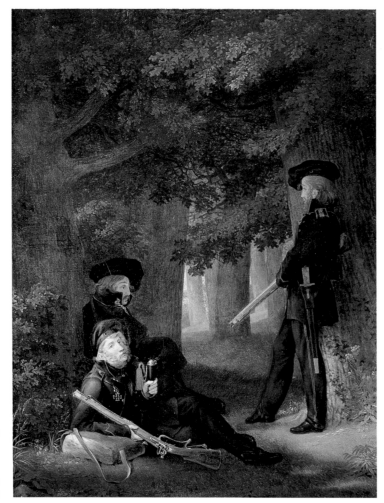

Georg Friedrich Kersting
At the Outpost, 1815
Oil on canvas, 46 x 35 cm
Berlin, Nationalgalerie,
Staatliche Museen zu Berlin
– Preussischer Kulturbesitz

GEORG FRIEDRICH KERSTING
1785–1847

Kersting fought in the War of Liberation against Napoleon as a volunteer in a unit known as the Lützow Jäger. With this painting he set a movingly simple memorial to three of his friends who were killed in action. Their names are carved into the bark of the mighty oaks. On the right, rifle at the ready, stands Karl Friedrich Friesen. Resting at the left are Hartmann – not to be confused with the painter Ferdinand Hartmann – and the poet Theodor Körner. This and related paintings by Kersting, which rather than striking such a martial tone evoked more pensive thoughts, were shown together with other works by Saxon artists at an exhibition of "Patriotic Art" held by the Russian governor, Prince Repnin, in Dresden in 1814.

Among Kersting's finest accomplishments were interiors which, unlike later Biedermeier depictions of domestic comfort and self-suffi-ciency, captured the mood of individual rooms and the way they reflected the thoughts and feelings of their occupants.
 In the present picture it is the mental world of reading that determines the overall impres-sion. The concentration of the man immersed in his book is echoed in the spartanic simplic-ity of the furnishings and the way the book-shelves serve to formally delimit the room. Contemplative thought, which is just as capa-ble of opening up new worlds as an actual jour-ney to exotic lands, has been translated into compositional elements and visual signs. The light cast by the reading lamp on the empty back wall, where it congeals into strange con-figurations, becomes an outward expression of the inward illumination which, at that period, forged knowledge into a weapon of the edu-cated German middle class against censorship and suppression of freedom of opinion.

Kersting's picture of a woman plaiting her hair fairly demands comparison with Friedrich's *Woman at a Window* (ill. p. 10). While that composition builds on tense contrasts, espe-cially that between enclosed room and land-scape view, Kersting's Romantic "window painting" concentrates on the intimacy of a tidy room, the ambience of a well-ordered do-mestic sphere. Even the clothing of the young woman before the mirror lies carefully folded on the table and chair at the right. The artist's coloristic approach is seen in the sensitive dis-tribution of hues over the picture plane. The image exudes a calmness approaching that of still life, which points beyond the momentary character of the situation and reflects the fun-damental aim of Romantic art, to lend, as No-valis said, "the common a high meaning, the familiar a mysterious aspect, the known the dignity of the unknown, the finite an aura of the infinite."

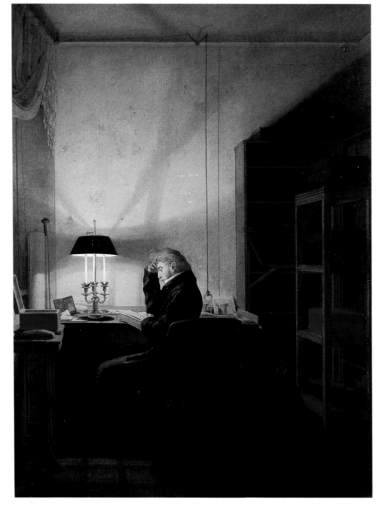

Georg Friedrich Kersting
Man Reading by
Lamplight, 1814
Oil on canvas, 47.5 x 37 cm
Winterthur, Stiftung Oskar
Reinhart

Georg Friedrich Kersting
Before the Mirror, 1827
Oil on wood panel, 46 x 35 cm
Kiel, Kunsthalle zu Kiel

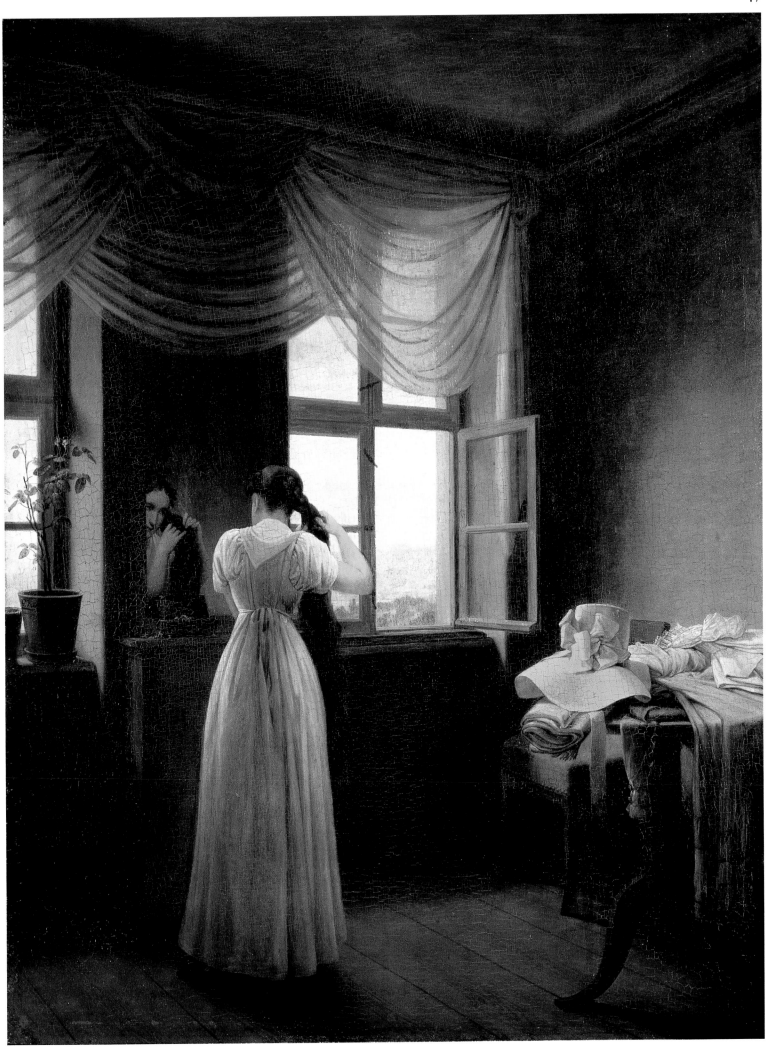

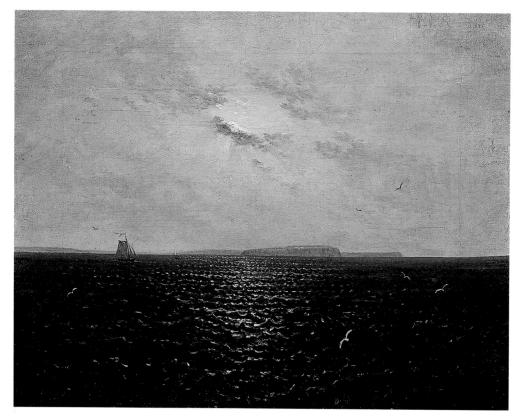

Carl Gustav Carus
Moonlight Night near Rügen, c. 1819
Oil on canvas, 38 x 47.5 cm
Dresden, Gemäldegalerie Neue Meister,
Staatliche Kunstsammlungen Dresden

CARL GUSTAV CARUS
1789–1869

Carus, not only a painter but a physician and natural scientist, was a close friend of Friedrich's in Dresden. Carus's painting *Moonlight Night near Rügen* in many respects recalls the compositional principles used by Friedrich. As in that artist's *Monk by the Sea* (ill. p. 39), the horizontal format is taken up almost entirely by sea and sky. And as there, an omission of lateral elements that would frame and stabilize the composition lends the natural scene the appearance of infinite expanse. Still, with Carus the horizontals of water, horizon and sky tend to block our access as spectators, while with Friedrich, the narrow wedge of dunes in the foreground and the figure of the monk standing with his back to us veritably draw us into the scene.

Also completely different is the realism with which Carus depicts the agitated waves. This reflects his personal, more empirical and scientifically objective approach to landscape painting. It also explains why, for all their emotionality, Carus's paintings do not have the existential drama so strongly felt in Friedrich's.

Carus was a great admirer of Goethe, who in turn highly appreciated both Carus's theoretical writings and his painting. His picture of 1831 is described thus in *Das Kunstblatt*, no. 18, 1836: "In a lonely rocky area stands Goethe's sarcophagus, and upon it a harp; moonlight falls through its strings, illuminating two angels who kneel reverently before it. Mists swirl around the base of the monument. It would seem that Goethe's manifold and magical contacts with Nature have inspired the ingenious artist to this Ossianic idea." Goethe, who devoted himself so intensively to questions of the world and humanity, has been recast in Carus's picture into an unworldly and lonely Romantic figure. His imaginary grave evokes Romantic yearning in terms of an actual destination, an envisioned place of pilgrimmage, an altar, a holy of holies.

From the door of a dark boat cabin, our eye takes in the figures of a fashionably dressed young woman and a man in shirtsleeves, seated with their backs to us in the stern, and beyond them the far shore of the Elbe River, where the city of Dresden is silhouetted.

Basically, this juxtaposition of dark cabin and sunny landscape represents a compositional and thematic variation of the Romantic "window picture." But now, at the onset of the Biedermeier period, the contrast between near and far is hardly exploited to evoke a yearning for spiritual liberation. Everything has become more familiar and homely; the far shore no longer harbors the promise of a better future or a better life in the hereafter, but seems merely the destination of a pleasant outing.

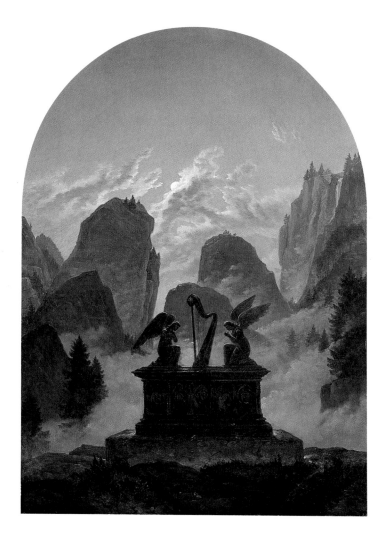

Carl Gustav Carus
The Goethe Monument,
1832
Oil on canvas,
71.5 x 53.5 cm
Hamburg, Hamburger
Kunsthalle

Carl Gustav Carus
Boating on the Elbe, 1827
Oil on canvas, 29 x 21 cm
Düsseldorf, Kunstmuseum Düsseldorf im Ehrenhof

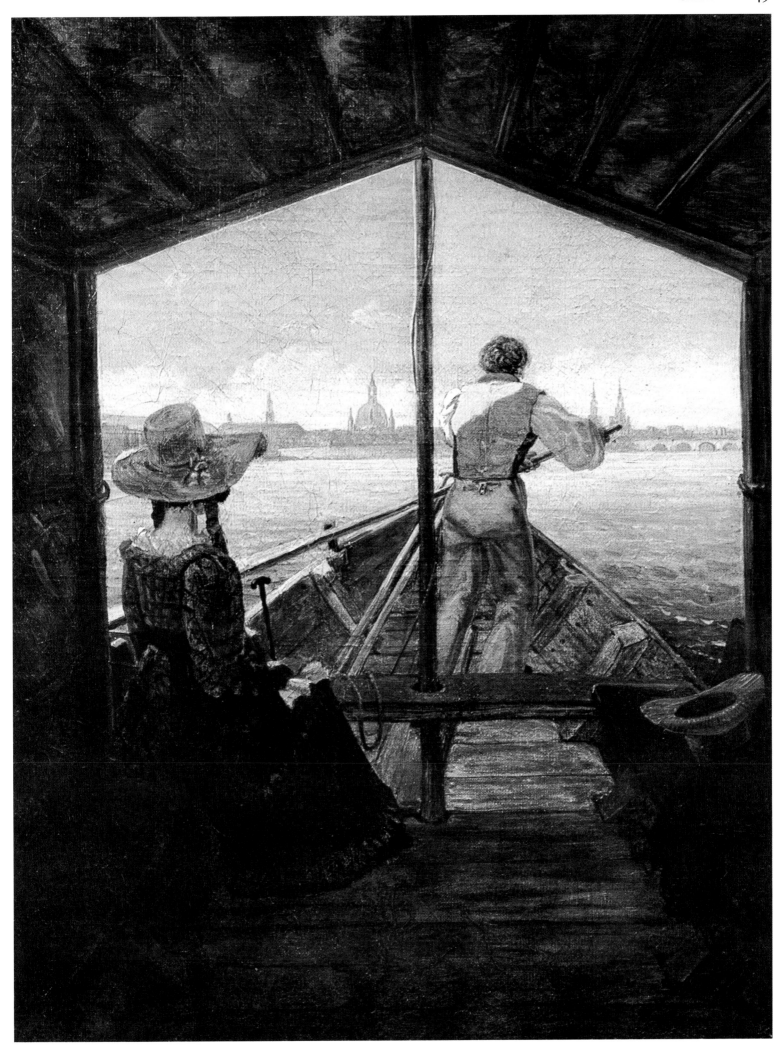

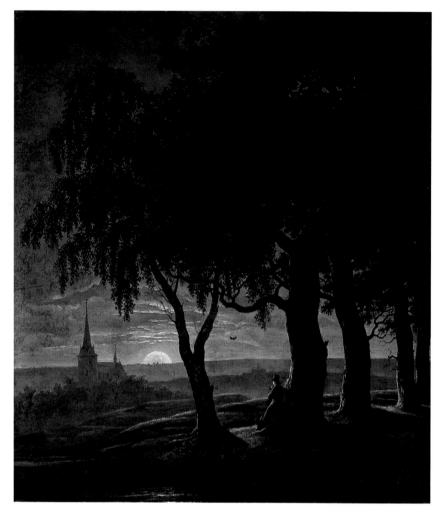

Carl Wagner
Moonrise, 1821
Oil on canvas, 59.5 x 54 cm
Cologne, Wallraf-Richartz-Museum

CARL WAGNER
1796–1867

Like Ernst Ferdinand Oehme (ill. p. 45), Wagner, who initially studied forestry, associated with the Norwegian Dahl in Dresden, and for a while was strongly influenced by Caspar David Friedrich.

In his painting *Moonrise* of the year 1811, a lone man leaning on a tree contemplates the beauty of this natural phenomenon. He looks out over the gently rolling hills in the middle ground towards the silhouette of a church. The atmospheric contrasts among the dark shadow in the foreground under the mighty trees, the backlit insubstantiality of the middle ground, and the horizon illuminated by the rising moon, are skilfully rendered to evoke a mood, whose mental and symbolic depth, however, cannot compare to that of Friedrich's compositions.

Indeed Wagner's interpretation of the natural scene tends to reduce it instead to little more than sentimental terms. Though the way the figure leaning against the tree gazes at the church and its soaring steeple may distantly recall the early Romantic view of religion as a stimulus for a new political beginning, the motif is ultimately treated as no more than a vague, emotive element.

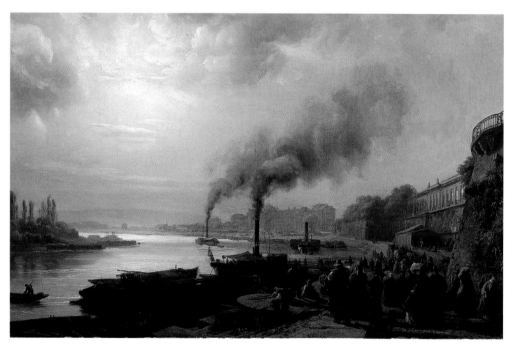

Christian Friedrich Gille
The Brühl Terrace in Dresden, 1862
Oil on canvas, 34 x 53 cm
Hannover, Niedersächsisches Landesmuseum

CHRISTIAN FRIEDRICH GILLE
1805–1899

Gille's painterly œuvre attests to the long duration of Dresden Romanticism, if in a modified form that tended to an increasing naturalism. A pupil of Dahl, as were Oehme and Wagner, Gille managed to escape the overweening influence of Friedrich to a greater extent than many of his colleagues. His interest in lunar illumination and cloud formations was marked less by pantheistic ideas or notions of the sublime and the beautiful than by close observation of coloristic phenomena and sheer pleasure in the process of painting. With scant regard for stringent composition, Gille set out to capture fleeting visual impressions.

For his view of Dresden, he chose not the famous, often depicted silhouette of the town but the picturesque area on the banks below Brühl Terrace. A sidewheel riverboat full of excursionists is just making ready to cast off. Its billowing smoke plume, echoed by one from another ship on the river, is contrasted as an emblem of technology to the natural golden light reflections on the water. The atmospheric dissolution of the motif distantly recalls the paintings of William Turner (ill. pp. 78–81), though he admittedly carried such effects much farther.

KARL FRIEDRICH SCHINKEL
1781–1841

In addition to oils, Schinkel executed a series of set designs for Wolfgang Amadeus Mozart's opera *Die Zauberflöte (The Magic Flute)* (1791), in a new performance held at the Royal Opera House, Berlin, on 18 January 1816. In making the designs Schinkel attempted to put into practice his key idea for theater reform, the demand that word, visual image, and performance form a unity. His stage backdrops, painted on canvas, were unique in the context of contemporaneous set design as regards the monumentality of their architectural or landscape motifs. The premiere in the presence of the king was a dazzling success, not least due to Schinkel's sets.

In his design for the palace of the Queen of the Night, the diminutive female figure standing on a crescent moon is overarched by a brilliant dark blue firmament whose bands of stars create the impression of a cupola or even of a planetarium.

It is a profoundly Romantic notion that expands the queen's uncanny nocturnal kingdom into a cosmic, universal symbol and confronts it, in the other designs, with Sarastro's kingdom of light. At the time, the poet E. T. A. Hoffmann praised the scene in a newspaper review as Schinkel's "most sublime and brilliant."

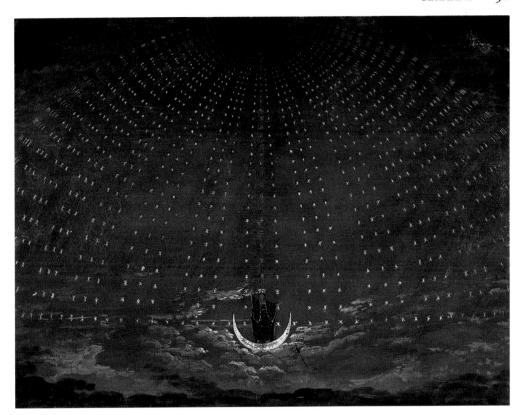

Karl Friedrich Schinkel
Set Design for "The Magic Flute": Starry Sky for the Queen of the Night, 1815
Gouache, 46.3 x 61.6 cm
Berlin, Kupferstichkabinett, Staatliche Museen zu Berlin – Preussischer Kulturbesitz

Schinkel is known as one of the most outstanding neoclassical architects of Germany, and indeed of Europe. But at the onset of his career, when the French occupation precluded large building projects, he was active as a painter, inspired especially by Dresden Romanticism and its major proponent, Caspar David Friedrich.

Schinkel's major work in this vein is the *Gothic Cathedral by the Waterside*, the two original versions of which were lost and which have come down to us only in the form of apparently faithful copies, one now in Berlin and the other in Munich.

The cathedral, rising straight from bedrock and silhouetted against the background light, dominates the left side of the painting. At the right appears a brightly illuminated city with buildings in diverse styles – mansions of a Gothic, Renaissance, and neoclassical character, buildings of a more rustic kind, fortifications, and, at the right near the water, a Doric temple. The position of the cathedral, seen from a low vantage point against the sky, sets the religious tone of the picture, which is supplemented by a political one.

Since Schinkel, like so many of his contemporaries, considered Gothic to be a German invention, he interpreted the cathedral, at the outbreak of the War of Liberation, as an anti-Napoleonic symbol. The sunset and threatening stormclouds were meant as an allusion to the imminent battle, whose successful outcome would mark the beginning of a new era.

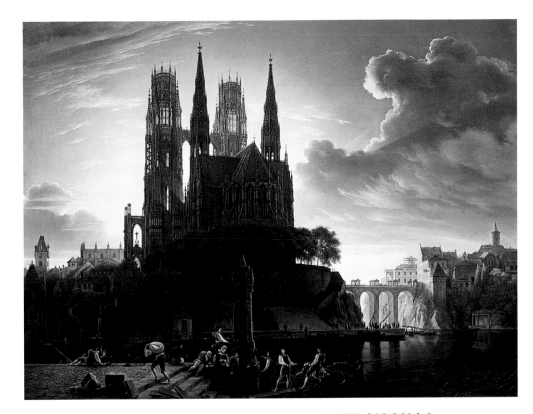

Karl Friedrich Schinkel
Gothic Cathedral by the Waterside, c. 1813/14
Copy by Wilhelm Ahlborn, 1823
Oil on canvas, 80 x 106.5 cm
Berlin, Nationalgalerie, Staatliche Museen zu Berlin – Preussischer Kulturbesitz

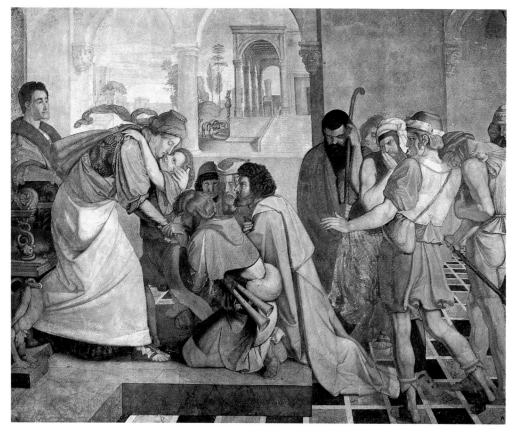

Peter von Cornelius
Joseph Reveals himself to his Brothers
(from Palazzo Zuccaro, Rome), c. 1816/17
Fresco, 236 x 290 cm
Berlin, Nationalgalerie, Staatliche Museen
zu Berlin – Preussischer Kulturbesitz

PETER VON CORNELIUS
1783–1867

In his Roman period, from 1811 to 1819, Cornelius became a member of the artists' brotherhood of the Nazarenes and untiringly propagated its foremost aim: to revive large-scale Christian art, that is, fresco painting, and at the same time to make it the basis of a popular, patriotic art.

The first culmination of Cornelius's work in this regard came with frescoes in the Palazzo Zuccaro and the Casa Bartholdy in Rome, whose subjects were taken from the Old Testament story of Joseph. "But now I have finally arrived at that," he himself said, "which I... hold to be the most forceful and... unfailing means to give German art a foundation for a new direction, adequate to the great era and the spirit of the nation: This would be none other than the reintroduction of fresco painting... [it concentrates], as in a focal point, the vital rays flowing out from God into a brilliant flame that benificiently illuminates and warms the world."

By comparison to these passionate and ambitious words, the Roman frescoes are surprisingly straightforward. On a relatively narrow proscenium in an open loggia, a frieze-like sequence is devoted to the scene in which Joseph, in the meantime a high dignitary at the Pharaoh's court, reveals himself to his brothers, who had sold him as a boy to Egyptian slave-traders.

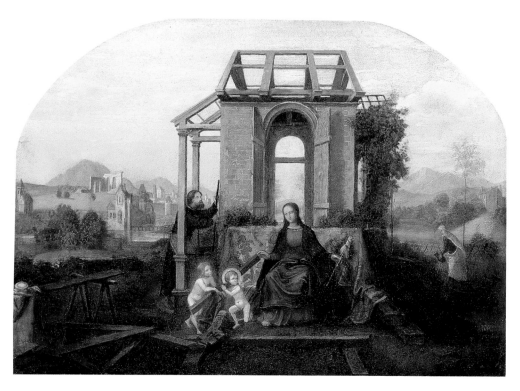

Ferdinand Olivier
The Holy Family on a Working Day, 1817
Oil on wood panel, 21.5 x 31 cm
Schweinfurt, Sammlung Georg Schäfer

FERDINAND OLIVIER
1785–1841

Unlike the other Nazarenes, Ferdinand Olivier did not orient himself so much to Florentine quattrocento painting as to the more colorful Venetian painting of the late fifteenth and early sixteenth century, especially that of Giorgione. Yet though he was a member of the St. Luke's Brotherhood in Vienna, Olivier never set foot on Italian soil.

The group picture of saints of the type cultivated in Venice, known as the *Sacra conversazione*, probably left its mark on Olivier's *Holy Family on a Working Day*. The Madonna is seated in front of a house under construction, depicted against the sky.

In terms of Christian iconography this signifies the New Testament, which began with Christ's work of redemption. Joseph, the carpenter, is one of those helping to build the house. In the foreground, John and the Christ Child are playing with building materials that are rendered in great detail. Behind the house to the left appears a medieval-looking town surrounded by mountains, and to the right, an open landscape with mountains and lakes. The entire picture is suffused with a dreamlike atmosphere, a meditative mood that brings an ideal realm of Christian values into the here and now.

JULIUS SCHNORR VON CAROLSFELD

1794–1872

Overbeck wrote in 1818 about Schnorr von Carolsfeld, by far the best draughtsman in the Lukasbund: "I may say, without fear of exaggeration, that he is not only a great credit to our circle but one of those highly gifted men who at all times will stand alongside the very best."

Schnorr's portrait of Clara Bianca von Quandt is surely one of the most beautiful portraits not only in the art of the Nazarenes but in that of German Romanticism in general. Depicted as a three-quarter length figure as she plays a lute, the sitter is brought up very close to the edge of the picture, which lends her pensively musing expression great immediacy. Clad in a brilliant, light red velvet gown and barette, she is seated in an open loggia, through whose Romanesque arcades the spectator's gaze is led past orange trees into a delightful Italian landscape. Not only the ambience and the sitter's attire but, and especially, the handling of color were consciously intended to recall Venetian Renaissance painting. Clara Bianca was the daughter of the author August Gottlieb Meissner. She was married for the second time in 1819, to Johann Gottlob von Quandt, a Dresden collector and litterateur. The couple were in Italy in 1819–1810, where the artist belonged to their circle of friends.

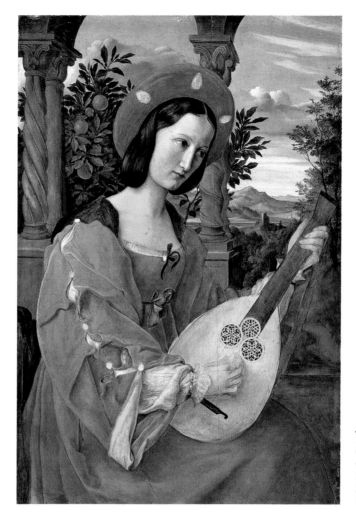

Julius Schnorr von Carolsfeld
Portrait of Clara Bianca von Quandt, c. 1820
Oil on wood panel, 37 x 26 cm
Berlin, Nationalgalerie, Staatliche Museen zu Berlin – Preussischer Kulturbesitz

FRANZ PFORR

1788–1812

My predilections draw me to the medieval era, where the dignity of man still showed itself in full force." With this confession Pforr not only stated the credo of his own art but of that of the Nazarene group as a whole. Pforr's rendering of the *Entry of Emperor Rudolf of Habsburg into Basel* reflects this enthusiasm for the Middle Ages, which was simultaneously a patriotic enthusiasm.

In a consciously ingenuous and naive narrative style, the artist depicts a street running diagonally into the picture towards a festively decorated square. Crowds of onlookers in their Sunday best look on as the emperor and his retinue parade past them. Every aspect of the scene is rendered with the same picture-book attention to detail.

The way in which the details are tied into the plane, the poster-like flatness of the local colors, the seemingly frozen movements of the figures, and the linear elegance of the contouring, all contribute to a stylization of the scene that lends it an appearance of unreality. Though intended to have popular appeal, the result is little more than an artful, and artificial, evocation of a fairy-tale past, a Golden Age without any real relationship to historical truth.

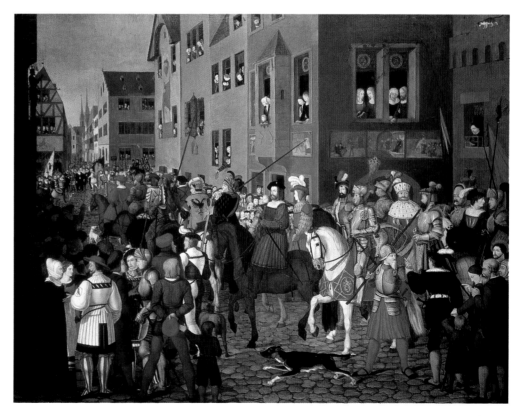

Franz Pforr
Entry of Emperor Rudolf of Habsburg into Basel in 1273, 1808–1810
Oil on canvas, 90.5 x 118.9 cm
Frankfurt am Main, Städelsches Kunstinstitut und Städtische Galerie

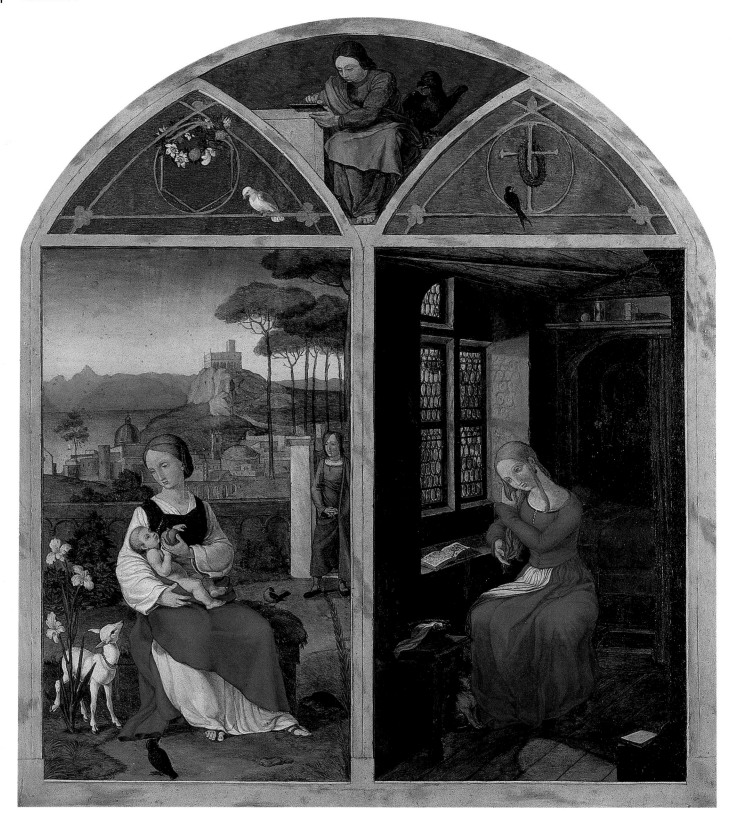

Franz Pforr
Shulamit and Mary, 1811
Oil on wood panel, 34 x 32 cm
Schweinfurt, Sammlung Georg Schäfer

FRANZ PFORR

1788–1812

Pforr's small panel in the shape of a medieval two-winged altarpiece stands in the tradition of the Romantic friendship picture.

The female figure of Shulamit, on the left, symbolically represents the artist's friend and fellow painter, Friedrich Overbeck, while Pforr associates himself with Mary, on the right. Shulamit's name, calling to mind the Song of Solomon in the Old Testament, signifies riches, a love of luxury, and the worldliness and beauty of the South. On the right panel, the figure of Mary serves as an image of contrast. She is depicted in an interior whose bull's eye panes and exposed-beam ceiling characterize it as an Old German parlor of the type seen, for instance, in Albrecht Dürer's engravings. Pforr's ideal of feminine beauty is the blonde, upstanding German maiden. The canopy over her bears the comforting symbols of death: cross and wreath. Next to her perches a dove, evoking the flight of yearning. Shulamit's canopy, in contrast, with its entwined flowers and dove, contains the joyful symbols of life and fertility.

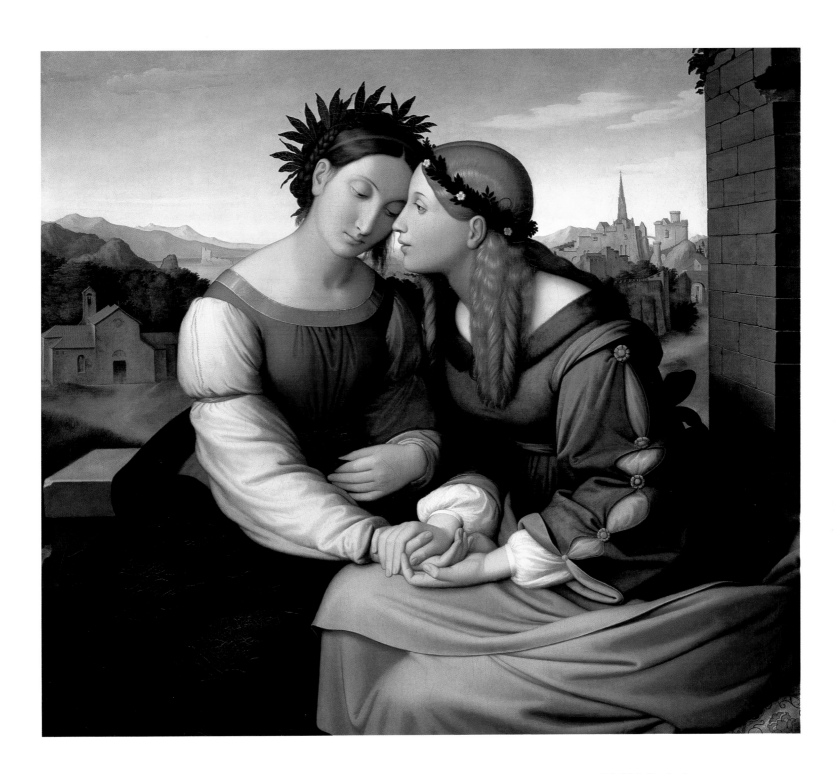

FRIEDRICH OVERBECK

1789–1869

This painting was begun in 1811 as a companion piece to Pforr's *Shulamit and Mary*, and remained unfinished after Pforr's death in 1811. Sixteen years later Overbeck addressed the theme again, giving it a new emphasis of content and a new title. Now called *Italia and Germania*, the picture referred to a key point in the Nazarene agenda: an attempt to harmoniously unify features of Italian and German painting of the late Middle Ages and Renais-

sance, up to Raphael. Shulamit, on the left, appears as a dark-haired, laurel-wreathed Italian woman, idealized to a type that conformed to an ideal of feminine beauty harbored not only by German artists in Rome. Mary, on the right, embodies the Nordic, "Gretchen" type, with braids and a myrtle wreath in her blonde hair. Behind Shulamit extends the corresponding Italian ideal landscape, and behind Mary, the narrow lanes of a German town. The two women, facing each other with an expression of intimate trust, possess an inner monumentality that was completely lacking in Pforr's companion picture.

Friedrich Overbeck
Italia and Germania (Shulamit and Mary), 1828
Oil on canvas, 94.4 x 104.7 cm
Munich, Bayerische Staatsgemäldesammlungen,
Neue Pinakothek

Philipp Veit
Italia: Introduction of the Arts through
Christianity, completed 1833
Fresco (left side), transferred to canvas,
284.5 x 191 cm
Frankfurt am Main, Städelsches
Kunstinstitut und Städtische Galerie

Philipp Veit
Germania, 1848
Oil on canvas, 482 x 320 cm
Nuremberg, Germanisches
Nationalmuseum

PHILIPP VEIT

1793–1877

Veit assumed the directorship of the city art
institute of Frankfurt, the Städelsches
Kunstinstitut, in 1829. The frescoes in the
institute building, completed in 1833, were
historical and allegorical compositions that
programmatically illustrated the Nazarenes'
philosophy of art and history. The only part of
the cycle to have survived is the picture in-
tended as its climax, *The Introduction of the Arts
into Germany through Christianity*, with the
flanking depictions *Italia* and *Germania*, which
were executed by Veit. In the center of the
principal image, the youthful figure of Reli-
gion stands in front of a Gothic cathedral, ac-
companied by representatives of heathen and
Christian art. The flanking picture on the left
shows a female personification of Italy, seated
in a monumental pose in front of an Italian
landscape. She is simultaneously a symbol of
the Church, whereas the figure of Germania on
the right flanking picture represents the
worldly regime. Veit's *Italia* is doubtless one of
the most beautiful works of later Romanticism
in Germany.

Veit's monumental painting *Germania* was
done in March 1848. It hung on the high wall
over the chair of the National Assembly in St.
Paul's Church in Frankfurt, flanked by two cir-
cular panels with a rhymed inscription that
translates: "The Fatherland's greatness, the Fa-
therland's fortune / O take them, o bring them
back to the People." The Germania figure in
St. Paul's was developed out of that in Veit's
1836 fresco in the Städel, which helped him
obtain this commission as well.
 The over double life-size figure is depicted
from a very low vantage point, against the
background of a rising sun. She is clad in the
imperial coronation mantle with breastplate
bearing the German double eagle, but not the
imperial crown. This is a reference to the fact
that, while parliament had yet to decide on the
final constitutional form of the future nation-
state of Germany, the artist himself advocated
a constitutional monarchy. At Germania's feet
lie broken chains as a symbol of liberation.
Like the rising sun, these allude to the long-
awaited goal of ratifying a constitution valid
for all Germans, at last cementing national
unity. The previously forbidden colors black,
red and gold on the tricolor go back to the stu-
dent fraternity movement active during the
Wars of Liberation against Napoleon and the
French occupation. The sword entwined with
an olive branch symbolizes the strength and
peaceful intentions of the imperial power, and
the wreath of oak leaves in the figure's hair
stands for the German nation, the oak having
been considered since the middle of the eigh-
teenth century the quintessential German tree.
 In short, this programmatic image repre-
sents almost the whole range of the great ideals
of the Nazarenes. After the dissolution of the
German Confederation, a commission decided
in 1867 to present "a few objects of historical
interest from the furnishings of St. Paul's" –
including Veit's *Germania* – to the Germani-
sches Nationalmuseum in Nuremberg.

CARL PHILIPP FOHR

1795–1818

The painting *Knights at the Charcoal Burner's Hut* depicts one of the final episodes in the novel *Zauberring* (1813), or *The Magic Ring*, by Friedrich, Baron de la Motte Fouqué, in which Otto von Trautwangen, thinking a magic potion has robbed him of his knightly honor, comes at night with his mother, Hildiridur, and two companions to a charcoal burner's hut to seek refuge.

The painting is like a compendium of typical motifs of German Romanticism: nighttime, moonlight, rugged cliffs, dark forest, solitude, knights, charcoal burner. These elements are combined into a compelling unity of mood and signification. The moon shining between the clouds casts an eerie, silvery glow over Hildiridur's dapple gray and reflects in points of light on the men's armor. Like the promise of home and hearth, the small rectangle of the window glows with a warm illumination that suffuses the dreamlike twilight of the nocturnal scene.

Fohr probably painted the picture in the late autumn of 1816, after he had returned to Munich from Heidelberg and joined the group of students around Adolf Follen, who playfully revived the world of medieval chivalry. For the figure of the knight Arinbjörn, leading the band in golden armor, Fohr relied on Albrecht Altdorfer's *St. George* (1510; Munich, Alte Pinakothek), which had been acquired in 1816 by the Boisserée brothers for their Heidelberg collection, which Fohr viewed on several occasions.

The *Ideal Landscape near Rocca Canterana* of the year 1818 is one of Fohr's best-known paintings. To a greater extent than many other Nazarenes, Fohr turned to the tradition, cultivated since the eighteenth century, of a stylized depiction of nature derived from the classical ideal.

The composition shows a rocky pastoral landscape in the central mountains of Italy. In the foreground, a path winds past craggy rocks and old, gnarled trees. Walking along it is a festively clad country girl with a child in her arms, holding the hand of another child balancing a jug on her head. To the right, under the trees, a group of pilgrims passes into a defile, in the direction of a distant, illuminated valley. Ahead of the girl, two shepherds follow the path into the picture, where a peaceful, hilly region rimmed by steep mountains opens out.

This painting stands in the tradition of the Arcadian landscape, which emerged in the Renaissance and inspired countless variations on the theme of a paradise on earth – a paradise that, in this case, due to the presence of pilgrims, also makes allusion to the Christian Heaven. By depicting the various stages of walking and wandering, Fohr evokes the transience of all earthly things and the journey into the future which is the true goal of human existence.

Carl Philipp Fohr
Knights at the Charcoal Burner's Hut, 1816
Oil on canvas, 54 x 66 cm
Berlin, Nationalgalerie, Staatliche Museen
zu Berlin – Preussischer Kulturbesitz

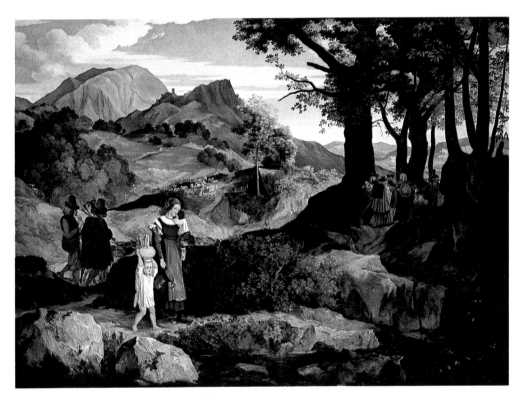

Carl Philipp Fohr
Ideal Landscape near Rocca Canterana, 1818
Oil on canvas, 98 x 135 cm
Darmstadt, Grossherzogliche Privatsammlung

Johann Anton Ramboux
Adam and Eve after Expulsion from Eden, 1818
Oil on canvas, 115 x 139.5 cm
Cologne, Wallraf-Richartz-Museum

JOHANN ANTON RAMBOUX
1790–1866

In 1807–1812 Ramboux was a pupil of the renowned neoclassical artist Jacques-Louis David in Paris. During his first stay in Rome, 1816–1822, he established close contacts with the Nazarene Brotherhood. In addition to Friedrich Overbeck's pictures and Joseph Anton Koch's ideal landscapes, Ramboux was impressed above all by Italian Renaissance painting.

The narrative mode and the palette of his *Adam and Eve* of 1818 are obviously influenced by the Italian quattrocento, that is, fifteenth century works. On the right is a seated, nude Eve embracing her children, Cain and Abel. Abel extends his hand toward a lamb – a reference to Christian iconography, in which Cain's murder of Abel was interpreted as a premonition of the Passion of Christ. On the left, a muscular Adam handles a spade, for after the Fall from Grace (acted out by small figures in the background) the carefree life in Eden will be over, and mankind's progenitors will be forced to subdue the earth in "the sweat of their brows."

In this picture, as a result of his thorough study of the nude, Ramboux succeeds in treating the human body in a considerably freer, bolder, and thus to all intents and purposes more monumental manner than is generally the case with the Nazarenes and other German Romantic artists.

Josef Führich
The Passage of Mary through the Mountains, 1841
Oil on canvas, 52 x 69 cm
Vienna, Österreichische Galerie Belvedere

JOSEF FÜHRICH
1800–1876

Führich, an Austrian, was a pupil of Overbeck. A reading of Wackenroder's *Effusions of an Art-Loving Friar* (1797) drew his attention to Dürer. In his autobiography, Führich recalled his first confrontation with Dürer's woodcuts: "I sat down, concentrated and with a kind of reverential awe; I looked, and looked again, and could not believe my eyes.... Here before me stood a form in sharp contrast to that which has found the blessing... of the denigrators of our great predecessors, and which attempts to sell its characterless suavity..., borrowed from a misunderstood Antiquity, as beauty and its affected insipidness as grace. Here stood a form engendered by a profound insight into its significance, and this was reflected, on the foundation of religiosity... and nationality...."

Führich's *Passage of Mary* is sadly not entirely free of the "affected insipidness" he himself so deplored. Mary is shown on the way to visit Elizabeth. Above her, three angels cast roses, one of which Joseph bends to pick up. The pair is preceded by three other boy angels. In the background, the warm hues of an expansive landscape form a contrast to the particolored, as if *cloissoné* figures in the foreground. Though intended to have an intimate, popular appeal, the composition is marred by a certain cloying sweetness, and cannot begin to approach Führich's great idol, Dürer.

WILHELM VON SCHADOW
1788–1862

The painting *Pietas and Vanitas*, which still has its original gilded frame, is built up of two small rounded arches resting on a column, spanned by a larger arcade. Derived from medieval and early Renaissance altarpieces, this configuration was very popular among the Nazarenes. Depicted in the upper lunette is a half-length figure of Christ, emerging from clouds and giving the benediction. In the arches below appear female personifications of piety (Pietas) and vanity or transience (Vanitas). Pietas, raising her head as if to listen, guards the flame of an oil lamp with her left hand. Simply clad in a white gown and red mantle, her only adornment is a myrtle wreath in her hair. Vanitas, in contrast, wears an exquisite red-and-gold brocade gown and her vanity is characterized by the way she braids ribbons into her long hair. She wears a necklace and an elaborate wreath. The two figures are linked by a continuous Italian landscape behind the column, its center occupied by a shell-shaped niche with fountain.

The complicated allegorical depiction, which recurs to the medieval tradition of personifications of virtue and vice (including the parable of the Wise and Foolish Virgins) the contrast between two different female types, and the historical costume and smooth, painstaking paint handling, all make the picture a typical product of Nazarene art.

Wilhelm von Schadow
Pietas and Vanitas, 1840/41
Oil on canvas, 194 x 144 cm
Bonn, Rheinisches
Landesmuseum

FRANZ LUDWIG CATEL
1778–1856

Catel is one of the many German artists of the Romantic era who resist classification in any one school or style. With his in part very naturalistic and in part idyllic paintings he paved the way for Biedermeier. The present work, done in 1814, shows the Bavarian crown prince and later king, Ludwig I, and the Danish sculptor Berthel Thorvaldsen in convivial company with other artists at the "Rooms of the Vatican," a tavern on Ripa Grande where the crown prince regularly invited his artist friends to a breakfast with *frutti di mare* and wine. Ludwig, seated not at the head of the table but on a bench beside Thorvaldsen, gestures to the innkeeper, who approaches with fresh bottles. Through the open door we see a view of Aventine Hill, beyond the Tiber.

In the wake of the Napoleonic Wars and in the political doldrums of the Biedermeier period with its civil order, maintained with the help of a curfew and newspaper censorship, Rome increasingly became a place of temporary escape for German artists and intellectuals. While at home "frosty winter cold broods," wrote Ludwig Richter, "here in Rome... the most glorious Spring [has] broken out." Due to the freedom and good spirits obtaining in their studios and haunts, travel guides now began recommending their gentle readers to look up the German artists in Rome, whose parties became something of a tourist attraction.

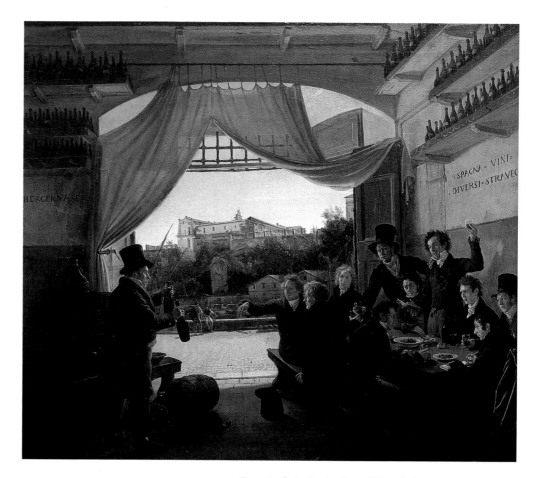

Franz Ludwig Catel Crown Prince Ludwig in the Spanish
Wine Tavern in Rome, 1824. Oil on canvas, 63 x 73 cm
Munich, Bayerische Staatsgemäldesammlungen, Neue Pinakothek

Carl Rottmann
View of the Eibsee, 1825
Oil on canvas, 76 x 99.5 cm
Munich, Bayerische Staatsgemäldesammlungen,
Neue Pinakothek

CARL ROTTMANN

1797–1850

When Carl Rottmann came from Heidelberg to Munich in 1811, he saw Joseph Anton Koch's *Heroic Landscape with Rainbow* (ill. p. 2) and *Schmadribach Falls* (ill p. 22). It turned out to be a crucial experience. Beginning from such models, Rottmann developed a unique landscape style that made him one of the major German landscapists of the nineteenth century.

Intimations of this are already seen in his painting of the Eibsee. By means of sweeping horizontals Rottmann evokes the majesty and sublimity of the mountains, emphasizing them all the more by contrast with the tiny figure on the outcrop in the left foreground. Otherwise the scene shows no trace of human presence or habitation. Water, rocks, and sky speak with their own voice, underscoring their wild, primeval character.

For all his precise observation of detail, Rottmann never loses himself in details but retains an eye for comprehensive form. In order to heighten the effect of the landscape almost to the point of pathos, he eschews topographic

exactitude to include in the panorama view peaks that could never be seen simultaneously from a single vantage point – even adding a gigantic Mont Blanc that outsoars the Zugspitze. The result is a monumental background composition rising in pyramidal form, which appears detached from the remainder of the landscape by the intense, virtually supernatural illumination. The composition is given a solid visual base by the shadowy terrain sloping up from the lake.

The rocky outcrop in the foreground with the two figures marks the farthest point to which we as viewers can imaginatively enter the composition. The distant mountains, in contrast, are accessible only to the eye or to the flight of a bird – and perhaps only to one of the hikers depicted.

Rottmann placed great store in this painting, and, as he instructed in a letter from Italy in 1816, definitely wished it to be shown at the Great Munich Art Exhibition, held only once every three years. This never came to pass, for reasons that remain unexplained.

Rottmann was commissioned by King Ludwig I of Bavaria to paint a cycle of landscape frescoes with Italian views for the Hofgarten Arcades in Munich, which were executed from 1830 to 1834. The preparatory works included the painting *Taormina with Mt. Etna*.

The view of the Sicilian town chosen by Rottmann was unusual, since it is far from the ancient Greek theater that usually occupied the foreground of depictions of this famous scene. Yet topography was no more than an occasion for the artist to depict atmospheric phenomena in a dazzling play of color and light. The actual landscape is transmuted into a vision of nature, whose drama at the same time evokes memories of the historical events that took place here.

In illumination and palette, in the tectonics of the countryside and the transparent expanse of sky, real blends with unreal to engender an ideal, that of a landscape of longing whose presence is all the stronger for the traces of historical grandeur it contains.

From 1838 to 1850, after he had completed the cycle of Italian landscapes, Rottmann executed a series of twenty-three murals with Greek motifs, which likewise were preceded by preparatory oils. In view of the Greeks' war of independence against the Turks, such subjects had become popular throughout Europe, especially in Bavaria, which in 1831 had, with Otto I, provided the first king of Greece.

The spectator looks out over a desolate landscape cut through by a watercourse, whose very harshness lends it the effect of wild sublimity. Jutting into the picture on the left is a rocky outcrop, and standing on it the small figure of a lone monk. On the broad plateau at the upper right one recognizes the ruins of the acropolis of Sicyon, an important city of antiquity.

In the background, towards the sea, lies ruined Corinth with its fortress hill. All human achievements are as nothing in face of the destructive forces of nature and time, the artist would seem to be saying, a notion contemplated by the monk as well. The Golden Age of Greece has fallen into ruins which are hardly distinguishable from the rocks around them. Only the elemental forces of nature remain. But beyond this symbolic message, which certainly partakes of Romantic notions of historical philosophy, the painting exhibits a coloristic intensity and sophistication the likes of which would be hard to find in German painting of the day.

With the inauguration of the Neue Pinakothek in Munich in 1846, Rottmann's cycle of Greek paintings found its final location, in a circular room designed expressly to take the paintings and unite them into a continuous panorama. The sole source of illumination, a skylight, further heightened and vivified the coloristic effects, especially in the skies of Rottmann's visions of Greece.

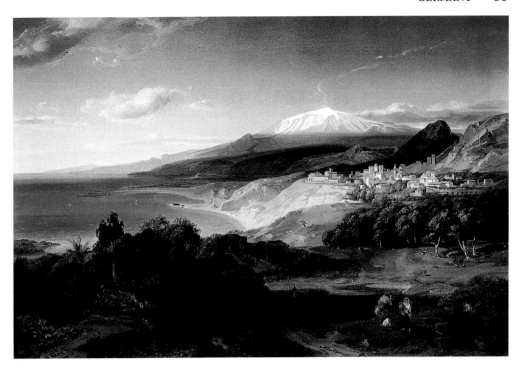

Carl Rottmann
Taormina with Mt. Etna, 1828/29
Oil on canvas, 49 x 73 cm
Munich, Bayerische Staatsgemäldesammlungen,
Neue Pinakothek

Carl Rottmann
Sicyon with Corinth, c. 1836–1838
Oil on canvas, 85.2 x 102 cm
Munich, Bayerische Staatsgemäldesammlungen,
Neue Pinakothek

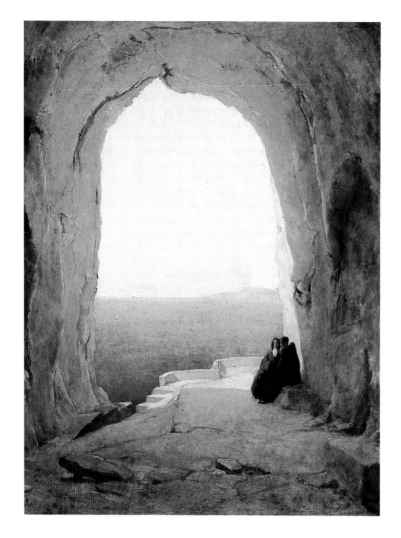

Like Carl Rottmann, Blechen was one of the finest colorists in nineteenth-century German painting. During his apprentice years in Dresden his style was shaped by the work of Johan Christian Clausen Dahl, but above all by that of Caspar David Friedrich. Many paintings of the period have the character of variations on Friedrich, especially in terms of theme.

A journey to Italy in the years 1828–1829 brought a decisive change in Blechen's art. His interest began to focus on visual phenomena, on the effects of light and color in landscape, rendered in a way that occasionally even seemed to anticipate Impressionism. Yet this did not preclude Blechen's propensity to place a Romantic emphasis on sentiments and sensations.

In his small oil painting of about 1829, the artist's painterly sophistication is seen especially in the nuanced play of colors on the walls of the cave, juxtaposed to the delicate blue of the sea, the hazy horizon, and the pastel sky. The two monks in black cowls are not gazing into the distance, as they would probably in a Friedrich, but into the interior of the cave. Instead of a yearning for the freedom of infinity, Blechen evokes an introspective contemplation, a profound tranquillity that suffuses the scene and lends it almost the character of still life.

Karl Blechen
Monks on the Gulf of
Naples, c. 1829
Oil on wood panel,
37.5 x 29 cm
Cologne, Wallraf-Richartz-
Museum

Despite many later changes, the Villa d'Este and its park on the outskirts of Rome has remained a typical Renaissance estate of the sixteenth century. Blechen leads our eye through a lane flanked by tall cypresses to the stairway and main entrance of the upper building.

The exaggerated perspective marked by the two lines of trees veritably compels us to imaginatively retrace, step by step, the ceremonious path through the gardens to the villa. At the same time, this arrangement gives Blechen the opportunity to use the cypresses like the darkened wings of a stage set. Beams of diffuse light fall between their trunks, dramatically highlighting both statues and the historically garbed accessory figures.

Like actors in a play set somewhere between dream and reality, past and present, unconcerned with historical accuracy, the tiny figures move with measured steps through a zone of extreme lighting contrasts rendered in a scintillating range of colors.

Blechen's artistic enjoyment of optical phenomena, often denounced as daubing by contemporary critics, is as evident here as his Romantic attempt to reconstruct the past not archaeologically but through a free play of imagination. That his endeavor to evoke a mood sometimes bordered on the feverish, is obvious in the passage with figures here, in which strange violet gradations predominate.

Karl Blechen
The Gardens of the Villa
d'Este, c. 1830
Oil on canvas, 126 x 93 cm
Berlin, Nationalgalerie,
Staatliche Museen zu Berlin –
Preussischer Kulturbesitz

When Blechen returned from Italy, the *Teufels-brücke*, or Devil's Bridge, at St. Gotthard Pass was still under construction. Its site in a valley enclosed by soaring mountains, the wild rapids of the Reuss River flowing beneath it, the uncanny lights and shadows in which the changing light of day plunged the scene – all of this conformed perfectly with the Romantic notion of the sublime, of a chilling, thrilling loneliness remote from the crowds and comforts of civilization.

Three preparatory sketches were made for the composition. One, quite summarily executed in pencil, only suggests the topographical situation; the other two, in oil, show the final framing of the scene with its awesomely towering rocks and the arch structures of both old and new bridges.

Yet the laborers resting by the path at the right, the scatter of building materials, the scaffolding and masonry of a new, higher bridge arch, announce that even in this mountain wilderness, technology is on the advance. Yet is it really an optimistic belief in progress that speaks to us from this image? The bridge would seem too fragile, too exposed, to be able to lastingly defy the awesome forces of nature that reign in this Alpine realm. The new art of engineering is confronted here with the timeless sublimity of nature, as is a painterly emphasis that borders on the autonomy of color with a retention of the Romantic landscape motif as a conveyer of mood.

Karl Blechen
Devil's Bridge, c. 1830
Oil on canvas, 77.6 x 104.5 cm
Munich, Bayerische Staatsgemäldesammlungen,
Neue Pinakothek

WILHELM VON KOBELL

1766–1853

Kobell's composition is devoted to the imminent sortie of the Prussian troops occupying the fort of Kosel in Silesia, which was beaten back in 1808 by Bavarian forces under Major General Raglovich. This is the first of a total of twelve monumental battle paintings Kobell executed for Crown Prince Ludwig of Bavaria, and finished in 1815.

From their vantage point on a strategic hill in the foreground, cavalry officers look down into the valley with town and over to the mountains on the far horizon. The sun has just risen and casts its light on the hills and the figures in the foreground, while the fort in the middle ground, in front of the silvery bends of the Oder River, still lies largely in twilight.

The filigree branches of the bare trees at the right edge have prompted many authors to think of Caspar David Friedrich and an affinity with Romantic art. Yet it should be emphasized that in executing this commission, Kobell functioned as a sort of war artist, attempting to capture the relevant events with a reporter's precision. On the other hand, the virtually overwhelming atmosphere of the vast landscape surpasses any merely documentary objectivity, and ultimately leads into the sphere of emotive determination.

Wilhelm von Kobell
The Siege of Kosel, 1808
Oil on canvas, 202 x 305 cm
Munich, Bayerische Staatsgemäldesammlungen,
Neue Pinakothek

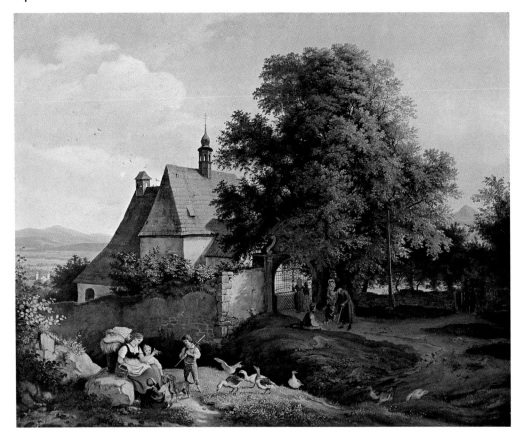

Ludwig Richter
The Church at Graupen in Bohemia, 1836
Oil on wood panel, 56.7 x 70.2 cm
Hannover, Niedersächsisches Landesmuseum

Ludwig Richter
Pond in the Riesengebirge, 1839
Oil on canvas, 63 x 88 cm
Berlin, Nationalgalerie, Staatliche Museen
zu Berlin – Preussischer Kulturbesitz

LUDWIG RICHTER
1803–1884

As a student at the Dresden Academy, Richter took his point of departure in that version of Romantic painting which had been shaped by Friedrich, Dahl, Oehme and others. During a trip to Rome in 1832–1836, despite close contacts with the Nazarenes, he then launched into idealized landscapes in the manner of Joseph Anton Koch.

Yet Richter's attempts lacked the heroic pathos, the classical grandeur, and the inner monumentality that marked Koch's work. With their numerous and lovingly rendered details, pleasing colors, and figures dressed as if in holiday attire, Richter's landscapes managed to evoke little more than idyllic charm in the Biedermeier mode. It was not without reason that he condemned the "mystifying tendency" and "sick melancholy" of a Caspar David Friedrich.

The Church at Graupen, done at a period when, after walking tours through Saxony and Bohemia, Richter turned to local scenes, is suffused with this naive and idyllic mood. In place of Italian shepherds, good simple people from the artist's home surroundings now serve as foils to emphasize an unspoiled harmony with nature. Nothing disturbs their equanimity, no existential or social tensions are detectable. The church is the reference point for life, both human and natural. Down to our own day, and particularly in trivial and department-store art, imagery of this type continues to perpetuate the fiction of The Good Old Days.

In the center of *Pond in the Riesengebirge* lies a small, seemingly unfathomable lake, in which the sky is reflected as if in the pupil of an eye. The far shore is framed by hills and mountains whose leftmost peaks are veiled in tattered clouds. In front, a path winds through fallen rocks and boulders, and along it moves a bizarre group: an old man with pointed cap and knapsack who is apparently fighting against the blustering wind, a young boy who turns a seemingly anxious gaze towards the water, and dog trotting along behind.

The artistic daring with which Richter captures the dramatic mood of the natural scene and his self-imposed limitation to only a few, broadly conceived forms, are unique within his œuvre. The picture shows what coloristic accomplishments and uncanny flights of fancy he would have been capable of, had he not continually retreated into the quiet nook of the Biedermeier idyll.

From the late 1830s onwards, Richter devoted himself increasingly to book illustrations, especially in the woodcut technique, and revelled in cozy, homely subjects. Yet in the present canvas he rose to a height of painterly brilliance and realistic view that puts this landscape nearly on a par with those of Dahl and Blechen.

Even as his study period in Rome was drawing to a close, Richter was convinced he had to orient his efforts entirely towards the ideal Classical landscape, despite the risk of falling into an anemic mannerism of the kind to which many a Nazarene artist had succumbed. After his return to Germany in 1826, and especially after a hiking trip through the mountains of Bohemia, his intentions and with them his landscape style changed, in the direction of increased topographical accuracy. He also held fast to the notion of explaining the idea and content of a landscape through suitable accessory figures.

These factors immediately came into play in a quick succession of depictions of the Schreckenstein in which Richter displays his closest stylistic and thematic affinities with Caspar David Friedrich.

The *Crossing at the Schreckenstein* was enthusastically received by Richter's contemporaries, and is still one of his most popular pictures in Germany today. The idea for it likely occurred to him during the hiking tour mentioned above.

In his memoirs Richter recalled, "As I remained standing on the bank of the Elbe after sunset, watching the activities of the boatmen, I was particularly struck by an old ferryman who was responsible for the crossing. The boat, loaded with people and animals, cut through the quiet current, in which the evening sky was reflected. So eventually it happened that the ferry came over, filled with a colorful crowd among whom sat an old harpist who, instead of paying the penny for his passage, played a tune on his harp."

In his picture Richter attempts to catch the simple, moving tone of a folksong, in order to lend resonance to the venerable idea of a "ship of life" in which all ages of man, from infancy to old age, are united. The young vagabond gazing up towards the castle ruins becomes a personification of Romantic yearning – depicted from behind to encourage us as viewers to identify with him – while the old singer invokes bygone times. The boat itself appears much too small to carry the people crowded into it, and seems immobilized in the middle of the river. The arch overspanning the composition is probably intended to give it a solemn, sacramental air.

Ludwig Richter
Crossing at the Schreckenstein, 1837
Oil on canvas, 116.5 x 156.5 cm
Dresden, Gemäldegalerie Neue Meister,
Staatliche Kunstsammlungen Dresden

Moritz von Schwind
Fairy Dance in the Alder Grove, c. 1844
Oil on wood panel, 62.8 x 84 cm
Frankfurt am Main, Städelsches Kunstinstitut
und Städtische Galerie

MORITZ VON SCHWIND

1804–1871

With Moritz von Schwind, German Romantic painting irrevocably escaped into the realm of legends and fairy-tales, leaving unpleasant realities behind for a non-committal world of wishes and dreams.

Rendered in a graceful and even musical linearity, a group of fairies and their elfin queen are shown dancing through wisps of fog, meandering around a meadow tree whose leaves and branches extend, mysterious and lovely, into the light sky.

In the literature of the day, especially in Jacob Grimm's *German Mythology* of 1835 but also in the various fairy-tale anthologies of the Romantics, the elves of Nordic legend were described as "local" spirits of nature as opposed to the nymphs of ancient Greece and Rome. But von Schwind's group has very little transcendental magic about it. Though the figures might seem to hover over the ground, the stronger impression is one of a down-to-earth and convivial family group. The women and children, rendered in a linear style then considered to be "typically German" and national in character, represent a fairy-tale version of the family as a refuge and stronghold of fundamental values. In fact, the family was declared to be the nucleus of the State by political theorists of the Restoration in the period leading up to the events of 1848.

In 1826, von Schwind wrote to Peter von Cornelius that for the past five years he had been involved in a series of lyrical pictures. One of these was the present landscape study.

The peace of the scene, the harmony of man, animal and nature it exudes, make this small panel with its hermit leading horses to the trough one of the most convincing paintings in von Schwind's œuvre. One senses the proximity of the poems of Joseph von Eichendorff, or those of Eduard Mörike, a friend of the artist's, for here, the notion of "sylvan solitude" has taken on material form. And one also senses last reverberations of the profound view of nature of early Romanticism, its religious roots and pantheistic spirituality.

Beyond this, the rugged, looming cliffs that cut the scene off in the background, the gloomy shadows of the mountains against which the pale white horse takes on the look of an apparition, and the faceless, hooded figure of the hermit, lend an undertone of Gothic horror to the scene.

When von Schwind died, Ludwig Richter announced in his diaries the end of "a great, glorious epoch in art." Now, he predicted, "everything will aim at superficial brilliance and dazzle, with little or no ideal content."

Moritz von Schwind
A Hermit Leading Horses to the Trough, c. 1845
Oil on wood panel, 46.7 x 38.5 cm
Munich, Bayerische Staatsgemäldesammlungen,
Schack-Galerie

FERDINAND GEORG WALDMÜLLER

1793–1865

The late work of the Austrian artist Wald-müller may be taken to represent those final efforts of the Biedermeier period which Ludwig Richter criticized as lacking in ideal content.

In *The Emergency Sale* (or *The Last Calf*) of 1857, for instance, Waldmüller very realistically depicts the often bitter and harsh side of peasant life. Yet this is not yet socially critical painting in the true sense, because the social causes which have forced the man to sell his calf for less than it is worth are not addressed. The fate of the poor cottager's family is still embedded in the tradition of a genre painting that focussed on the depiction of popular characters or types.

Even more, the picture would seem almost to advocate the virtue of what the German author Jean Paul called "happiness within limitation," an aspect of sublimation which manifests itself, in formal terms, in the exquisite play of color in the sunlight falling on the house wall and the figures. Nevertheless, by comparison with early Romantic symbolism, the picture is neither idealized nor profoundly philosophical in intent. Its sharp-focus rendering of details marks the transition from the Biedermeier phase of German painting to naturalism.

Ferdinand Georg Waldmüller
The Emergency Sale (The Last Calf), 1857
Oil on wood panel, 44 x 56.3 cm
Stuttgart, Staatsgalerie Stuttgart

CARL SPITZWEG

1808–1885

The Poor Poet, an early work, is surely the most famous of Spitzweg's, a painter of the Munich Biedermeier.

It shows an eccentric representative of the brotherhood of poets – or perhaps philosophers – in his attic hovel, trying to keep warm by burning his manuscripts in lieu of the firewood he cannot afford. But the stove has gone out, and, clad in nightgown and nightcap the Biedermeier intellectual lies shivering in bed, an umbrella open above him to fend off the water dripping through the ceiling. Yet all undaunted, his quill clamped between his teeth like a dagger, he continues to compose, scanning a hexameter whose accents are marked on the wall over the bed.

At that period the hexameter was the basic building block of epic poetry, considered its highest form. Correspondingly ambitious are the Latin titles of the folios stacked beside the bed, *Gradus ad Parnassum* (The Way to Parnassus). Yet one fears these too, despite their claim to perpetuity, will soon merely find their way into the stove. Thus a strain of humor, indeed caricature, runs through this depiction of a bohemian life which, when it was painted, was generally viewed in the Romantic light of the artist as intrepid outsider.

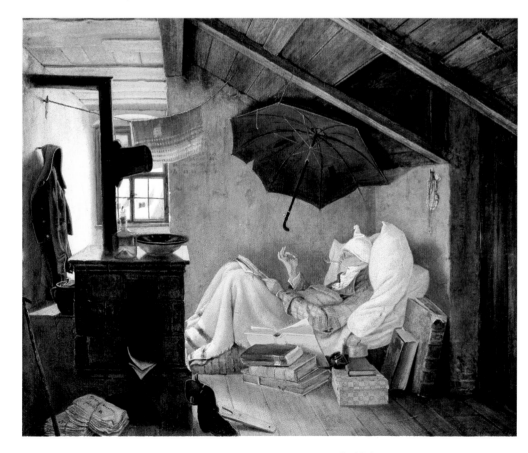

Carl Spitzweg
The Poor Poet, 1839
Oil on canvas, 36.3 x 44.7 cm
Berlin, Nationalgalerie, Staatliche Museen
zu Berlin – Preussischer Kulturbesitz

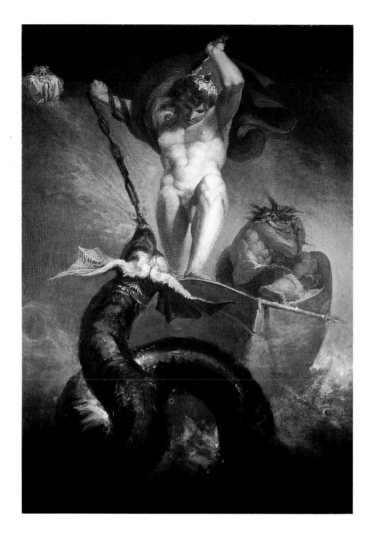

Henry Fuseli
Thor Battering the Midguard
Serpent, 1790
Oil on canvas, 131 x 91 cm
London, The Royal Academy
of Fine Arts

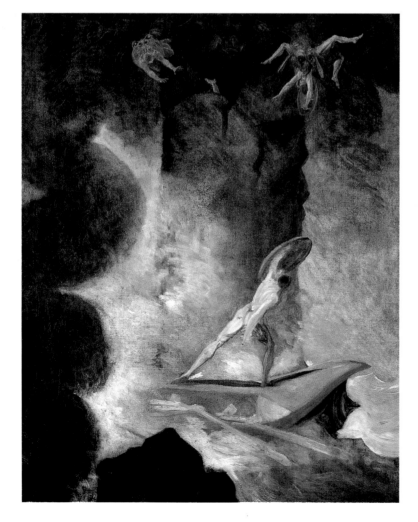

Henry Fuseli
Odysseus between
Scylla and Charybdis,
c. 1795
Oil on canvas,
126 x 101 cm
Aarau, Aargauer
Kunsthaus

HENRY FUSELI
1741–1825

In *Thor Battering the Midguard Serpent*, Fuseli puts the chief god of the ancient Scandinavians, the god of free peasants who protected men against the giants, at the center of interest. According to Germanic legend, in the twilight of the gods Thor would manage to split the serpent's skull, but only to succumb to its poisonous breath. Fuseli depicts him at the moment of triumph, from a low vantage point that further underscores the heroism of the monumental figure. The giant Eymer crouches fearfully in the stern of the boat, as Wotan observes the battle from the clouds. Rather than merely illustrating the Nordic saga, Fuseli transformed it into an individual myth, a very personal statement. This can be seen in his approximation of the Thor figure to an earlier depiction of the Swiss freedom fighter Wilhelm Tell, as well as in the suggested association with the battle of Archangel Michael with the dragon of hell. Thor becomes an embodiment of the principle of eternal good in conflict with eternal evil. Four years later, the same serpent would reappear in William Blake's work, as a symbol of the French Revolution.

This painting in sketchy, flocculent gradations of gray shows Odysseus in his struggle against the forces of nature, embodied by the Scylla and Charybdis of Greek mythology. In the belligerent pose of a famous antique statue, *The Borghese Fencer*, armed only with a shield, the Greek hero stands in the red prow of his ship, which is being driven through foaming seas past the rock of Scylla towards the maw of Charybdis. Visible on the heights of the cliff is the head of Scylla, who is preparing to devour Odysseus's companions. Fuseli, initially an ardent adherent of the French Revolution, also included allusions to contemporary events in his work. His Odysseus is rising against an overweening monster whose seat resembles a despot's castle, which suggests a parallel with the revolutionary battle against aristocratic oppression. However, since Fuseli condemned the bloody excesses of the revolution, his *Odysseus* cannot be considered mere political propaganda, but rather seems to represent a symbol of the existential struggle of the free, imaginative individual.

Fuseli did a total of four variations on *The Nightmare*, probably his best-known theme. The example in Frankfurt is the second variation. Though the motif was not inspired by any specific literary model, it would be unthinkable without a knowledge of ghost stories, especially English ones. The figure of the woman lying asleep or unconscious is extremely elongated and distorted, not because Fuseli could do no better but in order to visualize the horrible oppressiveness of the gnome crouched on the woman's breast, a nightmare and incarnation of unconscious terrors. In the gap between the curtains in the background appears the ghostly head of a blind horse, which anticipates the demoniac aspect given this animal especially in later French Romanticism.

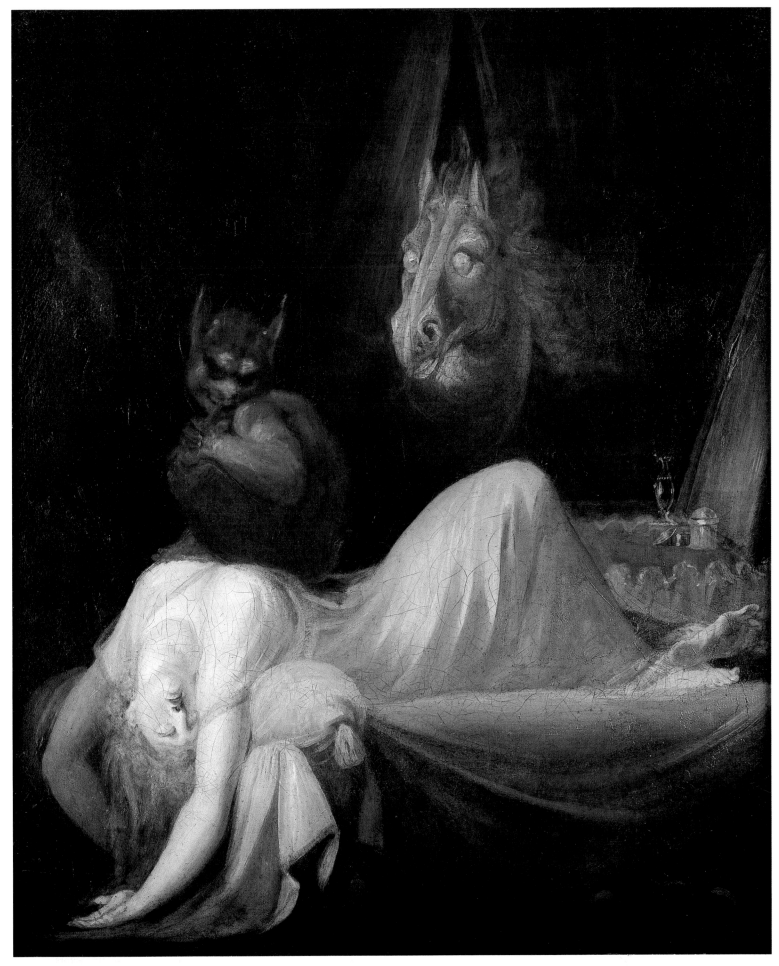

Henry Fuseli
The Nightmare, 1790/91
Oil on canvas, 76.5 x 63.5 cm
Frankfurt am Main, Freies Deutsches Hochstift,
Frankfurter Goethe-Museum

WILLIAM BLAKE
1757–1827

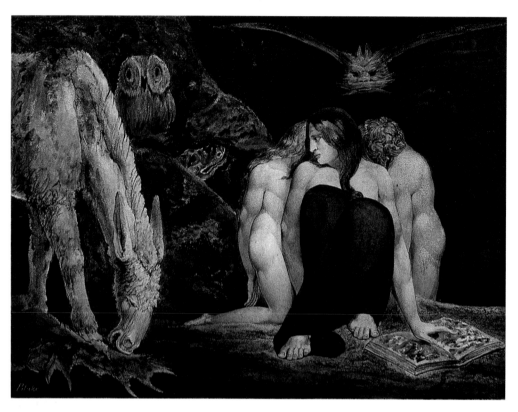

William Blake
Hecate, 1795
Color monotype, 43 x 57 cm
London, Tate Gallery

In Greek mythology, Hecate was a goddess of
the moon, earth, and underground realm of the
dead, and was later regarded as the goddess of
sorcery and witchcraft. Blake emphasizes this
latter role, showing Hecate reigning in a
gloomy nocturnal realm, her hand resting on
an open book, accompanied at the left and in
the background by uncanny, threatening ani-
mals.

This monotype, a color print created using a
technique that had been invented by Blake
himself, was not intended as a book illustra-
tion like most of the English artist's other
work. It formed part of a 1795 trilogy, devoted
to the subjects of superstition, the evils of an
overemphasis on reason, and the power of sen-
suality, which holds an outstanding place in
Blake's œuvre.

The image evinces certain formal and sub-
stantial influences, recalling the work of the
German artist Asmus Jakob Carstens, but even
more that of Fuseli and, by way of him, the
phantasmagorical animal realm of Goya's
Caprichos. Elements of neoclassicism and hallu-
cinatory Romanticism are combined into a
compelling image rife with subjective mystical
symbolism.

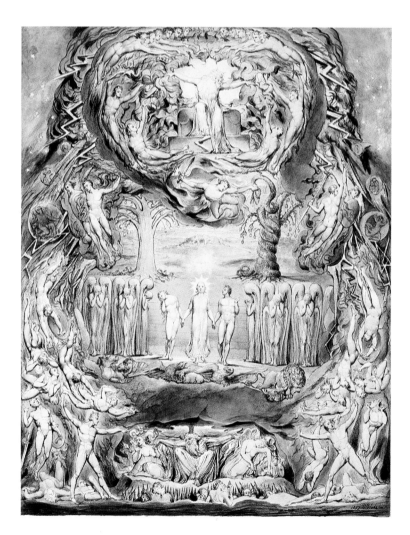

William Blake
The Fall of Man, 1807
Watercolor,
49.6 x 39.3 cm
London, Victoria and
Albert Museum

In this print, made by Blake for his patron,
Thomas Butts, the venerable Christian theme
of the Fall from Grace becomes the point of de-
parture for a cosmic drama. In the center,
Christ leads Adam and Eve through the gates
of Eden, past weeping angels whose figures
were likely inspired by medieval funerary
sculptures.

While this act of the expulsion from Para-
dise takes place with unusual mildness, God
the Father above, an implacable power by com-
parison to Christ, reacts with fury to Adam
and Eve's loss of innocence. On both sides of
the sheet rebellious angels fall into Hell, de-
picted at the bottom, where Satan, mighty
counterpart to the Lord of Heaven, awakens
Sin in the shape of the Whore of Babylon and
Death with plague bell and sword. Apart from
the Bible, Milton's *Paradise Lost* served Blake
as a source of inspiration, though there, Christ
is described as an angry warrior.

Like his friend Fuseli, Blake developed a
highly subjective religious philosophy and, in
an abstracted linear style that seemingly ig-
nored the laws of gravity, lent it a radically vi-
sionary expression that sent all familiar tradi-
tions by the board. This new, spiritually
nurtured "mythology" perfectly conformed
with the Romantic desire to derive a universal
scheme of things from an interplay of opposing
forces.

After 1790, in the wake of two profound
revolutions, the French and the American, the
story of Genesis would be rewritten for a mod-
ern Western world and under the sign of a new
cosmology.

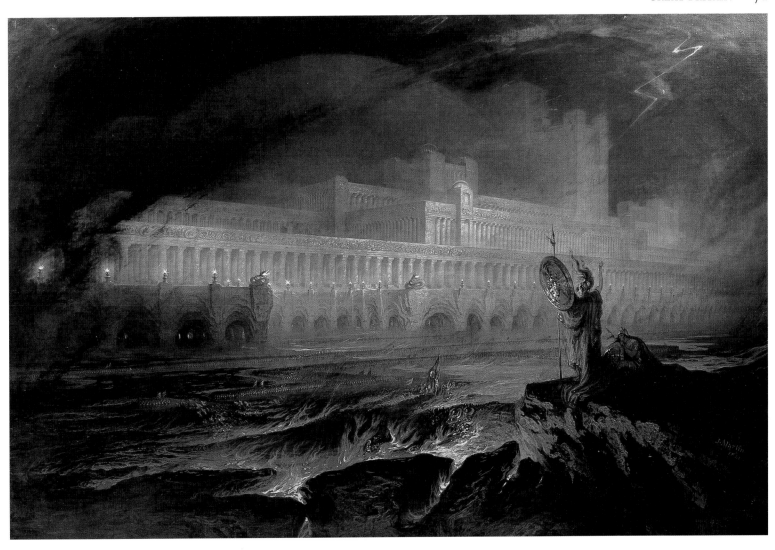

JOHN MARTIN

1789–1854

Pandemonium goes back to a passage in the first book of Milton's *Paradise Lost*, in which "Pandemonium, the palace of Satan, rises suddenly built out of the deep."

In a diagonal perspective characteristic of Martin, a gigantic building complex extends along the waterfront. This recalls fantastic reconstructions of cities of antiquity as much as it does Martin's own designs for a walled road along the bank of the Thames in London. At any rate, despite the lightning-scored night sky and the eerie torchlight illumination, the structure makes one think of some hybrid administration building in a totalitarian state. A contemporary critic was even moved to compare Satan's palace to the rail terminal of an "all-too self-confident railway magnate."

Martin's Satan, whose invocatory figure stands on a rocky outcrop in the right foreground, has the look of an ancient Greek hero. Like Achilles outside Troy, he appears with shield and feathered helmet, but commanding an army not of besiegers but of demons and damned souls in their Cyclopean city.

But it would be wrong to classify Martin as merely a teller of trivial horror stories. Doubtless he loved to depict conflagrations, eruptions or deluges in lurid illumination, never tired of rendering buildings from past ages

that extended to infinity and dwarfed humans to insignificance, devoted himself to the rise and fall of civilizations as parables of inexorable transience. But these panoramas of catastrophe were the result of precise calculation and amazingly diligent historical and scientific investigation. Martin's imagination was fired by the prodigious and portentous, though at times it did not go beyond mere pomp and circumstance.

His subject matter stemmed largely from the tradition of "black Romanticism," and he was also inspired by Turner's early depictions of awesome catastrophes. It was no coincidence that Victor Hugo lavishly praised Martin and Heinrich Heine in 1844 compared him to Hector Berlioz. On the whole, though his fantasy was admired both in Europe and in America, his palette was not, one commentator even saying Martin's paintings were palatable only in the form of engraved reproductions.

At first Martin prepared his own mezzotint plates, but soon began to employ various professional engravers. The European market was flooded with prints of all sizes and prices based on Martin's compositions, including bootleg versions and copies. Martin became embroiled in copyright proceedings to an extent matched by no other artist of the period.

John Martin
Pandemonium, 1841
Oil on canvas, 123.2 x 184.1 cm
New York, FORBES Magazine Collection

Richard Parkes Bonington
At the English Coast, 1825
Watercolor, 14.1 x 23.1 cm
Budapest, Szepmüvészeti Muzeum

Richard Parkes Bonington
Beach in Normandy, c. 1826/27
Oil on canvas, 33 x 44 cm
London, Tate Gallery

RICHARD PARKES BONINGTON
1802–1828

Bonington settled in 1818 in Paris, where he became completely engrossed in the Romantic painting being done there. Concentrating on the watercolor technique, he developed a painterly style that soon found admirers throughout Europe and even entered the text-books as "Boningtonism."

In his early works the artist operated with a time-tested principle of landscape painting, in which a warm-hued, shady foreground, a familiar, inviting zone, was contrasted with a wonderfully cool and airy distance. Then, influenced by French art, especially that of Paul Huet and Eugène Delacroix, the foregrounds in Bonington's landscapes became increasingly suffused with brilliant and luminous tones.

A watercolor like this marine piece of the year 1825, *At the English Coast*, shows Bonington's style at its best, with its characteristic emphasis on light-dark value contrasts interspersed with islands of brilliant color and its sharply contoured areas of rapidly applied wash. The sea, horizon and sky seem virtually to extend beyond the edges of the sheet into infinity, and the fishing cutter is treated as if it were just as much an elemental natural event as the waves.

The delicate cloud formations reflect an enthusiasm shared by most English landscapists of the period for atmospheric effects of light and color, which found expression in innumerable studies of clouds by artists working in the most diverse styles.

In 1824 Bonington worked on lithograph illustrations for a volume on Normandy, part of Baron Taylor's *Voyages pittoresques et romantiques dans l'ancienne France (Painterly and Romantic Journeys through Old France*, 1825). In this context he also painted numerous oils of scenes on the Normandy coast.

The compositional principles he developed in watercolors – based on influences from French Romanticism – combined with inspirations from earlier Venetian and Flemish art, came to full flower in these paintings, which included this *Beach in Normandy* – the dominant atmospheric effect, the light, luminous colors that seem more important than the subject itself; in short, a painterly approach that sets the basic mood and is occasionally supplemented by picturesque accessory figures. The musing or even dreamlike mood generally found in Bonington can be viewed as a typical constant of the English painting of the period.

An accent of this kind is given here by the two women and a child resting amidst fish baskets, figures that serve as a contrast to the horizontals of the sea receding at low tide, a distant strip of coastline, and the expanse of sky.

Bonington's picture of *St. Mark's Column in Venice* of the years 1826–1828 is characterized by an especially light and brilliant palette, whose luminosity was surely influenced by the watercolor technique. Typically for Bonington, the blue, nearly cloudless sky takes up a large portion of the composition. Depicted from an extremely low vantage point, the column with its bronze lion of St. Mark stands out starkly against the sky.

The scene, the result of a trip to Venice undertaken in 1816, attests to the artist's thorough study of the monuments on the Piazzetta, the Doges' Palace and St. Mark's Church. This view stands in the European tradition of veduta painting, popular since the Renaissance. However, rather than giving a topographically accurate rendering, Bonington has used artistic license and altered details of the situation to suit his conception. As works of this type were extremely successful, Bonington repeated them in several versions.

Whether they can properly be called "Romantic" – apart from the general interest in travel impressions and more or less exotic lands – is doubtful, since they contain little trace of that religious view of nature which is so conspicuous especially in German landscapes of the period. Such works by Bonington are better classified as forerunners to an open air painting that issued in naturalism.

Richard Parkes Bonington
St. Mark's Column in Venice,
c. 1826–1828
Oil on canvas,
45.7 x 44 cm
London, Tate Gallery

JOHN SELL COTMAN

1782–1842

In England, landscape art as a vehicle of moods and sensations had already begun to come to prominence in the middle of the eighteenth century. Watercolor in particular, with its subtle gradations of tone and the brilliancy of transparent colors on paper, was ideal for the depiction of unlimited spaces and the evocation of emotional values. In 1805 the recently established English Watercolour Society held its first exhibition in London. The art it furthered represented a protest against the established academies and their style.

John Sell Cotman was one of the many English artists who devoted themselves primarily to watercolors. On 17 September 1810 he wrote to his wife from Normandy that he had drawn the village of Juneville, from whose church steeple James II had seen the Battle of La Hougue, which was to prove so ominous for his fate, and had sat in the same room where the king had slept the night before the battle.

Cotman expected this historical reminiscence to spark the interest of potential English buyers of his work. Yet instead of devoting himself to architectural detail, he depicted a distant view of the landscape beyond the still surface of the water, and, on the left, a lowering sky – a landscape of mood, in other words, which at that period seemed best suited to conveying a tragic historical event of the seventeenth century.

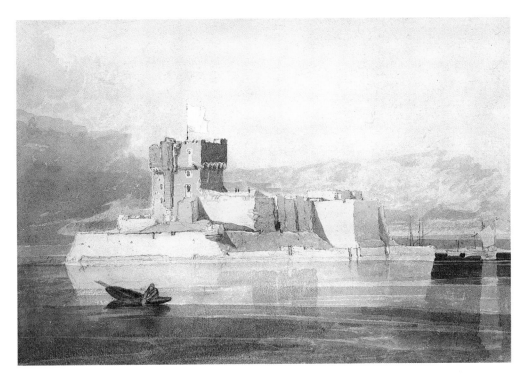

John Sell Cotman
Fort St. Marcouf, near Quinéville, in the Rade de la Hougue, Normandy, c. 1820
Watercolor, 22.4 x 33.3 cm
Cambridge, Fitzwilliam Museum, University of Cambridge

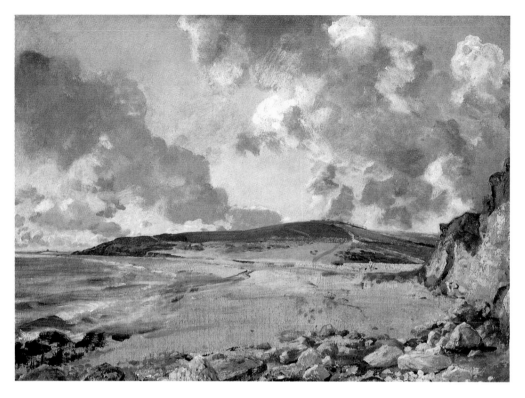

John Constable
Weymouth Bay, c. 1816
Oil on canvas, 53 x 75 cm
London, National Gallery

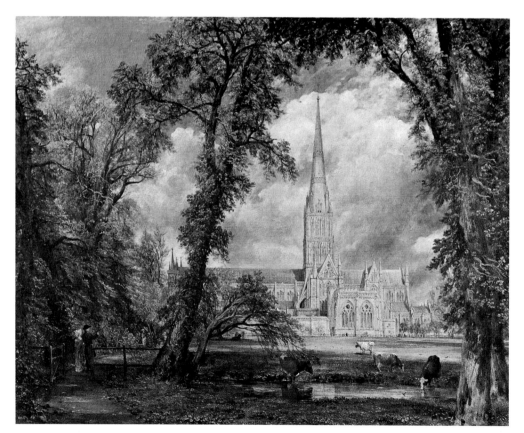

John Constable
Salisbury Cathedral, from the Bishop's Grounds, 1828
Oil on canvas, 34 x 44 cm
Berlin, Nationalgalerie, Staatliche Museen
zu Berlin – Preussischer Kulturbesitz

JOHN CONSTABLE
1776–1837

Constable was one of the major European land-scape artists of the nineteenth century, whose painterly handling of the phenomena of light and color was admired by Delacroix and Géricault in France, and subsequently influenced the masters of Barbizon and even the Impressionists.

His picture entitled *Weymouth Bay* might in reality represent Osmington Bay in Dorset, where Constable's honeymoon trip took him and his wife in 1816. The painting, of which two further versions exist, depicts the lonely bay with its steep cliffs in gradations of reddish-brown and bluish-gray, applied in passages visibly textured by brushstrokes and flecks of paint.

By no means Romantic or unusual, let alone sublime, the landscape derives its charm mainly from the broad, cloudy sky, which plunges the scene in a strange twilight. When Constable once said that feeling and painting were one for him, he was not referring to a reflection of the Romantic ego in universal nature but simply to a direct translation of fleeting visual impressions into painting – though such impressions are certainly capable of releasing poetry and prompting thoughts about the eternal, divine presence in nature.

Constable did this painting on commission from his friend, the Bishop of Salisbury, who also stipulated the point of view and framing of the scene. The Anglican dignitary is depicted with his wife in the left foreground, out for a stroll and pointing to the cathedral.

"My cathedral looks very fine," wrote Constable, then adding that it was the most difficult landscape he had ever had to execute. The view of the Gothic structure with its soaring steeple and stone walls seemingly dissolved into lacy patterns by the glowing sunlight is artfully framed by the arching trees. As with the German Romantics of this period, the house of God seems to function here as a symbol of national history and a sign of a harmonious universal order.

A Romantic effect of sorts is produced solely by the rural site, for unlike Gothic churches on the Continent, surrounded by a confusion of urban buildings, those in England were erected in parklike settings which inevitably carried connotations of the mood of landscape gardens.

Yet by comparison to the works of Caspar David Friedrich, the overall, painterly impression of Constable's canvas is much more objective and oriented to this world rather than to the next. This is underscored by the bishop's reaction to the picture. If only Constable had left out the black clouds, he exclaimed. Clouds were black when it begins to rain. In fine weather the clouds were white, the bishop wrote, and returned the canvas to the artist for reworking.

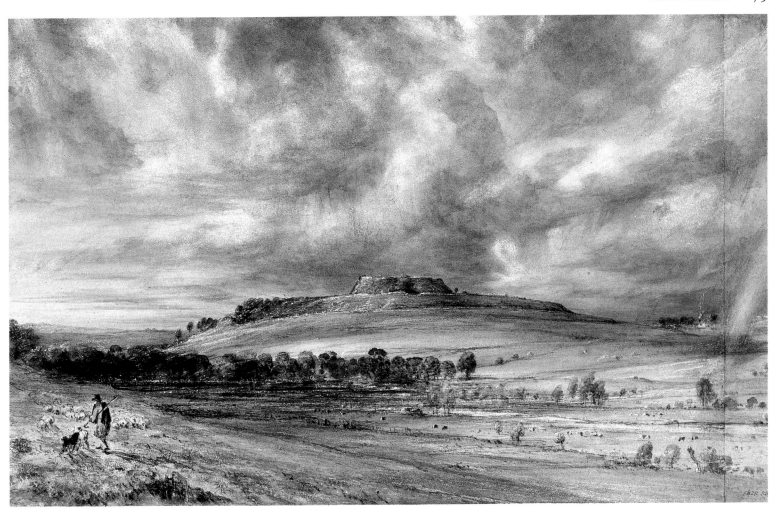

The watercolor *Old Sarum*, the right margin of which was later added on, is one of Constable's most "romantic" works.

Already a fortified hill in the Iron Age, Old Sarum was expanded by the Romans into a town with massive walls. The first cathedral was begun on the site around the year 1080. William the Conquerer established his rule in Old Sarum, and later monarchs and princes of the church resided there. In the thirteenth century it began to fall into ruin.

By Constable's day only the foundations of the once flourishing town remained. Thus Old Sarum represented a national historical monument of the first order, and at the same time a symbol of ubiquitous decay. With landscape elements used to evoke a mood, such as the impressive cloud formations and the gloomy light-dark contrasts, Constable heightened this view into a dramatic staging of the limitless sublime.

Since the consituency of Old Sarum lost its seat in the London parliament due to a reform of 1832, the motif also became a symbol of past glory for the politically conservative artist. Still, such considerations of content and symbolism were entirely secondary to Constable, who concentrated on form and composition with an audacity unsurpassed at that period. Here, too, the subject is taken as an occasion to capture the incessantly changing phenomena of nature.

The entire picture surface seems to shimmer and vibrate, since the contours of things veritably dissolve in light and color, which is applied in the finest tonal gradations and with incredible sensibility. The composition, instead of adhering to academic rules, has more the appearance of a chance slice of life.

The watercolor medium was particularly suited to a spontaneous approach of this kind. But Constable managed to retain spontaneity even in his oils, which thus often took on a sketch-like appearance. The traditional difference in rank between study and finished painting was ignored, in favor of a fundamental tendency to immediately record the sensations of a moment in time. When he sat down to do a sketch from nature, Constable explained in a letter, the first thing he did was try to forget ever having seen a painting before; in other places he wrote that he tried to depict "dew and breezes," "silvery, windy and delicious." Never before, he confidently judged, had such an interpretation of nature been "perfected on the Canvas of any painter in the world."

Old Sarum conforms to the view of landscape Constable expressed in 1821, when he said that it would be difficult to name a class of landscape in which the sky was not the "keynote," the measure, and the main conveyor of feeling. The aesthetic value attached to the amorphous and atmospheric here serves to link the naturalism that otherwise dominates in Constable's work with a Romantic yearning for infinity.

John Constable
Old Sarum, 1834
Watercolor, 30 x 48.7 cm
London, Victoria and Albert Museum

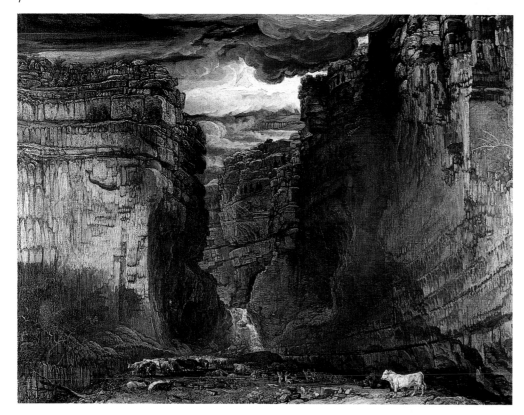

James Ward
Gordale Scar, Yorkshire, 1811–1815
Oil on canvas, 332 x 421 cm
Bradford, Bradford Art Galleries and Museums

JAMES WARD
1769–1859

Ward had a reputation throughout Europe especially for his animal subjects and large-format history paintings, but he also did landscapes such as this huge canvas depicting Gordale Scar, a mountain gorge in Yorkshire.

Ward has expanded the scene to monumental proportions, yet at the same time used a matte grayish-green palette that minimizes the sensuous or atmospheric effect. Though the landscape around Gordale Scar had been "discovered" for eighteenth-century literature as the epitome of sublime nature, it had long been considered unpaintable. The artist places his enormously dimensioned view in this tradition of the sublime wilderness and, for all realism of detail, lends it the character of an ominous vision that primarily reflects his own personal ideas and sensations. Seen from a very low vantage point, the cliffs bordering the gorge loom up into a stormy sky. Their natural history is illustrated with a well-nigh scientifically accurate rendering of strata and signs of erosion, their wild and elemental character underscored by the presence of deer (which actually had long since disappeared from the area) and a spotlighted bull, which appears liliputian by comparison to the natural wonder of the looming jagged cliffs. The eerie illumination and colors combine to give an unreal, symbolic overall impression.

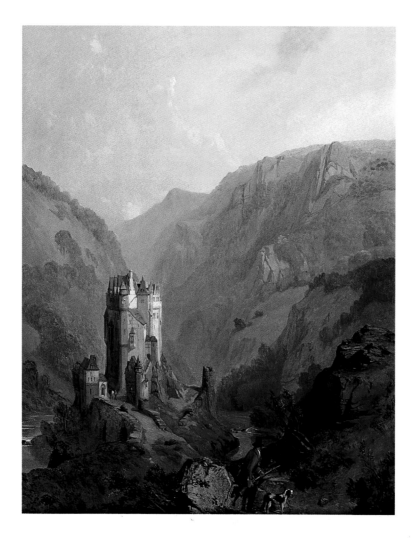

Clarkson Stanfield
Burg Eltz, 1838
Oil on wood panel,
51 x 40.5 cm
Bonn, Rheinisches
Landesmuseum

CLARKSON STANFIELD
1793–1867

Burg Eltz, a castle on a tributary of the Moselle, was a favorite destination of English tourists in Germany. In Edward Murray's travel handbook of 1836 the medieval site was described in good Romantic manner as being the cradle of one of the oldest families of the country and an almost unique example of a feudal seat that had been spared by fire, war and time and remained nearly unchanged over the last two or three centuries.

The strong vertical of the prism-shaped castle walls is placed close to the left edge of the canvas, accentuating the place where the wooded slopes in the background converge on a gorge.

Stanfield, who in 1838 also published a sequence of lithographs entitled *Sketches on the Moselle, the Rhine and the Meuse*, emphasizes in his painting the magnificent site of the castle in the midst of steep mountain slopes, whose actual height, however, he dramatically exaggerates. The small figures of a few visitors among the walls and a hunter in the foreground tend more to underscore the loneliness and sublimity of the castle than to diminish them. In this way Stanfield succeeds in merging nature and history with Romantic sensibility.

FRANCIS DANBY
1793–1861

The present painting is presumably one of four depicting scenes from the Apocalypse which were ordered by the millionaire collector William Beckford as companion pieces to Danby's large-format work *The Opening of the Sixth Seal* (1828; Dublin, National Gallery of Ireland).

In a romantic nocturnal landscape evoking the infinity of the cosmos appears a vision of the giant angel described in Chapter 10 of the Apocalypse, descending in a cloud from heaven with a rainbow over his head and legs like columns of fire. The natural scene in which the visionary apparition is set evinces a coloration and sophisticated painterly handling that explain Danby's rank as one of the finest British landscapists of the nineteenth century.

It is strange that despite the majesty and potential violence of the scene, which after all represents an omen of the end of the world, it has a quite serene, dreamlike effect. In this it differs from the more sensationalist depictions of disasters by John Martin (ill. p. 71) whom Danby, influenced at the onset of his career by his friend William Turner, considered his rival at the time this painting was done.

Francis Danby
Scene from the Apocalypse, c. 1829
Oil on canvas, 61 x 77 cm
New York, Collection of Mr. and Mrs. Robert Rosenblum

SAMUEL PALMER
1805–1881

After 1830 Samuel Palmer's style grew increasingly naturalistic, and by the middle of the century his landscapes had the look of carefully observed topographies. Yet prior to this change his approach to nature had been every bit as mystical as that of the German Romantics, his search for sacred symbols in natural phenomena paralleling Philipp Otto Runge's or Caspar David Friedrich's.

The small painting *Coming from Evening Church* of 1830, for instance, was inspired by a wing of Jan van Eyck's *Ghent Altarpiece*, 1432, which depicts among other things a procession of barefoot pilgrims and hermits to the Adoration of the Lamb. Palmer has recast the scene into a dreamlike moment from the early history of Christianity in the British Isles. A rural congregation in timeless costume are just leaving a village church in the Gothic style, surrounded by thatched-roof houses against a mountainous background. The buildings seem to merge with the natural surroundings, just as the villagers seem to be at one with nature. The disk of the moon, overlarge and flaming with color, hangs in the night sky immediately next to the church steeple and as if framed in a pointed arch formed by the foliage of the flanking trees – an allusion to the contemporary belief that Gothic architecture was inspired by the configurations of woods and forest.

Samuel Palmer
Coming from Evening Church, 1830
Oil and tempera on canvas, 31 x 20 cm
London, Tate Gallery

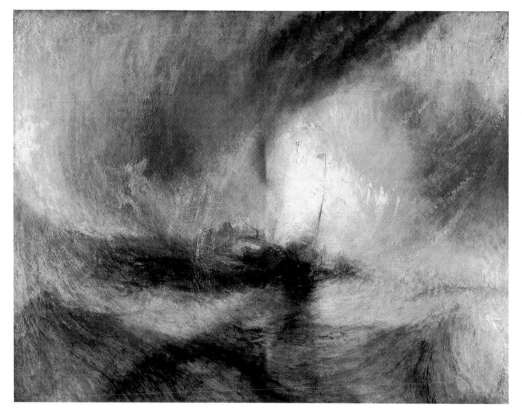

William Turner
Snow Storm – Steam-Boat off a Harbour's Mouth Making Signals
in Shallow Water, and Going by the Lead. The Author was in
this Storm on the Night the Ariel left Harwich, 1842
Oil on canvas, 91.5 x 122 cm. London, Tate Gallery

WILLIAM TURNER
1775–1851

Wishing to closely observe a storm at sea,
Turner once spent four hours voluntarily tied to
a mast of the ship *Ariel*. The entire surface of
the ensuing painting is shot through with con-
trasting masses of light and dark color. Various
gradations of brownish-black are set against
white and dirty whitish-gray. Only in the cen-
ter is there a passage of diaphanous sky blue
where the clouds briefly part in the midst of
raging snow squalls. This blue is repeated, as if
in a reflection, at the upper left and lower right.

The strongest color contrast is found at
about the vertical midpoint of the composi-
tion. Within the black area, a few light brush-
strokes mark a small semicircle that suggests
the wheelbox of a paddle-wheel steamer. Above
this, a black line running diagonally upwards
to the right evokes a mast with fluttering pen-
nant. The spectator is drawn into the whirling
tumult of natural forces, which nowhere per-
mit the eye to come to rest.

To create a tissue of light and color that re-
mains independent of solid objects – that was
the aim of Turner in his late period. The un-
usually long title of the picture would seem to
underscore the artist's assurance that depite the
disintegration of forms in his work, it still re-
lied on actual visual observations. Yet few
shared this opinion. Contemporary audiences
ridiculed the painting as a "heap of soapsuds
and whitewash."

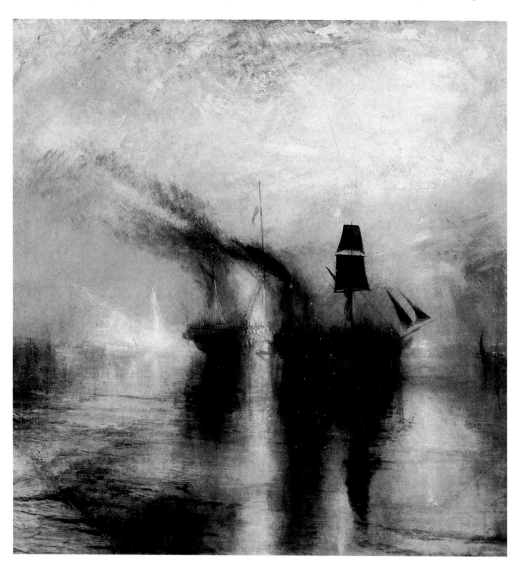

William Turner
Peace – Burial at Sea, 1842
Oil on canvas, 87 x 86.5 cm
London, Tate Gallery

Peace – Burial at Sea was painted in memory of
one of Turner's colleagues, the Scottish painter
David Wilkie, who died on board a steamer re-
turning from Palestine on 1 June 1841, near
Gibraltar. Since the harbor had been closed out
of fear of the plague raging in the Near East,
Wilkie's body had to be given over to the sea
that same night.

Turner translated this sad occasion into one
of his most moving and impressive images, by
contrasting a visionary rendering of light phe-
nomena in the sky, in the reflections on the
water, and on the distant coastline with the
gloomy black solidity of the steamer under
sail. When the painter Clarkson Stanfield told
Turner he thought the sails unnaturally black,
Turner is said to have replied that he only
wished he had a color with which he could
make them even blacker. Like an apocalyptic
omen the dark ship drifts over the water, its
solid hull seemingly split in two by the golden
glow of torches at the spot where Wilkie's
body is being lowered into the sea. This verti-
cal accent of light has the effect of some super-
natural, heavenly apparition.

The most sublime cannot exist without
mystery, said Ruskin, postulating Turner's
compositions with their evocation of the infi-
nite, their negation of objective description,
and their ambiguous, "mystifying" themes as
the adequate form in which to address the inef-
fability of this world.

Turner exhibited the present canvas in 1842
alongside its companion piece, *War. The Exile
and the Rock Limpet* (London, Tate Gallery), an
allegory on Napoleon, suggesting that it, too,
contained allusions to current political events.

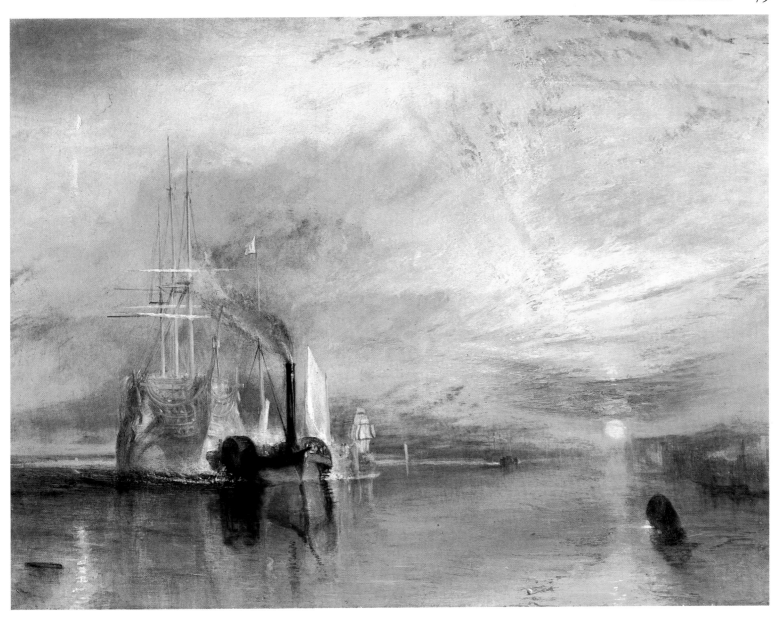

In Turner's day England was the leading maritime power in Europe, with regards both to merchant marine and to ships of war. In 1838, Admiral Nelson's flagship, the *Téméraire*, was towed from the naval base at Sheerness in the Thames estuary to a private dockyard to be scrapped.

Here the *Téméraire*, once a glory of British prowess in the Napoleonic Wars, is depicted against the background of a sunset of almost cloying prettiness, which lends the ship's hull and masts the eerie translucency of an apparition. Like a spectre of its former self the great warship embarks on its final cruise; or rather, is towed, sailless, to its ignominious end by a squat, sooty, by no means heroic steam tugboat. The glory of the nation's past has made way for the new technological era, which henceforward would celebrate its triumphs in more mundane and anonymous circumstances.

In this phase of his career Turner combined fidelity to detail – as in the rendering of the two vessels – with a considerable dissolution of form in the treatment of the atmosphere. The resulting all-encompassing play of color is given a note of threat by the predominant yellowish-reds, which show the superficial beauty of the scene to be deceptive.

John Ruskin, Turner's contemporary and ardent advocate, exclaimed on the end of the *Téméraire* that never again would the sunset drape her in golden gowns or the starlight tremble on the waves she made while gliding through the sea. Beyond the historical reference, the general mood of *vanitas* in the painting, which Turner called his favorite one, has been interpreted as reflecting the artist's thoughts about his own aging and mortality. Due to the contrast between the relative corporeality of the things in the foreground and the vagueness of those in the seemingly inaccessible realm beyond, it has been seen as a metaphor for the last journey of the human soul.

The quiet yet constrast-rich color harmony makes the canvas a culmination in Turner's development. The basic polarity of blue and yellow, as described in Goethe's color theory, seems demonstrated here in the phenomena of sun, clouds, and smoke curling into the sky.

William Turner
The Fighting Téméraire Tugged to her Last Berth to be Broken up, 1838
Oil on canvas, 90.8 x 121.9 cm
London, National Gallery

WILLIAM TURNER

1775–1851

With Turner, English Romanticism undeniably reached its apex. The *Snow Storm* belongs to a phase of his development in which a disintegration of form had already begun to give way to an interplay of sheer color, engendering an almost mystical effect. A confrontation in 1799 with the paintings of Claude Lorrain, which Turner said moved him deeply, had provided the crucial impulse to investigate the potentials of a painterly approach to the effects of light – and darkness – on the atmosphere of landscape.

Here a tremendous snowstorm moves like an apocalyptic omen over the Alps. The dull orange disk of the sun breaking through the black sky at the upper edge of the picture casts an uncanny light on the roiling masses of snow.

Visible at the lower edge, among the boulders, are scenes of murder, rape and pillage. Behind these is an apparition of the mercenary army of Hannibal, the Carthaginian general who, after a daring and decimating crossing of the Alps in the year 218 B.C., sets out to conquer the Roman Empire.

The horizontal format of *Rain, Steam and Speed* is divided into two halves, the upper zone consisting of relatively loose-textured gradations of yellow heightened by large passages of white and interspersed with occasional shadings in grayish-blue. This agitated area can be read without much trouble as sky filled with wind-driven mist and clouds. The lower half of the picture, in contrast, shows a completely diffuse texture of the same, if more intense and saturated colors which would hardly be decipherable were it not for the small boat at the left and the bridge span, concrete reference points by which the whole can be seen to represent a landscape.

Toward the right and the lower edge of the canvas the hues grow increasingly dense, gradually forming the contour of a blackish-brown diagonal which represents the bridge at Maidenhead, with a train rushing out toward us in an evocative perspective rendering of motion. Flecks of red and white paint applied with the palette knife over the black of the locomotive represent flying sparks and steam and suggest its sheer power. Cutting across the diagonal of the train's direction of motion are paint strokes that apparently represent the driving rain in which sunlight is refracted. The extreme speed Turner wishes to evoke is further underscored by the presence of a – barely detectable – hare running for its life along the track in front of the train.

The painting not only illustrates the onset of the Age of Steam but itself has the effect of a sketch made from a rapidly moving train. In fact Turner, during a train ride, reputedly leaned out of the compartment window in the rain in order to study the new perceptions involved in moving at such unprecedented speed, including the visual blurring of the vanishing point and the sense of the foreground being out of focus on the periphery of the field of vision.

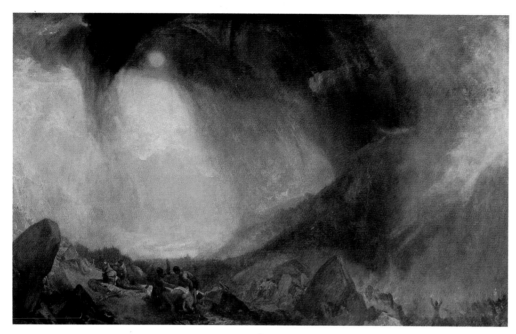

William Turner
Snow Storm: Hannibal and his Army Crossing the Alps,
c. 1810–1812
Oil on canvas, 144.7 x 236 cm
London, Tate Gallery

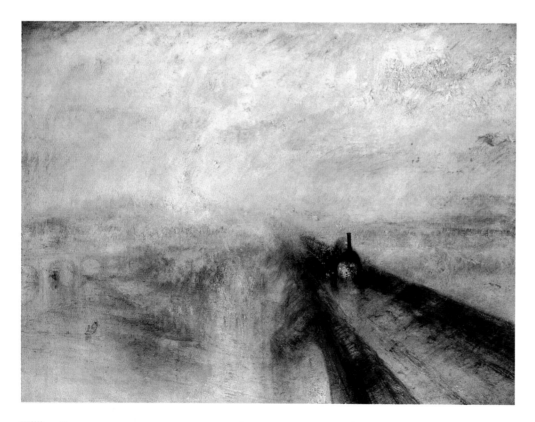

William Turner
Rain, Steam and Speed – The Great Western Railway, 1844
Oil on canvas, 91 x 122 cm
London, National Gallery

As early as 1804/05 Turner painted a depiction of the Deluge, and in about 1810 held a lecture on colors in the Royal Academy, the draft of which has survived. The biblical subject and the theoretical discussion were united in these two companion paintings of 1843.

Rather than merely recording a disaster, the canvases concentrate on elemental events happening in the paint itself, vortices in which the figures of the story, human and animal, are caught up and divested both of individual presence and the ability to influence their fate. The square format and inscribed circle augment the overall, rotating rhythm. In the *Evening of the Deluge* the circular motion is overlain by dissonant curves, suggesting a natural process raging out of control. In the middle appears a shadowy Arc, a symbol of hope.

In the *Morning* Turner transforms a rainbow into a glowing ball of light, a natural phenomenon that is no longer part of the landscape but entirely dominates and determines it, and that symbolically represents the Old Covenant. Above a luminous sea rises the peak of Mount Ararat with the stranded Ark. Moses, standing in the midst of a whirl of light, is apparently writing the Book of Genesis on the Tablets of the Law. This figure may well represent a mythical embodiment of the artist himself, a point of calm within the storm. It is as if he were capturing the fleeting interplay of light and shadow in their reciprocal negation, lending permanence to transience.

What one can read from these two paintings of 1843, as from Turner's œuvre as a whole, is an incessant testing of the means of visual art. Still, his sophisticated artistic method is never used as an end in itself. It always entails a "poeticizing" and cyclical "mythologizing" of landscape, comparable to that in the motifs of early German Romantic art, if incomparable in terms of intensity and visionary effect.

"In this sum of the potentials of landscape," said Werner Hofmann, "there appear once again, as if in the evening light of landscape painting, the old gods and cultic sites of the religious and intellectual formation of the western world, but also premonitions of the technological age.

English scientists of the day, too, postulated a continual interflux of natural processes, which in turn would permit man to transmute nature into changing forms of matter and aggregate states. Especially the chemist and physicist Michael Faraday, who from 1827 held popular and very effective lectures at the Royal Institution, was a personal acquaintance of Turner's and greatly admired his works, viewed matter, energy, and force as existing in a permanent reciprocal relationship. Inspired by ideas of this kind, Turner treated pigments as results of the effects of light and employed them autonomously to fill his landscapes with energy-charged passages, which nevertheless remained tied to substantial motifs.

William Turner
Light and Colour (Goethe's Theory) – The Morning after the Deluge – Moses Writing the Book of Genesis, 1843
Oil on canvas, 78.5 x 78.5 cm. London, Tate Gallery

William Turner
Shade and Darkness – The Evening of the Deluge, 1843
Oil on canvas, 78.5 x 78 cm
London, Tate Gallery

Edwin Landseer
The Old Shepherd's Chief Mourner, c. 1837
Oil on wood panel, 45.7 x 60.9 cm
London, Victoria and Albert Museum

EDWIN LANDSEER
1802–1873

Around the middle of the century Landseer was the most successful animal painter in England. His fame rested not only on his extraordinary skill and craftsmanship but, and especially, on his ability to project human feelings and moods into animals, thus "romanticizing" them.

The Old Shepherd's Chief Mourner was one of Landseer's most popular pictures in this regard. John Ruskin cited it in the first volume of his *Modern Painters* as proof of the premise that "the greatest picture is that which conveys to the mind of the spectator the greatest number of the greatest ideas."

A closed coffin stands on a diagonal in the middle of a plain room, dramatized by a play of light and shade. A staff on the floor recalls the deceased man's occupation. His shepherd dog sits by the coffin, despondently resting his head on the sheet draped over it. An entire lifetime of mutual trust and affection is concentrated in this motif, whose poignancy is further heightened by the presence of things which death has rendered useless.

The details that allude to the shepherd's life and the soulful mourning of his faithful dog prompted Ruskin to call the painting "one of the most perfect poems or pictures (I use the words as synonymous) which in modern times have been seen."

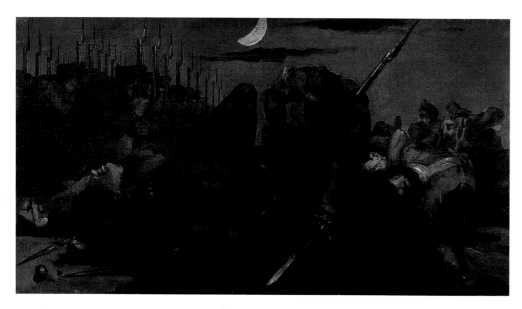

David Scott
Russians Burying their Dead, 1831/32
Oil on canvas, 49 x 91 cm
Glasgow, Hunterian Art Gallery, University of
Glasgow, Mackintosh Collection

DAVID SCOTT
1806–1849

The Scottish painter David Scott, who as as art theoretician also discussed French and German art of the period, took his themes by preference from Romantic and pre-Romantic literature, supplemented from 1840 onwards by subjects from English history.

The present canvas goes back to a newspaper report describing the valiant Polish battle against Russian occupation troops during the 1830–1831 Uprising. The Russian general had requested a cease-fire in order to be able to bury his casualties.

Scott has composed the horrific scene in terms of relatively few, if all the more massive and monumental groups of figures. In the middle crouches a heavyset, archaic-looking soldier in the midst of clothed and half-naked dead. His huge fist still grips a saber which, though lowered to the ground, still points threateningly out toward the viewer.

The crescent moon shining through the bands of cloud calls up associations with Romantic longing, seemingly mocking the rough men below, yet at the same time it can be seen as a sign of hope, the humanitarian act of the cease-fire having at least temporarily brought a halt to the bestiality of war. In this regard Scott's picture goes beyond mere reportage to evoke the potential extremes of human behavior and the way nature, unconcerned, continues to follow her course.

JOHN RUSKIN

1819–1900

Ruskin was the great spokesman of later English Romanticism. His five-volume work *Modern Painters*, published from 1843 to 1860, was initially conceived as a defence of Turner, but soon burgeoned into a general theory of art. Though a writer foremost, Ruskin had also been trained in drawing and watercolor painting.

His *Cascade de la Folie* is a grandly atmospheric view of an Alpine chain whose expansiveness recalls early depictions by Turner, but also Koch's *Schmadribach Falls* (ill. p. 22). However, this comprehensive point of view is untypical of Ruskin, who generally treated much more limited subjects. In these especially he conformed to his own credo of turning to nature, refusing nothing, selecting nothing, scorning nothing. Yet such a statement should not be viewed as a manifesto of naturalism. Rather, it reflects Ruskin's belief that the divine order expressed itself in even the lowliest natural phenomena.

Through his opinion that every plant and flower had its specific, intrinsic and perfect beauty, that every kind of stone or soil and every form of cloud should be studied with the same diligence and depicted with the same precision, Ruskin exerted a seminal influence on the art of the Pre-Raphaelites, which he defended against its critics with the same eloquence as he defended Turner's pictures.

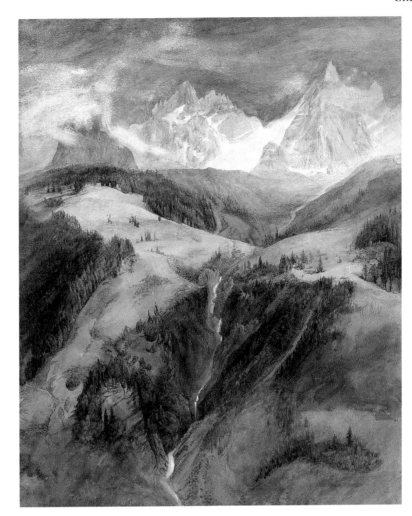

John Ruskin
Cascade de la Folie,
Chamonix, 1849
India ink and
watercolor,
37.5 x 45.72 cm
Birmingham,
Birmingham Museums
and Art Gallery

WILLIAM MORRIS

1834–1896

After studying architecture, the subsequent social reformer and utopian thinker Morris turned to painting in a Pre-Raphaelite style. For his arts and crafts firm, Morris, Marshall, Faulkner & Co., founded in London in 1861, he gained the assistance of Edward Burne-Jones and Dante Gabriel Rossetti, who put their individuality in the service of fine craftsmanship in a way that reflected the ethos both of the medieval guild and the socialist cooperative.

A number of their decorative designs for furniture, ceramics, stained-glass windows, carpets, wallpapers, textiles and so forth are on display in the Morris Room of the Victoria and Albert Museum, London.

A focus on crafts also seems to mark the only known painting from Morris's hand, *Queen Guinevere*, a motif from the legend of King Arthur and the Round Table, which he also treated in a concurrent cycle of poems, *The Defence of Guinevere*, that evoked a rough and barbarous yet noble medieval era.

The queen, whose features are those of the artist's wife and reflect the Pre-Raphaelite ideal of beauty, stands musingly before a chest filled with medieval manuscripts. Yet the historical revival theme would appear to be not much more than an excuse to depict an array of various exquisite materials, draperies and garments.

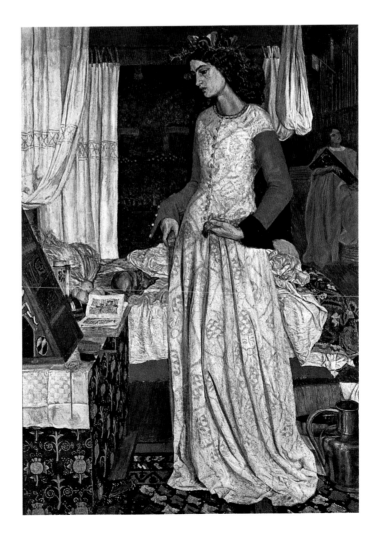

William Morris
Queen Guinevere, 1858
Oil on canvas, 72 x 50 cm
London, Tate Gallery

Charles Lock Eastlake
The Champion, 1824
Oil on canvas, 122.5 x 174 cm
Birmingham, Birmingham Museums and Art Gallery

CHARLES LOCK EASTLAKE
1793–1865

The Pre-Raphaelites were part of a larger current in Britain which in the first half of the nineteenth century turned away from neoclassicism and its models of Greco-Roman antiquity and the High Renaissance, and revived interest in the Middle Ages, especially in Gothic art.

This trend received official sanction around the middle of the century when Eastlake, later president of the Royal Academy, became the titular head and subsequently the director of the National Gallery. In 1872, with his book *A History of Gothic Revival*, Eastlake published the standard work on the movement.

The theme of *The Champion* was described by Eastlake himself as a Norman-Sicilian knight who is challenged by a Saracen and prepares to follow the herold as he receives a scarf from a lady.

The hero of the title is clad in darkly shimmering iron armor which in fact conforms more to the late medieval type than to that of the Norman-Sicilian epoch, just as his heroically idealized facial features recall some Romantic "crusader" from the time of Lord Byron. He looks leftwards, where a Saracen herold

waits to take him to his challenger, apparently the small mounted figure on the bridge in the middle ground.

At his right a voluptuous lady presses herself against him as she ties an exquisite scarf around his waist. Her low-cut dress recalls Italian Renaissance fashions – probably one of the reasons Eastlake's friend, Charles Armitage Brown, described the picture as being painted in the "Ariosto style." To the right, towards the castle, a monk and a page leading the knight's charger complete the group of figures, which is depicted in close-up view and accoutered with a congeries of historical revival accessories.

The exotic motif, the palette recalling the Venetian Renaissance painter Titian, and a certain anecdotal and sentimental basic mood, are typical of Eastlake's work at that period. Possibly this history picture was inspired by Julius Schnorr von Carolsfeld's frescoes executed between 1818 and 1824 in the Casino Massimo in Rome.

WILLIAM DYCE

1806–1864

Dyce spent four relatively long periods in Italy, mainly in Rome, and acquainted himself with early Italian painting and the style derived from it by the German Nazarenes. He met Peter von Cornelius and Julius Schnorr von Carolsfeld and became a friend of Friedrich Overbeck. At one point he and Eastlake were commissioned by the British government to study fresco technique on the Continent, especially in Munich, an endeavor in which Dyce could again rely on the advice of Cornelius and Schnorr von Carolsfeld.

This experience stood him in good stead in a series of public fresco designs for the Houses of Parliament in London, for a garden pavilion at Buckingham Palace, and for the stairwell at the royal summer residence, Osborne House. Nazarene painting, as regards the ethical values of its content and its graphically oriented composition, was Dyce's great ideal, though he criticized its coloring for being pale and wooden. Such views largely accorded with the ideals of Pre-Raphaelitism.

For his 1844 painting Dyce chose a theme from the Old Testament: At the behest of the prophet Elijah, Joab, King of Israel, fires off the arrow that insures victory over the Syrians. The picture illustrates the close tie between secular and ecclesiastical leadership which the artist believed contemporary society should strive to emulate. The composition, dominated by aescetic line, reflects a Nazarene influence, while the dramatic illumination and the interest in historical costumes reveals a knowledge of French academic art.

Pegwell Bay in Kent reflects an attempt to faithfully record a stretch of the English coastline in Kent where Dyce once spent a holiday with his family. In the foreground his wife and her two sisters are gathering shells as one of his sons looks on.

The diffuse reflected light of the sinking sun throws every detail of the chalk cliffs and mudflats at low tide into relief and suffuses the scene with the cool, melancholy mood of twilight. The title Dyce chose for the picture proves the importance he attached to characterizing this strangely visionary seascape as a memory of a place actually seen.

The clarity and isolation of the individual figures, comparable to Friedrich's, and the overall character of a dreamlike detachment, lend a personal view of an actual impression of nature an aspect of timelessness. This is underscored by the – barely visible – rendering of the Donati Comet in the evening sky, an astronomical phenomenon that was observable on 5 October 1858 and that occurs only once every 2100 years or so.

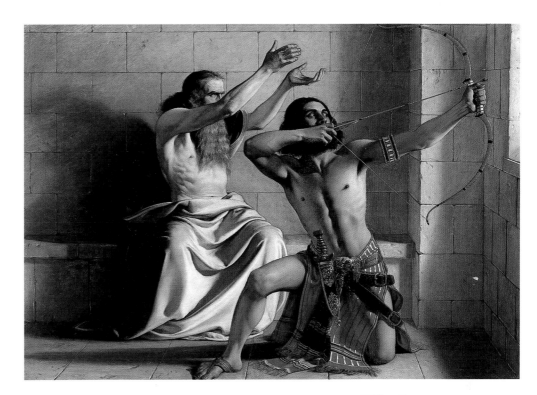

William Dyce
Joab Looses the Arrow of Grace, 1844
Oil on canvas, 76 x 109 cm
Hamburg, Hamburger Kunsthalle

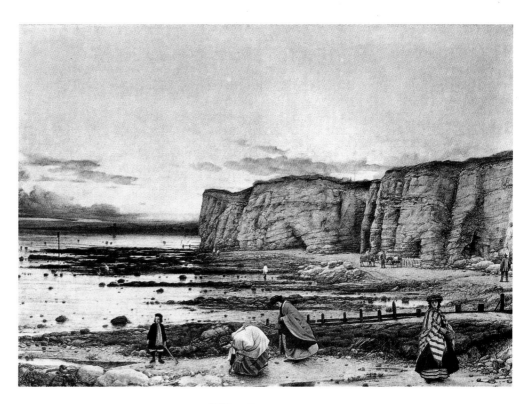

William Dyce
Pegwell Bay in Kent. A Memory of the 5th of October 1858, c. 1859/60
Oil on canvas, 63 x 89 cm
London, Tate Gallery

William Holman Hunt
Claudio and Isabella, 1850
Oil on canvas, 77 x 45 cm
London, Tate Gallery

WILLIAM HOLMAN HUNT
1827–1910

The painting *Claudio and Isabella* of 1850 was a product of the great enthusiasm for Shakespeare which began to spread through England in the latter half of the eighteenth century. In 1786 the London publisher and etcher John Boydell founded the Shakespeare Gallery, and in 1801 published over 170 engraved reproductions after works by Fuseli, Blake and others.

The Romantic artists and the Pre-Raphaelites took their subjects primarily from the great tragedies, *Hamlet*, *King Lear*, *Othello* and *Macbeth*, but also from the phantasmagorical comedies *The Tempest* and *A Midsummer Night's Dream*. For them Shakespeare represented the poet of England's national past and historic greatness.

In the present picture Hunt turned to a more rarely quoted play, *Measure for Measure*. Antonio, deputy of the Duke of Vienna, has condemned Claudio to death for seducing a maiden. Yet since he desires Claudio's sister, Isabella, Antonio promises to save her brother if she accepts his suit instead of entering a convent as planned.

Hunt concentrates on the dramatic debate between Claudio and Isabella, emphasizing, as so often in his art, the conflict between duty and morality, the seriousness of which is conveyed through clear, intense colors and cogent gestures and expressions.

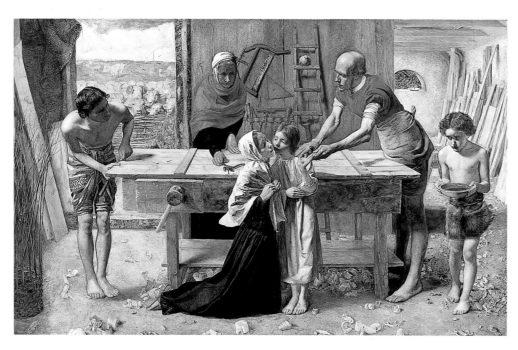

John Everett Millais
Christ in the House of his Parents, 1849/50
Oil on canvas, 85 x 137 cm
London, Tate Gallery

JOHN EVERETT MILLAIS
1829–1896

In England in the 1830s, church reform efforts were undertaken by the Oxford Movement to reconcile Protestant principles with Catholic dogma. The same period, thanks not least to the Gothic Revival, witnessed a renascence of Catholicism. In this connection the art of the Nazarenes served as a welcome ideal.

The religious paintings of the Pre-Raphaelites adopted such tendencies, which provoked the criticism of Protestant circles. Millais' *Christ in the House of his Parents* was rejected with particular vehemence. The composition shows an extremely detailed rendering of a carpenter's shop where a young boy has hurt his hand on a nail. His relatives' reactions extend from pity to practical first aid. The meaning of this consciously plain genre-like scene, in which every material thing – garments, tools, various varieties of wood – is depicted with great virtuosity, becomes clear only when we read the Bible quotation on the frame. To the Holy Family and the young John the Baptist, the wound in Jesus' hand appears as a foreboding of the Passion.

Charles Dickens even found the young Christ "loathesome" and full of self-pity, and said he had evidently hurt himself while "playing in the gutter." His mother Mary, Dickens went on, looked like a "monster in the vilest cabaret in France, or the lowest gin-shop in England".

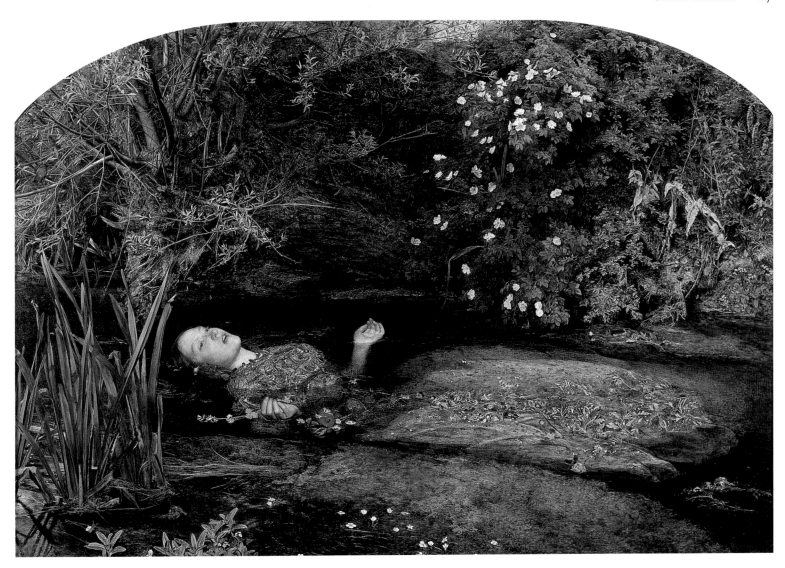

The theme of Ophelia derives from Shakespeare's *Hamlet* (Act 4, Scene 7). Millais' model for the drowning heroine was Elizabeth Siddal, the later wife of his friend Dante Gabriel Rossetti, who had to pose for the scene lying in a bathtub. Tall and slender with coppery red hair, she embodied the Pre-Raphaelite ideal of womanhood. The landscape was based on open-air studies made on an estate in Surrey in the summer and autumn of 1851, and Millais discussed it there at length with his friend and colleague, William Holman Hunt.

Millais has mastered the difficult task of combining painterly precision with profound imagination, of transmuting painstakingly rendered natural detail into visual poetry. Wreathed in garlands of flowers, Ophelia drifts singing down the river, her madness making her oblivious to the danger of drowning. The plants on the bank, rendered with an almost surrealistic sharpness of focus, correspond to the hallucinatory clarity of Ophelia's dream world, and reflect a sense of beauty born of melancholy and a sense of fate. Millais's obsession with detail went so far that he painted over a yellow flower he had chosen as a suitable color accent when he realized that it was botanically impossible at that particular point.

The veritably microscopic close-up view of the vegetation, replying to an unconcern with deep pictorial space frequently found in Pre-Raphaelite art, helps symbolically to convey the heroine's threatened mental state.

With his *Ophelia* Millais placed himself in the Romantic tradition and its fascination with the link between woman and water, as instanced by the figures of Undine and Loreley. The painting was executed under the eyes, as it were, of John Ruskin, who, however, was not entirely satisfied with it, feeling it lacked the qualities of the elemental and sublime, as found, for instance, in Turner.

When it was exhibited in Paris in 1855, the painting was admired above all for its naturalistic details. These were also the very reason why Théophile Gautier, in a review, denied it any Romantic or Shakespearean traits. The art historian Richard Muther was of quite different opinion, writing in 1903, "One knows how exactly Shakespeare describes all the plants and flowers that bloom by the pond, and also the bouquet Ophelia has picked and the jewellery she wears. Millais has adhered precisely to these descriptions..."

John Everett Millais
Ophelia, 1852
Oil on canvas, 76 x 112 cm
London, Tate Gallery

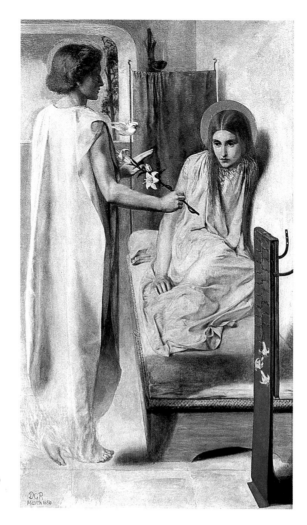

Dante Gabriel Rossetti
Ecce Ancilla Domini!
(The Annunciation) 1849/50
Oil on canvas, 73 x 42 cm
London, Tate Gallery

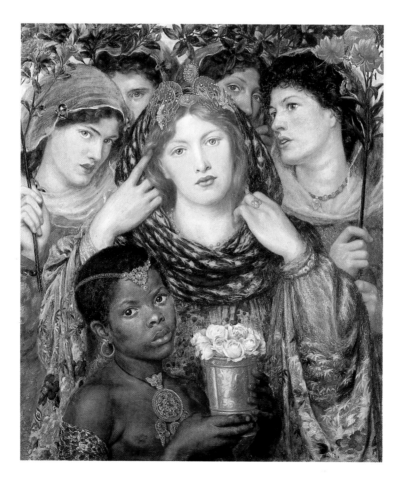

Dante Gabriel Rossetti
The Bride, 1865
Oil on canvas, 80 x 76 cm
London, Tate Gallery

DANTE GABRIEL ROSSETTI
1828–1882

The prevailing color in *Ecce Ancilla Domini!*, a depiction of the Annunciation, is white. The few accents of color – the gold haloes, the blue sky in the window, the sumptuous blue bed curtain, the red embroidery in the frame in the right foreground – appear even stronger by contrast and combine to form a complementary triad whose brilliance stands in contradiction to all academic painting. The pictorial space, with its extremely foreshortened floor and bed, appears tipped forward into the plane of the picture, much as in early Netherlandish paintings of the fifteenth century. This feature, too, runs counter to the academic rules of the day, which stipulated a continuous transition from foreground to middle ground to background.

The specific coloration and the archaic look of the compositional structure were chosen purposely by Rossetti to do justice to the simplicity and purity of the biblical scene. But even more unusual is the way the Annunciation is treated as a psychological drama. The angel, taking up almost the entire height of the picture, approaches the Virgin Mary as she cowers on the bed, pressing herself against the wall as if seeking protection. Mary's face, its features those of Rossetti's sister Christina, has an anxious and inner-directed expression that by no means conforms to the Nazarene ideal, but does anticipate female faces of *fin de siècle* art and their covert eroticism. Like Millais' *Christ in the House of his Parents* (ill. p. 86), this picture was roundly rejected by Protestant critics.

This picture reflects one of the key central themes of Pre-Raphaelite art, an obsession with female beauty and its irresistably transfixing effect on men. The motif is loosely based on the Song of Solomon in the Old Testament. Rossetti shows the exquisitely attired bride mentioned there pulling back her veil to reveal her beauty to us, as though we were stand-ins for her bridegroom. Related verses from the Song of Solomon and the 45th Psalm are inscribed on the frame.

Rossetti originally conceived the picture – whose colors, he said, were to have a jewel-like effect – as an imaginary portrait of Dante's beloved, Beatrice, but then reinterpreted it in the course of painting. The model for the central figure, clad in a Peruvian leather headdress and a Japanese kimono, was Marie Ford, and the bridesmaids can be identified as well – the one on the right, for instance, was a gypsy girl by the name of Keomi, the mistress of an artist colleague.

The black boy in the foreground presents a vase of roses, symbolizing love. The bridesmaids hold lilies, which are generally considered a symbol of purity or chastity, but which here, due to their red color, might refer to the passion of physical love.

Proserpine (Persephone) was the queen of Hades, the ancient Greek underworld, and wife of the god Pluto. Here she is depicted holding a pomegranate, after tasting which the permission previously granted her to return at regular intervals to the upper world would be forever rescinded.

In this painting, an early version of a total of eight variations on the theme, Rossetti has reduced the complex myth to a small number of encoded symbols and concentrated on the beauty of the female figure, the ornamental waves of her luxuriant hair, and the decorative arabesques formed by the folds of her gown. Its graceful curves are continued in her bowed neck and the curve of the ivy sprig beside the window.

Such ornamentalization, apart from being influenced by Italian Mannerist painting, was probably derived from John Ruskin, who declared elongated sinuous lines to represent a canon of beauty in the first volume of his *Stones of Venice*, published in 1851. Rossetti, who admired the writings of the Marquis de Sade and loved Poe's stories, developed this style not least with an eye to creating ideal embodiments of destructive female temptation and lascivious unapproachability.

Rossetti himself also wrote a sonnet on the painting, the Italian version of which appears on a rendering of a sheet of old parchment in the upper right hand corner, and the English version of which is inscribed on the picture frame (whose ornaments recall pomegranates). It is a sonnet that poignantly expresses the artist's love for his model, Jane Morris – William Morris's wife – and the profound pain their separation caused. It also corresponds to the sensuality of the portrait.

Proserpine's full, red lips, flowing hair, and yearning gaze underscore the mood of passion as much as the reddish, open pomegranate in her hand and the burning incense in the bowl in front of her, a sign of her divinity. The way Proserpine grasps the wrist of one hand with the other, as if to prevent herself from tasting the fateful fruit, despite the fact that it is already too late, may be seen as reflecting the inner conflict touched off by Rossetti's passion for his friend's wife.

Yet since Jane Morris actually continued her marriage, the figure of Proserpine with whom she is identified might symbolize the tension felt by a woman who is torn between two men.

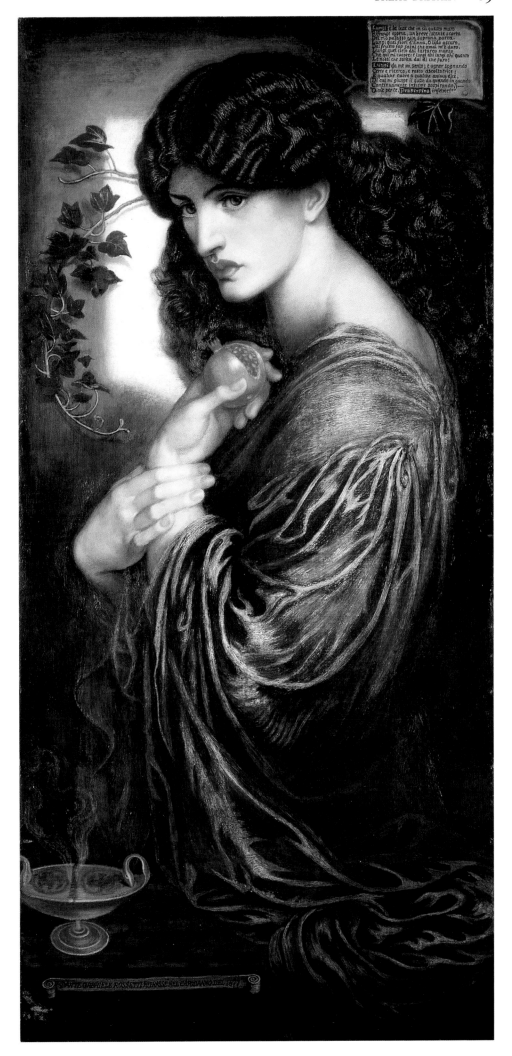

Dante Gabriel Rossetti
Proserpine, 1874
Oil on canvas, 127 x 61 cm
London, Tate Gallery

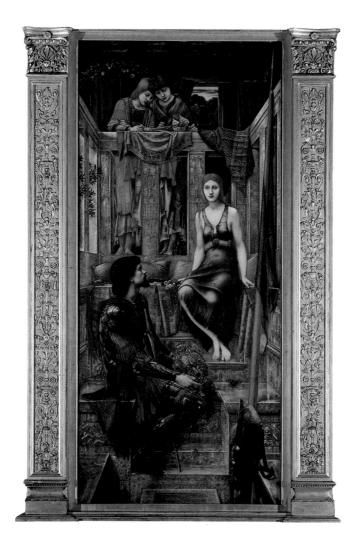

Edward Burne-Jones
King Cophetua and the Beggar
Maid, 1884
Oil on canvas, 293.4 x 135.9 cm
London, Tate Gallery

EDWARD BURNE-JONES
1833–1898

The subject of Burne-Jones's painting is taken
from a ballad by his contemporary, Tennyson,
in which the African king Cophetua marries a
lovely beggar girl by the name of Penelophen.
In reality a princess, she has come to the court
with her father, who had been robbed by
thieves.

In the exquisite architecture of a fantastic
throne room, the young couple sits apart, as if
immobilized by melancholy, the king appar-
ently lost in contemplation of his bride and her
charms. Among Victorian aesthetes it was the
vogue to be exquisitely unhappy, as Burne-
Jones once put it, for instance to adore another
man's wife without actually becoming em-
broiled in an affair – an attitude that corre-
sponded to medieval troubador ideals. The en-
throned Penelophen represents both madonna
and object of desire for the kneeling Cophetua;
she is surrounded by the brilliance of costly
materials, which also fascinated the poets of
the *fin de siècle*.

The picture perfectly accorded with the
taste of the day, and was celebrated as Burne-
Jones's masterpiece and one of the finest
achievements in English painting at exhibi-
tions in London in 1884 and in Paris in 1889.
In 1900 it was purchased by the Tate Gallery,
the first Pre-Raphaelite work to be so honored.

The painting *The Baleful Head* belongs to a
series of eight depictions on the antique myth
of Perseus which were commissioned in 1875
by Arthur Balfour, the later British prime
minister. The complete Perseus cycle is pre-
served in eight large-format tempera paintings
in the Art Gallery in Southampton.

Here Perseus is shown presenting to An-
dromeda the ominous head of Medusa, which
transforms anyone who looks at it into stone.
To avoid this danger, the two gaze at its reflec-
tion in the well. With a gentle, melancholy
elegance the forms and colors are intermerged
to evoke a timeless, exquisite dream. In the
Perseus cycle Burne-Jones made his figures
ageless and pale, and depicted them in poses
redolent of a precisely measured ritual. It as if
their passions were dissipated in an eurhythmi-
cal meditation.

The melodic grace of the lineature, the or-
namental interlinking of details, the exquis-
itely rendered materials, all lead directly to Art
Nouveau. Burne-Jones combines the notion of
the Christian knight with that of the heathen
hero into a melancholy contemplative figure
who devotes himself to a mystical work of re-
demption. The artist was confirmed in his ap-
proach by the musical dramas of Richard Wag-
ner, whom he revered.

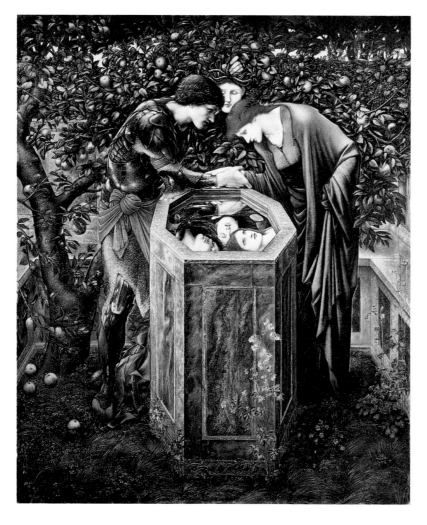

Edward Burne-Jones
The Baleful Head, 1886/87
Oil on canvas, 155 x 130 cm
Stuttgart, Staatsgalerie Stuttgart

FORD MADOX BROWN

1821–1893

Ford Madox Brown's major painting, *Work* of 1852–1865, is a comprehensive depiction of Victorian reality and, with its multiple allusions to contemporary persons and institutions, represents a social-reform program with a didactic thrust. Through Bible quotations like "In the sweat of thy face shalt eat bread" on the frame with its lunette-shaped top, the painting celebrates human labor as a moral and religious duty.

The composition represents Heath Street in the London suburb of Hampstead, with a group of road workers in the center. Crowded around them are representatives of various social strata and walks of life: street vendors, idlers, unemployed men, middle-class ladies with sunshades and religious tracts, and members of the upper class out for a morning ride. The contemptible manual labor of plain people apparently provides the basis for all this activity and for the common weal, from which even loafers profit.

The intellectuals – among them a portrait of Thomas Carlyle, a Scottish writer – are banned to the right edge of the picture, idle spectators to the scene. It is enriched by an abundance of anecdotal details: a policeman knocking over an orange-vendor's basket, a thoroughbred greyhound in a red vest confronting a mutt, sandwich men on the road in the background whose placards recommend the election of a sausage manufacturer into parliament.

Of all the Pre-Raphaelites, Brown was the one who most strongly attacked the social injustices of the Victorian period. In *The Last of England* he addressed the issue of unemployment and the mass emigration this caused at the period.

Forced to abandon their homeland, a family watches from the deck of a ship as the coast of England sinks below the horizon. Brown's own financial difficulties had caused him to contemplate taking such a step, and going to Australia to prospect for gold. This is likely why the emigrants who confront the viewer from the foremost picture plane are portraits of the artist and his second wife. The picture was contemporary in the strictest sense of the word, Brown later emphasized in an explanatory text.

The oval shape of the frame is based on the tondo of Renaissance painting, and the pyramidal grouping of the figures moreover recurs to the traditional composition of the Holy Family. The real achievement here, however, lies in a precise rendering of observed reality, as in the figures' cold-reddened complexions. The group is skilfully placed in the oval, which is repeated by the umbrella, the left contour of the male figure, and by the railing. Thus everything in the picture combines to underscore the central theme, a family's sad gaze back on the country that was unable to support them. As Günter Metken noted, Brown's work represents a "counterimage to colonial optimism."

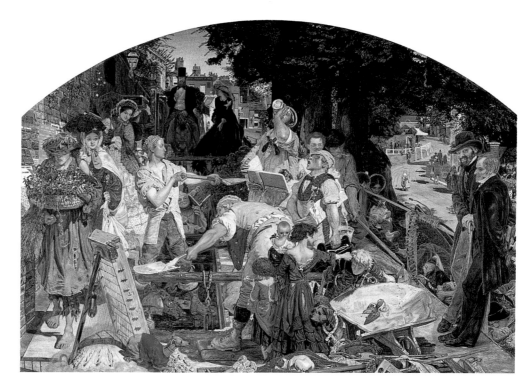

Ford Madox Brown
Work, 1852–1865
Oil on canvas, 135 x 196 cm
Birmingham, Birmingham
Museums and Art Gallery

Ford Madox Brown
The Last of England, 1852–1856
Oil on canvas, 82 x 74 cm
Birmingham, Birmingham Museums
and Art Gallery

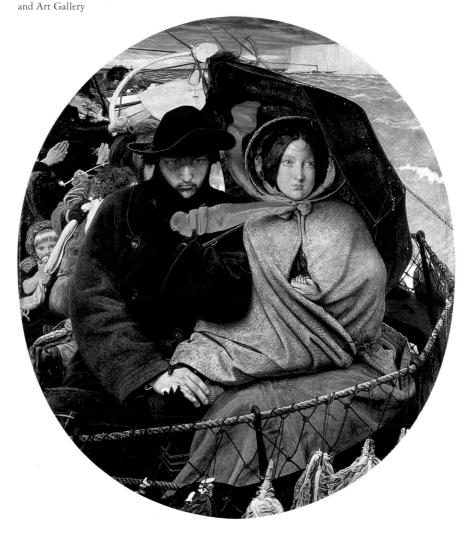

François Gérard
Madame Récamier, 1802
Oil on canvas, 225 x 145 cm
Paris, Musée Carnavalet

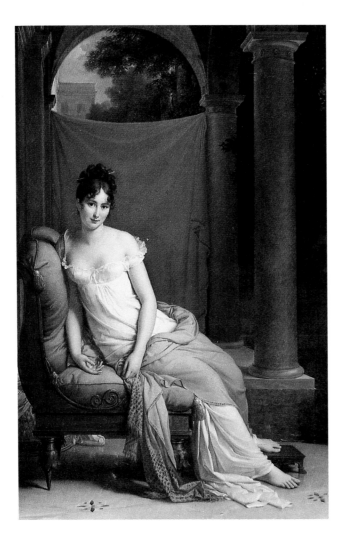

François Gérard
Ossian on the Bank of the Lora,
Invoking the Gods to the Strains of a
Harp, undated
Oil on canvas, 184.5 x 194.5 cm
Hamburg, Hamburger Kunsthalle

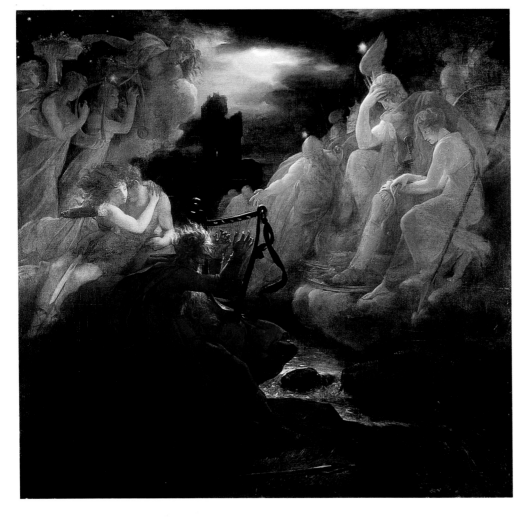

FRANÇOIS GÉRARD

1770–1837

The Paris salon of Juliette Bernard, who married the much older Jacques Rose Récamier in 1793, was a gathering place for artists and intellectuals opposed to Napoleon. Due to her celebrated beauty she was also much in demand as a portrait model.

A few years before Gérard, his teacher Jacques-Louis David, the neoclassical painter of the Revolution, had done a portrait of her in an empty room, reclining on the type of couch named after her, the *récamier*. She was dissatisfied with David's classical revival, low-key depiction, which therefore remained unfinished. Madame Récamier commissioned Gérard, the most popular portraitist of the day, to do a new portrait, showing her in a more natural setting in which the graceful curves of her figure and the hues of her complexion are echoed in the forms and colors of the surroundings. The slight twist of her body, the low neckline of the Empire dress that barely covers her breast, and the naked feet make for a highly effective pose quite beyond the norms of the time. The erotic magnetism of her appearance is both mitigated and made more suggestive by the musing pose and the stillness of the room, isolated from the hurly-burly of the outside world.

At the time Madame Récamier's pose was considered intimate and thoughtful – sentimental in the best sense of the word. This aspect of sentimentality played its part in the development of the Romantic attitude.

Gérard created a first version of this Ossian composition in 1800, for Napoleon's palace, Malmaison. As it was being shipped to Sweden in 1810, as a gift for Count Bernadotte, the picture went down with the vessel when it foundered in a storm. Since the Hamburg version originated from Sweden, it is generally considered a replica which Bernadotte ordered to replace the lost work. Yet some historians believe that Gérard did not do the replica until after Napoleon's fall.

The scene evokes an epic poem, loosely based on old Scottish ballads and published by Macpherson from 1760 to 1773, which caused a great sensation throughout Europe. The old, blind bard Ossian is shown invoking, to the strains of a harp, the figures of his songs, his deceased relatives, his parents and his son Oscar with Malvina. Like inward visions materializing out of misty clouds and moonlight, they hover as silvery-gold apparitions against the night sky. Before them looms the figure of Ossian, rendered in dark fiery reds. Lost in reverie, he seems to be pulled irresistably along by the current of the river flowing toward the lower right. His extended arms, behind which precipitous castle ruins rise in the background, give his action a dramatic, almost despairing aspect. Profoundly melancholy and in part veritably ghostly, the painting forms a connecting link between the terrifyingly sublime and mood of horror cultivated in the eighteenth century and the Romantic "Weltschmerz" of the nineteenth.

ANNE-LOUIS GIRODET DE ROUSSY-TRIOSON
1767–1824

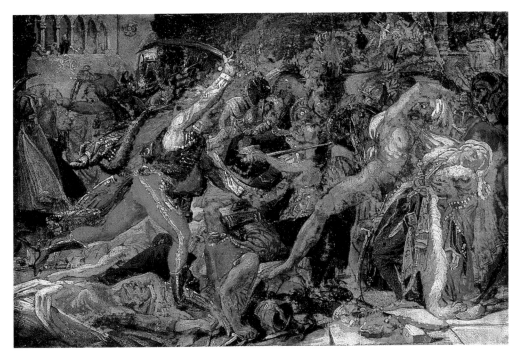

On 21 and 22 October 1789, French occupation troops in Egypt faced embittered resistance fighting in Cairo. The rebel forces concentrated especially in the Azhar mosque and were defeated only after a heavy cannonade. The final stages of this battle are depicted in Girodet's painting.

The Egyptian rebels are in a hopeless situation, their backs to the wall on the right. One man, completely naked, defends himself with a mighty swing as a French officer with raised sword storms in from the left, a presage of imminent victory.

This small oil sketch basically conforms to the five-meter-wide composition Girodet exhibited at the 1810 Paris Salon. Yet the somewhat more compressed proportions of the study bring out the violence of the battle even more, and it is underscored by an expressive impasto brushwork that has almost a modern, abstracting look.

The sketchlike character of such works and the "open" structures thus obtained, which give the spectator the opportunity to imaginatively complete the image in his own mind, were to become particularly important for French Romanticism.

Anne-Louis Girodet de Roussy-Trioson
The Revolt of Cairo, 1810
Oil on canvas, 15.2 x 23.3 cm
Cleveland (OH), The Cleveland Museum of Art,
Gift of Eugene Victor Thaw, 1965.310

HORACE VERNET
1789–1863

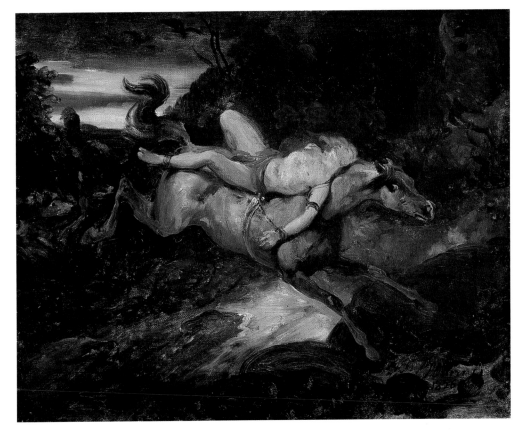

After 1830 Horace Vernet's military and battle pictures, portraits and orientalist genre scenes made him perhaps the most popular painter in France.

His oil study *Mazeppa* of 1826, done in advance of the large painting in the Musée Calvet in Avignon, was based on a theme from Lord Byron's verse epic of the same name, which was translated into French soon after its publication in 1819. The story relates how Mazeppa, a Cossack chief, made illicit advances to the daughter of a Polish prince. In punishment he was tied naked to the back of a wild horse, which galloped off with him. Exhausted to the point of death, he was finally saved by a Cossack girl.

Mazeppa not only represents a man whose animal instincts caused him to be subjected to an animal fate; he also embodies the outcast and pariah who is condemned by society. In this regard Mazeppa could figure as a romantic symbol of artistic self-reliance and determination.

Théodore Géricault, Eugène Delacroix, and other painters treated the subject and in the year 1829 Victor Hugo wrote a poem on Mazeppa (*Les Orientales*, XXXIV), in which he interpreted the swift horse as the genius of the martyred man and merged the two into a single character.

Horace Vernet
Mazeppa, 1826
Oil on canvas, 32.5 x 40.5 cm
Bremen, Kunsthalle Bremen

Pierre-Paul Prud'hon
Justice and Divine Vengeange Pursuing Crime,
1804–1808
Oil on canvas, 243 x 292 cm
Paris, Musée du Louvre

PIERRE-PAUL PRUD'HON

1758–1823

In 1805 Prud'hon received a commission to ex-
ecute a monumental painting for the council
chamber of the Palace of Justice in Paris. After
several changes of plan, he finally exhibited
Justice and Divine Vengeance Pursuing Crime at
the 1808 Salon, drawing the highest praise
from Napoleon and accolades from a public
that had grown jaded to the neoclassical cool-
ness represented by Jacques-Louis David's
compositions. Though the clarity of lineature
and the relief-like arrangement of the figures
in the foremost picture plane still recalled
David, the overall emotionally charged impres-
sion created by dramatic poses, illumination
and coloring amounted to a daring innovative-
ness in approach.

In the midst of a stark, rocky landscape, a
thief and murderer looks anxiously back at the
naked body of his victim, garishly illuminated

by the full moon, as the goddesses of ven-
geance swoop down upon him from the upper
right. The wasteland in which this takes place
represents the "classical" site for such events.
The bush and cliffs in the background run
parallel to the figure on the ground, while
the diagonal of the fleeing figure is likewise
compositionally underscored by the dark rock
formation behind him to the left. The overall
configuration of the allegories of supernatural
powers has a semicircular contour that corre-
sponds with the zone where the victim lies on
the one hand, and with the line of the crimi-
nal's back on the other.

Though it would be mistaken to describe
this impassioned and somewhat bathetic visu-
alization of the mental state of a man who has
stooped to crime as "romantic" in the narrower
sense of the word, the way everything in the
scene is suffused with a sense of dread does in-
deed mark the transmission of the French tra-
dition of romantic horror into the nineteenth
century.

Napoleon ordered this portrait of his wife from the artist only a few months after she was crowned empress of France. Though Napoleon had considered abandoning Joséphine because she was unable to bear him children, she managed to convince him to have a church marriage prior to coronation day. In 1809 the emperor separated from her.

Prud'hon's portrait evokes all the insecurity of Joséphine's life, the loneliness she suffered despite outward recognition and fame. Filled with melancholy, leaning her head on her hand with a somewhat affected gesture, she sits in a gracefully nonchalant pose on a rocky outcrop in Malmaison park, cut off from all society. The pose and the way the figure is embedded in the natural surroundings recall eighteenth-century English portraiture, but the mood is much more elegaic, even by comparison to François Gérard's *Madame Récamier* (ill. p. 92).

Joséphine's state of mind is evoked with great sensitivity, and it finds a resonance in the autumnal gloom of the park. Yet Prud'hon also suggests the mysterious charm of Joséphine, a Creole born on the island of Martinique. Her enigmatic gaze points back to Prud'hon's great idol, Leonardo da Vinci, from whom the *sfumato*, the finely nuanced transitions from light to dark, and the silky gloss of the paint surface, also derive.

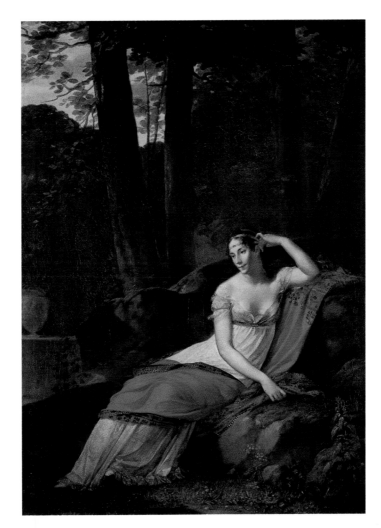

Pierre-Paul Prud'hon
Empress Joséphine at
Malmaison, 1805
Oil on canvas, 244 x 179 cm
Paris, Musée du Louvre

THÉODORE CHASSÉRIAU
1819–1856

Henri Lacordaire, who worked as a lawyer before entering the priesthood, was summoned to Rome by Pope Gregor XVI in 1839 on grounds of his subversive teachings. He submitted himself to the Holy See and became an ardent representative of strict Catholicism, to the revival of which he materially contributed during the vicissitudes of the French Uprising of 1848.

Chassériau's portrait of the clergyman, who had joined the Dominican order, was executed in Rome. Clad in his monk's habit he stands in front of the cloister in Santa Sabina. His is depicted in three-quarter figure in the very near foreground, against the columns of the arcade, where two of his bretheren are visible at the right. Lacordaire's great intelligence, but also his fanaticism, radiate from his sharply cut face and piercing eyes, which seem to look right through us.

The light impinging on the figure engenders stark light-dark contrasts, and harsh, precise contours cut it off from the softly rendered background architecture. In a fascinating combination of realistic detail and sensitive psychological penetration, this character portrait reveals above all the sitter's inner life and attitudes.

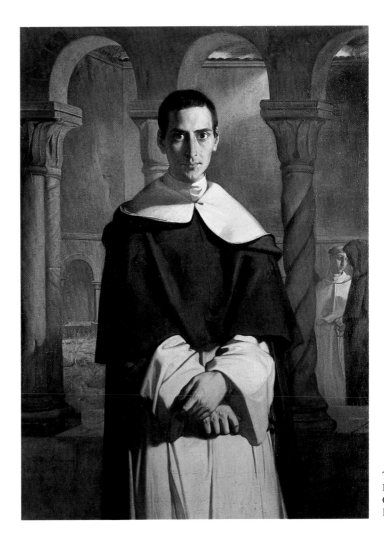

Théodore Chassériau
Father Lacordaire, 1840
Oil on canvas, 146 x 107 cm
Paris, Musée du Louvre

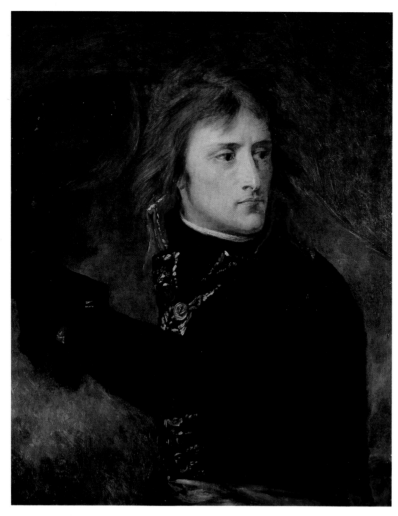

Antoine-Jean Gros
Napoleon at Arcola, 17 November 1796, 1796
Oil on canvas, 73 x 59 cm
Paris, Musée du Louvre

ANTOINE-JEAN GROS
1771–1835

In his depiction of a historical battle, the storming of the bridge of Arcola occupied by the Austrians, Gros picks out the half-figure of Napoleon Bonaparte as though through a telescopic lens. He shows him at the head of his troops, charging to victory waving the flag, his hair flying in the wind. The fate of nations is concentrated in the great individual, the brilliant general – this idea, central to the eighteenth-century cult of genius, was eagerly taken up by early French Romantic artists. Gros's version of the psychologizing portrait of a superman in the Nietzschean sense alludes both to triumphant success and to the loneliness of the military genius.

The battle of Eylau in Prussia, Napoleon's difficult victory over the Russian army, cost 25,000 dead and wounded. Gros shows Napoleon on the day after the carnage, riding across the battlefield. A group of wounded enemy troops has attracted his attention. A Lithuanian officer prepares to kiss the eagle emblem on his boot, thankful for the aid the emperor has apparently just ordered with heavenward gaze.

Gros has treated the event in terms of a relief of figures in the foremost plane, to which the winter landscape and scattered fires provide no more than a foil. Lacking definite lateral framing elements, the scene appears virtually to continue beyond the canvas edges. The impression of boundlessness thus evoked combines with the subdued palette to give the masses of men an abandoned look and lend the picture an undertone of despair.

Charles Legrand was killed on 1 May 1801 in Madrid, when rebelling peasants attacked a regiment of Napoleon's curassiers on the Puerta del Sol, tore the men from their horses, and knived them. Legrand was the son of a French general. In his memory, his parents commissioned Gros to execute a life-size portrait. The result was the artist's masterpiece.

The lieutenant has dismounted and led his horse to the trough. The path descends to the right, where a view opens out of a peaceful, classically stylized landscape. Legrand stands nearly frontally to the viewer, slightly off the central axis of the picture, in a relaxed attitude. He rests his right arm on the rump of his black horse, whose neck and head are silhouetted in a beautiful curve against the sky. Holding the reins in one hand, with the other he supports his magnificent helmet with horsetail and peacock feathers against his hip. Legrand's handsome young face is turned slightly aside as he gazes into the distance with a musing look. Such works with their cultivated, painterly coloration and true depth of feeling placed Gros at the inception of French Romanticism.

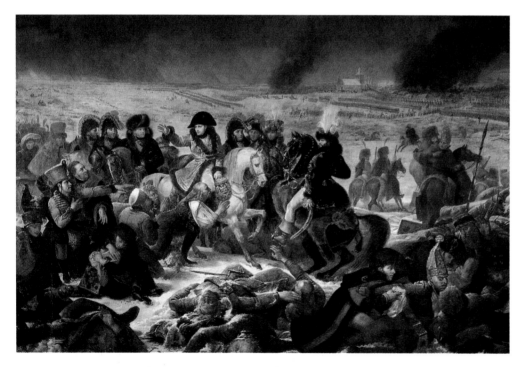

Antoine-Jean Gros
Napoleon on the Battlefield at Eylau, 9 February 1807, 1808
Oil on canvas, 533 x 800 cm
Paris, Musée du Louvre

Antoine-Jean Gros
Lieutenant Charles Legrand, c. 1810
Oil on canvas, 249.6 x 174.6 cm
Los Angeles, The Los Angeles County Museum of Art

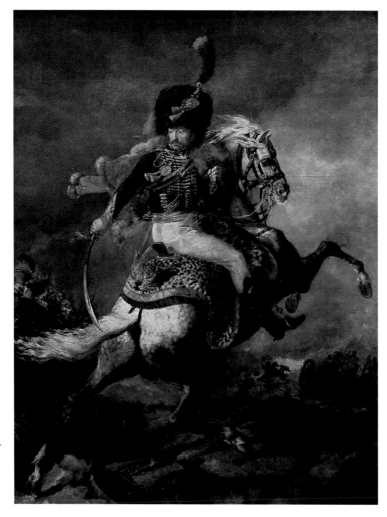

Théodore Géricault
The Charging Light Cavalry
Officer (Chasseur), 1812
Oil on canvas,
292 x 194 cm
Paris, Musée du Louvre

Théodore Géricault
Heads Severed, 1818
Oil on canvas, 50 x 61 cm
Stockholm, Nationalmuseum

THÉODORE GÉRICAULT
1791–1824

Géricault participated in the Paris Salon exhibition for the first time in 1811, showing the *Charging Light Cavalry Officer* or *Charging Chasseur*, which made him famous overnight. The motif was originally inspired by a horse that suddenly reared among the crowd at a fair in Saint-Cloud. The sight made such an impression on Géricault that he began making sketches of it that same evening.

The resulting, brilliantly colored painting, rather than representing an outstanding individual or an actual episode, embodies the military man and war per se. The stallion galloping diagonally into the picture goes back to Baroque traditions, from which Géricault also derived an approach to painting based on the expressive values of color and light.

In his hands, however, color and light were used not to glorify the subject but to convey its visual appearance, the sense of movement and fleetingness in a momentarily glimpsed situation. In pursuit of this end even anatomical accuracy was sacrificed, because no rider could ever hold himself on a horse in the way Géricault, whose knowledge of horses and horsemanship was profound, depicts it here. The background consists of an atmospherically agitated plane, which lends the officer's attack an uncanny look, as if it were aimed at nothingness, at intangibility, giving it almost cosmic connotations.

When Géricault began his *Raft of the Medusa*, he obtained body parts of executed men in order to study the changes in color that take place at various stages of decay. The resulting pictures are not merely preparatory in character, however, being finished compositions in their own right.

In the two faces in the Stockholm painting Géricault captures traces of the anguish felt in the final moment before death. That of the woman on the left, as if turned inward upon itself, is veiled by a scarf, while the man's scream is gruesomely amplified by the red of the blood.

The transition to nothingness – also visualized by the contrast between white sheet and dark ground – is depicted with well-nigh clinical directness and yet with a painterly brilliance which has nothing in common with the German Romantics' flirtings with the idea of death, but much in common with Goya's superbly painted visions of horror.

Géricault exhibited *The Raft of the Medusa* at the Salon of 1819. The monumental canvas enraged most of those who saw it, despite the fact that the perfect modelling of the figures and the strong chiaroscuro must have been familiar to the public from neoclassical art. Nor were dramatic depictions of shipwrecks with survivors drifting helplessly in lifeboats anything particular innovative at the time, as indicated by the paintings of Claude-Joseph Vernet or Loutherbourg from the late eighteenth century.

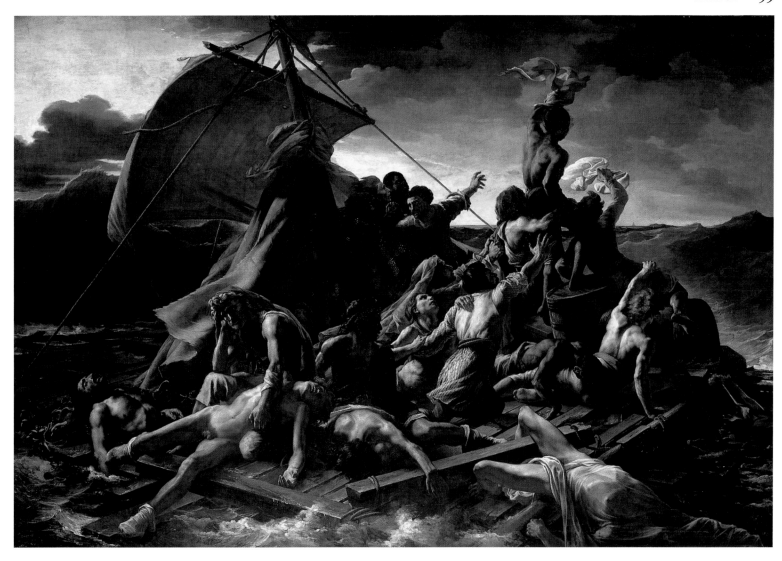

What caused the audience's anger was the artist's presumption in using a huge format without, as academic rules demanded, depicting anything classical, heroic, or edifying. Nor was his treatment of the subject sufficiently idealized and thus non-committal. Depictions of disasters were supposed to evoke a universal human fate, not become too concrete or personal, not get under one's skin.

Géricault, in contrast, turned with shock and shame to an actual event that involved human error on the part of the French navy. On 2 June 1816, the frigate *Medusa* had sunk off the West African coast. The crew had left 150 passengers to their fate on a raft. They drifted for thirteen days, in the course of which horrifying scenes of madness, death, murder and cannibalism took place. When the raft was finally sighted, only fifteen survivors remained, five of whom died after the rescue. The affair was suppressed in official echelons. Then, in the autumn of 1817, a report by the survivors was published which caused waves of revulsion and was immediately confiscated.

With an artist's obstinacy Géricault launched into an attempt to transform this governmentally tabooed scandal into a composition that far surpassed reportage or genre to evoke human behavior under extreme conditions and sum it up in an existential parable. Despite his criticism of the government's hushing-up campaign, in other words,

Géricault was not ultimately concerned with political propaganda. He did everything in his power to depict inconceivable human suffering as drastically as he could. He went to the survivors themselves for information, had a model of the raft constructed, and did great numbers of studies of dead and dying people in clinics and morgues.

With the pyramid of men and women clinging to the raft, whose figures were in many cases based on Michelangelo, at its peak a black man waving a cloth to attract the attention of the distant rescuers, the arrangement of figures is lent a solidity that stands in stark contrast to the chaos of the surrounding waves. The prominence Géricault gives to a black figure here may be linked with the efforts to abolish slavery that had been underway since the latter half of the eighteenth century.

When he went to London in 1810, Géricault had *The Raft of the Medusa* shipped after him, and it attracted great throngs in the English capital. It had less success the following year in Dublin, where a sensational panorama picture, a kind of early precursor of the cinema, devoted to the sinking of the *Medusa* was concurrently on display. A new medium had begun to challenge the reign of painting.

Théodore Géricault
The Raft of the Medusa, 1818/19
Oil on canvas, 491 x 716 cm
Paris, Musée du Louvre

Théodore Géricault
The Epsom Derby, 1821
Oil on canvas, 92 x 123 cm
Paris, Musée du Louvre

Théodore Géricault
The Quicklime Works, c. 1821/22
Oil on canvas, 50 x 60 cm
Paris, Musée du Louvre

THÉODORE GÉRICAULT
1791–1824

Worlds seem to lie between Géricault's *Raft of the Medusa* and his depiction of the Epsom Derby, done two years later during a stay in England. Instead of the monumentality with which he envisioned an extreme human fate, here he captured a moment in a horserace, the Britons' favorite sport and one which fascinated the enthusiastic horseman Géricault.

The observer's gaze is focussed on the horses and jockeys, by contrast to which the surroundings blur into summary, as if fleeting bands of color. This change of focus serves to emphasize the illusion of speed as the horses gallop down the track. But it would be mistaken to describe the picture merely as a kind of sports reportage. It does have this aspect, but we should recall the importance attributed to equestrian iconography in Romantic painting, especially in England and France, where the horse took on a well-nigh mythical significance. It could figure as the embodiment of animal instincts, or as a demoniac embodiment of Eros, as a rule standing for the male component.

Gros, Géricault, and Delacroix, recalling the Napoleonic campaigns, enthusiastically viewed the horse as a noble battle steed, or depicted the fleeting contours of a fiery thoroughbred, or the rippling muscles of an untamed Arabian stallion. When Géricault represented the Epsom Derby taking place under a stormy sky that plunges the colors into a strange twilight, he may have been referring to an actual personal experience, but the prime effect is to transform the scene into a wild chase in which the horses fly along as if soundlessly, their hooves not even touching the ground.

This small-format painting, its palette reduced to an almost monochrome range of earth tones and its content reduced to only a few objects, depicts a work break in the muddy yard of a lime factory.

In the left foreground, in front of a two-wheeled workcart, two massive dapple greys, still laden and harnessed, eat oats from feed bags. In the right middle ground, in front a wing of the primitive factory, two other horses stand before the high gateway through which another cart is visible, its horses likewise feeding. The smoke rising in thick white clouds from an opening in the left side of the building is the only reference to labor and human activity in the otherwise unpopulated scene. The painting exudes a sense of poverty and despair, a dark and melancholy mood which may reflect a personal experience on the artist's part. He had invested capital in this rather rundown factory and on his first visit there, he had immediately recorded the not very optimistic situation in a sketch.

Unlike Loutherbourg in his industrial landscapes, Géricault hardly emphasizes the demoniacal aspect of technological progress – except perhaps in the dark, as if ominous sky. The mood he creates serves rather to point out its actual darker side.

In the years between 1821 and 1824, Géricault painted ten portraits of inmates of the Salpê-trière insane asylum in Paris, presumably on order of the psychiatrist Dr. Georget, who is considered one of the founders of social psychiatry. Only five of these paintings now survive, in various museums.

Georget looked upon madness as a specific symptom resulting from modern civilization and industrialization. He liberated the mentally ill from the previously unworthy conditions of their custody and treated them as human beings in need of help.

Géricault's paintings, perhaps intended as demonstration material for lectures, accordingly rest on objective, clinically straightforward observation. Instead of seeking the effect of the abnormal or grotesque, they concentrate on tacit signs of mental derangement. It is as if the artist had set out to investigate mental illness as a normal phenomenon in society. This reserved approach heightens the physiognomic intensity of the heads, which exhibit no distortion of features, extraordinary attributes, or threatening aggressiveness.

Their illness becomes evident in a tense, watchful facial expression, an as if listening tilt of the head which reveals mistrust, and a glint in the eyes which fix an imaginary interlocutor or stare emptily into space. Further indications, as in the *Mad Woman with a Mania of Envy*, are a certain disorder of dress, and in the *Cleptomaniac*, ruffled hair, unkempt beard, and dirty collar.

Géricault's Romantic realism corresponded to the psychiatric doctrine of the day, which posited that the insane were capable of feeling anxiety, pain, and joy with a greater intensity than normal people. The realism of his approach inheres in the fact that it raises no dogmatic barriers, as it were bringing the insane back into human society and recognizing the possibility of a transition between "common sense" and its derangement.

Yet Géricault's approach is also Romantic in the sense that it attributes to the insane a more strongly articulated, demonaical vitality and therefore a greater capacity for experience. An artist like Géricault, a keen observer of everything real, authentic, vital and instinctive, could not remain unaffected by the aliveness of people suffering from obsessions, especially as he must have realized that his own temperament, not unfrequently suspected of madness, lay outside the conventions of the normal.

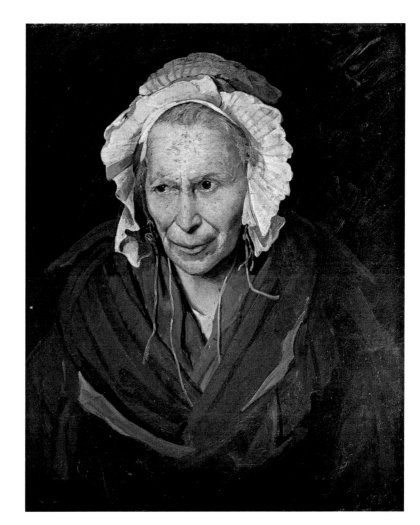

Théodore Géricault
The Mad Woman with a Mania of Envy, 1822/23
Oil on canvas, 72 x 58 cm
Lyon, Musée des Beaux-Arts

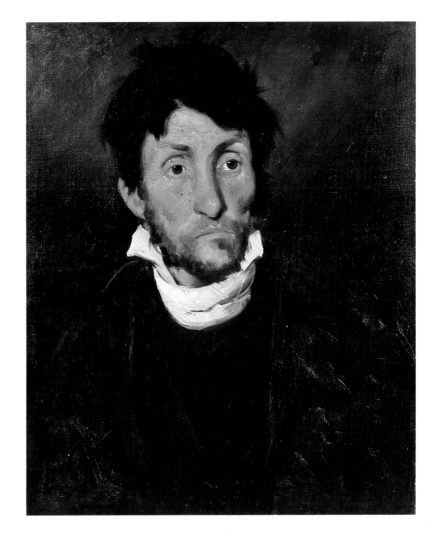

Théodore Géricault
The Cleptomaniac (Portrait of an Insane Man), c. 1822/23
Oil on canvas, 61 x 51 cm
Ghent, Musée des Beaux-Arts

Jean Auguste Dominique
Ingres
Joan of Arc at the Coronation
of Charles VII in Reims
Cathedral, 1854
Oil on canvas, 240 x 178 cm
Paris, Musée du Louvre

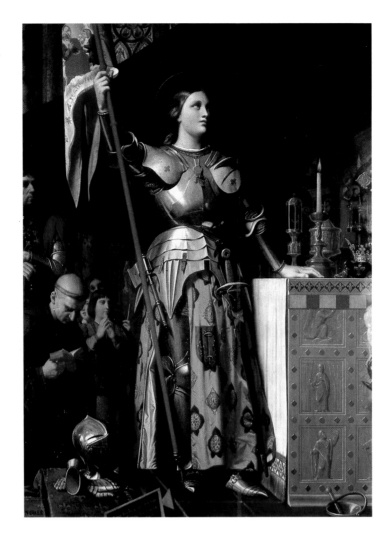

JEAN AUGUSTE DOMINIQUE INGRES
1780–1867

The painting shown here was commissioned
from Ingres in 1852 by the director of the
Academy of Fine Arts in Orléans, for celebra-
tions in honor of Joan of Arc. Though a neo-
classicist, throughout his long career Ingres
was repeatedly receptive to Romantic under-
tones, as is clearly evident in this work.

He represents the valiant girl who liberated
Orléans from an English siege in 1429 as a tri-
umphant Christian heroine clad in armor and
raising her eyes soulfully to heaven before an
altar. Three pages, the monk Paquerel, and In-
gres himself in the guise of a royal official, pay
homage to St. Joan. The many exquisite ob-
jects and materials painstakingly reproduced in
luminous colors that quietly unfold in the
plane, the noble ambience, and the monumen-
tal figure of the saint against a black back-
ground, are all intended to increase the profun-
dity of the picture's religious and pious mood.
Yet ultimately the elegance of the contouring
and the enamel-like gloss of the colors strike
one as being overly academic and facile. The
artist's attempt to emotionally move the
viewer, especially through St. Joan's gaze,
seems too cool and calculated to be truly con-
vincing.

Jean Auguste Dominique
Ingres
The Turkish Bath, 1862
Oil on canvas,
diameter 108 cm
Paris, Musée du Louvre

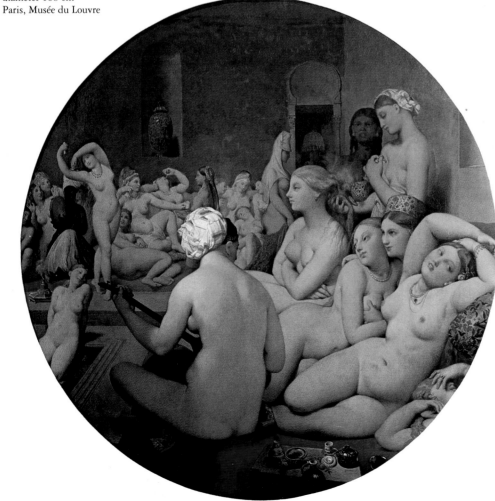

With this round painting, or tondo, Ingres
went back at the age of eighty-two to a theme
of his early period, bathers and odalisques. It
was his last recurrence to a motif he had
treated as early as 1859, in a work that was
subsequently lost, of which only a photograph
now exists. As regards details the artist relied
closely on travellers' descriptions of the Orient,
for instance of the baths in the harem of Ma-
homet, or Lady Montagu's letters describing
the Turkish women's baths. Such sources often
mentioned beautiful women with milk-white
skin and full, sensual figures. Yet despite all
their erotic magnetism, noted Lady Montagu
in surprise, the naked harem women never be-
haved in a lascivious way, but rather appeared
to her to exist in a state of innocent, natural
beauty.

In this painting, whose round format was
intended to recall ideal compositions of the
Renaissance, such as those of Michelangelo or
Raphael, Ingres attempts to emphasize this
paradisal state through the soft and yet
strongly modelled forms of the female nudes.
Nevertheless, those in the right foreground in
particular seem to exhibit their bodies, and
perhaps a hint of lesbian love, in a direct ap-
peal to the viewer's voyeuristic instincts. And
the nudes next to them, due to their idealized
forms and lack of individual characterization,
legitimated by their exotic appearance and
redolent of "Romantic charm," inadvertently
call up mental associations with the stylized
bordello eroticism and pornographic photogra-
phy of the period.

GEORGES MICHEL

1763–1843

Georges Michel remained almost completely unknown during his lifetime. In the first decades of the nineteenth century he concentrated on landscapes based on simple everyday motifs found in the vicinity of Paris. Michel had the ability to suffuse even the most commonplace slices of life with an evocative mood that reflected states of mind, particularly as experienced by the lone individual.

In *Landscape with Windmill, View from Montmartre* a high stormy sky arches over a flat landscape, partly brilliantly illuminated, partly plunged in darkness. At the lower left a curving road leads into the space and provides visual access.

While the windmill of the title lies in complete gloom, its vanes project above the horizon – the only form in the picture to do so – as if reaching out toward the sunlight beginning to break through the clouds. Possibly Michel was aware of the symbolic meaning that attached to the windmill in seventeenth-century art. With its vanes at the mercy of inconstant and fickle winds, the windmill figured as a symbol of capricious fate and the vicissitudes of human life.

With works of this type Michel came very close to the landscape approach of early Romanticism in Germany or England.

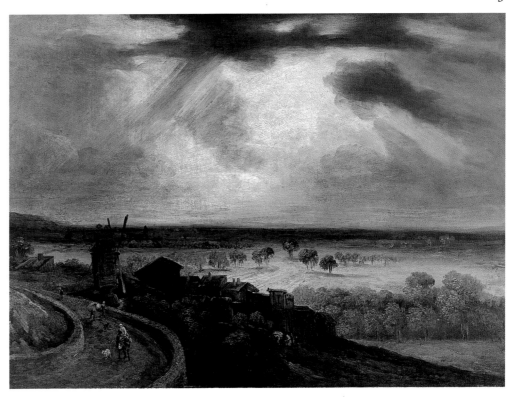

Georges Michel
Landscape with Windmill, View from Montmartre, undated
Oil on canvas, 60.5 x 81 cm
Bremen, Kunsthalle Bremen

THÉODORE GUDIN

1802–1880

In the bay where Normandy meets Brittany a granite island rises out of the water off the coast. From times immemorial a Celtic burial place, in the eighth century it was crowned by a small Christian chapel. At the foot of this ecclesiastical settlement a small fishing town gradually grew up. By representing the precipitous island at low tide and backlighted, in dark shadow against an expanse of cloudy sky, Gudin dramatizes and monumentalizes a famous sight. The contrast is further heightened by the two small figures looking for mussels or crabs in the mud. The wide horizontal sweep of the landscape is offset by the vertical of the church, tapering upward from a broad base. The sensations engendered by the natural coastal scene transfer themselves without a break to the seemingly almost organic and natural architecture of the island, a national historical monument that has been described as a prayer become stone or a palace of God. Yet at the same time, its shadowy silhouette suggests a symbol of transience that has defied elemental forces for centuries but must ultimately succumb to them – even the rising tide will visually decrease the impressiveness of the defiant, as if fortified island. In its treatment and symbolism, Gudin's painting recalls many early German Romantic paintings and their similar intentions, though a direct influence cannot be presumed.

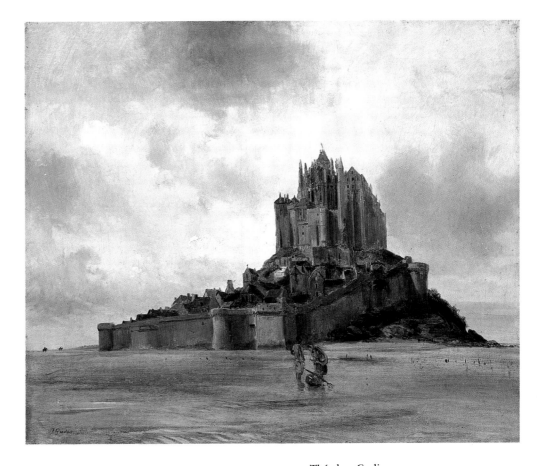

Théodore Gudin
Mont-Saint-Michel, 1840
Oil on canvas, mounted on cardboard, 53 x 64 cm
Hannover, Niedersächsisches Landesmuseum

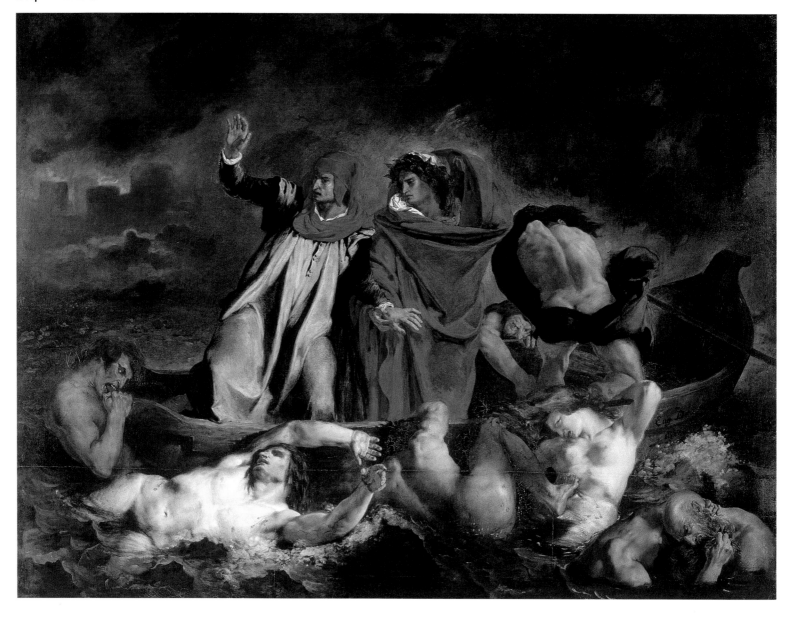

Eugène Delacroix
Dante and Virgil in Hell (The Barque of Dante), 1822
Oil on canvas, 189 x 246 cm
Paris, Musée du Louvre

EUGENE DELACROIX

1798–1863

With his first major work, *The Barque of Dante*, 1822, Delacroix introduced a number of innovations in content and painting technique which were to determine his work from that point on. When he presented the painting in the Paris Salon, it was with the hope that the powerful figures, their expression of profound mental torment, and the superb and sumptuous palette would make a deep public impression. Immediately after the Salon *The Barque of Dante* was acquired by the French state for 1000 francs and taken to the Musée de Luxembourg, at that time the Paris museum of contemporary art.

The large format, according to academic conventions, promised a work of history painting, and the subject was in fact taken from Dante's *Divine Comedy*. In her autobiographical novel *Corinna*, which Delacroix admired, Madame de Staël had praised Dante as "a latter-day Homer" gifted with a bizarre and visionary imagination, and described him as a predecessor of the modern, alienated artist.

The poet, in a greenish-white cloak with red hood, stands to the left in the boat on the way to Hell. On the fifth level, where the choleric and morose do penance, Dante must cross the muddy underworld river Styx in order to reach Dis, the infernal city. The sight of fellow Florentines wallowing in the bottomless pit triggers a feeling of profound shock and empathy. As if seeking support, Dante extends his left arm to the central figure, the ancient Roman poet Virgil, his guide on the journey through Purgatory and Inferno. Clad in a brown cloak and crowned with laurel, Virgil exudes calm and composure.

The boat is steered by the ferryman Phlegias, whose muscular back and blue cloak fluttering in the storm, like the tense, twisted bodies of the damned, one of whom clings by his teeth to the boat at the far left, are redolent of sheer creaturely struggle and existential despair. As if in a spotlight, light-dark contrasts play over the figures and throw their contours into sharp relief.

In terms of composition, Delacroix attempts to do justice to traditions, as indicated by his study of Michelangelo, Rubens, and – his most recent model – Géricault's *Raft of the Medusa* (ill. p. 99), while at the same time introducing daring innovations, particularly as regards the painterly style and the impasto, sketchy paint application.

The Greeks' struggle to liberate themselves from Turkish occupation aroused deep sympathies throughout Europe. Their cause even prompted that leading figure of the Romantic movement, Lord Byron, to a personal involvement from which he would never return. From the long history of events Delacroix has chosen the year 1822, the date of the massacre of Chios, in which 20,000 inhabitants of the Greek island were killed.

In the close foreground, in immediate proximity to the viewer, attackers and victims intermingle. The dead and the survivors, whose fate would be slavery, are depicted in poses redolent of defeat. As the turbaned rider at the right throws a victor's glance at them, his rearing horse charges off toward the coast, dotted with burning houses and clumps of humanity in which butchers and the butchered are hardly distinguishable from one another. The natural scene with its bare rocks and sparse vegetation adds its voice to the requiem on the bestiality lurking in human nature.

Yet over the entire scene, even the faces of the martyred, Delacroix casts a veil of glowing, exquisite color, and renders the desolate yet light-flooded landscape in a free and fluent manner that was completely new in France at the time. The paradoxical gap between the gruesome subject and the beautiful style cannot, however, be viewed as reflecting a sheer refinement of suffering, as contemporary critics maintained. The artist himself saw this discrepancy as offering the possibility of combining current reality with timeless ideality of statement.

In the overwhelming painting on *The Death of Sardanapalus*, Delacroix's Romantic endeavors found probably their most radical expression, though one which deeply alienated the public and critics of the day. The theme was taken from Byron's poem *Sardanapalus*, which was published in London in 1822 and a short time later in a French translation. The composition represents the culmination in the artist's œuvre of an approach that aimed at extreme and extravagant effects.

An oriental monarch who, threatened by rebels, decides to commit suicide after killing his wives and horses and having everything he owns put to the torch – this episode becomes an occasion to render dramatic poses in a rhythmical succession, exotic treasures in brilliant, even garish colors. Obvious is his connoisseurship of sensual female bodies, rising and falling as if to a wild melody. Long before Charles Baudelaire, Novalis had already recorded the insight that the "true basis of cruelty is lust."

Yet the critics were disturbed less by this ecstatic mass murder than by the lack of perspective and what they considered poor drawing. In fact, the foreground in particular possesses no clear spatial logic, everything there seeming to have left the ground. However, Delacroix was not concerned with realistic, perspective vision but, in a very modern sense, with the dominance of the picture plane, in which color, light and movement were integrated. Here he tested this design possibility with a radicality that would, in his later œuvre, again be toned down.

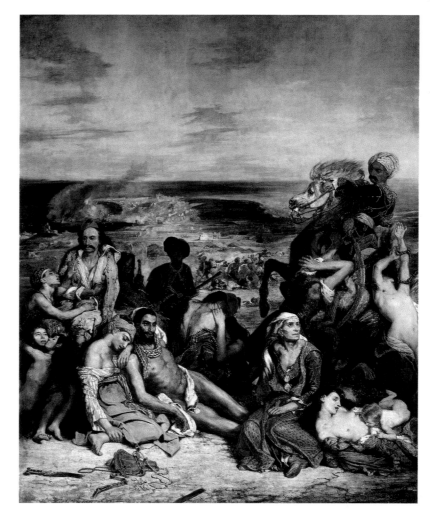

Eugène Delacroix
The Massacre of Chios, 1824
Oil on canvas, 417 x 354 cm
Paris, Musée du Louvre

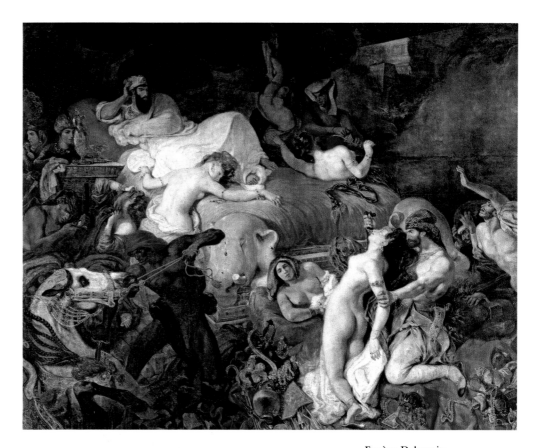

Eugène Delacroix
The Death of Sardanapalus, 1827/28
Oil on canvas, 395 x 495 cm
Paris, Musée National du Louvre

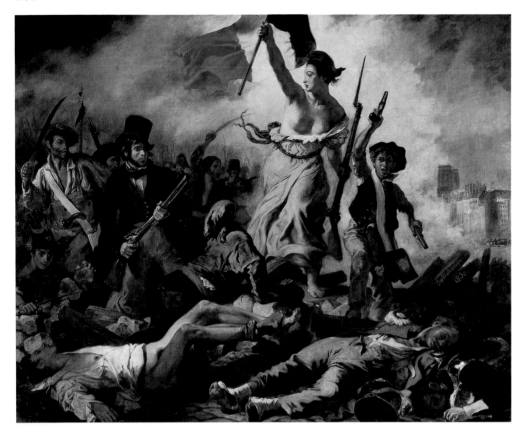

Eugène Delacroix
Liberty Leading the People (28 July 1830), 1830
Oil on canvas, 260 x 325 cm
Paris, Musée du Louvre

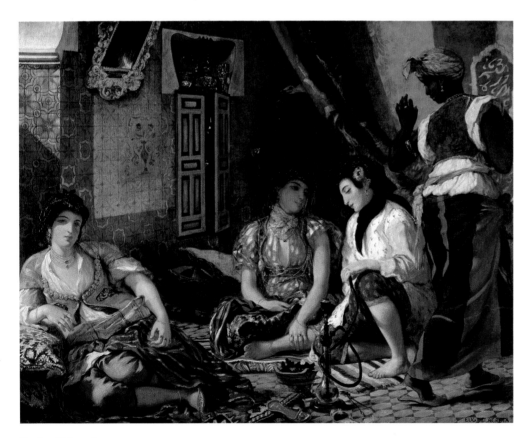

Eugène Delacroix
Women of Algiers, 1834
Oil on canvas, 180 x 229 cm
Paris, Musée du Louvre

EUGENE DELACROIX
1798–1863

The infringement of the French constitution by King Charles X, who strove to reinstate absolute monarchy, led to the bloody popular revolt of 1830 which Delacroix represented in this famous painting, destined to become the programmatic image for many a revolutions to come.

The dramatic event is composed in a classically rigorous manner, inscribed in an equilateral triangle. In the foreground, fallen freedom fighters and a barricade of cobblestones and beams form a kind of barrier between spectator and scene. Led by an allegory of liberty, a semi-nude female figure with a Jacobin cap grasping a musket and waving the Tricolor, statuesque and yet in vehement movement, the enraged rebels charge towards us. In the eyes of Heinrich Heine, "A grand idea has nobilitated and sanctified these common people, these *crapule*, and reawakened the dignity slumbering in their soul." Detectable in the clouds of dust and gunsmoke in the background are shadowy gun barrels that suggest the presence of a huge crowd of people.

Delacroix has included himself in the picture, beside the allegorical liberty figure inspired by a current song, in the guise of the top-hatted student. In contrast to the boy wildly firing off his pistols at the right, he holds his gun gingerly, looking off thoughtfully into the distance as if asking himself about the meaning of the slaughter.

During a stay of several months in Africa, Delacroix obtained permission to visit a harem in Algiers. The man who accompanied him, a French emissary, reports the artist's enthusiastic exclamation: "Isn't this lovely! Just like in Homer's times." In this hermetic and exotic realm Delacroix believed to have found the quintessence of tempting beauty and a Dionysian antiquity that had nothing in common with neoclassical coldness and perfection.

Charles Baudelaire saw in the decoratively clad female figures who seem strangely to hover between reality and dream an embodiment of "luxe, calme et volupté" (luxury, peace and sensual indulgence). And they conformed completely to Delacroix's romantic ideal of beauty, which he described thus: "The charm that makes us love them rests on a thousand things.... But what seduces the heart and triggers passion are beauties that are still more vague and unbounded, less known, never explained, mysterious and unutterable." This enthusiasm fit in with the oriental vogue of the day, but at the same time went far beyond the mere ethnological anecdotalism found in the work of lesser artists.

In addition, Delacroix created an image whose colorism was to anticipate Renoir and Matisse. After his African journey his palette grew increasingly colorful, the bright hues even beginning to permeate the traditional brownish backgrounds. Floods of light illuminated great passages of his pictures and a multiplicity of superb materials in costumes and draperies united with light reflections to engender a vibrant overall texture.

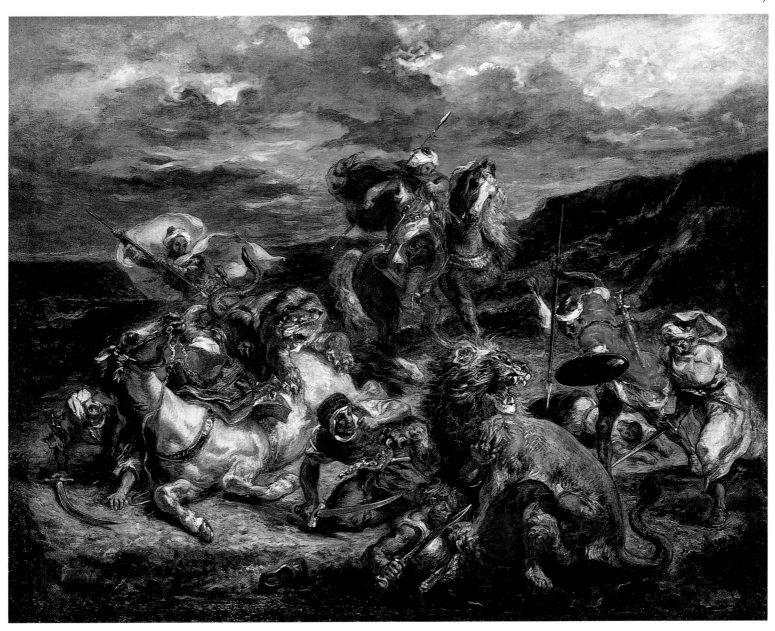

In the *Lion Hunt* we again find evidence of the great influence exerted by Rubens on Delacroix. One is especially put in mind of the Baroque master's 1611 painting of a lion hunt, which is now in the Alte Pinakothek in Munich. This composition too is dominated by mounted warriors, some being thrown off by their rearing horses and a few, as in Delacroix's picture, characterized as Moors.

In Rubens's case the subject probably goes beyond a depiction of a hunt per see to take on the allegorical meaning of the victory of good over evil. By comparison to this composition, though, we can also see the extremes to which Delacroix took the Baroque master's dynamic figure composition and painterly treatment of color.

Especially after his stay in Morocco, Delacroix devoted numerous studies and paintings to the subject of struggles between men and wild animals and the violent forces these set free. In the present work, the elemental event taking place in a coastal landscape is composed in terms of a circular movement which repeats itself in the separate scenes, in the twists of the figures' bodies, and in details of the drapery and cloud formations. One Arab already lies dead on the ground, two others have fallen, but four are in process of dispatching the beasts with lances and sabres. In the background, another man on a superb charger rushes to the scene.

The dramatic cloudy sky appears to echo the fight on the ground. Everything in the picture – hunters, animals, landscape – seems wild and untamed, and thus the violent battle becomes a metaphor for the primal forces of nature, of which, in "exotic" areas of the world, humanity is still an integral part. All of this is exemplary of Delacroix's fundamental urge to treat every theme and motif in terms of human passions, rather than in terms of preconceived ideas or schemes. Even his historical and exotic subjects draw their sustenance from such impassioned fervor, the life force which for Delacroix represented the basis of all natural existence.

Eugène Delacroix
The Lion Hunt, 1861
Oil on canvas, 76.5 x 98.5 cm
Chicago (IL), The Art Institute of Chicago

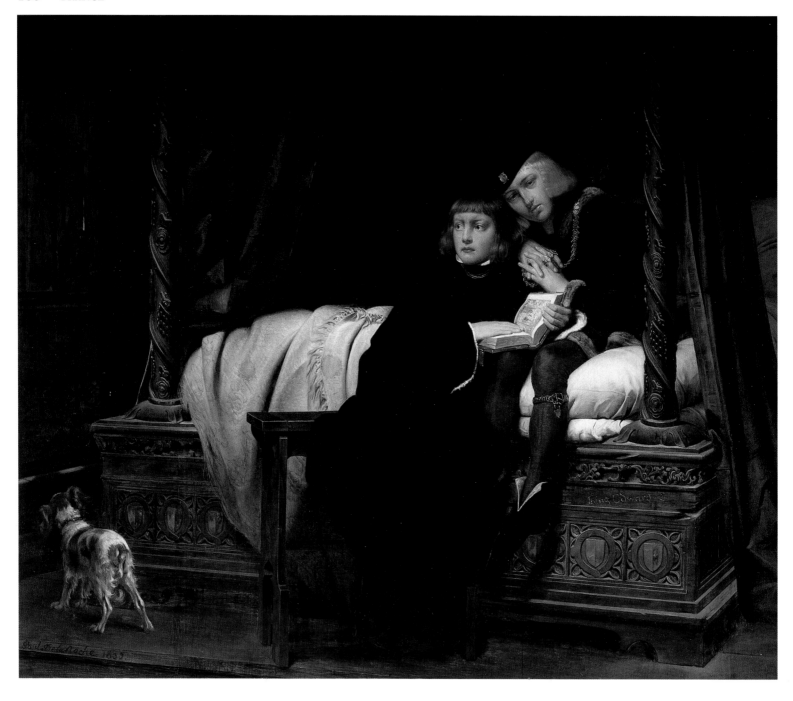

Paul Delaroche
The Sons of Edward IV, 1830
Oil on canvas, 181 x 215 cm
Paris, Musée du Louvre

PAUL DELAROCHE

1797–1856

Paul Delaroche was among those French history painters who were famous and highly popular during their lifetime but whom the contemporary viewer approaches with a certain reserve.

In the large-format composition *The Sons of Edward IV*, which was exhibited at the 1831 Salon, Delaroche depicts a scene from Shakespeare without really having much sense of true drama. Apparent historical precision – the carved base and posts of the bed might have come straight from an antique shop – congeals into unimaginativeness.

As Delaroche himself once asked, "Why should a painter be prevented from competing with the historians? Why shouldn't a painter, too, be able to teach, using his own means, the truth of history in all its dignity and poetry? A picture often says more than ten volumes, and I am absolutely convinced that painting is just as much qualified as literature to affect public opinion."

These ambitious ends are sadly marred by a triviality of means. The artist attempts to build suspense as in a crime or horror novel: The murderer of the king's sons lurks in hiding, but the little dog hears him coming and the elder of the princes is warned by the dog's reaction.

The two boys are supposed to appear romantically soulful, quaking with a premonition of death – and yet are not much more than protagonists of a sentimental melodrama. Théophile Gautier wrote of "polished depictions, this art for the semi-educated embellished with false philistine realism, this historical illustrational art for bourgeois domestic use." Romantic trappings combined with purely formal realism serve here to offer escape from an unpleasant contemporary reality.

THÉODORE ROUSSEAU
1812–1867

Rousseau, one of the main representatives of
the Barbizon School, painted *The Chestnut Av-
enue* in the park of Château Souliers in Vendée,
the family home of his artist-friend Charles le
Roux. The composition, rounded off at the up-
per corners, recalls a theater set in which an il-
lusion of extreme depth is created by the sym-
metrical lines of tree trunks extending into the
background.

The overall impression is one of gloom and
oppressiveness, the impenetrable arch of fo-
liage and dense shadows underneath the trees
engendering a pervasive darkness relieved by
only a few points of impinging light. The sky
is entirely invisible. This darkness of hue sets
the painting off from the general character of
Barbizon landscapes and makes it quite diffi-
cult to categorize in terms of style.

Though the straightforwardness of observa-
tion of nature precludes speaking of this as a
Romantic picture, a certain undertone of
melancholy does convey reminiscences of the
Romantic landscape approach.

The closest comparison in terms of stylistic
level, without positing any reciprocal influ-
ence, would perhaps be with works of the
German Biedermeier.

Théodore Rousseau
The Chestnut Avenue, 1837
Oil on canvas, 79 x 144 cm
Paris, Musée du Louvre

LÉOPOLD ROBERT
1794–1835

The œuvre of the Swiss painter Robert, a pupil
of Jacques-Louis David, belongs by its nature
to French Romanticism. With *Arrival of the
Scythers in the Pontine Marshes* he created a
model of the Italian folk genre scene then very
much in vogue. In Italy the cultivated Euro-
pean city-dweller found not only sites of classi-
cal education and great Western art but rem-
nants of a strange and picturesque life, an aura
of the attractively exotic, accessible in compar-
ative comfort by post chaise.

Robert's picture contains no hint of the fact
that, at that period, the malaria-infested Pon-
tine Marshes were a hell on earth for their in-
habitants. Just the opposite: He depicts the
area as an earthly paradise, full of beauty and
joie de vivre, where people dance the tarantella
from dawn to dusk. Basically the artist and his
audience still dreamed of Rousseau's "back to
nature," especially as embodied in "the peo-
ple," common peasants, shepherds, even
thieves who in their eyes represented the "aris-
tocrats" of the unspoiled natural life.

The usually so critical Heinrich Heine en-
thused over Robert's painting: "Looking at it
one forgets that there is a shadow realm and
one doubts whether it is anywhere more bliss-
ful and bright than on this earth. 'The earth is
heaven and humans are saints, imbued with di-
vinity,' that is the great revelation which
shines with beatific color from this picture."

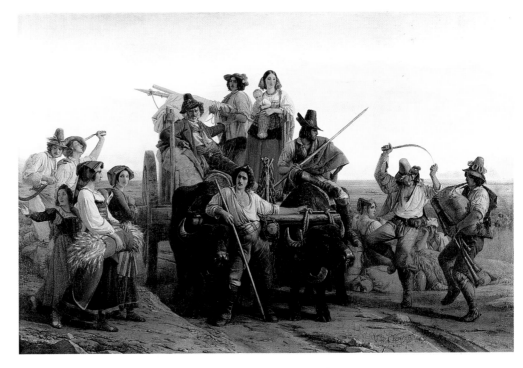

Léopold Robert
The Arrival of the Scythers in the Pontine Marshes, 1830
Oil on canvas, 141.7 x 212 cm
Paris, Musée du Louvre

JEAN-BAPTISTE CAMILLE COROT
1796–1875

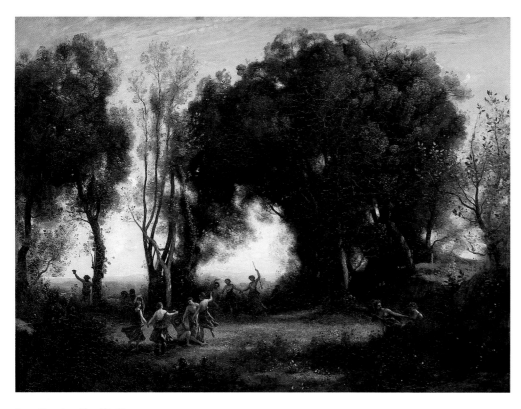

Jean-Baptiste Camille Corot
A Morning, Dance of the Nymphs, 1850
Oil on canvas, 98 x 131 cm
Paris, Musée du Louvre

The painting illustrated is Corot's first depiction of nymphs dancing in a landscape, in this case accompanied in the left background by the ancient Greco-Roman god of wine and revelry, Bacchus. The great model for the composition was provided by Claude Lorrain's renowned *Landscape with Rural Dance* of the seventeenth century (Paris, Musée du Louvre). The dance scene reflects Corot's love of theater, opera, ballet and music.

A covert musicality also pervades the play of light and shade and the silvery veil that seems cast over everything in the picture. Landscape becomes a locale of synaesthetic sensations, with the mythical figures serving as embodiments of human longings and dreams projected into nature.

In the 1850s Corot, who usually favored the brighter, more sunny aspect of nature, began depicting landscapes troubled by cold, gusty winds. These were generally located in northern France, as in the present picture of a wilderness of dunes extending to a low horizon.

The sky is filled with scudding clouds. A storm wind sweeps through a group of mighty, gnarled oaks, bending their branches leftwards and sending leaves flying. The typically humid, misty atmosphere near the sea is evoked by means of flickering color gradations that extend from bright hues to greyish-greens and browns, and by a veil of silvery color that lies over the whole. The result is a strange mixture of realistic details, tangible atmosphere, and a lyrical, Romantic mood which is characteristic of Corot's late style.

Seen slightly from below as she leans on a stone balustrade, the figure of a young Italian woman rises monumentally and with well-nigh classical statuesqueness against an atmospherically diaphanous background, consisting of a rocky slope with farmhouses, a tree trunk cut off at the right edge of the canvas, and a predominant sky dotted with small, gold-tinged clouds. The dense blue and black hues of the woman's garments set the figure off markedly from the background ambience.

The dignified and serious basic mood of the picture is concentrated above all in the melancholy, shaded eye area of the face. The Italian costume, exquisite pearl necklace, and especially the noble facial features framed by wonderfully arranged black hair, exude a classical dignity, as if some figure of ancient legend had suddenly materialized before our eyes. She embodies the land of longing, Italy, and the charm of that intermingling of classical grandeur and subjective mood which every Romantic current in art again and again sought in the Mediterranean world.

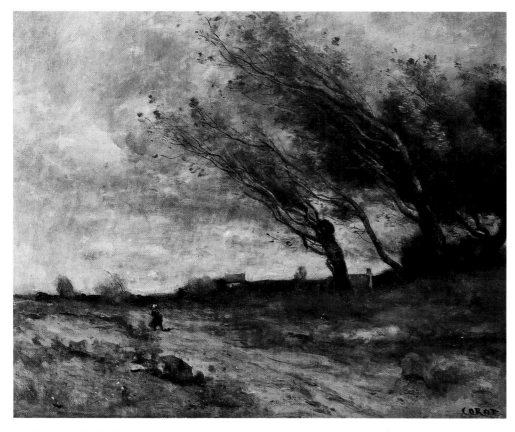

Jean-Baptiste Camille Corot
The Gust of Wind, c. 1865–1870
Oil on canvas, 47.4 x 58.9 cm
Reims, Musée Saint Denis

Jean-Baptiste Camille Corot
Agostina, 1866
Oil on canvas, 130 x 95 cm
Washington (DC), National Gallery of Art

Paul Huet
Breakers at Granville Point, c. 1853
Oil on canvas, 68 x 103 cm
Paris, Musée du Louvre

PAUL HUET

1803–1869

Most of Huet's landscapes were dominated by storms, cloudbursts, and floods. The churning sea off the point near Granville in Normandy, where he stayed in 1850, inspired numbers of sketches from which his famous wave paintings were developed.

Here, waves breaking against cliffs are depicted in extreme closeup. Whitecaps and flying spray – highly transient phenomena, in other words – form the composition's center of interest. Broad brushstrokes are used to evoke the flow patterns of the murky green waves and the rock formations vaguely visible in the background gloom. The threatening aspect of violent natural forces is heightened still further by the stormy illumination.

The eminent critic Charles-Augustin Sainte-Beuve described Huet's art as follows: "In this way of observing and depicting a place, man no longer plays a great role... nature ranks first, nature pure." This statement can be qualified to the extent that while the human figure indeed remained absent from such scenes, man was nevertheless present in the Romantic sense, in that nature was made to reflect human sensations and notions of the sublime. On the other hand, the immediacy of Huet's on-site depictions of natural phenomena was to influence the *plein air*, or outdoor painting of the Barbizon School a short time later.

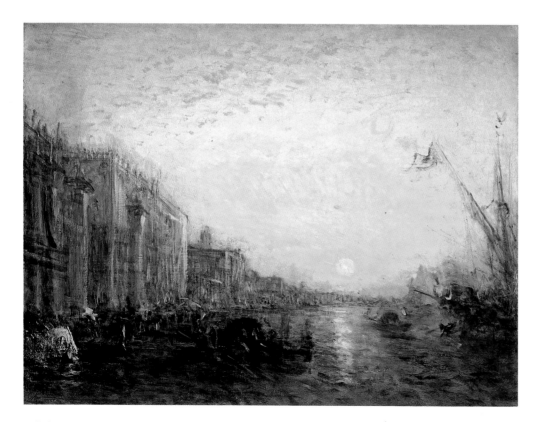

Félix Ziem
Venice with Doges' Palace at Sunrise, c. 1885
Oil on canvas, 72 x 101 cm
Paris, Musée du Petit Palais

FÉLIX ZIEM

1821–1911

Ziem, the son of a Croatian father and a French mother, initially trained as an architect and was a friend of Théophile Gautier and Chopin. He undertook many journeys through Europe and North Africa, staying for extended periods in various cities. In Berlin, for instance, he founded a school for watercolor painting in the 1860s. Ziem also visited Barbizon and familiarized himself with its art. He achieved rapid fame, and his works drew top prices. Ziem's œuvre, scattered around the world, comprises over 1600 paintings and approximately 10,000 watercolors and drawings. In 1910 he became the first living artist to be represented in the Louvre.

Venice with Doges' Palace at Sunrise is an indicator of the great contribution Ziem made to the northern European nostalgia for Italy, which since the Romantic period focussed increasingly on Venice. The view, seen from the Dogana, has a sketchy approach that brings out the brilliancy of the colors and the fluency of paint application. The motif, a harbor framed by a row of mansions on one side and ships and masts on the other, distantly recalls the compositions of Claude Lorrain.

Such light-flooded views, whose details blur in a shimmering veil of textured brushwork and whose overall effect is that of a nostalgic charm, place Ziem in an intermediate position between Romanticism and Impressionism.

JACOBUS THEODORUS ABELS

1803–1866

At first glance one is tempted to attribute
Abels' small painting *Landscape by Moonlight* to
a seventeenth-century Netherlandish Baroque
artist. Yet the multicolored light reflections on
the foliage of the trees along the banks of the
river running diagonally through the picture
bear definite affinities with Romantic design
principles, with which Abels familiarized him-
self especially on a journey through Germany
in 1816.

Otherwise, however, the composition relies
on almost literal citations from the work of
Aert van der Neer (1603 or 1604–1677), even
the effect of the moon obscured by the dark sil-
houette of a dominant windmill being derived
from this artist. Thus conceivably Baroque
symbolism comes into play here, according to
which the windmill represented the fickleness
of fate.

Abels' style and repertoire of subjects devel-
oped hardly at all from 1840 to 1866. Shortly
after the artist's death, the critic Jozef Alberd-
ingk was unable to suppress the ironic com-
ment, "It is a touching thing that from now
on, Abels will be missing from the usual exhi-
bitions. May the moon to which he so persis-
tently and chastely paid homage shine gently
on his grave."

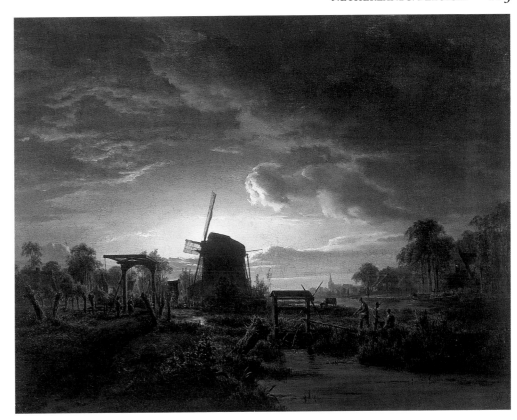

Jacobus Theodorus Abels
Landscape in Moonlight, c. 1845
Oil on wood panel, 34.3 x 47 cm
Rotterdam, Museum Boijmans Van Beuningen

ANTOINE WIERTZ

1806–1865

The Belgian painter Wiertz idolized Rubens
above all. He was only nineteen years old when
he announced his intention to become a second
Rubens – or nothing. This obsession to imitate
his ideal ultimately took on pathological traits,
prompting the psychologist Lombroso to write
an article entitled "Genie et folie dans l'œuvre
de Wiertz".

In *The Lovely Rosine* the painter confronts a
nude adolescent girl just blossoming into
womanhood with a skeleton, evidently a studio
prop. The two contemplate one another, while,
to their right, an easel vicariously brings the
artist into their silent moralizing dialogue
about beauty and horror, youth and decay.

Except for certain aspects of the color
scheme there is not much here to remind one
of Rubens, the arrangement instead recalling
medieval dances of death or representations of
vanitas. Moreover, the work of Wiertz calls to
mind a tendency that emerged throughout Eu-
rope in the closing years of the nineteenth cen-
tury and came to known as Symbolism. Bel-
gium was major center of Symbolist art, in
which a morbid fascination with eroticism and
death plays an important role.

In this painting by Wiertz the face of the
woman, and her expression, are marked by a
cloying sentimentality verging on kitsch. The
attempt at Romantic profundity in addressing
existential questions and anxieties is marred by
forced posing and superficial thes-pianism.

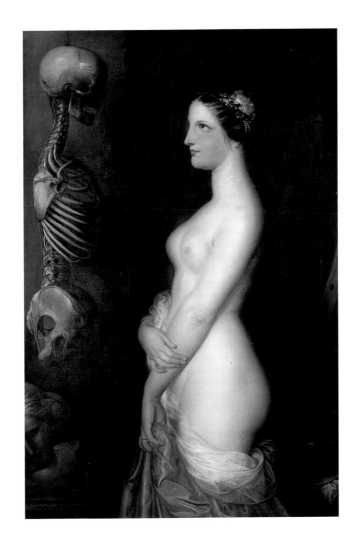

Antoine Wiertz
The Lovely Rosine
(Nude with Skeleton), 1843
Oil on canvas, 140 x 110 cm
Brussels, Musées Royaux des
Beaux-Arts de Belgique

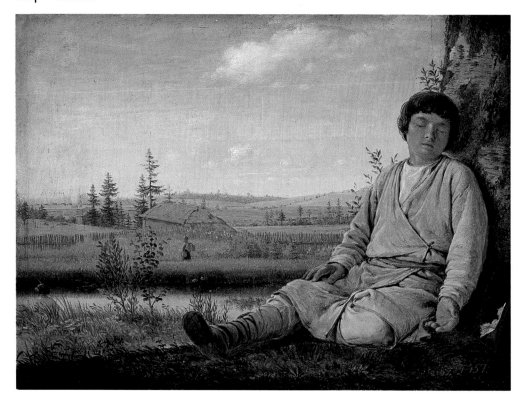

Alexei Venezianov
Sleeping Shepherd Boy, 1824
Oil on wood panel, 27.5 x 36 cm
St. Petersburg, State Russian Museum

ALEXEI VENEZIANOV
1780–1847

Venezianov's early works, above all his por-
traits, had already brought him considerable
recognition in Russia. In 1818 he purchased
the estate Safonkovo in the Tver District,
where from 1824 until his death he gave art
instruction to numerous pupils, most of them
children of serfs. There he also painted an en-
tire series of subjects drawn from rural Russian
life, principally depictions of peasants' and
shepherds' children.

The small painting of the *Sleeping Shepherd
Boy* belongs to this series. In the midst of a
peaceful village landscape composed in terms
of horizontal bands, a shepherd boy leans
against the trunk of a great birch tree. His eyes
are closed, his legs crossed, his left hand lies
open on the ground – in a strangely submissive
gesture, as if inviting the trust of someone ap-
pearing to him in a dream.

The great size of his figure in the fore-
ground by comparison to the finely articulated
landscape behind lends the boy a statuesque
appearance, and yet he still retains a childishly
melancholy, musing air. The earnestness, com-
munion with nature, and close-up view of the
shepherd boy put one in mind of Philipp Otto
Runge's pictures of children (ill. p. 36).

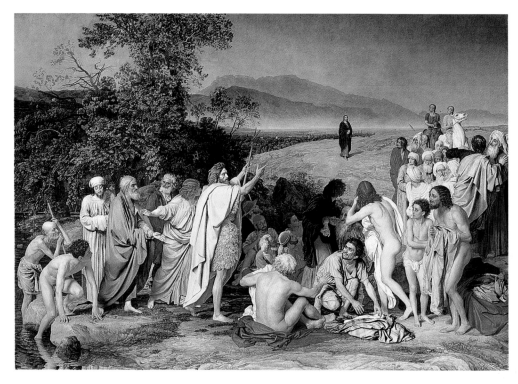

Alexandr Ivanov
Christ Appears to the People, 1837–1857
Oil on canvas, 540 x 750 cm
Moscow, Tretyakov Gallery

ALEXANDR IVANOV
1806–1858

Christ Appears to the People is Ivanov's major
painting, on which he worked for over twenty
years. Over 100 sketches, numerous detail
drawings, and large-scale designs, most of
them in oil, preceded the monumental compo-
sition. It was exhibited with great success in
1858 in Rome and St. Petersburg, and was
purchased by the Russian government for
15,000 rubels.

In a friezelike arrangement in the fore-
ground plane a number of male figures, some
already undressed, await to be baptized in the
Jordan River by John the Baptist. Yet he, in
his garb of animal skin under a long mantle,
a crosier in his left hand, turns and raises his
arms dramatically towards the lone figure
of Christ, who appears on a rocky rise in the
middle ground, behind him a broad plain and
distant mountains.

The painting contains certain reminiscences
of Italian Renaissance art, the boy just dipping
his foot in the water at the far left, for instance,
having been borrowed from Michelangelo's
cartoon for the *Battle of Cascina* (1504–1506).
But in its emphasis on line and its cool, decor-
ative palette it also reflects Nazarene ideals,
while the juxtaposition of a precisely delin-
eated foreground with a more softly rendered
distant landscape brings a generally Romantic,
atmospheric tension into play.

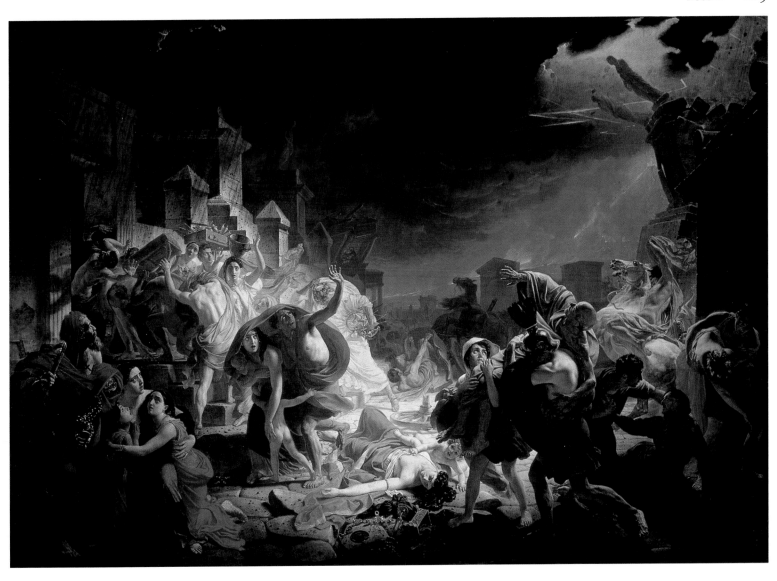

KARL PAVLOVIC BRÜLLOW

1799–1852

Brüllow came of a family of German artists who had settled in Russia in the eighteenth century. From 1809 to 1821 he attended the St. Petersburg Academy, then in 1822 travelled on a grant from the "Society for the Furtherance of Artists" to Italy, where he stayed until 1836.

The painting that made him famous, *The Last Day of Pompeii*, dates to this Italian period. It was begun after a visit to the excavations of the ancient city, destroyed by an eruption of Mt. Vesuvius in 79 A.D., and finished during a sojourn in Rome.

The predominant compositional element of the monumental painting is the diagonal which begins at the lower left and leads into the background at the upper right. It reveals a glimpse of the distant horizon and the eruption of Vesuvius, from which the fateful, lightning-scoriated cloud of ashes rolls towards the city. To the sides of the diagonal leading back into space, temples, houses, and statues are already toppling in the earthquake.

Plunged in a dramatic play of darkness and light, the inhabitants react to the disaster – assuming admittedly quite decorative poses, which were borrowed from many models in early Italian art. The intended scenario of horror congeals into a pompous historical revival illustration which does not trigger any real depth of feeling.

Though lacking Delacroix's brilliant palette and masterful composition of the plane, the colossal spectacle is related to the French artist's *Death of Sardanapalus* (ill. p. 105) in terms of its pathos of terror and inexorable natural forces. The illusion of depth engendered by the flanking building facades and the pyrotechnic lighting effects recall the theater or opera productions of the period. In addition, the accumulation of scenes of horror amidst architectural perspectives bears a certain resemblance to John Martin's panoramas of disaster (ill. p. 71).

The nascent Russian art scene acclaimed the work as a true national product which indicated that their country had at last caught up with international standards in art. Pushkin wrote a poem in praise of Brüllow's painting, and Gogol celebrated it in an essay as a "complete, universal creation." Conceivably even Edward Bulwer-Lytton's novel, *The Last Days of Pompeii*, 1834, was inspired by the picture, which the author had seen in Rome.

Karl Pavlovic Brüllow
The Last Day of Pompeii, 1830–1833
Oil on canvas, 456 x 651 cm
Moscow, Tretyakov Gallery

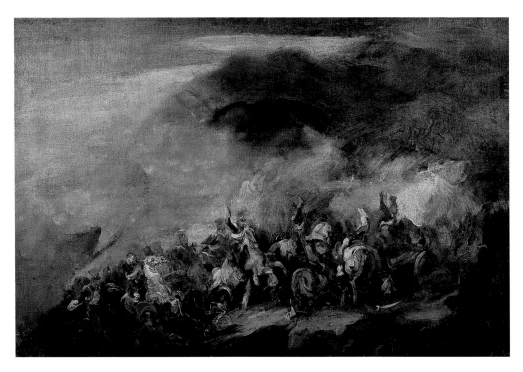

Pjotr Michałovski
The Battle of Somosierra, undated
Oil on canvas, 58 x 86.5 cm
Paris, Musée du Louvre

PJOTR MICHAŁOVSKI
1800–1855

At Somosierra, a Spanish village located at a strategically important pass in the Sierra de Guadarrama, Napoleon forced his way through the mountains on 30 November 1808, opening the French army's path to Madrid.

Michałovski was a Polish artist who, after training in Warsaw and Cracow, went to Paris in 1831, where he was active for two years. He has depicted the event in a manner strongly reminiscent of Géricault and Delacroix. The latter especially provided the model for the painterly dissolution of form seen in many passages, and for an intense, glowing color which in places Michałovski takes to extremes.

This lends an incredible dynamism to the cavalry battle raging in the foreground and in the lower third of the composition, with the figures arranged in an arc in front of a background landscape obscured by gunsmoke. The true protagonists here seem to be elemental natural forces, of which the men and horses are mere embodiments. The fateful character of the mostly monumental depictions of the Napoleonic Wars is combined in this small painting with the sketchy style familiar from French Romanticism to produce a pathos worthy of Delacroix. And like Delacroix, instead of emphasizing the presence of the great individual Michałovski merges anonymous men into dramatic groupings evocative of the forces of history.

KÀROLY MARKÒ The Elder
1791–1860

A Hungarian landscape painter, Markò moved to Italy at the age of forty-one and remained there to the end of his life. His contemporaries called him the "Hungarian Claude", because his compositions were strongly influenced by the seventeenth-century landscapes of Claude Lorrain. These of course were a key stimulus not only for Markó but for the development of landscape painting throughout Europe during the Romantic Era.

The present painting, too, with its biblical theme and figures, its bridge, rocks, and dominant central group of trees, recalls Claude. But Markò heightens the drama of the illumination and the expressiveness of the rock formations, shaping the long, cast shadows and contours of the rocks and trees against the sky into an effective, complex pattern. And unlike the roads or paths in Claude's work, the broad road here leads over a bridge and back into the perspective depths of the picture – an emphasis on depth quite different from Claude's layerings parallel to the picture plane, and a favorite device of Romantic painting. This feature underscores the Romantic traits of the composition, whose religious subject may well have been inspired by the German Nazarenes.

Kàroly Markò the Elder
Landscape with the Walk to Emmaus, 1845
Oil on canvas, 138 x 200 cm
Milan, Civica Galleria d'Arte Moderna

JENS JUEL
1745–1802

Juel's stay in Geneva from 1777 to 1779 proved particularly important in this regard, because it brought him into the circle around the natural philosopher Charles Bonnet, a follower of Rousseau. His turn to landscape painting at the time was likely largely inspired by Rousseau's philosophy and the views of his host. His *View over the Lesser Belt* exemplifies a certain neoclassical precision of drawing and a crystalline light that would remain characteristic of Juel's art. The small figures in the foreground are not involved in any plot or story, but serve as accessories to emphasize key compositional axes of the landscape. Instead of creating an effect of depth by means of a continual perspective transition, the artist uses separate layers or planes parallel to the picture plane, arranged one behind the other. The motif, rather than appearing fixed within the bounds of the frame, seems virtually to continue beyond it into infinity. Though this feature, combined with the other compositional elements, may not evoke the metaphysical boundlessness seen, for instance, in Caspar David Friedrich's *Monk by the Sea* (ill. p. 39), it does expand the landscape into a medium to convey emotion and mood, a harbinger of Romanticism. Otherwise, the sharp-focus description of objects in Juel's work in a way recalls the somewhat later landscapes of the German artist Wilhelm von Kobell.

Jens Juel
View over the Lesser Belt, c. 1800
Oil on canvas, 42.3 x 62.5 cm
Copenhagen, Thorvaldsens Museum

CHRISTEN SCHJELLERUP KØBKE
1810–1848

Købke, a pupil of Eckersberg, belonged to a young generation of Danish artists who strove for an original style by turning to the landscapes of their homeland. For them, the quiet, undramatic scenery of Denmark was every bit as interesting as the famous views of Italy or sublime landscapes in the Ossianic mode. Købke in particular concentrated on the serene surroundings of villages and towns, the clarity of their colors and light, and the simple lives of their inhabitants.

That the *Seacoast near Dosseringen* represents a Danish scene is emphasized by the national flag which, placed slightly off the central axis, forms the dominant vertical in the composition. The flagpole also marks the end of a pier that juts into the picture from the left as the dominant horizontal. On it stand two women clad in traditional costume, looking out over the sea to a rowboat full of people approaching them. Unlike Caspar David Friedrich's figures, who gaze into the infinite distance, the focus of the women's gaze, like their entire environment, is near and familiar. In terms of basic mood, then, Købke's painting might best be compared to the art of the German Biedermeier period.

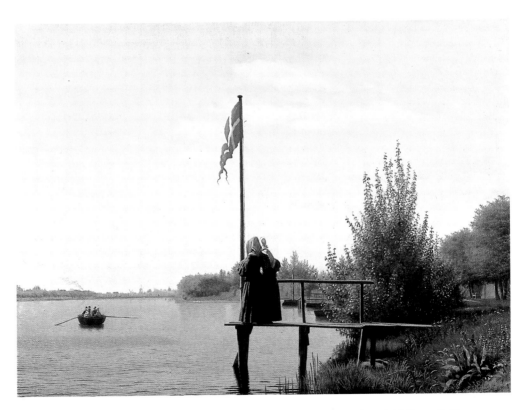

Christen Schjellerup Købke
Seacoast near Dosseringen, 1838
Oil on canvas, 53 x 71.5 cm
Copenhagen, Statens Museum for Kunst

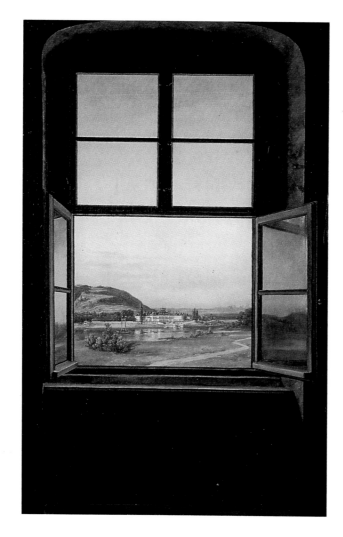

Johan Christian Clausen Dahl
View of Pillnitz Castle from a Window,
c. 1824
Oil on canvas, 70 x 45.5 cm
Essen, Museum Folkwang

JOHAN CHRISTIAN CLAUSEN DAHL

1788–1857

When with the aid of a travel grant from Prince Frederik of Denmark, the Norwegian artist Dahl went to Saxony, his first stop was Dresden. What was intended to be a temporary stay turned into a permanent one. Dahl married Emilie von Block, daughter of the director of the "Grünes Gewölbe" (Dresden museum), settled in the city on the Elbe, and became the friend of Caspar David Friedrich.

As a young student at the Dresden Academy his landscapes, marked by great fidelity to nature combined with a pervasive Romantic mood, caused a great sensation. As Ludwig Richter wrote, "The spring breeze of a new era began to show its effect, the old pedantry [Zopftum] was dying out."

Dahl's friendship with Friedrich and his concomitant close artistic ties are evident in his *View from a Window*, a motif that formed an independent category of Romantic art. The excerpt of the interior is plunged in complete darkness except for the window, whose open lower panes reveal a view of the pleasure seat Pillnitz on the Elbe, erected in the "Indian style" by Matthäus Daniel Pöppelmann at the beginning of the eighteenth century. Unlike the window pictures of Friedrich (ill. p. 10) or Carl Gustav Carus (ill. p. 49), Dahl's is dominated by the landscape outside, transmuted by mild, shimmering light and yet very naturalistically depicted all the same. The landscape is also reflected, in more subdued nuances, in the window panes.

Apart from the optical and physical effects that interested Dahl, the motif contains a strange refraction of reality in that it brings specific early Romantic values of mood into play – a sense of transience in and through nature, a melancholy feeling, a symbolism of human existence between the here and now and the world beyond.

Dahl's *View of Dresden*, painted for the Austrian attaché Count Colloredo, is observed from the same spot on the New Town side of the river where, about 90 years previously, the Italian artist Bernardo Bellotto stood to prepare his famous view in the Zwinger museum, which the Norwegian artist must have known.

By comparison to Bellotto's, Dahl's nocturnal depiction of the city has a great deal more poetic charm, as seen especially in the subtle treatment of the sky transmuted by silvery moonlight and its reflection in the water. A woman on the riverbank enjoying the lovely panorama recalls the lonely figures seen from the back in Friedrich's landscapes. Yet while these usually symbolize moments of aloneness, abandonment in face of infinity, Dahl disrupts the contemplative mood by depicting bustling life on the river, with horses being watered, women taking washing off a line in the foreground, and Augustus Bridge thronged with people, horses and carriages.

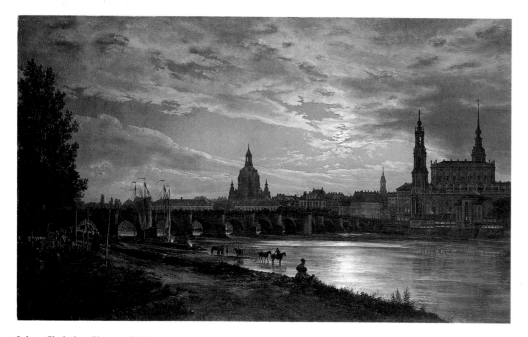

Johan Christian Clausen Dahl
View of Dresden in Full Moonlight, 1839
Oil on canvas, 78 x 130 cm
Dresden, Gemäldegalerie Neue Meister,
Staatliche Kunstsammlungen Dresden

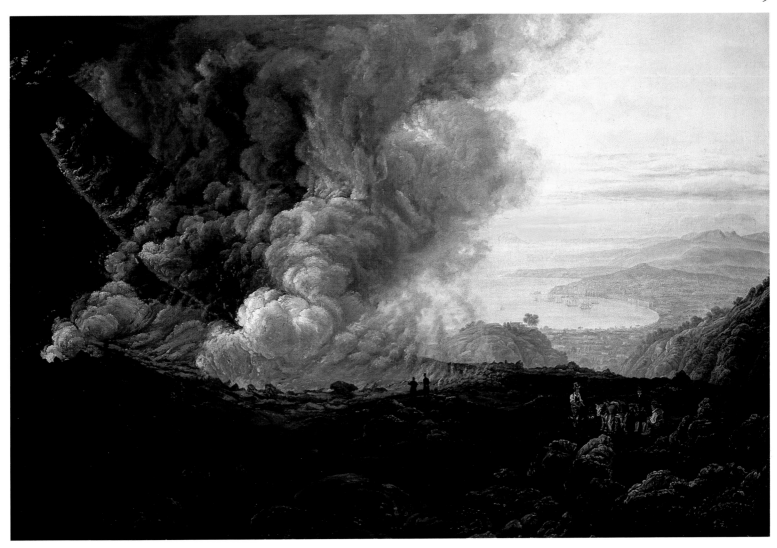

In 1820 Dahl made an Italian journey. Staying only briefly in Rome, where the weight of tradition oppressed him, he concentrated on Naples, where the natural scene revealed itself to him in all its multifarity of form and abundance of light. Dahl became completely engrossed in a study of color nuances and effects of illumination. He had little contact with the German artists working in Italy, meeting frequently only with Franz Catel, who may have introduced him to Turner's watercolor landscapes, which were exhibited in Rome in 1819.

Dahl looked upon the fresh, spontaneous studies he made in the environs of Naples solely as preliminary works for subsequent oils. When Mt. Vesuvius erupted in December 1820, he was among the first to climb the volcano in order to see and depict the phenomenon at first hand. The Oslo painting goes back to this experience. Already in the eighteenth century, depictions of Vesuvius erupting were among the most popular subjects of pictorial reportage, intended not only to satisfy a public thirst for sensations but to embody the aesthetic ideals of the sublime and picturesque.

As motif Dahl chose one of the flowing streams of lava and the emerging windblown flames and smoke clouds. The tiny figures of people observing the natural spectacle stand on the edge of the crater, as at the right, before a panorama of sea and bright sky, a herd of cattle indifferently grazes.

As the subject and approach indicate, Dahl did not seek stylized arcadias in the South but viewed the overwhelming forces of nature as picturesquely suspenseful and captured them as elemental experiences in paint. It is as if, like a second creator of the world, he had attempted to participate with his art in the generative forces of nature.

Dahl was certainly not a sober, scientific painter of the kind Carus had envisioned in his late letters on landscape painting. For that his painterly attack was too expressive and too suffused with atmospheric elements, too filled with pathos. On the other hand, his compositions were not the result of mere sentimental moods.

"Pictures like *Vesuvius...*," notes Christian Baur, "are Romantic paintings turned back right side up, as it were. Much in them has become more real, i.e. more tangible, heavier and nearer, just as the colors have combined into austere, mixed tones, and been condensed into a small number of main groups, juxtaposed to one another. All of this may seem realistic — yet the intent of these landscapes still remains Romantic: They are the manifestos of a brilliant creative artist and his urge to shape the world."

Johan Christian Clausen Dahl
Eruption of Vesuvius, before 1823
Oil on canvas, 93 x 138 cm
Oslo, Nasjonalgalleriet

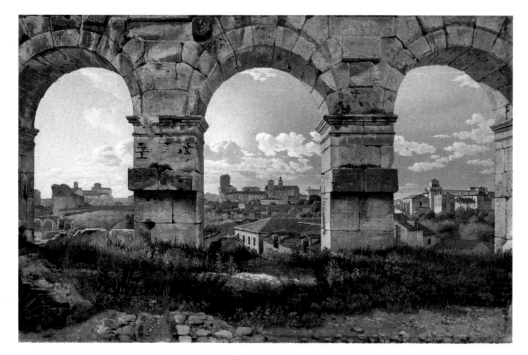

Christoffer Wilhelm Eckersberg
View through Three Northwest Arcades of the
Colosseum in Rome. Storm Gathering over the City, 1815
Oil on canvas, 32 x 49.5 cm
Copenhagen, Statens Museum for Kunst

CHRISTOFFER WILHELM ECKERSBERG
1783–1853

Though it may be only a ruin, the Colosseum, amphitheater of ancient Rome, unforgettably embodies the former glory of the Eternal City. Eckersberg has depicted only a small section of the edifice, three monumental masonry arches, which focus the eye on landmarks in the background.

Visible through the arch on the left is the Capitol, seat of the ancient Roman government and symbol of its dominion over the known world. In the middle aperture there appears, among other buildings, the Torre delle Milizie, a feudal tower from the thirteenth century that recalls the power wielded by medieval barons and their families. On the right, finally, is an early Christian church that was renovated during the Renaissance, San Pietro in Vincoli, which stands for the dominating role played by Roman ecclesiastical institutions in more recent eras.

Eckersberg's painting continues the centuries-long tradition of Roman *vedute*, or views, souvenirs of artists' travels which, whether freely composed or archaeologically accurate, combine a depiction of points of interest with an evocation of historical grandeur. The present example, with its precise architectural rendering, calm composition based on planes parallel to the picture plane, and uniformly bright illumination, contains no hint of pathos. Only the signs of a storm gathering in the distance anticipate a certain portentous Romantic symbolism.

This depiction of a girl from the back, her hips draped in the elaborate folds of a white cloth, has a serene, sculptural form and *contrapposto* pose that recall a classical statue. In contrast, the gesture of putting up her hair and the view of the model's face in soft, half shadow in the mirror evoke a mood of almost Romantic musing. Strongly modelled volumes are confronted with a painterly picture-within-the-picture as if to exemplify the expressive possibilities of sculpture and painting, which are brought into a harmonious balance with a concentration that recalls that of still life.

Eckersberg's training included studies with Jacques-Louis David in Paris from 1811 to 1813, and while in Rome from 1813 to 1816, he maintained close contacts with the Danish sculptor Berthel Thorvaldsen. Thus his style was shaped by the international neoclassicism of the period. Yet after his return to Copenhagen in 1817, his usually poetically heightened paintings, of which the present one is an outstanding example, contributed materially to the emergence of Romantic painting in Denmark. Eckersberg's rank in Danish painting is comparable to that of Ingres' in France.

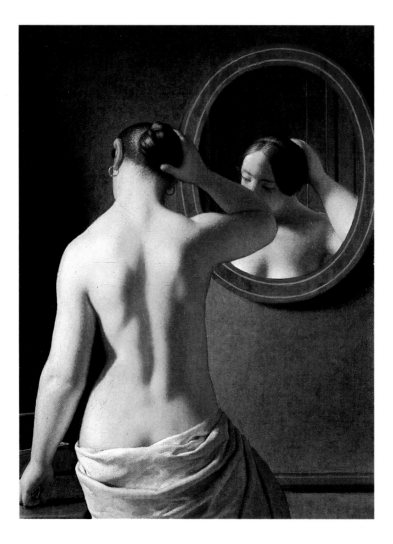

Christoffer Wilhem Eckersberg
Nude (Morning Toilette),
c. 1837
Oil on canvas, 32 x 25 cm
Copenhagen, Den
Hirschsprungske Samling

THOMAS FEARNLEY
1802–1842

After attending the Copenhagen and Stock-holm academies, Fearnley, a Norwegian of English family origin, became a pupil of Dahl in Dresden, where the work of Caspar David Friedrich also made a great impression on him. His outstanding painterly qualities are especially evident in his numerous, loosely rendered oil studies from nature, which include this depiction of a *Northern Region*.

Similar renderings by Dahl of the wild and sublime natural scene in Norway, as Ludwig Richter reports in his memoirs, caused an enormous sensation in Dresden. They made him one of the pioneers of a type of landscape in which Romantic and realistic elements were combined. Dahl's achievements encouraged German artists to go to Norway and Sweden, and Scandinavian artists to come to Germany. Of these, probably the most gifted was Fearnley, who with his panache and dramatic heightening of Nordic motifs soon began to represent serious competition for his mentor, Dahl.

In the present work, a heavily clouded sky hangs over a rough, forbidding landscape. A lonely hunter and his dog climb a slope at the top of which, in front of a boulder, an old, almost bare oak extends its branches into the gloomy sky.

Fearnley possessed an unusual sense of color, which from the 1830s onwards may well have been partly inspired by the landscapes of Constable and Turner. This was just as much in evidence in his local motifs as in the oil studies made during an Italian journey in 1831–1835. His interest concentrated on southern Italy, and especially, as in Dahl's case, on the environs of Naples.

In *Moonlight in Amalfi*, a lone woman at a balustrade has just risen from her chair to look over the sea toward ruins on the foothills to the left. This is a profoundly Romantic motif, and it is underscored by the soft, harmonious palette. The moon, obscured by a canvas awning, suffuses the terrace with a mysterious, transmuting light, whose warm golden orange stands in complementary relationship to the luminous blue of the water.

A Romantic love of home and a nostalgia for Italy are, as it were, married here. As Fearnley noted in a letter to Dahl in 1836, "I consider this journey merely a study trip, in order once again to enter into the nature of our homeland and to collect the necessary material to paint that to which I am attached with love, although the milder Italian climate and the free life have a magnetic effect on me: I would like to live in Italy in a material sense, occupy my imagination with the proud, earnest character traits of the North, and paint our raw, stormy autumn days...."

Thomas Fearnley
Northern Region, 1829
Oil on cardboard, 19.8 x 28.5 cm
Dresden, Gemäldegalerie Neue Meister,
Staatliche Kunstsammlungen Dresden

Thomas Fearnley
Moonlight in Amalfi, 1834
Oil on cardboard, 25.5 x 29.5 cm
Oslo, Nasjonalgalleriet

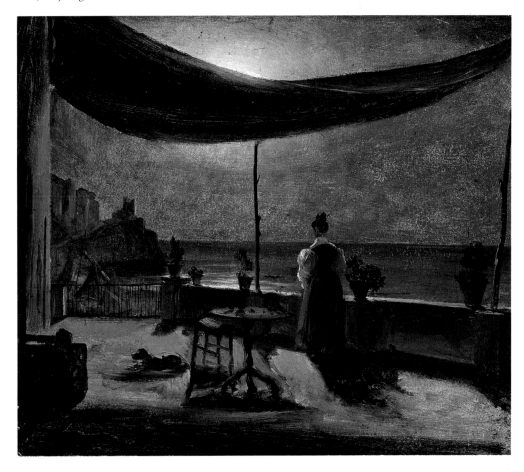

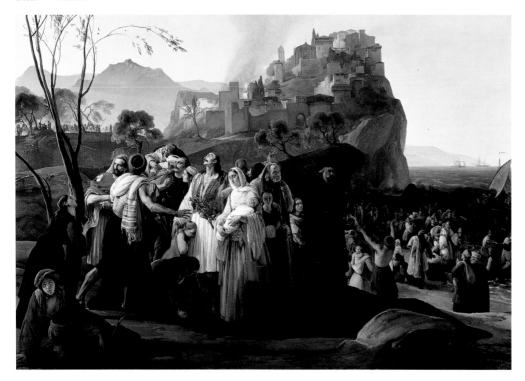

Francesco Hayez
The Refugees of Parga, 1828–1831
Oil on canvas, approx. 200 x 290 cm
Brescia, Pinacoteca Tosio Martinengo

FRANCESCO HAYEZ
1791–1882

Hayez is the best-known representative of Romantic classicism in Italy. With the *Refugees of Parga* he, like Delacroix before him, treated a subject from the Greek wars of liberation against the Ottoman Turks, and the result was highly acclaimed by his countrymen.

The two female figures in the left foreground, one cowering on the ground and the other leaning in a pose of desperation against an almost leafless tree, lead the eye to the main motif, a group of figures clad in picturesque local costumes. From there our gaze is directed diagonally upwards to a city built like an eagle's nest on a cliff over the sea. The houses are stacked like building blocks next to and over one another, angularly silhouetted against the light sky. Though the surf rolling in from the right was probably intended to introduce a suggestion of motion, it has a strangely static appearance.

The poses of the people being driven from their refuge in mountain caves have a classical nobility. Eschewing sensationalism, the artist translates the event into epic terms rather than attempting a detailed reportage. Even though the viewer's empathy may be appealed to through the protagonists' saddened or angry gazes, furrowed foreheads or sparing gestures, the overall effect of the painting is ultimately too calculated to convey true concern, let alone deep emotion.

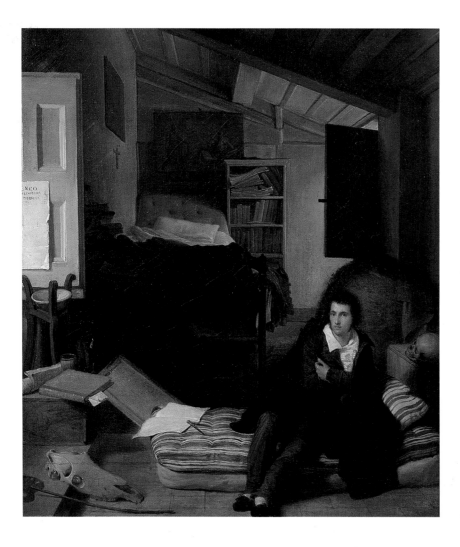

Tommaso Minardi
Self-Portrait, 1807
Oil on canvas, 37 x 33 cm
Florence, Galleria d'Arte Moderna

TOMMASO MINARDI
1787–1871

The brilliant early work of Minardi combines merciless realism with that profound suffering at the state of the world which was so characteristic of Romantic art.

In his *Self-Portrait*, the artist depicts himself sitting on a mattress, wrapped in his coat, in a humble but tidy room. The oblique wooden ceiling of the mansard room forms the strongest diagonal accent in a composition that is otherwise determined by a quiet contrast of horizontals and verticals. On the back wall of the room there is a full bookcase, and books are piled on the desk at the left. A number of other everyday things are distributed picturesquely around the room.

Light falls into the interior from two windows on opposite walls whose shutters open into the room. A death's head and animal skull underscore the melancholy mood of the as yet unrecognized, starving genius. The motif would later be treated by Carl Spitzweg (ill. p. 67) with an ironic, eccentric twist. Minardi himself subsequently adopted the style of the German Nazarenes.

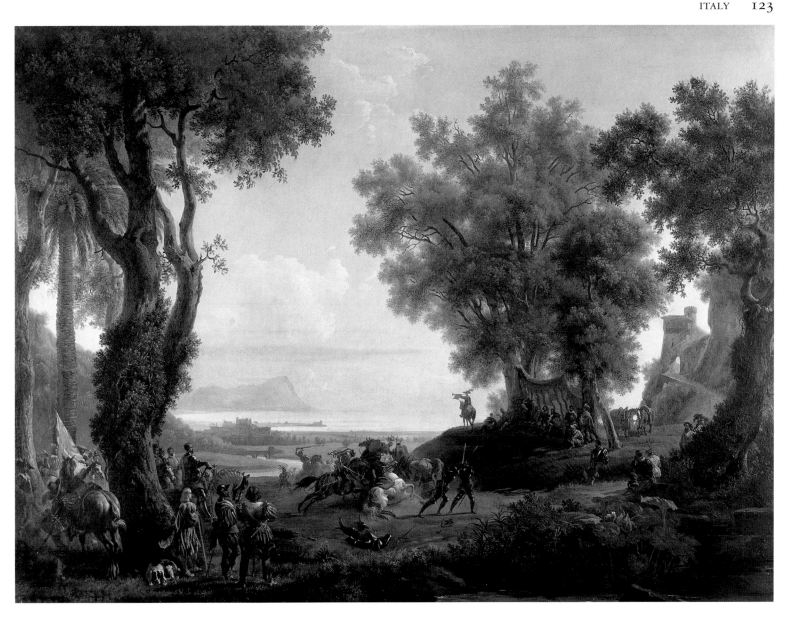

MASSIMO D'AZEGLIO

1798–1866

D'Azeglio was an Italian statesman, author, and painter of Romantic landscapes who favored moonlight scenes and Greek and Oriental subjects. In addition he produced hunting and battle pictures as well as illustrations to Ariosto, Tasso, and Shakespeare.

The *Battle of Barletta* is the best known of his few large-format works, and it inspired numerous copies and imitations. The picture shows an episode related by the Florentine Renaissance historian Guicciardini, which took place on 13 February 1504 during the French campaign in Italy. In Barletta, a town in Apulia, before a tribunal depicted here at the right under a baldachin, twenty-six French and Italian knights held a duel that ended in victory for the Italians under Condottiere Ettore Fieramosca.

In other words, this is a patriotic scene of the type that was so popular among Romantic artists. In this respect d'Azeglio can be compared with the English artist Charles Lock Eastlake in his *Champion* (ill. p. 84) or the German Nazarene, Franz Pforr, in his *Entry of Emperor Rudolf of Habsburg into Basel* (ill. p. 53). Yet since Azeglio had no first-hand knowledge

of Apulia, he reinvented the region around Barletta with Monte Gargano in the background based on a painting by Claude Lorrain. As he was working on the canvas, Azeglio reports, he realized the literary potential of the subject as well. In Milan he began writing a two-volume historical novel, *Ettore Fieramosca o la disfida di Barletta*.

The subjective experience conveyed by d'Azeglio's picture ultimately goes back to an emotionalization of events, historical and otherwise, that began in the late eighteenth century. In Germany, this was described as "Einfühlung", or empathy, by Johann Gottfried Herder. Spurred by an increasingly enlightened historiography, this attitude grew ever more widespread during the Romantic period. Especially in poetry and prose, historical subjects were dramatized, treated in the form of epics or ballads or novelistic narratives.

The narrative painting of the day followed the same path. It increasingly relied on the then-emerging historical novel, telling a story in much the same way. All of these developments reflected an deep-felt need to re-experience the past, including its emotional values. D'Azeglio, history painter and storyteller in one, is a prime example of this significant current within European Romanticism.

Massimo d'Azeglio
The Battle of Barletta, 1831 (?)
Oil on canvas, 118 x 164 cm
Milan, Collezione Porro Schiaffinati

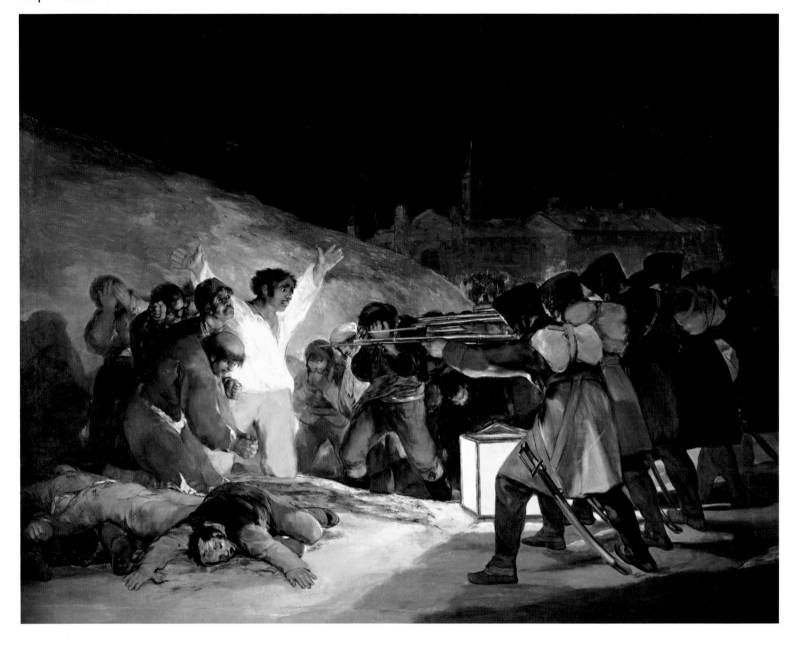

Francisco de Goya
Execution of the Rebels of 3 May 1808, 1814 (?)
Oil on canvas, 265 x 345 cm
Madrid, Museo Nacional del Prado

FRANCISCO DE GOYA
1746–1828

The Execution of the Rebels of 3 May 1808 is one of Goya's most famous paintings. It represents the shooting of Spanish patriots who had attacked French occupation troops in Madrid on the preceding day.

At the right of the large-format composition, the firing squad is depicted as a group of faceless, anonymous figures seen from behind. Standing in a perfectly straight rank, as if welded into a blind machine of destruction, a uniform mass, the soldiers lower their rifles to aim at close range at their victims, who await the fatal salvo. Visible in the middle ground are other condemned men being led to the place of execution. The diagonally sloping mound of earth and the buildings of Madrid with city gate stand out against an oppressively dark night sky. The only visible source of illumination in the picture, the large lantern at the French soldiers' feet, casts a garish light on the figure of a peasant in a white shirt. Together with his raised arms – a gesture of resistance that simultaneously exposes his chest to

the bullet – this dramatic lighting makes him the compositional center of interest and meaning. The other rebels, including a trembling monk murmuring a prayer for the dead, are depicted in various stages of despair, from dull submission to sheer terror. In the left foreground, executed men lie in pools of blood.

This red is the only unbroken color in a scene pervaded by subdued tones. Though the gloom reflects the early morning hour at which the executions actually took place, its principal effect is symbolic. Even more frighteningly than in Delacroix's later *Massacre of Chios* (ill. p. 105), this darkness seems to convey the blackest side of human nature.

Goya, one of the most significant artists of all time, cannot be strictly classified in terms of style. Still, his œuvre does contain the key elements of that transitional epoch around the year 1800, neoclassicist, realistic, and indeed romantic, as seen in his painterly approach, a predilection for fantastically heightened shock-effects, and a visionary sense of the unreal that always lurks just beneath the real. Yet in terms of the existential power of its statements and its aesthetic qualities, Goya's work far surpasses all of these currents.

EUGENIO LUCAS Y PADILLA

1824–1870

From June 1808 to 11 February 1809, the Spanish city of Saragossa under General José de Palafox y Melzi mounted heroic resistance to a siege by Napoleon's troops, surrendering only after over half of its inhabitants and defenders had fallen. Scenes from this bloody struggle were depicted in many pictures and leaflets of the day, as well as in numbers of works later in the nineteenth century.

Padilla shows an event taking place on the bastions in which only civilians, including many women, are involved. Darkly silhouetted in the foreground is a man gripping his rifle and preparing to attack, while a woman, turned away from us, tries desperately to stop him. Behind this pair the composition culminates in a group of three figures, picked out as if by a harsh spotlight: a boy angrily brandishing his gun and two priests raising their crucifixes into a night sky ominously illuminated by distant conflagrations.

The important part played by women in Padilla's painting may seem surprising, but this circumstance reflects an attitude that was widespread in Western and Southern Europe around 1800. The terrors of the French Revolution and the Spanish War of Liberation had not only largely expunged the difference between soldiers and civilians, but had levelled that between the sexes as well. Goya in particular addressed this circumstance in many of his graphic works and showed the courage, and the occasional cruelty, of which women were capable in war.

The handling of lighting effects, the painterly treatment of details, and the background figures welded into an anonymous mass, all indicate the overwhelming influence of Goya, which extended to Padilla's entire œuvre. Yet despite great efforts, Padilla never managed to achieve either Goya's skill or his well-nigh nihilistic transgression of thematic limitations, as seen for instance in the *Execution of the Rebels*.

Eugenio Lucas y Padilla
The Defence of Saragossa, 1850–1855
Oil on canvas, 73 x 106 cm
Cologne, Wallraf-Richartz-Museum

Jenaro Pérez Villaamil
Herd of Cattle Resting on a Riverbank in Front
of a Castle, 1837
Oil on canvas, 90 x 114 cm
Madrid, Museo Nacional del Prado

JENARO PÉREZ VILLAAMIL
1807–1854

In the foreground of this painting, which bears
affinities with both English and German Ro-
manticism, a group of steers rests peacefully as
they are watched over by two cowherds in the
distance, at the left edge of the picture. Two
boats filled with people are just pushing off
from the left bank of the river and the large
farm buildings there. Behind them, on a
wooded slope, lies an imposing castle, many-
towered and divided into several separate
wings, an ideal image of the Spanish manor.
The topmost parts of this fortification seem al-
most to dissolve in the delicately hued sky that
extends across the plane and forms an effective
contrast to the river valley below and its
stronger color gradations.

Such sensitively formulated passages and
the overall picturesque effect clearly point to
the seminal influence of English Romantic
landscape (William Turner, John Martin), to
which the Spanish artist remained faithful
throughout his career, and which he brilliantly
translated into a uniquely personal style.

A good part of the painting's charm derives
from the contrast between the humble rural
scenery and the monumental castle, a typically
Romantic juxtaposition of transitory historical
monument and everlasting nature.

Mariano Fortuny y Carbó Marsal
Fantasy on "Faust", 1866
Oil on canvas, 40 x 69 cm
Madrid, Museo Nacional del Prado

MARIANO FORTUNY Y CARBÓ MARSAL
1838–1874

In a scene that has the effect of being inter-
mediate between reality and dream, the Span-
ish piano virtuoso Juan Bautista Pujol
(1835–1898) is shown performing his ima-
ginative improvisations on Gounod's *Faust*.
At the right, in an enclosed interior rendered
in great detail, his artist-friends Lorenzo
Casanova (1845–1900) and Agapito Francés
(d. 1869) listen attentively, deeply moved by
the music.

An aspect of Romanticism comes into the
picture at the left, where the theme of the pi-
ano improvisations takes material shape – the
visionary apparition of an illuminated cloud
entering the room, rendered in amorphous,
nervous brushwork and encompassing the hov-
ering, phantom figures of Mephisto, Martha,
Faust, and Gretchen. In these passages, aug-
mented by the surreal theme, the depiction al-
most approaches the character of modern ab-
stract painting. As regards content, Fortuny's
composition relies on a device known as the
"empty space," commonly employed in nine-
teenth-century European painting – passages
purposely left indeterminate in order to stimu-
late the viewer's imagination.

Fortuny's painting represents an attempt to
visually express the close affinity among Ro-
mantic painting, poetry and music, and relies
on the motif of religious visions as treated in
Spanish Baroque art.

THOMAS COLE
1801–1848

Prompted by the picture's title, one might well imagine oneself gazing with a giant's eyes over an infinite expanse of mountains, high plateaus, and ocean bays that diminishes into the distance and virtually continues beyond the picture edges, with a seaside town lost, like a tiny anthill, in the grandiose wilderness panorama.

The compositional structure might recall earlier universal landscapes, were it not for a disturbing factor. On a rocky plateau projecting into the picture like a crossbar rises a huge stone chalice whose shaft consists of a gigantic primordial tree and whose base and rim are overgrown with forests interspersed with ancient settlements. The chalice is filled with water that serves tiny sailboats as a landlocked sea. It creates the impression of being a relic of the age of titans, who, according to Greek myth, populated the earth before men and gods.

The trick here is the employment of the Gulliver principle. What appears to tiny humans to be an entire boundless world is to the imaginary giant, the titan, merely an excerpt from it. Instead of Gulliver one might think of the novella *Micromegas* by Voltaire. Published in 1752, it describes the journey of an inhabitant of Sirius through the universe and his experiencing of himself as alternately enormously huge and infinitesimally small, a total relativizing of dimensions, depending on what star he happens to be visiting. The fantastic quality of Cole's image, its play with levels of reality, would much later be appreciated by the Surrealists.

Founder of the Hudson River School, Cole in 1836 published an essay in the *American Monthly Magazine* in which he extolled the American wilderness as an expression of Divine Creation. To depict it he recurred to the idealized composition and illumination of Claude Lorrain's seventeenth-century landscapes. In addition, Cole placed great store in the cyclical arrangement of pictures, sequences in which a tragic light is cast on man's role in history. "The space of redemption, the paradisal garden," as M. Christadler notes, "is no longer a mythological object of actual longings for salvation. It has declined to mere fantasy, to an emblem of the unreal."

In the present painting, the idea of youth is linked to the sunny optimism of the summer season. A young man, his arm emphatically raised, steers a boat accompanied by angels along a river symbolizing his life's path. An architectural vision in the sky, a castle in the air that might have come from the *Arabian Nights*, embodies his dreams and expectations. The fertile landscape around the young man becomes a synonym for a longing for redemption, the necessity of which is illustrated by the three other scenes in the painting sequence. The cycle, of which Cole executed two versions and which was originally commissioned by a deeply pious banker, rests on a key idea of European Romanticism – the dream of travelling to distant, uncharted regions, be they geographic or, as here, more mental and spiritual in nature.

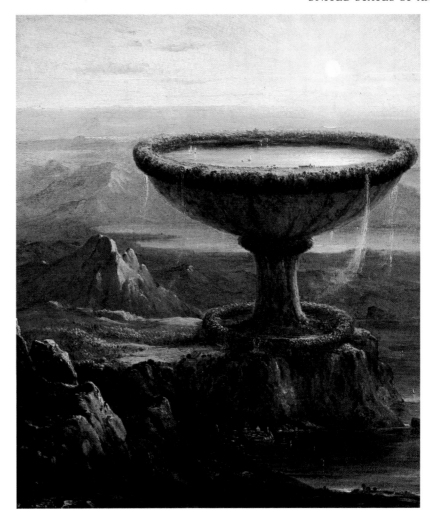

Thomas Cole
The Giant's
Chalice, 1833
Oil on canvas,
49.3 x 41 cm
New York,
The Metropolitan
Museum of Art

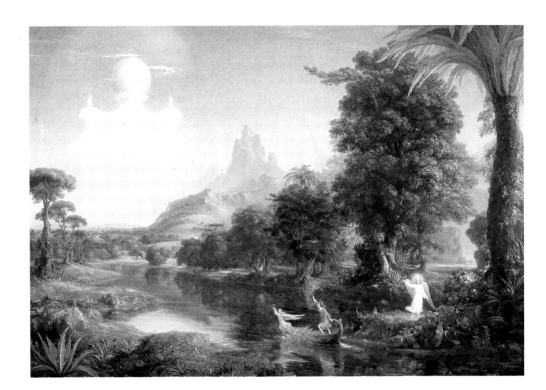

Thomas Cole
The Ages of Life: Youth, 1842
Oil on canvas, 134 x 194.9 cm
Washington (DC), National Gallery of Art

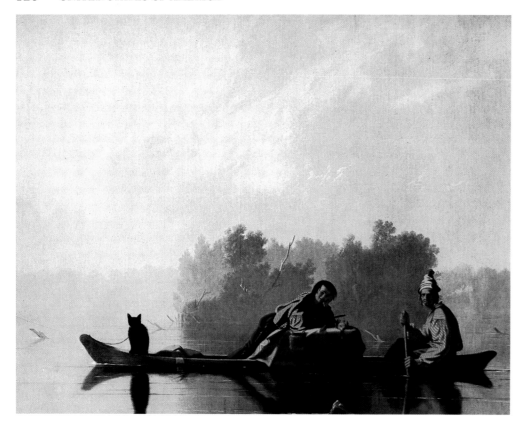

George Caleb Bingham
Fur Traders Descending the Missouri, 1845
Oil on canvas, 73.5 x 93 cm
New York, The Metropolitan Museum of Art

GEORGE CALEB BINGHAM
1811–1879

At the same time as a number of American painters were exploring the still unspoiled wilderness of the western frontier, another group were devoting themselves to genrelike depictions of everyday life in the new nation's towns and countryside.

In his *Fur Traders Descending the Missouri*, Bingham depicts what was already a nostalgic memory of the world of hunters and trappers, as also described in James Fenimore Cooper's *Leatherstocking* novels from 1823 onwards. By the date of Bingham's painting the fur trade had long been dominated by large companies that shipped their commodities by steamer and barge. Here, a father and son are still shown bringing pelts from animals they themselves have trapped to the nearest trading post in a primitive dugout canoe. In a subtly balanced composition and with great sensitivity for atmospheric values, the boat lying in shadow – with a sharply silhouetted cat in the bow providing a marked accent – is confronted with a misty river landscape and a pastel-hued expanse of sky. The considered distribution of compositional emphases and the profound calm pervading the picture lend it a quality far surpassing conventional genre painting. At the same time, the natural scene is redolent with a melancholy mood that can justifiably be termed Romantic.

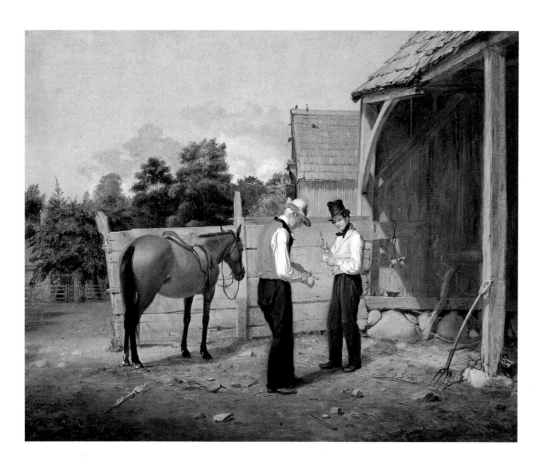

William Sidney Mount
The Horse Trade, 1835
Oil on canvas, 61 x 76 cm
New York, The New York Historical Society

WILLIAM SIDNEY MOUNT
1807–1868

Mount was one of the most important representatives of rural genre painting in the United States in the nineteenth century. In the painting shown here he has given a straightforward record of an everyday scene, two men quietly negotating the sale of a brown horse, which stands quite unconcerned to the left, in front of a high wooden fence. In accordance with local custom the men are whittling sticks, and will continue to do so until they have reached agreement.

In the background is a view of the artist's own farm in Stony Brook, a small town on Long Island. It is rendered with the same attention to detail devoted to everything in the picture, whether inanimate things or animals, people, or the natural environment suffused with summer light.

Mount obstinately resisted recommendations, of which there were not a few, to develop his art by studying in Europe. His work nonetheless evinces a number of affinities with contemporaneous European painting. It is no coincidence that many of his compositions are strongly reminiscent of German Biedermeier, since he apparently had access to reproductions from which he derived certain motifs and stylistic idiosyncracies, then translated these into original terms suited to American subjects.

GEORGE LORING BROWN

1814–1889

The *Italian Scenery*, painted in Florence, is one of the finest and most typical examples of Brown's art. It unites in a very personal way elements of classicism and Romanticism, and indicates how important the model of Claude Lorrain was for a certain branch of American landscape painting in the nineteenth century.

Observed from a distance the impression is dominated by the brilliance of the sunny sky, but the closer we approach to the canvas, the more clearly evident become the dynamic structures of an impasto paint application. The motif of a wilderness area enclosed by soaring mountains is an imaginative invention on the artist's part. The illusion of space is overemphasized in every respect, the cliffs at the right, for instance, rising to improbable heights, an impression further underscored by the miniscule temple ruin on an outcrop.

Towards the front, a strongly foreshortened perspective leads the spectator's gaze to the shore of a lake, where the tiny figures of hunters appear. Behind them a landscape opens out with suggestions of primitive buildings. This effect of a paradisal wilderness could easily be transferred from European to American landscape motifs and their claim to sublime beauty.

George Loring Brown
Italian Scenery, 1846
Oil on canvas, 103.8 x 137.6 cm
Washington, DC, Smithsonian Institution, National Museum of American Art, Museum Purchase / Victor D. Spark

WILLIAM LOUIS SONNTAG

1822–1900

After growing up in Cincinnati, Sonntag went to Italy for several extended stays, and subsequently painted a small number of landscapes whose motifs reflected this experience.

His *Classical Italian Landscape* has a strangely visionary appearance, due to its combination of a spacious, paradisal landscape vista with a strongly illusionistic rendering in intense, cool colors. The impasto paint is applied in short, energetic strokes. Light impinges from the left on the landscape with its Mediterranean vegetation and, at the right, a depiction of the Temple of Venus – the only actual Italian motif in the scene. Visible in the background are a few unidentifiable ruins.

At the beginning of his career Sonntag collaborated on a panorama devoted to the theme of *Paradise Lost and Regained*. There, ruins in the lonely landscape alluded to transience, and tiny figures to the insignificance of man. Something of this panorama effect and the work's romantic, phantasmagorical mood reappear in the present painting, as realistic, indeed hyperrealistic the treatment of details may be. It was precisely this manner in which American artists depicted the landscapes of their own country, consciously infusing untouched wildnernesses with an aspect of nature religion.

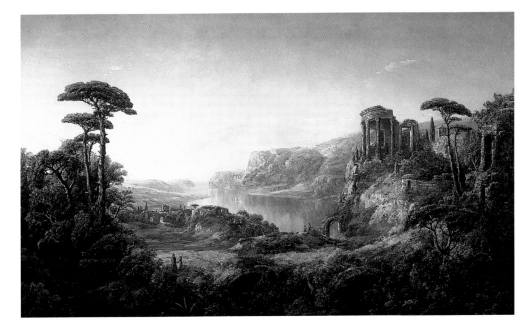

William Louis Sonntag
Classical Italian Landscape with Temple of Venus, c. 1858
Oil on canvas, 91 x 150 cm
Washington (DC), Collection of The Corcoran Gallery of Art, Gift of Charles A. Munn and Victor G. Fischer in Memory of Orson D. Munn 12.1.

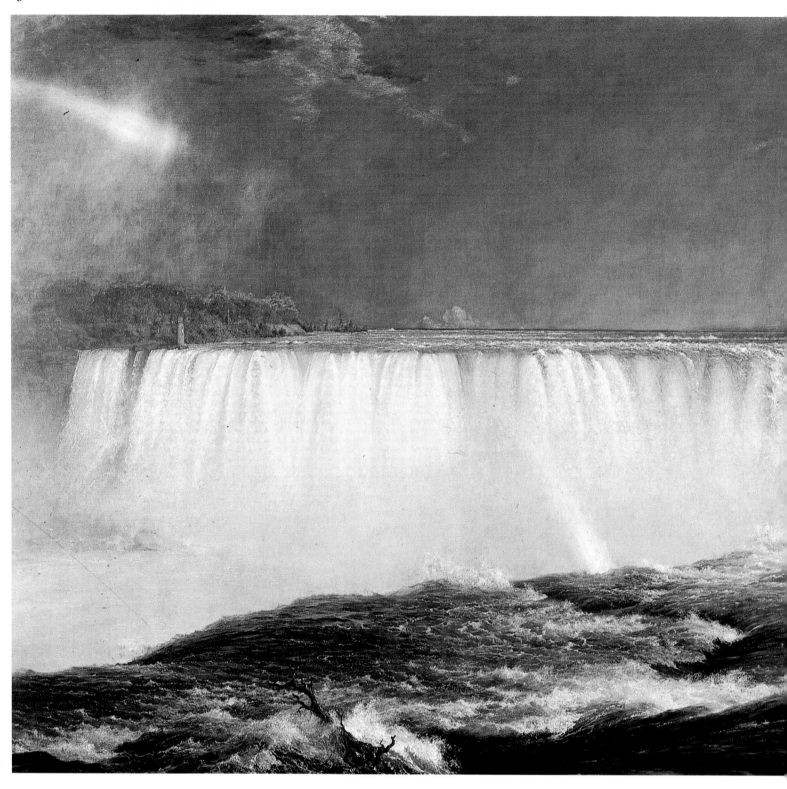

FREDERIC EDWIN CHURCH

1826–1900

In both the painting and the literature of the period, the American landscape was frequently seen as being closer to the origins of Creation and as better embodying the symbolism of divine salvation than that of other countries. In view of the ensuing environmental destruction, compressed into the space of only a few decades, these notions soon had to be revised. Yet such artists as Church and Albert Bierstadt, in landscape compositions of the 1850s and 1860s, obstinately continued to produce what M. Christadler has termed "heroically symbolic cosmogonies and operas in space."

The American landscape was increasingly viewed in a nostalgic light, with a yearning look back to the days of the Pilgrim Fathers and pioneers; or ever more obvious attempts were made to salvage its sacred connotations for American viewers. This is the context in which Church's depiction of Niagara Falls should be seen.

With this painting Church, a pupil of Thomas Cole (ill. p. 127), created one of the icons of American art, described by the critics as a symbol of the young nation. The extremely wide horizontal format, the horseshoe-shaped course of the masses of water roaring over the falls and confronting the viewer face on, and the horizontal strip of landscape running across the entire background of the picture, combine to produce the monumental effect of a gigantic panorama.

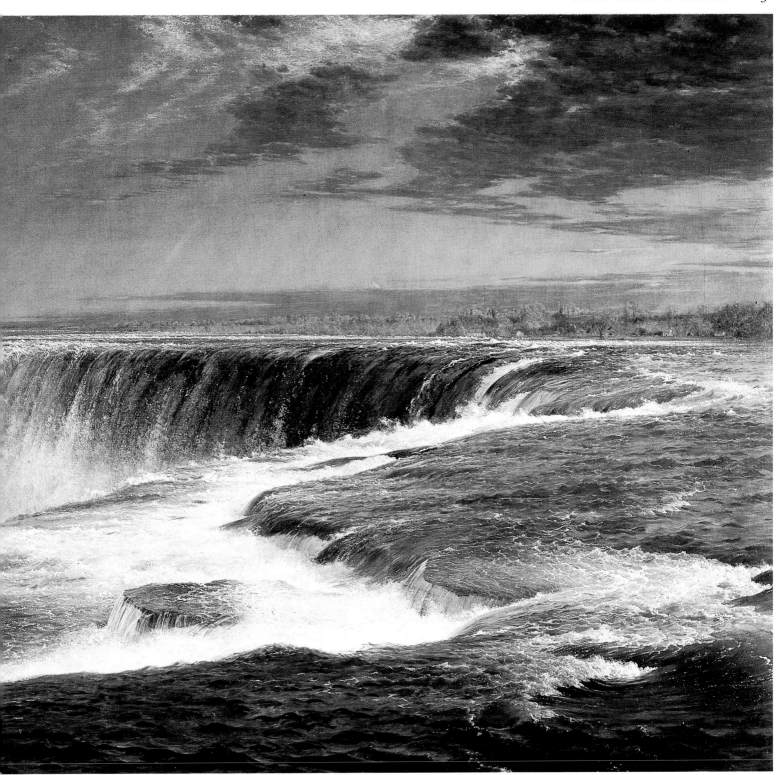

Remarkable are the delicate and, in many passages, diaphanous plays of color, which contribute to atmospheric transparency and stand in conscious contrast to the massive tectonics of the geological formations and the dynamic force of the element of water. One senses how intensively Church devoted himself to studies from nature and to understanding the laws of optics, an effort that enabled him to treat this daunting subject with such realism and immediacy.

The natural wonder in an unspoiled and awesome landscape depicted from a high vantage point, takes on the aspect of a secular symbol of the political energy of a country and people who felt themselves called to redeem the world. The rainbow and the violet hue of the sky, shot through with astonishingly delicate gradations, seem to dissolve in the mist rising from the depths. The suggestion of the mysterious this conveys raises the image of nature, this "seat of God," to use the poet Thomas Moore's phrase of 1804, to a transcendent, symbolic level.

When it was exhibited in New York and London in 1857, the painting caused a great sensation and brought European recognition for the young art of the New World. The London *Times*, for instance, enthusiastically greeted the arrival of a "significant picture by an American landscape painter on an American theme."

Frederic Edwin Church
Niagara Falls, 1857
Oil on canvas, 108 x 229.9 cm
Washington (DC), The Corcoran Gallery of Art

ALBERT BIERSTADT

1830–1902

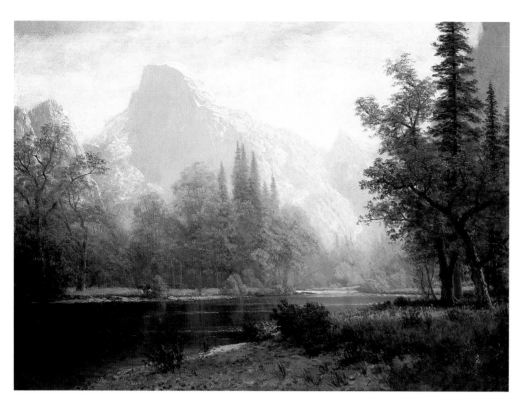

Albert Bierstadt
Half Dome, Yosemite, 1864
Oil on cardboard, 30 x 49 cm
Private collection

The American painters known as "Luminists," in visions of landscapes transformed by light, aimed above all at suffusing natural scenery with the symbolism of Christian salvation. The mystical effects of light were to serve as a sign of divine transcendence. The expanses of sky over broad horizons in their works were rendered in a range of scorching reds, yellows, and violets of an intensity which, despite Turner, was unknown in European painting.

Employing such means, the German-born Albert Bierstadt (who had studied for three years at the Düsseldorf-Academy) discovered the American West for art. Yet in spite of the sublime and romantically visionary character his prospects doubtless possess, the idealistic, religious connotations they were intended to convey remain no more than vague.

Half Dome, Yosemite was done as a preliminary study for a large-format work. As impressive as the area is in reality, Bierstadt exalts it to an almost mythical level and suffuses it with a visionary illumination that, admittedly, is not entirely free of a staginess that recalls the later technicolor productions of Hollywood. Still, Bierstadt's views, and the stereoscopic photographs of the Yosemite Mountains made by his two brothers, did contribute to the designation of the region as a national park. Apparently by this date the only way to salvage the romantically sublime was in a nature preserve.

In 1863, with the author Fritz Hugh Ludlow, Bierstadt undertook a great expedition to the Wild West that led them thousands of miles through the wilderness of Colorado, Wyoming, Utah, Nevada, California, and Oregon before the two went on to Panama and thence by ship back to New York. Bierstadt recorded his impressions of the journey in a number of paintings, including the *Storm in the Rocky Mountains*, a view of the Chicago Lakes Region southwest of Denver, Colorado.

In this monumental composition botanical, geological, and meteorological phenomena are depicted with superreal accuracy, while the dramatic light-dark contrasts and the great wall of clouds seem to transform the upper part of the scene and the background into an indeterminate and infinite primeval landscape suffused with a play of elemental forces.

The picture was exhibited in 1869 at the Paris Salon and the Munich International Art Exhibition, and in 1887 in London. It was a great success and contributed to Bierstadt's celebrity in Europe, which lasted for decades and has recently experienced a renascence.

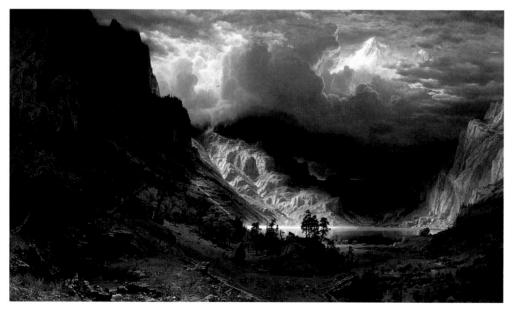

Albert Bierstadt
A Storm in the Rocky Mountains – Mt. Rosalio, 1866
Oil on canvas, 210.8 x 361.3 cm
Brooklyn (NY), The Brooklyn Museum of Art

BIOGRAPHIES OF THE ARTISTS

with a list of illustrations

ABELS Jacobus Theodorus

1803 Amsterdam – 1866 Abcoude
Abels received his first artistic
training from Jan van Ravenswaay.
In 1826 he travelled to Germany to
study, then was active in Hilversum
und The Hague. From 1828 he
worked in Baarn, from 1830–1848
again in The Hague, until 1857
in Haarlem, and until about 1865
in Arnhem. He married the daugh-
ter of Pieter Gerardus van Os, one
of several artists who often con-
tributed accessory figures to Abels's
works.

A member of the Amsterdam
Royal Academy, Abels concentrated
on summer landscapes, later also
producing cityscapes and – his forte
– idyllic moonlight landscapes in-
spired by Aert van der Neer. Most
in demand during his lifetime,
however, were his drawings and
watercolors.
Illustration:
113 Landscape in Moonlight,
 c. 1845

D'AZEGLIO Massimo

(actually Massimo Taparelli,
Marchese d'Azeglio)
1798 Turin – 1866 Turin
D'Azeglio trained with M. Ver-
stappen, a Flemish neoclassical
landscapist influenced by Claude
Lorrain, in Rome, where he lived in
1813 and from 1820 to 1830. Ini-
tial painterly landscape studies from
nature were followed by several
large-format canvases on historical
revival subjects, northern Italian
landscapes, and Alpine scenes.
While in Milan, d'Azeglio fre-
quented the circle of the author
Alessandro Manzoni, whose daugh-
ter he married.

His political activity led to a
high position in the Piemontese
government from 1849–1852, but
thereafter he returned to painting.
D'Azeglio's œuvre encompasses a
great diversity of modes, from *plein
air* landscapes to Romantic sub-
jects, from hunting and battle
themes to moonlight scenes, neo-
classical and oriental subjects, and
illustrations to Ariosto, Tasso und
Shakespeare.
Illustration:
123 The Battle of Barletta,
 1831 (?)

BIERSTADT Albert

1830 Solingen – 1902 New York
A year after Bierstadt's birth his
parents emigrated from Germany to
New Bedford, Massachusetts. In
1853 he embarked on three years of
study at the Düsseldorf Academy,

where, like a number of other
young American artists, he was in-
fluenced especially by the naturalis-
tic landscapes of Karl Friedrich
Lessing, Andreas Achenbach, and
Johann Wilhelm Schirmer. After
spending a winter in Italy, where he
presumably first saw works by
Claude Lorrain, Bierstadt returned
to New Bedford in 1857.

That same year he joined an ex-
pedition to Wyoming und Utah,
followed in 1863 by even more ex-
tensive travels through the Ameri-
can West. These experiences re-
sulted over the next few years in
large-format panorama views of
regions previously undiscovered
for art.

Bierstadt became the founder of
the Rocky Mountain School, a
branch of American landscape
painting that concentrated on ro-
mantically dramatized, sublime
motifs rendered in heightened col-
ors and striking illumination. After
1870 he lived for an extended pe-
riod in San Francisco. Further
Western travels followed, as well as,
from 1867 to 1891, six sojurns in
Europe, where Bierstadt devoted
himself especially to depictions of
Alpine landscapes.
Illustrations:
132 Half Dome, Yosemite, 1864
132 A Storm in the Rocky
 Mountains – Mt. Rosalio,
 1866

BINGHAM George Caleb

1811 Augusta County (Virginia) –
1879 Kansas City
Bingham grew up on a tobacco
farm in Franklin, on the Missouri
River. After an apprenticeship as
cabinetmaker and a brief study of a
theology and law, he attended the
Philadelphia Academy of Arts in
1837–1838. Returning to Missouri
in 1844, he began to paint scenes
from the everyday lives of farmers,
trappers, traders and raftsmen, as
well as genre pictures. Bingham's
fame as a recorder of the domestic
customs and traditions of the West-
ern States rapidly spread, especially

as a result of the wide distribution
of copper engravings made from his
drawings.

On a visit to Europe from 1856
to 1859, Bingham spent most of his
time in Paris and in Düsseldorf,
where he had contacts with the
German-American painter Emanuel
Leutze and the Düsseldorf School.
After returning to the United
States, he held political posts that
considerably restricted his artistic
activity.

Bingham once described his aim
as the depiction of "social and polit-
ical characteristics." Yet his lyrical,
delicately colored renderings of the
Missouri River region seem more
reminiscent of the early pioneer
days as commemorated by Mark
Twain.
Illustration:
128 Fur Traders Descending the
 Missouri, c. 1845

BLAKE William

1757 London – 1827 London
Blake, the son of a stocking weaver,
already had visionary experiences
in childhood which anticipated the
prophetic character of his singular
combination of visual art and
poetry. At the age of ten he received
drawing lessons from Henry Pars,
then was taught engraving by
James Basire, for whom he pro-
duced medievalist pictures. His
early works were influenced espe-
cially by Michelangelo, whose mon-
umental human figures were to
lastingly shape Blake's style. While

attending the Royal Academy (from
1778), he became embroiled in an
argument with Joshua Reynolds
about the relative importance of
color and drawing.

Blake took the classical view, and
his entire œuvre shows his disincli-
nation to use color for effect. In his
illustrations to the Bible, Dante
Allighieri, or his own writings, the
traditional relation between picture
and text was abandoned, and a sym-
bolic unity of word and image was
achieved which would not be
accepted until decades after Blake's
death.
Illustrations:
70 Hecate, c. 1795
70 The Fall of Man, 1807

BLECHEN Karl Eduard Ferdinand

1798 Cottbus – 1840 Berlin
Blechen was born in Cottbus as the
son of a tax official, and was ini-
tially employed in a bank in Berlin.
In 1822 he began art studies at the
Berlin Academy. An important
stimulus came from his acquain-
tance in Dresden with Caspar David
Friedrich and Johann Christian
Clausen Dahl, two artists who rep-
resented the poles that would char-
acterize Blechen's own œuvre: Ro-
manticism and Realism.

A journey to Italy in 1828–1829
proved decisive to his development.
The innumerable oil studies done
there showed him to be a *plein air*
painter with an affinity to William
Turner, who was also active in Italy
at the time, as well as to the French
painter Jean-Baptiste Camille
Corot, who had settled there. These
studies made Blechen the major
representative of early Realism in
Germany.

In subsequent years his Romantic
strain again came to the fore. In
pictures of an often somber mood,
he depicted humans on the brink of
disaster or just overtaken by it. Al-
though he was given a professorship
at the Berlin Academy in 1831, the
public recognition he so coveted re-
mained meager. The extreme sub-

jectivity of Blechen's work was too much out of tune with contemporary German painting. He became deeply depressive in 1835, and four years later was diagnosed as mentally deranged.
Illustrations:
62 Monks on the Gulf of Naples, c. 1829
62 The Gardens of the Villa d'Este, c. 1830
63 Devil's Bridge, c. 1830

BÖCKLIN Arnold
1827 Basel – 1901 San Domenico (near Fiesole, Italy)
In 1845 Böcklin went from Basel to Düsseldorf to study at the academy for three years under Johann Wilhelm Schirmer, a painter of heroic landscapes in the style of Claude Lorrain. Travelling by way of Geneva, Brussels and Paris, he arrived at Rome in 1850, and was thrilled and inspired by Greco-Roman art and the Italian landscape.

His friendship with Reinhold Begas, Anselm Feuerbach, H. Franz-Dreber and Hans von Marées, known as the "Deutschrömer" or "German Romans," proved decisive to Böcklin's development. Seven years later he returned via Basel to Germany, where in Munich he achieved his first success. Adolf Friedrich, Count von Schack, became his patron, and in 1859 King Ludwig I of Bavaria bought his picture *Pan in the Reeds* for the Neue Pinakothek. At this period his friendship with Franz von Lenbach began; a year later he became a professor at Weimar.

Böcklin had a penchant for symbolist themes full of pathos, mythological scenes set in fantastic landscapes, and allegories. Towards the end of his life his work became darkly visionary, almost apocalyptic. While criticized for an emotionalism that occasionally bordered on the comic, his supporters admired him fervently. He experimented with color and explored old and new techniques and materials,

including colored underpainting, and used a wide range of color values whose intensity deepened the mood of his themes.

A yearning for independence soon induced Böcklin to resign his Weimar post; he moved to Basel, then in 1871 back to Munich, then to Florence. In 1887 he went to Zurich for seven years before finally settling at San Domenico, where he died in 1901.
Illustration:
24 The Island of the Dead, 1883

BONINGTON Richard Parkes
1802 Arnold (near Nottingham) – 1828 London
Bonington came from a Nottingham family who left England in 1817 to settle in Calais. There the fifteen-year-old was taught the watercolor technique by Louis Francia. In 1818 Bonington went to Paris, where he met Eugène Delacroix and made watercolor copies of Dutch and Flemish landscapes in the Louvre.

In 1821–1822 he studied under Antoine-Jean Gros at the Ecole des Beaux-Arts, and in 1824 won a gold medal at the Paris Salon. He travelled all over France and especially Normandy, painting a number of atmospheric coastal and seaport scenes; he also went to England and Scotland, occasionally accompanied by his friend Eugène Delacroix, in whose studio he later worked. A journey to Italy in 1826 took Bonington to Venice, where he was deeply impressed by Veronese and Canaletto.

Bonington, like the painter and theoretician John Constable, was one of the English artists whose landscapes were highly regarded in France on account of their fresh and spontaneous composition. He was among the first artists in France to paint watercolors outdoors rather than in the studio. His approach to nature as well as his technique stimulated the Barbizon painters and – with Eugène Isabey, Eugène Boudin and Johann Barthold

Jongkind as intermediaries – paved the way for Impressionism.
Illustrations:
72 At the English Coast, 1825
72 Beach in Normandy, c. 1826/27
73 St. Mark's Column in Venice, c. 1826–1828

BROWN Ford Madox
1821 Calais – 1893 London
Growing up on the Continent, the son of English parents, Ford Madox Brown visited the Bruges studio of a pupil of Jacques-Louis David as a boy. He then studied with Gustave Wappers at the Antwerp Academy, which gave him a first-hand acquaintance with Belgian history painting. Brown was soon caught up in the current vogue for romantic, historical revival, and sentimental themes, frequently taken from the literary works of Walter Scott und Lord Byron. In 1840 he went to Paris and devoted himself to the study of the Old Masters in the Louvre. First trip to London in 1844. The year after, during a stopover in Basel on the way to Rome, Brown discovered the paintings of Hans Holbein the Younger, whose colorism he particularly admired; in Rome he was impressed by the linear approach and precise detail of the works of the German Nazarenes Friedrich Overbeck und Peter von Cornelius.

Back in England, Brown settled in 1846 in London, where he returned after spending the years 1881–1887 in Manchester. Friendships with Dante Gabriel Rossetti, William Holman Hunt und later Edward Burne-Jones brought him into close contact with the Pre-Raphaelites, whose initial efforts he supported without entirely identifying himself with them. Numerous quarrels with the London Academy reflected the relatively low esteem in which Brown was held in England. Not even a large exhibition of his works in 1865 nor a monumental commission for twelve frescoes in the Manchester City

Hall (1878–1883), depicting various epochs of the city's history, did much to enhance his reputation.
Illustrations:
91 Work, 1852–1856
91 The Last of England, 1852–1856

BROWN George Loring
1814 Boston – 1889 Malden
Brown was initially trained in wood engraving in Boston before turning to painting. During his first European journey, 1832–1834, he studied in Paris with Eugène Isabey and copied Dutch Baroque landscapes in the Louvre, as well as studying Constable's work and above all the atmospheric illumination of Claude Lorrain's ideal landscapes. After a few years in the United States, where he adopted the Hudson River School style, Brown moved in 1840 to Italy, where he would spend nineteen years, primarily in Rome and Florence.

Despite having established a great reputation there, he returned in 1859 to New York and Boston. Here Brown's repertoire began to extend from effective, romantic studio scenes to naturalistic oil sketches from nature, in which he experimented with combinations of impasto application and transparent glazes. His subjects were taken both from his American surroundings and from recollections of Italy, which enjoyed great popularity among American clients.
Illustration:
129 Italian Scenery, 1846

BRÜLLOW Karl Pavlovic
(Brjullo, from 1822 Brjullow, Karl Pavlovic)
1799 St. Petersburg – 1852 Manziana, near Rome
Born into a family of German artists who had settled in Russia in the eighteenth century, Brüllow initially trained with his father and then, in 1809, entered the St.

Petersburg Academy, from which he graduated with honors. In 1822 he and his brother were awarded a grant to study abroad by the Society for the Furtherance of the Arts, which, after sojourns in Dresden und Munich from 1823–1835, took him to Italy. Then, by order of the czar, Brüllow had to return to Russia, and on the way stopped over in Greece and Turkey. In Moscow he made the acquaintance of the poet Alexander Pushkin and found great recognition as an artist.

From 1836 to 1849 he taught at the St. Petersburg Academy. After receiving a number of national and international awards he travelled for health reasons to the island of Madeira, and lived in Rome from 1850 onwards. Beginning in the neoclassical tradition, Brüllow developed into one of the most significant artists of Russian Romanticism, concentrating on portraits and history paintings, and while in Italy, on genre scenes. In addition to oil-paintings he produced an outstanding œuvre of drawings and watercolors.
Illustration:
115 The Last Day of Pompeii, 1830–1833

BURNE-JONES Sir Edward Coley
1833 Birmingham – 1898 London
After studying theology at the Exeter College in Oxford, Burne-Jones turned to art, and with his friends William Morris and Dante Gabriel Rossetti formed the nucleus of the Pre-Raphaelite Brotherhood. His work was extensive and varied, including paintings, drawings, designs, and illustrations. Like the other members of the group, Burne-Jones endeavored to revive medieval crafts ideals, paving the way for the Art Nouveau movement. He produced designs for interior decoration, furniture, stained glass, tiles, tapestries and murals for the firm of Morris, Marshall, Faulkner & Co., of which he was also a partner.

Burne-Jones's paintings reveal a great admiration for the Italian Renaissance. His themes, mythological and allegorical in character, are derived from legends and history, and often include heroines whose beauty has a slightly menacing air. John Ruskin was one of his friends and admirers. In 1890 Burne-Jones was elected to the Royal Academy, but resigned only three years later.
Illustrations:
90 King Cophetua and the Beggar Maid, 1884
90 The Baleful Head, 1886/87

CARUS Carl Gustav
1789 Leipzig – 1869 Dresden
After an initial training in drawing, from 1804–1810 Carus studied natural sciences, philosophy, and medicine at Leipzig University. Until 1814 he served as assistant doctor at the maternity clinic of the Triersche Stiftung in his home town, then received a professorship in obstetrics in Dresden. There, in 1817, he met Caspar David Friedrich, who would become a lifelong friend and lastingly influence Carus's landscape style.

After wide travels in many countries including Italy and England, from 1815–1824 Carus devoted himself to writing his *Neun Briefe über Landschaftsmalerei,* or *Nine Missives on Landscape Painting,* one of the most fundamental theoretical studies in the field of German Romantic art.
Illustrations:
48 Moonlight Night near Rügen, c. 1819
48 The Goethe Monument, 1832
49 Boating on the Elbe, 1827

CATEL Franz Ludwig
1778 Berlin – 1856 Rome
Catel, whose family originated from France, came by way of wood engraving and illustration to painting. In 1802 his watercolor land-

scapes attracted the attention of Goethe in Weimar. In 1806 he became a member of the Berlin Academy, and the following year, in Paris, he devoted much of his time to oil painting. From 1811 onwards he was active in Rome, where he associated with the artists around Joseph Anton Koch. Specializing in *vedute,* or views, and genre scenes, Catel soon established a high reputation that brought him a plethora of international commissions, especially after a Sicilian journey in 1818.

Among his greatest admirers were the crown prince of Bavaria and the king of Prussia, and he associated with renowned authors, philosophers and artists. After his death his considerable fortune passed on to the "Pio Istituto Catel," a foundation devoted to the furtherance of young German artists in Rome.
Illustration:
59 Crown Prince Ludwig in the Spanish Wine Tavern in Rome, 1824

CHASSÉRIAU Théodore
1819 Sainte-Barbe-de-Samana (Santo Domingo) – 1856 Paris
At the early age of twelve Chassériau became a pupil of Jean Auguste Dominique Ingres, who was lastingly to shape his style. The clarity and stringency of his compositions, as well as his emphasis on outline, can be traced back to Ingres' classicism, particularly in the

portraits. However, a gradual adoption of Romantic elements brought independence from this dominant ideal. He began to leaven the classical style of Ingres with a lively, contrast-rich palette reminiscent of Delacroix, under whose influence he had been since 1838.

Chassériau was the only painter who succeeded in combining these two antithetical approaches into a unique style of his own. This was especially apparent in his depictions of the female nude. His *Esther Before Meeting Ahasuerus* (1841; Paris, Musée du Louvre), shows restrained sensuousness and a sophisticated handling of color, and his *Two Sisters* (1843; Musée du Louvre) was regarded by Edgar Degas as the best painting of the century. After a visit to Algeria in 1846 he concentrated on oriental scenes. Towards the end of his life he devoted himself to mural painting, his principal work being scenes of war and peace for the Court des Comptes of the Palais d'Orsay.
Illustration:
95 Father Lacordaire, 1840

CHURCH Frederic Edwin
1826 Hartford (Connecticut) – 1900 New York
After receiving instruction from two local artists at Hartford, Church studied under Thomas Cole at Catskill from 1844 to 1848 and was soon seen as Cole's successor in the American school of landscape painting. His panoramic large-format landscapes differed from Cole's in their more objective and detailed representation of the environment, which reflected the artist's profound knowledge of the natural sciences. In 1853 and 1857 Church travelled through unexplored regions of South America. A European journey in 1868 took him by way of Greece to the Middle East; in 1869 he travelled through Labrador. His depictions of these diverse natural scenes all showed a special interest in botany, geology, and meteorological phenomena, but rendered in a po-

etic, even Romantic manner, in the pale light of dawn or dusk.

Like Fitz Hugh Lane, Church belonged to that generation of artists after Cole who did not think it essential to go to Paris or London for inspiration. Their aim was to paint nature in the state in which God created it before He created man. To Church, the "paradise" of America in its "virginal" charm embodied the elemental forces of nature. His evocation of these forces was at the same time an expression of his belief in the powers of the New World, in what he called "America's sacred destiny."

Illustration:
130 Niagara Falls, 1857

COLE Thomas
1801 Bolton-le-Moor (Lancashire) –
1848 Catskill (New York)
Cole came of an Anglo-American family who left England in 1818 to return to the United States. With a training in drawing and wood engraving in England behind him, he entered the Philadelphia Academy of Art in 1823. Subsequently settling in Catskill on the Hudson, Cole became a co-founder and key representative of the Hudson River School, which established Romantic landscape painting in America. Direct, spontaneous landscapes painted in the wilderness of the Catskill Mountains brought rapid recognition and attracted New York buyers.

In 1829 and 1841–1842 Cole went to Europe, travelling through England, Switzerland and Italy and studying in particular the landscapes of Nicolas Poussin, Claude Lorrain, Salvator Rosa, and Jacob van Ruisdael.

On his return, having also absorbed philosophical and literary ideas, Cole introduced a new type of painting to America: the symbolic, moral landscape, as represented by the series on the themes of *The Course of Empire* (1832; New York, Historical Society) and *The Voyage of Life* (1839/40; Utica, Munson

William Proctor Institute). These are fantastic, symbolic scenes abounding in allegorical references. Rendered with a somewhat cloying colorfulness accentuated by theatrical lighting, they do not attain the fine quality of Cole's earlier atmospheric landscapes.

Illustrations:
127 The Giant's Chalice, 1833
127 The Ages of Life: Youth, 1842

CONSTABLE John
1776 East Bergholt (Suffolk) –
1837 London
Constable was the son of a prosperous mill-owner in Suffolk, a county whose scenery became central to his work. Though he took painting lessons in Suffolk, he was largely self-taught. In 1795 he went to London and entered the Royal Academy schools in 1799. As a student he copied Old Master landscapes, especially those of Jacob van Ruisdael.

Though deeply impressed by the work of Claude Lorrain and the watercolors of Thomas Girtin, Constable believed the actual study of nature was more important than any artistic model. He refused to "learn the truth second-hand." To a greater degree than any other artist before him, Constable based his paintings on precisely drawn sketches made directly from nature. His early work also included portraits and some religious pictures, but from 1820 onwards he devoted himself almost exclusively to landscape painting. His subjects were found in the parts of England that he knew best, mainly Suffolk and Essex, and also Brighton.

Constable inimitably captured the light-and-shade effects of clouded skies and the various moods of landscape. After 1820/21 and a concentration on a series of cloud studies, "wind and weather" and the changing illumination they produced began to determine his landscapes as never before. The fact that his oil sketches were mostly of

the same size as the finished picture, if not larger, suggests that Constable considered his studies full-blown works, containing everything that mattered. Yet despite growing public recognition, the critics never tired of pointing out the sketchy, unfinished character of his works.

In 1824 a great exhibition of his paintings in Paris was an instant success, crowned by a gold medal from the Salon. Constable's art became an enduring influence on French painting. In 1829 he was named a member of the Royal Academy.

Illustrations:
13 The White Horse, 1819
74 Weymouth Bay, c. 1816
74 Salisbury Cathedral, from the Bishop's Grounds, 1828
75 Old Sarum, 1834

CORNELIUS Peter von
1783 Düsseldorf – 1867 Berlin
Cornelius was one of several nineteenth-century German artists involved in a revival of idealistic fresco painting. In 1811 he joined the Nazarene group in Rome, having already made early German art his model at the encouragement of the Boisserée brothers and Consul Wallraf. In 1816 he painted two frescoes of the Old Testament story of the life of Joseph for the Prussian Consul-General Bartholdy at Palazzo Zuccaro. These were so well received that Cornelius was called both to the Düsseldorf and Munich Academies simultaneously in 1819. He accepted both appointments, commuting between these cities, but finally deciding on Munich. Here he was appointed director of the Academy in 1824 and given an opportunity he had not had in Düsseldorf – to paint large frescoes.

However, after a falling out with King Ludwig I of Bavaria over his murals in the Ludwigskirche in Munich, Cornelius went in 1840 to Berlin, where he made the designs

for the planned Camposanto. When these were exhibited in 1859 in Berlin and Düsseldorf, idealist religious art celebrated a late triumph.
Illustration:
52 Joseph Reveals himself to his Brothers, c. 1816/17

COROT Jean-Baptiste Camille
1796 Paris – 1875 Paris
After a five-year apprenticeship in a drapery business, Corot studied painting from 1822 to 1825, first with Michallon, then with the neoclassical landscapist Victor Bertin. He also copied works by Claude-Joseph Vernet and others, including the seventeenth-century Dutch masters. Convinced that "a man can only be an artist when he has recognized in himself a strong passion for nature," Corot painted, or mostly sketched, outdoors, working in the forest of Fontainebleau, at Dieppe, Le Havre, Rouen and at Ville d'Avray, where his father owned a house.

His first trip to Rome from 1825 to 1828 would become decisive to Corot's development. He painted numbers of oil studies from nature, views of historical Roman monuments and the scenery around Rome. These possess an unusual freshness, capturing the light and atmosphere of different times of day with delightfully subtle variations in tonal values. The paintings developed from these studies, such as *View of Narni* (1826; Ottawa, National Gallery of Canada), painted for the 1827 Paris Salon, are by comparison rather formal and neoclassical in manner.

On returning from Italy, Corot worked in various parts of France. He made two further trips to Italy (in 1834 and 1843), and went to Holland (1854) and England (1862). His friendship in the late 1840s with the Barbizon artists Théodore Rousseau, Jean-François Millet, Constant Troyon and Jules Dupré greatly influenced his art. Around this time Corot's style changed. In romantically lyrical

landscapes, or *paysages intimes*, he began to capture the fleeting moods of nature in silvery nuances of supreme delicacy. His landscapes had an inspiring influence on the Impressionists, who wished to include him in their first exhibition.

Illustrations:
110 A Morning, Dance of the Nymphs, 1850
110 The Gust of Wind, c. 1865–1870
111 Agostina, 1866

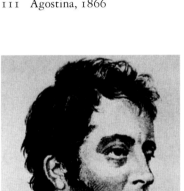

COTMAN John Sell
1782 Norwich – 1842 London
An etcher and landscapist, Cotman went in 1798 to London, where he initially earned his living by hand-coloring aquatint prints. Thanks to a contact made around 1799 with Dr. Thomas Monro, a prominent patron of many young watercolor landscapists, Cotman concentrated increasingly on this technique, in which he achieved great mastery. It was not until about 1807 that he began to paint landscapes in oil as well. Around the turn of the century he had met Thomas Girtin, whose work had the greatest stylistic influence on Cotman's, supplemented in later phases by impulses from Turner. In 1802–1804 Cotman headed the "Sketching Society", an informal study group founded by Girtin. The years 1801–1802 found him in Wales; from 1803 to 1805 he summered in Yorkshire, staying near the Greta River, where he developed his characteristic modelling style.

As he had little success in showing at the Royal Academy, Cotman moved back to Norwich in 1806 and over the next decades participated regularly in the exhibitions of the "Norwich Society of Artists", as whose president he served in 1811 and 1833. At the suggestion of his then patron, the banker and antiquarian Dawson Turner, he moved in 1812 to Great Yarmouth and made several journeys to Normandy, collecting visual material

for etched illustrations to Dawson Turner's *Architectural Antiquities of Normandy*, 1822. Cotman's watercolors of the period were characterized by an especially intense color range. In 1823 he opened a drawing school in Norwich. The following year, having accepted a position as drawing instructor at King's College, he returned to London.

Illustration:
73 Fort St. Marcouf, near Quinéville, in the Rade de la Hougue, Normandy, c. 1820

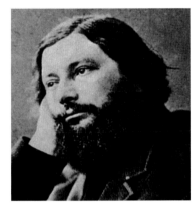

COURBET Gustave
(Jean-Désiré Gustave Courbet)
1819 Ornans (near Besançon) – 1877 La Tour-de-Peilz (near Vevey)
After attending the grammar school at Besançon, Courbet began to study law in Paris in 1840. In painting he was largely self-taught, learning his art by copying the Old Masters (Velázquez, Hals, Rembrandt and the Venetians) in the Louvre, and in Holland, where he stayed in 1846. In 1848 he met Camille Corot, Honoré Daumier and Charles Baudelaire. The subjects of his early works, taken from Goethe's *Faust* and the books of Victor Hugo and George Sand, were still strongly marked by the Romanticism he would soon reject. These early works included landscapes, painted at Fontainebleau, and portraits of members of his family (*Juliette Courbet*, 1844; Paris, Musée du Petit Palais) as well as self-portraits. His first acceptance at the Salon came in 1843, with *Courbet with Black Dog* (1842; Paris, Musée du Petit Palais).

In 1849–1850, in his home town of Ornans, Courbet's first "Realist" pictures emerged: *The Peasants of Flagey Returning from the Fair, The Stonebreakers* (formerly Dresden, Gemäldegalerie; destroyed in 1945), and *A Burial at Ornans* (c. 1849/50; Paris, Musée d'Orsay), which were considered revolutionary. Revolutionary they certainly were in their choice of subject,

depicting the life of plain people in an unsentimental, down-to-earth manner. Rejecting all traditional subject matter, Courbet envisaged a realistic art with a social function. "I maintain," he stated, "that painting is clearly a concrete art whose existence lies only in the representation of real and existing objects..."

These objects he characteristically rendered in dark hues, applying the paint with heavy brushstrokes, sometimes even with a palette knife. Maupassant observed Courbet at work in Etretat in 1869, and gave a graphic description of his method: "In a large, empty room a gigantic, grimy, and untidy man applied blobs of white paint to a large, empty canvas with a kitchen knife. From time to time he went to the window, pressed his face against the pane and looked out at the storm. The breaking seas came so close to the house that they threatened to smash it, inundating it with spray and din.... The work became *The Wave* and brought disquiet to the world."

When, in 1855, Courbet was rejected by the jury of the World Fair, in protest he set up his own "Pavillon du Réalisme" next door to the exhibition building. Here he demonstrated his personal perception of art in the form of forty paintings. One of these was the *The Painter's Studio*, which included a portrait of his friend, the socialist philosopher Proudhon, whose political convictions had a great influence on Courbet. His work was very successful in Germany, where he stayed in Frankfurt am Main in 1858/59 and in Munich in 1869. He joined the Paris Commune in 1871 and was given the task of protecting the museums from war damage. When the Commune was deposed, he was sentenced to six months' imprisonment, and took refuge in Switzerland in 1873. Courbet, who influenced and advised the fledgling Impressionists, was an outstanding representative of a naturalistic realism that employs the devices of art to point up the contradictions and inequities in society.

Illustration:
31 The Painter's Studio, 1855

COZENS John Robert
1752 probably London – 1797 London
A watercolorist and landscape painter, Cozens was trained by his father in this metier. From 1767 to 1771 he exhibited drawings with great success at the London Society of Artists, and in 1776 presumably

executed his first oil, *Hannibal's March over the Alps*, at the Royal Academy. These early works have all been lost.

A first journey by way of Switzerland to Italy in 1776–1779, accompanied by Richard Payne Knight, and a second tour in 1782–1783, as the companion of William Beckford, resulted in the larger part of Cozens's œuvre, comprising numerous watercolors of Roman landscapes and views of the Alpine regions. While the pictures and sketches from the first journey still strongly recalled Claude Lorrain's ink drawings of ideal Mediterranean landscapes, the later works evinced a vivid palette and an increasing dramatization of the motif.

After his return to England these subjects enjoyed extreme popularity. John Constable called Cozens "the greatest genius that ever touched landscape." Around 1792 he had begun to show symptoms of a nervous disorder that eventually would lead to mental illness. His patron, Dr. Thomas Monro, collected Cozens's watercolors and had Thomas Girtin and Turner make copies of them. In consequence, Cozens's work exerted a lasting influence on the following generation of English watercolor landscape painters.

Illustration:
17 View of Mirbella, c. 1782

DAHL Johan Christian Clausen
1788 Bergen – 1857 Dresden
After working as a decorative painter in his home town of Bergen, Norway, Dahl studied landscape painting at the Copenhagen Academy from 1811 to 1818. Here he was impressed by the work of Jens Juel and Christoffer Wilhelm Eckersberg, but the crucial influence came with a study of the seventeenth-century Dutch masters of landscape. One of them, Allaert Everdingen, had visited Norway and subsequently developed a type of "Nordic landscape" based on his

impressions. This style was later taken up by the Norwegian national movement in the nineteenth century. Alongside the "Italian landscape," the "Nordic landscape" also became established on the Continent early in the century.

Stimulated by his first extensive travels through Norway in 1826, Dahl supplemented his previous range of motifs – waterfalls, moving clouds and windswept trees – with depictions of the bare plateaus of the high mountain regions and their cloud formations, becoming an innovator in Norwegian as well as German landscape painting. In 1818 he settled at Dresden, where he associated with Caspar David Friedrich and Carl Gustav Carus. In 1824, like Friedrich, he was appointed professor at the Dresden Academy. Dresden and its environs began to feature frequently in his compositions, in which the sky often occupied the larger part of the canvas. During a journey to Italy in 1820–1821 he found subject matter for a third range of themes.
Illustrations:
118 View of Pillnitz Castle from a Window, c. 1824
118 View of Dresden in Full Moonlight, 1839
119 Eruption of Vesuvius, before 1823

DANBY Francis
1793 Killinick, County Wexford, Ireland – 1861 Exmouth, Devonshire
After attending the drawing school of the Royal Dublin Society and spending a brief period in London, Danby settled around 1813 for two decades in Bristol, in whose environs he painted the small, exquisite landscapes on which his fame today largely rests. In 1824 he moved to London, intending to challenge the reputation John Martin had achieved with large-format panoramas that sensationalistically appealed to the romance of horror and dread. William Turner and Richard Wilson now began to exert

a profound influence on Danby's style.

In 1825 he travelled to Norway, then in 1828 to Holland and Belgium. Forced to leave England in 1829 due to financial problems and a marital scandal, Danby established himself in Paris and Geneva, where he remained until 1840. Danby's oils, ink drawings, and watercolors, focussing on lyrically romantic landscapes, represented one of the most significant contributions made by any artist to nineteenth-century British landscape painting. He also concerned himself with religious themes, treated in a visionary manner.
Illustration:
77 Scene from the Apocalypse, c. 1829

DELACROIX Eugène
(Ferdinand Victor Eugène Delacroix)
1798 Saint-Maurice-Charenton (near Paris) – 1863 Paris
After studying music, Delacroix first received instruction in painting at the studio of Pierre-Narcisse Guérin in Paris. In 1816 he entered the Ecole des Beaux-Arts, where he met Théodore Géricault, his junior by seven years, whose work he greatly admired. He was also impressed by Goya's drawings and the paintings of Veronese and Rubens. Delacroix's first major work, *Dante and Virgil in Hell* or *The Barque of Dante*, excited much attention at the Salon in 1822.

Two years later his *Massacre of Chios* led to still greater recognition. Having seen John Constable's pictures at the Salon, Delacroix reworked this painting and added highlights a few days before the exhibition opening. The discovery of Constable, and his friendship with Richard Parkes Bonington, prompted Delacroix to visit London in 1825. His study of Constable's work led him to adopt a fresher and livelier palette.

Back in Paris, Delacroix found himself acclaimed as the leader of

Romantic painting in France, and became the target of criticism on the part of the Classical school, above all Ingres. Delacroix's subject matter was drawn from literary sources, such as Dante, Shakespeare and Goethe, but also from such Romantic works as the novels of Walter Scott and the poetry of Byron. In 1832 he travelled to Morocco as a member of an ambassadorial mission to the sultan, and also visited Algiers, Oran, Tangiers and southern Spain. His enthusiasm for this exotic world with its brilliant light knew no bounds, inspiring literally hundreds of drawings and watercolors. Based on these Delacroix later, in Paris, painted his most beautiful and colorful oils, including the famous Harem Scenes and the series of Lion Hunts.

From 1834 he was engaged in large-scale decorative works, including those in the Salon du Roi in the Palais Bourbon (1833–37), the library in the Palais du Luxembourg (1845–47) and the church of St. Sulpice (1861). In 1857 he finally became a member of the academy after seven years of candidature. Mounting criticism caused Delacroix to retire into seclusion towards the end of his life, and he died in complete isolation in 1863. The passion, subjectiveness and sensualism of his subject matter, as well as his methods of composition and coloration, made Delacroix a Romantic in a category by himself, and one of the greatest painters of the century. His conception of the intrinsic value of color and its overall effect would exert a seminal influence on the Impressionists.
Illustrations:
28 Orphan Girl at the Cemetery, 1824
104 Dante and Virgil in Hell (The Barque of Dante), 1822
105 The Massacre of Chios, 1824
105 The Death of Sardanapalus, 1827–1828
106 Liberty Leading the People (28 July 1830), 1830
106 The Women of Algiers, 1834
107 The Lion Hunt, 1861

DELAROCHE Paul
(actually Hippolyte Delaroche)
1797 Paris – 1856 Paris
In 1816 Delaroche, son-in-law of Horace Vernet, entered the Ecole des Beaux-Arts in Paris, and also became a pupil of Louis Etienne Watelet and Antoine-Jean Gros. Géricault, taken by the young artist's talent, suggested he devote

himself to subjects from recent history. Thus began a career that would soon make Delaroche one of the most popular and influential history painters of the period. Initially specializing in scenes from French and English history, he was commissioned in 1830 to decorate the Salle du Budget in the Paris City Hall, and in 1831 he submitted a whole series of canvases on related, anecdotal subjects to the Salon. An increasing concentration on portraits followed.

In 1832 he was granted membership in the Institute, and shortly thereafter in the Ecole des Beaux-Arts, for which, from 1837 to 1844, he painted a large mural in the semicircular hall of awards depicting *The Apotheosis of the Arts*. Though most of his contemporaries, among them Heinrich Heine, considered Delaroche a brilliant intermediary between the Classical and Romantic schools, a few, especially Eugène Delacroix and Théophile Gautier, pointed out weaknesses in his composition and coloring, and found the sentimental bathos and theatrical posing of his history pictures hard to digest.
Illustration:
108 The Sons of Edward IV, 1830

DYCE William
1806 Aberdeen – 1864 Streatham (Surrey)
Dyce trained at the Scottish Academy, Edinburgh, and the Schools of the Royal Academy, London, of which he would become a member in 1848. In 1825 and again from 1827 to 1830 he lived in Italy, mainly Rome, immersing himself in the works of Raphael and the earlier masters, and associating with the German Nazarenes Friedrich Overbeck, Peter von Cornelius, and Julius Schnorr von Carolsfeld, who greatly influenced his art.

From 1830 to 1837 Dyce worked as a portraitist in Edinburgh. His interest in art education and industrial design brought him a commis-

sion by the recently founded Government School of Design in London to visit and report on the methods of the state-run art colleges in France, Prussia and Bavaria

In 1840 he became director of the School of Design in London. His connections with the Nazarenes brought Dyce the reputation of an expert on fresco painting, resulting in various commissions in this field, including, in 1844, frescoes in the robing-room of the House of Lords and later for Lambeth Palace, Buckingham Palace and other sites. He also produced stained glass designs, usually on religious themes. A devout man, Dyce was an ardent supporter of the High Church. He maintained that society's aim should be to create a government that combined secular and spiritual powers. This corresponded with the views of the German Nazarenes, whose rather dry and harsh style Dyce adopted in his earlier work, before coming increasingly under the influence of the Pre-Raphaelites, especially John Everett Millais and William Holman Hunt.
Illustrations:
85 Joab Looses the Arrow of Grace, 1844
85 Pegwell Bay in Kent. A Recollection of October 5th, 1858, c. 1859/60

EASTLAKE Sir Charles Lock
1793 Plymouth – 1865 London
From 1809 Eastlake attended the Royal Academy in London, where his teachers included Benjamin Haydon. After a sojourn in Paris in 1815, he began to concentrate largely on portraiture. In 1818 he settled in Rome for twelve years. He immersed himself in the techniques of the early Italian masters, associated with the German Nazarenes, and devoted himself almost exclusively to landscape motifs. After further journeys to Athens, Malta and Sicily, Eastlake returned in 1830 to London, where

his interest increasingly turned to art theory and policy.

In 1840 he translated Johann Wolfgang von Goethe's *Farbenlehre* (Color Theory) and propagated the philosophically based and romantically oriented German approach to art in England. In 1841 he was named secretary of the royal commission on the interior decoration of the new Houses of Parliament. From 1843–1847 he served as keeper at the London National Gallery and from 1855–1865 as its first director. In addition, Eastlake was president of the Royal Academy from 1850–1865.
Illustration:
84 The Champion, 1824

ECKERSBERG Christoffer Wilhelm
1783 Sundeved – 1853 Copenhagen
Eckersberg's rank in Danish painting is comparable to that of Ingres' in France. A pupil of the neoclassicist Abraham Abildgaard at the Copenhagen Academy, Eckersberg established his style while working at Jacques-Louis David's studio in Paris from 1811 to 1813, mellowing neoclassical stringency by treating the painting surface in a more naturalistic manner. A visit to Rome, 1813–1816, extended his repertoire to include the *veduta*, or view, light in tone and based on strict perspective.

On his return Eckersberg settled in Copenhagen and became a professor at the Academy in 1818 and one of the most sought-after Danish portraitists. He also painted seascapes. Although upholding the old traditions, as seen in his objectivity of representation, strong line, unambiguous color, and perspectival construction, as a teacher Eckersberg was open to new ideas. Several of his pupils formed the nucleus of the second generation of Danish Realists in the nineteenth century, who developed a looser manner and favored unusual perspectives and a subjective treatment of color and light.

Illustrations:
120 View through Three Northwest Arcades of the Colosseum in Rome. Storm Gathering over the City, 1815
120 Nude (Morning Toilette), c. 1837

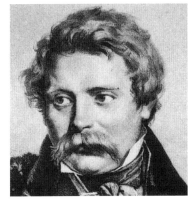

FEARNLEY Thomas
1802 Fredrikshald (Norway) – 1842 Munich
Fearnley attended the drawing school in Kristiania (Oslo) from 1819 to 1821, then continued his training at the academies in Copenhagen (1822–23 and 1827–28) and Stockholm (1823–1827). Moving to Dresden in 1829, he became a pupil of Johann Christian Clausen Dahl, whom he had previously met in Norway and whose landscapes he admired, while also coming under the crucial influence of Caspar David Friedrich.

Like many Romantic artists, Fearnley sought stimuli for his work in extensive travels. He lived from 1830 to 1832 in Munich, making frequent excursions to the Bavarian Alps to do studies from nature, and in the following years went to Italy and Paris. From 1836 to 1841 he alternated between London and Norway, Switzerland and Amsterdam. While in England he saw the work of Constable and Turner, and returned to Munich in 1841. His achievement made Fearnley one of the pioneers of anti-academic, Romantic landscape painting in Scandinavia.
Illustrations:
121 Northern Region, 1829
121 Moonlight in Amalfi, 1834

FOHR Carl Philipp
1795 Heidelberg – 1818 Rome
Fohr trained first with the genre and *veduta* painter Carl Rottmann and, from 1810, with Georg Wilhelm Issel in Darmstadt, then attended the Munich Academy. In 1815 a walking tour took him by

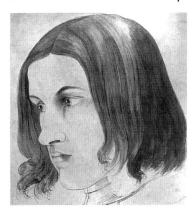

way of Tyrol to Verona und Venice. After a brief return to his home town, he went back to Italy, where, in 1816, he joined the group around his friend Joseph Anton Koch and the Romantics in Rome. The young artist's medieval-style German frock coat, worn as a sign of patriotism, was reputedly the talk of the town. In addition to many portrait studies of his artist colleagues, Fohr devoted himself largely to romantic landscapes. He drowned in 1818 while swimming in the Tiber.
Illustrations:
57 Knights at the Charcoal Burner's Hut, 1816
57 Ideal Landscape near Rocca Canterana, 1818

FORTUNY Y CARBÓ MARSAL Mariano
1838 Reus – 1874 Rome
Fortuny was raised by his grandfather, a cabinetmaker, woodcarver, and modeller. In 1850 he took drawing lessons in the atelier of Domingo Soberano, then with the miniaturist and silversmith Antonio Bassa. Moving to Barcelona in 1852, he attended the Escuola de Artes y Oficios and took courses with the sculptor Domingo Talarn. The following year found him at San Jorge Art Academy, where his teachers were Claudio Lorenzale (a Nazarene), Milá and Garvani. A grant took him to Rome from 1858 to 1860. That same year he was sent to Morocco as a war artist. There-

after he exhibited in Barcelona, and returned to Rome after a stopover in Paris.

In 1862 Fortuny was again in Morocco, and in 1863 his Rome scholarship was extended. In 1865 the Duke of Riánsares became his patron. He married the daughter of the painter Federico Madrazo in 1867 in Madrid. Primarily a history painter, Fortuny's eighteenth-century genre scenes enjoyed great renown. The year 1870 saw the sensational sale of his canvas *Visiting Day at the Parish* (Barcelona, Museu Nacional d'Art de Catalunya) by Goupil in Paris. Lived in Andalusia in 1870, followed by a third journey to Morocco in 1871. Returned to Rome in 1872.
Illustration:
126 Fantasy on "Faust", 1866

FRANQUE Jean-Pierre

1774 Le Buis (Drôme) – 1860 Paris
A painter and lithographer, Franque was a pupil of the great neoclassicist Jacques-Louis David. Around the turn of the century he belonged to the group of "Primitives" around Maurice Quay. By returning to archaic art, especially early Greek and Etruscan vase painting, this group hoped to renew not only art but their entire way of life, and they subsequently attempted to establish a Christian community in an abandoned monastery. The sect's spiritual sources included the somber ballads of the bard Ossian.

In 1806 Franque successfully debuted at the Paris Salon with a design for decorations in the Elysée Palace. In 1812 he exhibited a depiction of the battle of Zurich painted for Marshal Masséna, followed in subsequent years by a series of mythological and biblical subjects. Towards the end of his career he also devoted himself to portraiture.
Illustration:
30 Bonaparte in Egypt, Urged to Return by a Vision of Conditions in France, 1810

FRIEDRICH Caspar David

1774 Greifswald – 1840 Dresden
Friedrich was the son of a soapmaker and chandler, and studied under Jens Juel at the Copenhagen Academy from 1794 to 1798. That year brought him to Dresden, where he would spend his entire life, interrupted only by journeys to Greifswald, Rügen, Neubrandenburg, the Harz Mountains and northern Bohemia. In 1816 he became a member of the Dresden

Academy, and in 1824 professor extraordinary. Friedrich was the founder of German Romantic landscape painting. His style combined an unprecedented fidelity to reality, based on his travel experiences, with a metaphysical illumination inspired by Christian Neoplatonic ideas.

The origins of his landscape art lay in the eighteenth-century *veduta*, or view. Already in evidence here were the foreground with observer's standpoint, set against an interesting background landscape, in some cases already that type of grand natural scenery which in the nineteenth century would be termed "the sublime" – lonely mountain ranges or ocean vastnesses that, in the sensitive viewer, aroused feelings of religious awe and insight. But Friedrich's pictures have none of the travelogue character found so frequently in eighteenth-century landscapes. His views of nature are externalized embodiments of the mood of the figures in the foreground, "atmospheric landscapes," to use the nineteenth-century term. They are invariably determined by two elements: the observed environmental situation and the attitude of the person or persons observing it, figures usually seen from the back and often magnified in proportion to the scene.

Friedrich's contrast of boundless distance with the bounded position of the onlooker in the foreground evokes the two sides of human existence – body and soul, the earthbound and the divine – which from ancient times have comprised the fundamental dichotomy of Christian and Neoplatonist thinking. Friedrich was an intelligent and contemplative artist. His friends included not only painters such as Philipp Otto Runge, Johan Christian Clausen Dahl, Friedrich Kersting and Gerhard van Kügelgen, but also poets like Ludwig Tieck as well as scientists and philosophers. He was also a fervent patriot, which explains the symbolism in many of his pictures alluding to the German

wars of independence against French occupation.
Illustrations:
10 Woman at a Window, 1822
38 The Cross in the Mountains (Tetschen Altarpiece), 1807/08
38 Mountain Landscape with Rainbow, c. 1809/10
39 The Monk by the Sea, 1809/10
39 Abbey under Oak Trees, 1809/10
40 The Chasseur in the Forest, c. 1813/14
40 The Lone Tree (Village Landscape in Morning Light), 1822
41 Chalk Cliffs on Rügen, 1818
42 Moonrise over the Sea, 1822
43 Wanderer Watching a Sea of Fog, c. 1817/18
43 The Polar Sea (formely The Wreck of the Hope), c. 1823/24
44 Mountainous River Landscape (Day Version), c. 1830–1835
44 Mountainous River Landscape (Night Version), c. 1830–1835

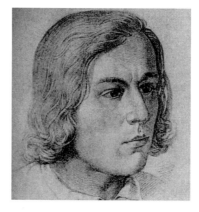

FÜHRICH Josef

1800 Kratzau (North Bohemia) – 1876 Vienna
Introduced to the basics of painting by his father, Wenzel, Führich continued his training at the Prague College of Art. At the behest of Prince Metternich he was awarded a travel grant to Rome, where he worked in 1827–1829. He collaborated with Joseph Anton Koch and the Nazarenes Schnorr von Carolsfeld und Philipp Veit, under the supervision of Overbeck, on fresco decorations in Villa Massimo. In 1828 he participated in the Second German Art Exhibition at Palazzo Caffarelli, and in 1829 helped found the German Art Association in Rome.

After returning to Prague in 1832, two years later he accepted Metternich's offer of a curator's post at the Prince Lamberg Gallery of

Painting in Vienna. From 1840 to 1851 he was professor of composition at the Vienna Academy. In 1861 Kaiser Franz Joseph I granted him a hereditary knighthood.
Illustration:
58 The Passage of Mary through the Mountains, 1841

FUSELI Henry

(also: Füssli, Füßli, Fuessli, Fueslin, Füßlin, Johann Heinrich)
1741 Zurich – 1825 Putney Hill (near London)
Fuseli was the second son of the Zurich portraitist and author Johann Caspar Füssli. His early contact with the teachings of Johann Jakob Bodmer familiarized him with the figures of world literature, which were to remain a major source of inspiration throughout his career. Ordained in 1761 as a pastor in the Zwinglian Reformed Church, he left Zurich two years later for political reasons, travelling by way of Berlin to London, where he settled. Initially Fuseli made his living by writing, while engaged in illustrating the works of his favorite authors, particularly William Shakespeare.

It was Joshua Reynolds who persuaded him to concentrate entirely on fine art. He travelled through Italy, visiting Florence, Venice and Naples, and lived for eight years in Rome. This period, during which Michelangelo's monumental style left a deep impression on him, became a lasting influence. After a short stay in Zurich on his return to London from Italy, Fuseli began to paint extensively. *The Nightmare* (Detroit, Institute of Arts, and Frankfurt am Main, Goethe-Museum), probably his most popular work, excited great attention when it was exhibited at the Royal Academy, to which Fuseli was elected in 1790.

In the history of style Fuseli's significance lies in the strain of early Romanticism he injected into the classical revival repertoire, the eerie, larger-than-life presence of his

dreamlike, sometimes macabre figures and scenes. His often overrated importance as colorist probably derives from his novel, draughtsman-like treatment of color.

Illustrations:

GÉRARD François Pascal Simon

1770 Rome – 1837 Paris

Gérard's family lived until 1780 in Rome, where his father served as steward at various courts. After the family's return to Paris, Gérard entered the atelier of Jacques-Louis David at the age of sixteen and soon became his favorite pupil. In 1790 he travelled to Rome to sort out family affairs after his father's death, and there married one of his mother's younger sisters. Soon Gérard had to return to Paris to avoid being registered as an emigrant.

When the French Revolution deprived him of the portrait commissions by which he made a living, he began illustrating the works of Racine and Virgil. He also became a successful painter of historical scenes, winning the competition to commemorate the meeting of the National Assembly of 10 August 1792. However, he soon returned to portraits, which were much sought-after on account of their careful preparation and classical detachment. Gérard's reputation remained high through the Restoration period. In 1817 he became court painter to Louis XVIII, and was ennobled in 1819.

Illustrations:

GÉRICAULT Théodore

(Jean Louis André Théodore Géricault)

1791 Rouen – 1824 Paris

Géricault's extensive œuvre came into being during a period of creative activity lasting only twelve years. His love of horses and riding was reflected in great numbers of sketches and paintings on the subject whose vividness and realism remain unsurpassed.

It was one of these equestrian pictures that established his fame, *Charging Light Cavalry Officer*, which in 1812 became the first of his works to be exhibited at the Salon. The passionate, impetuous treatment of the theme amounted to a renunciation of neoclassicism and heralded the onset of the Romantic era. With *The Epsom Derby*, painted just a few years before his death, Géricault paved the way for Impressionism.

Géricault entered the studio of the equestrian artist and battle painter Carle Vernet in 1808, then in 1810 went to Guérin, only to find his neoclassicism stifling. The crucial impetus came from an immersion in Greco-Roman art and the masters of the sixteenth and seventeenth centuries. Working in the Louvre, Géricault made innumerable copies of the works of Rubens, Caravaggio, Velázquez, Rembrandt, van Dyck and Raphael. While in Italy in 1816–17, he was particularly impressed by Michelangelo. In England, where he lived from 1820 to 1822, Constable became important, as did Wilkie and Hogarth. The influence of most of these artists can be traced in Géricault's work.

Still, the unprecedented realism of his portraits and pictures of animals was founded on an intensive study of life – in the countryside, at race courses, in stables and at public festivities. So determined was he to capture human nature, even under the most extreme conditions, that he dauntlessly worked in hospitals, mental asylums, and morgues. His pictures form an account of Géricault's own eventful life – his mer-

curial political enthusiasms, his joining of the Royal Musketeers, and also his long, passionate, unrequited love for the wife of a friend. At the age of only thirty-three, Géricault died in great pain, of injuries incurred in a riding accident.

Illustrations:

GILLE Christian Friedrich

1805 Ballenstedt – 1899 Wahnsdorf, near Dresden

After entering the Dresden Academy in 1825, Gille continued his studies until 1830 at the Atelier School headed by Dahl, to whose style he would remain beholdes throughout his career. Subsequently he worked as a reproduction lithographer and was active as a portraitist in various suburbs of Dresden, before beginning to concentrate on freelance painting in 1850. The loose impasto brushwork of his depictions of nature made Gille one of the forerunners of German Impressionism. From 1872 he was active in Moritzburg, and thereafter in Wahnsdorf.

Illustration:

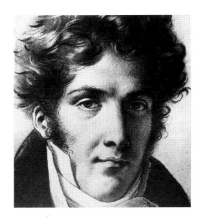

GIRODET DE ROUSSY-TRIOSON Anne-Louis

(actually Girodet de Roussy)

1767 Montargis – 1824 Paris

At age eighteen the future painter,

graphic artist, and writer Girodet was already one of the most gifted pupils in Jacques Louis David's Paris atelier. Receiving the Prix de Rome for painting in 1789, he went to Italy for five years. There, in 1793, he witnessed the siege and destruction of the French Academy in Rome, whose hoisted tricolor had raised the Italians' ire. Girodet might not have escaped had it not been for the help of a man who had sat for him. He went to Naples, and returned to France only in 1795, by way of Florence and Genoa, where he met Gros.

At the Paris Salon of 1793 he was represented by *Dream of Endymion* (Paris, Musée du Louvre), which overcame Jacques-Louis David's rigorous style and employed gentle nuances of illumination and color that anticipated the effects of Romantic art. In 1799 Girodet's *Danae* (Leipzig, Museum der bildenden Künste) caused a scandal when the facial features of the lascivious mythological figure were recognized to be those of a very popular actress of the day, Mademoiselle Lange.

The widespread attention Girodet had attracted led, in 1801, to a commission for a large-format painting for Malmaison Palace. He chose a theme from *Ossian*, a life-long favorite of Napoleon's. Based on works from Rubens's Medici cycle, the composition baffled Salon visitors, and its visionary, nebulous, phantasmagorical character was sharply criticized by David. Around 1806 Girodet's pathos-filled scene from *The Deluge* (Paris, Musée du Louvre) touched off a heated debate. He now gradually began to abandon his monumental style in favor of the early Romantic themes that were then modern in France. Towards the end of his life painting was increasingly supplanted by book illustrations, to Virgil, Racine, Bernardin de Saint Pierre (*Paul et Virginie*) and other authors. With these above all, Girodet-Trioson became a major forerunner of French Romanticism.

Illustration:

GOYA Francisco José de

(Francisco José de Goya y Lucientes)

1746 Fuendetodos (near Saragossa) – 1828 Bordeaux

Goya was trained in Saragossa by José Luzan, a pupil of Giordano and Solimena, before going to Madrid. There he entered the studio of Francisco Bayeu, his future brother-in-law, who worked under Mengs at the court of Charles III. After visit-

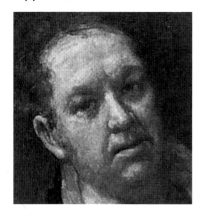

ing Italy in 1770–1871, Goya was asked to provide designs for the royal tapestry works. In 1780 he became a member of the Real Academia de San Fernando, which he would subsequently serve as deputy principal and principal. After carrying out court commissions from 1781, he was appointed court painter in 1786, painter to the royal chamber in 1789, and principal court painter in 1799.

Goya began in the Spanish version of the Rococo manner, intermingled with French and Italian elements, but in 1792, when a severe illness resulted in permanent deafness, his style changed drastically. In a series of uncommissioned paintings Goya began, under the mask of ordinary genre scenes, to invoke a world of terror and nightmare (*Funeral of the Sardine, Procession of the Flagellants*; *The Madhouse*; *Session of the Inquisition* – all Madrid, Academia de San Fernando). During the same period emerged "Los Caprichos," a series of 80 etchings published in 1799, intended to "scourge human vices and errors," as Goya wrote.

With his "black paintings" of the *Quinta del Sordo* (Madrid, Museo Nacional del Prado) he reached the pitch of his portrayal of the negative and unaccountable aspects of human existence. Under the pressure of the Restoration Goya left Spain and emigrated to Bordeaux. His evocations of the deeply dubious side of human nature, also reflected in the portraits, would not find full recognition until the twentieth century.

Illustrations:
33 El Gigante, c. 1808/09
124 Execution of the Rebels of 3 May 1808, 1814 (?)

GROS Antoine-Jean
1771 Paris – 1835 Bas-Meudon (near Paris)
Gros was only fourteen when he became a pupil of Jaques-Louis David, after having received instruction from his father, a miniature painter. In 1793, accused of royalist tendencies, he had to flee to Italy, where he lived mainly in Florence and Genoa, making a living from miniatures and portraits.

In 1796, an introduction to Napoleon in Milan established Gros's career. His first commission was *Napoleon at Arcola*, a work whose dynamic approach already set it apart from David's cool severity. After returning to France in 1799, Gros painted colossal and highly acclaimed battle scenes to celebrate Napoleon's martial prowess, including *Bonaparte Visiting the Plague-Stricken at Jaffa* (1804; Paris, Louvre) and *Napoleon on the Battlefield at Eylau*.

Under Rubens's influence his compositions took on increasing vitality and his palette grew more intensive. The Romantics, especially Eugène Delacroix, were impressed by the freshness and vigor of his work. As under Napoleon, during the Restoration Gros remained the official portraitist of high society. In 1824 he was made a baron. When David went into exile to Brussels in 1816, he handed over his studio to Gros and, as head of the Classical School, urged him to continue the good fight against Romanticism. The lifeless compositions on mythological subjects that ensued were rejected not only by the Romantics but by Gros's own pupils, who turned to the great Classicist Ingres. At the age of sixty-five, depressed by his failures, Gros committed suicide.

Illustrations:
96 Napoleon at Arcola, 17 November 1796, 1796
96 Napoleon on the Battlefield at Eylau, 9 February 1807, 1808
97 Lieutenant Charles Legrand, c. 1810

GUDIN
Jean Antoine Théodore
1802 Paris – 1880 Boulogne-sur-Seine
In 1817 Gudin became a student of Anne-Louis Girodet de Roussy-Trioson's at the Ecole des Beaux-Arts in Paris, which brought him into the circle of artists around Eugène Delacroix und Théodore Géricault. First representation at the Paris Salon followed in 1822. Gudin's most successful works were seascapes, the earliest still in part based on studies done on order of the "Citizen King" Louis Philippe, in 1838–1839 in Algiers. Active in Warsaw and St. Petersburg in 1841, Gudin devoted himself to views of Russian harbors commissioned by the czar. Several journeys to England and a visit to Berlin followed in 1844–1845. During the latter half of his career Gudin lost favor and popularity due to the vagaries of public taste.
Illustration:
103 Mont-Saint-Michel, 1840

HAYEZ Francesco
1791 Venice – 1882 Milan
Hayez trained in Venice, initially with Maggiotto und Querena, but then and more importantly with Teodoro Matteini at the Academy, from 1808–1809. The following year he was awarded the Prix de Rome. While in Rome, from 1809 to 1817, he concentrated on neoclassical compositions that reflected the influence of the sculptor Antonio Canova. After his return Hayez spent the next two years mainly on the interior decoration of various patrician mansions.

In 1820 he moved to Milan, subsequently taking a post at the Brera Academy, whose painting class he would head for the next thirty years, 1850–1880. Here Hayez associated himself with the realistic movement in history painting inspired by Alessandro Manzoni. The pervasive sense of national renewal led to large-format history pictures that combined Roman neo-

classicism with Venetian colorism. A painting like *The Kiss* (1859; Milan, Galleria d'Arte Moderna), on the other hand, partook of the emotional world of Romanticism. Hayez's finest works are probably his portraits of his family, friends and important personalities of the day.
Illustration:
122 The Refugees of Parga, 1828–1831

HUET Paul
1803 Paris – 1869 Paris
As a student at the Ecole de Beaux-Arts, Huet worked in the studios of Pierre-Narcisse Guérin and Antoine-Jean Gros, where Eugène Delacroix and Richard Parkes Bonington became lifelong friends. His greatest influence was Bonington, with whom he often worked and spent some time making studies in Normandy in 1827. More important still for his development, as for that of Delacroix, was Huet's encounter with Constable's work at the Paris Salon of 1824. This is how he described it: "The young school's admiration was boundless ... It was perhaps for the first time that one felt such warmth, such luxuriant nature, such greens, no blacks, no rawness, no mannerism."

Stimulated by John Constable, whom he often copied, Huet painted his landscapes mostly in Normandy and the forest of Compiègne, where he moved in the early 1820s. Unlike the other Barbizon artists, Huet was primarily interested in the dynamic aspects of nature. His wildly romantic renderings of primeval forests, agitated seas, and billowing windblown clouds, made him one of the founders of French *paysage intime* landscape painting.
Illustration:
112 Breakers at Granville Point, c. 1853

HUNT William Holman
1827 London – 1910 London
Hunt already began to paint during his business training, copying Old Master works including those of the fifteenth-century Flemish and Italian schools, which were to remain influential throughout his career. Much of his work was characterized by intense, sophisticated color, meticulous detail, a preference or painting from life, and a tendency to symbolism in presentation.

In 1844 Hunt entered the Royal Academy Schools and met Dante Gabriel Rossetti and John Everett Millais. It was a significant acquaintance, eventually leading to the foundation of the Pre-Raphaelite Brotherhood, a group of idealistic young men who set out to restore English painting to its former heights. John Ruskin, feeling an affinity with the group, supplied a theoretical foundation for its aims.

Hunt believed that a renewal of art must entail a return to venerable religious and moral ideals, and these became central to his work and inspired its solid, craftsman-like manner. Besides biblical subjects, he frequently took themes from old English myths and sagas, infusing them with an intense symbolism in which every small detail contributed to the intended message. To a contemporary eye, this approach might seem overly sentimental. Still, it was based on empirical observation and fidelity to nature, and evinced great skill in the handling of color and light. Hunt visited Palestine several times to paint the scenery there, and spent the years 1866–1868 in Florence. His work was highly regarded in his time and he received the Order of Merit in 1905.
Illustration:
86 Claudio and Isabella, 1850

INGRES Jean Auguste Dominique
1780 Montauban – 1867 Paris
Ingres's father, a sculptor and decorative stucco maker, instructed his son in drawing and sent him to the Toulouse Academy in 1791. In 1797 he became a pupil of David and in 1799 was accepted into the Ecole des Beaux-Arts. In 1801 Ingres won the Grand Prix de Rome with *The Envoys of Agamemnon* (Paris, Musée de l'Ecole Nationale Supérieure des Beaux-Arts).

In 1806 he introduced himself as a portraitist at the Salon, but drew negative reviews, even for his great portraits of the Rivière family. That same year an academy scholarship took him to Rome, where he stayed until 1819, producing much-admired portrait drawings of French society. He also immersed himself in Greco-Roman art and the works of Raphael, Holbein and Titian, and, while in Florence in 1819, was greatly influenced by Masaccio.

Ingres's independence from the style of his mentor, David, already became apparent in early works such as the *Bather of Valpinçon* (1808; Paris, Musée du Louvre). He returned to Paris in 1824 and began to teach. In 1825 he was awarded the Order of the Legion of Honor by King Charles X and was elected a member of the Academy. His *Apotheosis of Homer* (1827; Paris, Musée du Louvre), an embodiment of his artistic and literary credo, exemplified the neoclassical style Ingres derived from a study of Raphael. By comparison to his many works in this mode, the precisely drawn and painted portraits were both freer and based more strongly on observation. Ingres was also a master draughtsman, perhaps the most significant of the nineteenth century, and left 4000 sketches and drawings to his home town of Montauban.

The Salon's disapproval of his *Martyrdom of St. Symphorian* (1834; Autun Cathedral) prompted Ingres to accept the directorship of the French Academy in Rome, a post

he held from 1835 to 1841. On returning to Paris he finally met with enormous success and was awarded the Order of Merit in 1845. As president of the Ecole des Beaux-Arts (from 1850) Ingres became the leader of the Classical school. At the World Fair of 1855 he was represented by forty-eight works. In opposition to Eugène Delacroix and the Romantics, and to the Realism of Gustave Courbet, Ingres upheld classical idealism, with its clarity of line as opposed to a sensuousness of color, though he also persued a close study of nature.
Illustrations:
102 Joan of Arc at the Coronation
 of Charles VII in Reims
 Cathedral, 1854
102 The Turkish Bath, 1862

IVANOV Alexander Andreyevitch
1806 St. Petersburg –
1858 St. Petersburg
Initially trained by his father, a professor at St. Petersburg Academy, Ivanov went in 1830 on an academy grant to Italy, where he established friendly ties with the German Nazarenes and would remain until shortly before his death. Though his history paintings made Ivanov the last major representative of Russian academic art, in his numerous genre sketches and landscape studies he transcended academicism and – under the influence of Romantic currents – became a predecessor of *plein air* painting.

A reading of David Strauss' book *The Life of Jesus* (1835) and the failure of the 1848 revolution dispelled Ivanov's social utopian dreams and shook his Christian faith. Certain free-thinking traits entered his work, including the late series of watercolor sketches on biblical and other religious themes. A tragic schism became evident in his *magnum opus*, to which he devoted twenty years of his life (1837–1857), the monumental, unfinished canvas *Christ Appears to the People.*

Illustration:
114 Christ Appears to the People,
 1837–1857

JUEL Jens
1745 Balslev (Fünen) –
1802 Copenhagen
The most outstanding Danish artist of the late eighteenth century next to Nicolai Abildgaard, Juel trained with Johann Michael Gehrmann in Hamburg, then in 1765 settled in Copenhagen as a portraitist. Travels to Rome, Paris, Geneva, and Hamburg followed, 1772–1779. After being named court painter in Copenhagen in 1780, he became a member of the Academy in 1782. Apart from nature studies, Juel's œuvre comprised mainly realistic portraits. At first strongly influenced by Dutch Baroque portraiture, after the Geneva period and his association with Charles Bonnet, a natural list and follower of Henri Rousseau, Juel's portraits were increasingly based on English models, frequently showing the sitter before an atmospheric landscape background, precisely delineated and suffused with *lucid illumination.*
Illustration:
117 View over the Lesser Belt,
 c. 1800

KERSTING Georg Friedrich
1785 Güstrow – 1847 Meißen
Like many German artists of his

time, Kersting came from a humble lower-middle-class background. After the death of his father, a glazier and glass painter, a well-to-do relative sent Kersting to the Copenhagen Academy, which he attended from 1805 to 1808. He then settled in Dresden, where he was befriended by Gerhard von Kügelgen and Caspar David Friedrich. With the latter he went on a walking tour through Silesia and Bohemia.

Kersting concentrated exclusively on interiors, a genre established in seventeenth-century Netherlandish art. His pictures often show humble, even spartanic working and living quarters, redolent of the concentrated spiritual life led by their inhabitants, who are often occupied with reading. This was Kersting's favorite subject apart from portrayals of his friend, Friedrich, and quite in tune with his unemphatic but delicately colored compositions.

Illustrations:

19 Caspar David Friedrich in his Studio, 1812
46 At the Outpost, 1815
46 Man Reading by Lamplight, 1814
47 Before the Mirror, 1827

KOBELL Wilhelm von
1766 Mannheim – 1853 Munich
Kobell attended the Mannheim Academy of Drawing, where his teachers were Franz Anton von Leitenstorffer und Egid Verhelst. He was also taught by his father, Ferdinand Kobell, who encouraged him to study seventeenth-century Dutch landscapes, especially those of Philips Wouverman, Nicolaes Berchem and Paulus Potter in Munich collections, which in 1789 he copied, for the most part in watercolor.

In 1791 he was nominated member extraordinary of the Berlin Academy, and in 1792 court painter to Karl Theodor von der Pfalz. The following year his family moved to Munich, where Kobell soon found

entry to the circle around Johann Georg von Dillis, a major landscapist of the period. Though his commissioned work included animal subjects for the art publishers Artaria und Frauenholz, it was primarily a series of military pieces that established Kobell's reputation. After a battle cycle for King Max I Joseph in 1807, he worked from 1808 to 1817 on battle scenes from the Napoleonic Wars for the crown prince, which entailed numerous journeys to the former battlefields. The series was intended for installation in the banquet hall of the Munich Residence, designed by Leo von Klenze.

During a Paris sojurn in 1809/10 Kobell saw famous French battle paintings, but their pathos did not appeal to him. In 1814 he became professor of landscape painting at the Munich Academy, but ten years later the specialized departments were dissolved and he was pensioned off. He was given a personal knighthood in 1817 and a hereditary one in 1833. Kobell's œuvre, encompassing every nuance of the era, from late Baroque to a Romantically tinged neoclassicism all the way to Biedermeier, represents a culmination of southern German art. He is most remembered by posterity for his views of Munich and environs, and for picturesque Bavarian scenes, usually with precisely rendered figures and animals in the foreground of expansive landscapes suffused with clear light and cool colors.

Illustration:

63 The Siege of Kosel, 1808

KØBKE Christen Schjellerup
1810 Copenhagen –
1848 Copenhagen
Købke became Christoffer Wilhelm Eckersberg's pupil in 1828 after having studied at the Copenhagen Academy since 1822. Like his teacher, he concentrated on portrait and landscape painting. His pictures of everyday Danish life were usually small in format, ren-

dered in fine dots and dashes of paint that infused even the tiniest detail with vitality. Unlike Eckersberg he eschewed the all-inclusive panoramic vista, instead seeking out undramatic corners of the countryside or the environs of towns, which he rendered in limpid daylight and often from surprising vantage points. Købke was one of the most important representatives of light-toned open-air painting and early Realism in Copenhagen. Following an Italian sojourn from 1838 to 1840, he painted primarily from his Italian travel sketches, abandoning the small format. His work lost the freshness and immediacy of the earlier period.

Illustration:

117 Seacoast near Dosseringen, 1838

KOCH Joseph Anton
1768 Obergiebeln (Tyrol) –
1839 Rome
Born into a poor rural family, Koch started life as a shepherd boy. His talents attracted the attention of the Bishop of Augsburg, who funded his education at the Dilling Seminary and then his art training at the Karlsschule in Stuttgart. Yet like Schiller before him, Koch could not stand the school's harsh drill and fled, making his way first to Strasbourg and then to Switzerland. Having joined the Jacobin Club in Strasbourg, the young artist was inspired by the Alps and their remoteness from the political turmoil in his homeland to project his love of liberty into art. Mountain studies made on long walking tours formed the basis for large compositions, including *Schmadribach Falls, The Bernese Oberland* (1817; Innsbruck, Tiroler Landesmuseum Ferdinandeum), and *The Hospice on the Grimselwald Glacier* (destroyed; formerly Leipzig, Museum der bildenden Künste).

In addition to direct observation, however, these works also relied on the contemporary neoclassical landscapes Koch had seen in Rome,

which helped him develop a new, monumental type of Alpine painting. Apart from a brief period in Vienna from 1812 to 1815, Koch lived in Rome from 1795 until his death. He found his landscape subjects in the Alban Mountains and especially in the Olevano region. The resulting works combined Poussin's classical approach to landscape with immediate impressions recorded in sketches and watercolors.

Illustrations:

2 Heroic Landscape with Rainbow, 1815
22 Schmadribach Falls, 1821/22

LANDSEER Sir Edwin Henry
1769 Bristol – 1873 Saint-John's Wood, London
Landseer was born into a family of artists, his father, two brothers, and two of his sisters also being active in this field. In 1816 he attended the Royal Academy Schools in London, and studied with Benjamin Robert Haydon. He also dissected animal cadavers with an eye to lending his depictions of animals the greatest possible realism, and to the same end purchased George Stubbs's portfolio, *The Anatomy of the Horse.* The year 1824 brought Landseer's first journey to Scotland, where over the following years he would regularly return to make landscape sketches.

In 1831 he was voted a member of the Royal Academy. Thanks to his touching, indeed sentimental pictures of animals, sporting events, and hunts, as well as portraits, Landseer became the favorite artist of Queen Victoria, who often invited him to join the royal family in Scotland. In 1850 she knighted him, and in 1865 he was offered the presidency of the Royal Academy, which, however, he declined.

Illustration:

82 The Old Shepherd's Chief Mourner, c. 1837

LOUTHERBOURG Philippe Jacques de
1740 Strasbourg – 1812 London

The versatile French artist studied in Paris under the history painter Carle van Loo and continued his training in the landscape genre with Casanova. After first showing at the Paris Salon in 1763, he became a member of the Académie Royale in 1767. From 1765 to 1775 he collaborated on illustrations to the six-volume edition of La Fontaine's *Fables*, edited by Tessard. Yet before the project was finished, de Loutherbourg left his wife and children and went to England in 1771.

The famous actor David Garrick became his first patron and employed him until 1781 as a set painter at Drury Lane Theatre. Named a member of the Royal Academy in 1780, the following year de Loutherbourg presented an invention that would make him world-famous. The *eidophusikon* was a miniature stage with painted figures and landscapes, and mechanically produced lighting effects that created the illusion of movement and change – a sort of precursor of the cinema. In 1784 he was among the founding members of Emanuel Swedenborg's Theosophical Society.

That same year he met Cagliostro, a wonder-working doctor he followed to Switzerland for a few months in 1787. His growing interest in esoteric matters led, among other things, to an attempt to earn a living by therapeutic magnetism. This proving a failure, de Loutherbourg returned to painting. In 1793 he travelled to Flanders, to record the deeds of the Duke of York, supreme commander of the British forces, in sketches. In 1807 he became history painter in the service of the Duke of Gloucester. De Loutherbourg's achievement lay above all in the field of landscape. Often relying on seventeenth-century Dutch painting or that of Salvator Rosa, he produced works of dramatic virtuosity, including early examples of well-nigh Romantically staged industrial landscapes.
Illustration:
16 Coalbrookdale by Night, 1801

LUCAS Y PADILLA Eugenio
1824 Alcalá de Henares – 1870 Madrid

Although he trained at the Madrid Academy with V. Camarón, J. Madrazo and R. Tejeo, Lucas y Padilla was more or less self-taught and his work remained totally unacademic. Isolated from the general art scene, he concentrated in his early œuvre on impressions of Spanish life. Lucas y Padilla attracted public attention with dramatically agitated figure paintings. Largely scenes drawn from the revolution, the Inquisition, and bullfighting, these were in part copies, in part free reinterpretations of works by Goya and Velázquez. In 1852 he travelled to Paris where he got to know Edouard Manet. 1856 and 1898 he spent in Italy and studied, among others, the work of Giovanni Battista Tiepolo.

The fruits of a trip to North Africa in 1859 are Moroccan motifs reminiscent of Eugène Delacroix. Lucas y Padilla also painted romantic landscapes and church interiors which betray the influence of his brother-in-law Jenaro Pérez Villaamil with whom he often competed in his works.
Illustration:
125 The Defence of Saragossa, 1850–1855

MARKÒ the Elder, Kàroly
1791 Levoca, Slovakia – 1860 Florence

Initially trained by his father in engineering, the Hungarian artist began to study painting in Budapest and then, in 1822–1823, in Vienna. After ten years of activity in the capital of the Habsburg Empire he

went at the age of forty-one to Italy, where he would remain to the end of his life: 1832–1838 in Rome, followed by five years in Pisa, and, from 1843, in Florence and environs.

Early, topographically realistic depictions of the Hungarian countryside were followed, in Italy, by ideal Mediterranean landscapes with biblical and mythological elements, largely inspired by the major representative of this neoclassical genre, Claude Lorrain. These works earned the artist the nickname of the "Hungarian Claude." His suavely rendered views with their proliferating vegetation and atmospheric mood evinced a late Romantic approach, which would change hardly at all over the course of an almost thirty-year career. Internationally known during his lifetime and now unjustifiably nearly forgotten, Markò influenced great numbers of younger European painters.
Illustration:
116 Landscape with the Walk to Emmaus, 1845

MARTIN John
1789 Haydon Bridge, near Newcastle – 1854 Isle of Man

Martin came of an eccentric family. His eldest brother was an inventor and pamphleteer, and another brother set fire to the York Minster, completely destroying the roof of the choir, whereupon he spent the rest of his life in Bethlem Hospital.

John too occupied himself with more or less fantastic projects from early on, submitting suggestions for the development of a flexible iron ship, safety schemes for lighthouses and mines, and plans for London's water supply and sewers. Martin received his first artistic training in Newcastle, from the Italian painter Boniface Musso, then moved in 1806 to London, where for six years he earned his living as a glass painter. A confrontation with the works of William Turner proved crucial to his development. He was first represented at a Royal Academy exhibition in 1811. When, in 1814, his painting *Clythie* was ruined when varnish was accidentally spilled on it at the Academy, Martin became a sworn opponent of this institution. Still, he had his first great success there in 1816, with the canvas *Joshua Commands the Sun to Stop.*

The 1820s brought forth a series of paintings depicting scenes of disaster, set in infinite, visionary spaces and full of theatrical, nightmarish lighting effects. Their basic mood largely derived from the artist's involvement with John Milton's epic poem *Paradise Lost* and with the biblical Apocalypse. Despite huge public acclaim, the critics and the artist's colleagues remained unimpressed by these works, finding fault especially with their exaggerated and bombastic palette.

Due not least to this criticism, Martin reproduced the paintings in large-format engravings, which found approval even among experts. His trilogy on *The Last Judgement*, for instance, was posthumously engraved (1854) and sent on a touring exhibition through Europe and the United States, which continued into the 1870s.
Illustration:
71 Pandemonium, 1841

MICHAŁOWSKI Pjotr
1800 Kraków (Cracow) – 1855 Krzyztoporzyce, near Kraków

Michałowski studied the natural sciences and law from 1815–1820 in Cracow and from 1821–1823 in Göttingen in preparation for a civil service career, devoting himself to painting in his spare time, supplemented by a brief art course in Cracow in 1817/18. As a politician he undertook numerous trips abroad and participated in 1830/31 in the Polish November Rising (becoming a member of the Galician Sejm until 1848), after the failure of which he emigrated to Paris. He returned to art, copied Old Masters such as

Goya, Velázquez and seventeenth-century Dutch paintings, and acquainted himself with current developments in French art.

After a trip to London in 1835 he returned to Poland, where, interrupted by only a few further journeys, he spent the rest of his life. His predilection for equestrian and battle scenes went back to impulses from French Romanticism, especially from Delacroix and Géricault. Michałowski's œuvre also includes genre scenes from Polish folk life and excellent portraits. Stylistically it extends from Romantic idealization to an uncompromising realism.
Illustration:
116 The Battle of Somosierra, undated

MICHEL Georges
1763 Paris – 1843 Paris
A child prodigy, at age fifteen Michel began studying Dutch and Flemish Baroque masters in the Louvre, especially Salomon Ruisdael, Jan van Goyen, and Rembrandt. His early works correspondingly emphasized a naturalistic richness of detail, before a decisive change occurred around 1810–1815.

Michel began to discover the painterly potential of landscapes in the vicinity of Paris, especially Montmartre, then still a rural area dotted with windmills. The resulting straightforward landscapes, atmospheric in mood and romantic in

tone, combined the approach of old Netherlandish painting with a new and natural immediacy of observation and rendering which would make Michel a predecessor of the Barbizon School.
Illustration:
103 Landscape with Windmill, View from Montmartre, undated

MILLAIS Sir John Everett
1829 Southampton – 1896 London
Millais was one of the few artists of the day whose life and career were not marred by difficulties and enmities, and who was rewarded and honored in his lifetime. While attending the Royal Academy in London, he met William Holman Hunt and Dante Gabriel Rossetti and, sharing their contempt of contemporary English art and its academic rules, helped found the Pre-Raphaelite Brotherhood.

Setting out to convey lofty moral ideals and ideas through painting, the Pre-Raphaelites chose intense, imaginative scenes and rendered them with great fidelity to natural detail. Millais, preoccupied with social standing, later abandoned the Pre-Raphaelite style, broke with John Ruskin, the group's great supporter, and began to cater to popular tastes. Eventually he was made a baronet and became president of the Royal Academy.
Illustrations:
86 Christ in the House of his Parents, 1849/50
87 Ophelia, 1852

MILLET Jean-François
1814 Gruchy (near Gréville) – 1875 Barbizon
The son of a Normandy peasant, Millet received his first art training in Cherbourg. A civic scholarship enabled him to go to Paris and work in the studio of the history painter Paul Delaroche from 1837 to 1839. Subsequently he eked out

a living by selling portraits and pictures of gallant scenes in the Rococo manner.

Between 1841 and 1845 he lived in Cherbourg, a town he would often return to later in life. It was here, and also in Le Havre, that Millet produced his few seascapes. In 1849 he joined the Barbizon School and lived in relative poverty at Barbizon in the company of Constant Troyon, Diaz de la Peña, Jules Dupré and Théodore Rousseau. The early 1850s brought the discovery of his true *métier*, the depiction of peasant life.

Millet's best-known pictures date from this period, including *The Sower* (1850; Boston, Museum of Fine Arts), a success at the Salon in 1851; *The Sheavers* (1850) and *The Gleaners* (1857; both Paris, Musée du Louvre); and *The Angelus* or *Evening Prayer*. Though the hardships of peasant life were depicted here, it was not in the rational and unemotional manner of Gustave Courbet.

Rather, Millet endowed the frugal existence of these people with an almost religious solemnity, placing the large, silent figures in a twilight atmosphere that evokes "true humanity full of great poetry" in the peasants' plight. Though he received a prize at the 1867 Paris World Fair, Millet found little general recognition. His social conscience made him suspect, and his works were often considered sentimental. They nevertheless exerted a great influence on the development of Realism, in particular on Camille Pissarro and Vincent van Gogh. At an auction in 1889 his *Angelus* drew the sensational price of 553,000 francs.
Illustration:
30 The Angelus (Evening Prayer), c. 1858/59

MINARDI Tommaso
1787 Faenza – 1871 Rome
A painter, illustrator, and author, Minardi began his career as a pupil of Giuseppe Zauli. His initial activ-

ity in Rome consisted in ten years of employment with the engraver Giuseppe Longhi, for whom he did reproduction drawings of Michelangelo's *Last Judgement* in the Sistine Chapel; in addition he studied the works of Leonardo and Raphael. In 1819, on behest of the neoclassical sculptor Antonio Canova, Minardi was named director of the Academy in Perugia. From 1821 to 1858 he was employed as an instructor at the Accademia di San Luca in Rome.
Illustration:
122 Self-Portrait, 1807

MORRIS William
1834 Walthamstow (Essex) – 1896 London
Born into a well-to-do family, Morris studied in 1853–1855 at Exeter College, Oxford, where Edward Burne-Jones was a fellow student. But instead of continuing to devote himself to theology, he pursued his interest in art and history, being especially intrigued by the Middle Ages and Gothic architecture. After several journeys through England, Belgium, and France, and a brief study of architecture, under the influence of Dante Gabriel Rossetti he attempted a career in painting in 1857/58. This proving untenable, Morris turned to the field of arts and crafts, which he would spend his life attempting to reform.

In 1861 he became co-founder of the firm of Morris, Marshall,

Faulkner & Co., which he ran on his own from 1875. His final great enterprise was the creation, in 1890 in Hammersmith, of the Kelmscott Press, which subsequently exerted an enormous influence on Art Nouveau book design. Advancing in 1883 to become one of the leaders of the English Socialist movement, Morris attempted to counter the negative effects of capitalism on society, manufacturing, and art by championing utopian political and aesthetic ideas and projects.
Illustration:
83 Queen Guinevere, 1858

MOUNT William Sidney
1807 Setauket, New York –
1868 Setauket
William Mount was apprenticed to his brother, Henry, a sign painter, in 1824. After attending the National Academy of Design he returned in 1827 to his home on Long Island, where he spent the next two years. Until 1836 he made his livelihood as a portrait painter in New York, but it was depictions from contemporary life, now considered quintessentially American folk scenes, that established his reputation.

Mount was one of the first American artists to work out of doors. His fresh, well-nigh impressionistic style and straightforward composition brought rapid fame, and his works were soon disseminated in mass-produced reproductions. Mount held open house for a circle of writers and painters at his farm, Stony Brook. In the 1850s, when his creativity began to decline, he devoted himself increasingly to spiritualism.
Illustration:
128 The Horse Trade, 1835

NEUREUTHER Eugen Napoleon
1806 Munich – 1882 Munich
Son and pupil of the Palatinate-born landscape, portrait, and folk costume painter Ludwig Neureuther, Eugen enrolled in the Munich Academy in 1823. There he was furthered by Peter von Cornelius, who also entrusted him with ornamental work on his frescoes at the Munich Glyptothek.

The year 1830 found Neureuther in Paris, and 1836/37 in Rome. From 1847 to 1856 he headed the porcelain factory at Nymphenburg outside Munich, and from 1868 to 1876 held a professorship at the Munich School of Decorative Art. His late Romantic, lyrical drawing style influenced the work of Moritz von Schwind.
Illustration:
20 Cinderella, 1861

OEHME Ernst Ferdinand
1797 Dresden – 1855 Dresden
In 1819 Oehme enrolled at the Dresden Academy and worked in Johan Christian Clausen Dahl's studio, but just a year later came under the crucial influence of Caspar David Friedrich. In the summer of 1820 he was in Salzburg, then travelled in Italy in 1822–1825, where the art of Joseph Anton Koch left a lasting impression on him. The following years brought friendships with many artist-colleagues, including Moritz von Schwind. Oehme served as court

painter from 1825, and in 1846 was accepted into the Dresden Academy.
Illustrations:
45 Cathedral in Wintertime, 1821
45 The Greifensteine in the Saxon Erzgebirge, 1840

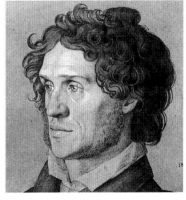

OLIVIER Ferdinand Johann Heinrich
1785 Dessau – 1841 Munich
In Dessau, Olivier devoted himself to the graphic arts, but a stay in Dresden, in 1804–1806, encouraged a turn to ideal and Romantic landscape painting. After a period in Paris from 1807–1810 he moved to Vienna, where he met Joseph Anton Koch. In 1830 he went to Munich, becoming secretary of the Academy and professor of art history.

Olivier's style was initially strongly influenced by the early German Romanticism of Caspar David Friedrich and Philipp Otto Runge, and later by the art of the Nazarenes. His reputation rested to a great extent on a portfolio of lithographs, Seven Areas from Salzburg and Berchtesgaden, 1817, with which he discovered these regions for art. Their sensitive, lucid drawing and sincere depth of feeling made these prints into a major work of German Romanticism.
Illustration:
52 The Holy Family on a Working Day, 1817

OVERBECK Johann Friedrich
1789 Lübeck – 1869 Rome
Overbeck, from an upper-class Lübeck family, is generally regarded as the founder of German Romantic art. Thanks to a study of Italian and German late medieval and Renaissance painting, he became disenchanted with instruction at the Vienna Academy, where he had enrolled in 1806.

In 1809, he and his like-minded friend Franz Pforr founded the

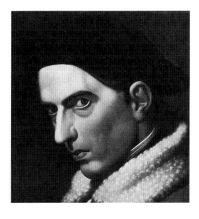

"Lukasbund," or St. Luke's Brotherhood (named after the patron saint of painters), the first modern association of artists. Their goal was to revive the religious basis of art and the honest craftsmanship of the Middle Ages. The Protestant members of the group, including Overbeck, converted to Catholicism. Before the year was out the young artists severed connections with the Academy and went to Rome, where they found refuge at the monastery of San Isidoro.

Their long hair prompted the Italians to make fun of them as "Nazarenes," a nickname that soon came to describe the movement they initiated. The group's first commission came from Consul Bartholdy, Prussian consul in Rome, to decorate the Casa Zuccaro with frescoes on the theme of the Old Testament story of Joseph. Decoration of the Casino Massimo with scenes from the *Liberation of Jerusalem* by Torquato Tasso was the next project, completed in 1827. Subsequently the group dispersed, and Overbeck was the only one to remain in Rome.
Illustration:
55 Italia and Germania (Shulamit and Mary), 1828

PALMER Samuel
1805 London – 1881 Reigate (Surrey)
Although he took drawing instruction from William Wate, a painter of conventional watercolor landscapes, Palmer was essentially self-taught. In 1822 he came in contact with John Linell, an artist-friend and patron of William Blake, who two years later introduced him to this shaper of fantastic visions. Blake became Palmer's key source of inspiration. In Shoreham, Kent, he collaborated from 1826 to around 1835 with other admirers of Blake and his mystical view of nature, including Edward Calvert and George Richmond. The group called themselves "The Ancients,"

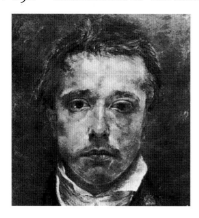

reflecting their belief in the superiority of ancient over modern man. After this phase Palmer returned to topographic watercolors based on travel impressions gained in Devon and Wales.

In 1837 he married Linell's daughter and then travelled in Italy until 1839. After his return he lived first in London, then, from 1861 onwards, in Surrey. Palmer devoted himself primarily to the watercolor medium, but also worked in pen-and-ink and did a few oils, as well as producing etchings from 1850 onwards. His style can be described as a visionary late Romanticism which, in the later phase, was occasionally marred by sentimentality.
Illustration:
77 Coming from Evening
 Church, 1830

PARS William
1742 probably London –
1782 Rome
The landscapist Pars attended a drawing school in the Strand until 1761, when his brother Henry took over its management and made William his assistant. In 1764 he accompanied Richard Chandler and Nicholas Revett to Asia Minor as a draughtsman, executing precise topographical sketches of classical sites. In the same capacity Pars became one of the first British artists to visit Greece.

The year 1770 took him to Italy as the companion of Lord Palmerston. The following year he travelled through Switzerland, executing watercolors of Alpine scenery. In 1775, in the name of the Society of Dilettanti, Pars returned to Rome, where he met a number of other British artists and would remain for the rest of his life.
Illustration:
14 The Rhône Glacier and
 the Source of the Rhône,
 c. 1770/71

PÉREZ VILLAAMIL Jenaro
1807 El Ferrol, La Coruña –
1854 Madrid
After cadet training in Santiago, Pérez Villaamil studied literature in Madrid. While serving as a military officer he was captured and taken as a prisoner of war in 1823 to Cadiz, where he subsequently turned to art and attended the Academy. His rapidly rising reputation brought a commission in 1830 for the interior decoration of the Tapia Theater in San Juan, Puerto Rico (Caribbean). In 1833 he returned to Spain and, in Seville, met the Scottish artist David Roberts, who acquainted him with British Romantic landscape painting. He would remain beholden to this style throughout his career, occasionally supplementing it with exotic, oriental motifs, and later coming under the influence of John Martin and William Turner. He settled in Madrid in 1834 and became an honorary member of the Royal Academy of San Fernando.

Increasing success brought many honors in its wake, especially in France and Belgium; the works he exhibited at the 1846 Paris Salon elicited the highest praise from Charles Baudelaire. Indeed Pérez Villaamil, who from 1845 served as professor of landscape painting at the Academia di San Fernando, can be considered the most significant Spanish landscapist of the Romantic era.
Illustration:
126 Herd of Cattle Resting on
 a Riverbank in Front of a
 Castle, 1837

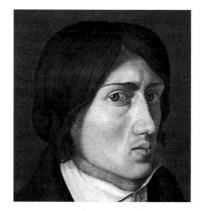

PFORR Franz
1788 Frankfurt am Main –
1812 Albano
From 1805 Pforr attended the Vienna Academy, where he and Johann Friedrich Overbeck, Joseph Wintergerst, Ludwig Vogel, Johann Konrad Hottinger, and Joseph Sutter in 1809 founded the "Lukasbund," or St. Luke's Brotherhood, an anti-academic group dedicated

to a renascence of German art out of the spirit of religion. After arriving in Rome in 1810, Pforr initially lived at Villa Malta, then moved with other members of the group into an abandoned monastery, S. Isidoro.

In 1811 he travelled to Nemi and Naples, and in 1812 to Albano, where tuberculosis ended the young life of one of the most outstanding representatives of Nazarene art.
Illustrations:
53 Entry of Emperor Rudolf of
 Habsburg into Basel in 1273,
 1808–1810
54 Shulamit and Mary, 1811

PIRANESI Giovanni Battista
1720 Venice, or Mogliano,
near Mestre – 1778 Rome
Piranesi came of a family of respected artisans and architects. In about 1734 he decided to pursue an architectural career, but soon thereafter entered the Venice studio of Carlo Zucchi, a teacher of perspective, stage architect, draughtsman, and etcher. In 1740 the Serenissima sent Marco Foscarini as an emissary to Rome, and the young Piranesi accompanied him as draughtsman. Here he became intrigued with the beauty of ancient ruins, and worked for the brothers Domenico and Giuseppe Valeriani on theater scenes, festival decorations, and architectural designs. He also attended classes with the late Baroque architects Nicola Salvi and Luigi Vanvitelli and perfected his etching technique in the studio of Giuseppe Vasi.

In 1743 Piranesi published his first series of prints, *Prima parte di architettura e prospettive*. The following year found him back in Venice, where he very likely worked in Tiepolo's workshop and studied his etching methods. In 1745 he settled permanently in Rome, marrying Angelica Pasquini, the daughter of the gardener of Principe Corsini, in 1752. Of the couple's eight children, Laura, Francesco

und Pietro would later work in their father's printing shop and continue his business until the early years of the nineteenth century. Piranesi's etchings, depicting the buildings of contemporary Rome, but above all the ancient remnants of the Eternal City, with a combination of antiquarian fidelity to detail and fantastic exaggeration, soon made him famous far beyond Italy's borders.

In 1757 he was made a corresponding member of the London Society of Antiquaries, in 1761 a member of the Accademia di San Luca in Rome, and from 1758 enjoyed the patronage of Pope Clemens XIII. In 1764 he was commissioned by Cardinal Rezzonico, Grand Master of the Knights of Malta, with the conversion of S. Maria del Priorato on the Aventin and with the redesign of the Piazza de Cavalieri di Malta. In 1767 the pope made him Cavaliere degli Speroni d'Oro, and in parallel Piranesi completed his conversion plans for S. Giovanni in Laterano. The final years of his life were spent on archaeological excursions to Tivoli, Paestum and Naples, with special attention to excavations at Pompeii. Above all with the two editions of his etching portfolio *Carceri*, depictions of dungeons whose spaces eerily interpenetrated in ways that defied perspective logic, Piranesi became a forerunner of "black" or "Gothic" Romanticism.
Illustration:
12 Carceri, Title page
 (second version), 1761

PRUD'HON Pierre Paul
1758 Cluny – 1823 Paris
Prud'hon began his career at the Dijon Academy under François Devosge and continued his studies at the Paris Academy. In 1784 he won the Prix de Rome, which took him to Italy from 1785 to 1788. Although this period coincided with David's triumphs in Rome, Prud'hon remained unimpressed by

his countryman's neoclassicism. He became a friend of the sculptor Antonio Canova and studied the art of antiquity, but was most lastingly influenced by the Renaissance masters, especially Leonardo and Correggio.

On his return to France he settled in Paris, supporting himself with the sale of drawings and miniatures. His first important commission came in 1798, for a ceiling painting in the palace of Saint-Cloud. This was followed by similar orders, devoted to allegorical themes. The Empress Joséphine was his most influential patron, and Prud'hon became the portrait painter of the royal family.

Napoleon's second wife, Marie-Louise, also admired his work, securing many commissions for him and employing him as her drawing master. In an art scene dominated by austere neoclassicism Prud'hon held a rather isolated position, yet his sensitive handling of color and composition helped to usher in Romanticism.

Illustrations:

94 Justice and Divine Vengeance Pursuing Crime, 1804–1808

95 Empress Joséphine at Malmaison, 1805

RAMBOUX Johann Anton
1790 Trier – 1866 Cologne
The career of the history painter, lithographer, restorer, and art collector Ramboux began in 1807 in Paris, where until 1812 he collaborated with the great neoclassicist Jacques-Louis David. In 1815 he travelled to Munich, attended the Academy there, and executed portraits in a style derived from Albrecht Dürer and Hans Holbein the Younger.

Arriving in Rome in 1816, he spent the following six years in the company of the Nazarenes and devoted himself to copying early Italian Renaissance works. After returning to Germany he settled in Trier in 1822. The years

1832–1844 found him in Italy once again. In 1843 Ramboux made 288 watercolor copies after Old Masters for the Düsseldorf Academy, and in 1844 took a post as conservator at the Wallraf Collection in Cologne. A pilgrimage to Jerusalem followed in 1854. Ramboux's œuvre, in addition to accomplished oils and watercolors, includes a series of Gobelin designs.

Illustration:

58 Adam and Eve after Expulsion from Eden, 1818

RICHTER Ludwig
(Adrian Ludwig Richter)
1803 Dresden – 1884 Dresden
The son of a copper engraver, Richter made a name for himself with wood-engraving illustrations for books of fairy-tales, folklore, and traditional songs. He began to work in this field in 1838 and retained an interest in it until the end of his life. Initially wishing to become a landscape painter, he was granted a scholarship to Rome by Herr Arnold, a Dresden book dealer, in 1823. In Rome he met Joseph Anton Koch and the Nazarene artists, and produced idyllic Italian landscapes.

Back in Dresden, Richter was appointed professor of landscape painting at the Academy in 1836. Being unable to obtain funding for a second trip to Italy, however, he began to expand his repertoire of subjects beyond pure landscape. Richter took his students on walking tours through the Elbe Valley and parts of Bohemia, making studies on which to base finished compositions. Here he evidently found what he had been searching for in his Italian landscapes: harmony between man and nature. Richter's last oil dates from 1847.

Illustrations:

64 The Church at Graupen in Bohemia, 1836

64 Pond in the Riesengebirge, 1839

65 Crossing at the Schreckenstein, 1837

ROBERT Léopold
1794 Les Eplatures, Canton of Neuchâtel – 1835 Venice
A native of Franco-Switzerland, Robert trained in business before going to Paris in 1810, where he intially studied printmaking and then spent five years in the atelier of the neoclassical artist Jacques-Louis David. In 1816 he returned to Switzerland, then moved to Italy in 1818. Interrupted only by a few journeys, he remained in Rome until 1832, and lived thereafter in Venice. He made the aquaintance of the Bonaparte family. Only three years after arriving in Venice, Robert took his own life.

While in Italy he devoted himself principally to depictions of folk life and brigands, but also executed views, interiors, and idealized portraits of women and girls in which neoclassical reminiscences blended with French Romanticism. His major work was a four-part cycle on the seasons in the four great regions of Italy, three of which are now in the Louvre in Paris and one in the Museum of Neuchâtel.

Illustration:

109 The Arrival of the Scythers in the Pontine Marshes, 1830

ROSSETTI Dante Gabriel
(Gabriel Charles Rossetti)
1828 London – 1882 Birchington-on-Sea (Kent)
Rossetti's father was a Dante scholar who was forced to leave his native

Italy because of his liberal political attitude. Rossetti began his training in 1843, studying from 1846 at the Royal Academy Schools in London.

He then worked with William Holman Hunt and Ford Madox Brown, and in 1848 became a co-founder of the Pre-Raphaelite Brotherhood. Most of his work was produced in the spirit of this movement, despite his leaving it at an early date. Many of his themes were taken from Dante or the *Morte d'Arthur*, and treated with strong overtones of symbolism. In his later period Rossetti concentrated on studies of single, allegorical female figures.

Illustrations:

88 Ecce Ancilla Domini! (The Annuciation), 1849/50

88 The Beloved (The Bride), 1865

89 Proserpine, 1874

ROTTMANN Carl
1797 Handschuhsheim (near Heidelberg) – 1850 Munich
Rottmann came of a family of artists, which brought early contacts with other Heidelberg painters. In 1821 he began courses in history painting at the Munich Academy, and went on excursions in the Bavarian mountains to do nature studies. Sojourns in Italy, 1826–1828, and again in 1829, introduced him to the Roman manner of open-air painting. A key event for his development was his meeting with the Bavarian crown prince, the future King Ludwig I, who lived in Rome. Ludwig commissioned Rottmann to paint the *Italian Cycle* in the Munich Hofgarten Arcades (1830–1833), a series of frescoes depicting Italian landscapes, which would remain a favorite subject.

Another major work was the *Greek Cycle*, based on studies made during a visit to Greece in 1834–1835 and destined for the Neue Pinakothek in Munich. These were done in encaustic

(a technique employing heated wax colors that fused after application), and Rottmann worked on them until his death. In these landscapes, the architectonic structure of rigorous, classical composition is combined with a dramatic treatment of color, expressed through light and other natural phenomena.

Illustrations:
60 View of the Eibsee, 1825
61 Taormina with Mt. Etna, 1828/29
61 Sicyon with Corinth, c. 1836–1838

concentrated on wooded scenery and trees, rendered realistically and yet atmospherically in their seasonal and diurnal changes. Long before Claude Monet, he captured one and the same motif at different times of day. For many years Rousseau's pictures were rejected by the Salon, and not until the 1850s did he begin to have a degree of success. Although his friends, the Barbizon painters Jules Dupré and Constant Troyon, gained more public recognition, Rousseau was the true spiritual leader of this artists' colony.

Illustration:
109 The Chestnut Lane, 1837

formed the basis for Runge's metaphysical treatment of light and color, supplemented by symbolic elements drawn from Protestant Baroque mysticism.

Illustrations:
21 St. Peter on the Sea, 1806/07
35 The Lesson of the Nightingale (second version), 1804/05
35 Rest on the Flight into Egypt, c. 1805/06
36 The Hülsenbeck Children, 1805/06
36 The Artist's Parents, 1806
37 Morning (first version), 1808

Rede Lecturer in Cambridge, and from 1869–1884 a professorship of fine arts in Oxford. His watercolors and drawings, for the most part depicting architectural details or rock formations, mountains and plants, were exhibited from 1873 to 1884 at the Old Water-Colour Society.

Ruskin was the most influential art critic of the Victorian Era, an opponent of capitalist industrialization, and an ardent admirer of Gothic art. He founded a museum and a drawing school in Oxford, and in Meersbrook inaugurated a night school for craftsmen, making him a pioneer of the decorative and applied art education movement. Towards the end of his life Ruskin increasingly suffered from a severe nervous illness.

Illustration:
83 Cascade de la Folie, Chamonix, 1849

ROUSSEAU Théodore
(Pierre Etienne Théodore Rousseau)
1812 Paris – 1867 Barbizon
At the age of ten, Rousseau had already begun to draw outdoors, in the Bois de Boulogne. In 1829 he became a pupil of Charles Rémond at the Ecole des Beaux Arts in Paris. In the Louvre he copied the works of Claude Lorrain and the Dutch Masters and studied recent British artists, including John Constable and Richard Parkes Bonington. He also painted outdoors and was probably the first to work in the woods of Fontainebleau.

Rousseau first became known in Paris with nature studies executed in the Auvergne, where he stayed in 1830. He travelled extensively to depict French landscapes, visiting Normandy, Brittany, Provence, the Jura region and the Vendée. From 1836 he painted regularly in Barbizon, a village near Fontainebleau, spending nearly all his time there between 1848 and 1863. In 1867 he served as chairman of the painting selection committee at the Paris World Fair.

Rousseau's enthusiasm was reserved for nature: "To hell with the civilized world! Long live nature, the forests, and the poetry of old," he declared. His determined effort to save the Compiègne Forest resulted in the formation of the first nature conservation movement in the world. His work not suprisingly

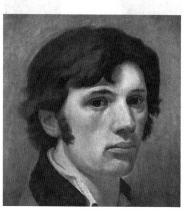

RUNGE Philipp Otto
1777 Wolgast (Pomerania) – 1810 Hamburg
Runge's father was a grain merchant and shipowner. In boyhood Runge already displayed an extraordinary talent at cutout silhouettes. His brother Daniel greatly furthered his career, introducing him to artists and financially supporting him through his Hamburg trading company. After attending the Copenhagen Academy, 1799–1801, Runge visited Caspar David Friedrich at Greifswald and went to Dresden. He immersed himself in the works of the poet and dramatist Ludwig Tieck, whom he visited in Berlin. He fell in love with Pauline Bassenge, a love that would prove fundamental to him not only personally but artistically. After their marriage in 1804, the couple returned together to Wolgast. Runge often suffered from illhealth, and from 1807 he and his family lived with his brother in Hamburg.

In Runge's drawings, etchings and paintings, real objects serve as mere physical embodiments of a metaphysical world imbued with the spirit of God. Here, matter and light represent two different levels, the material and the immaterial, of an all-embracing spiritual unity. His investigations into color theory

RUSKIN John
1819 London – 1900 Coniston, Lake District
In boyhood the future author, art critic, and artist accompanied his well-to-do parents on long travels through England and on the Continent, especially to Switzerland and to the Rhineland. After attending Christ Church College in Oxford, he made his first journey to Italy in 1840, for reasons of health. He would continue to travel extensively into old age, spending many years in Switzerland and Italy. Having met Turner on his first Italian trip, Ruskin defended his work against its many critics in 1843 in the first volume of *Modern Painters* (followed by four more volumes, published until 1860). Soon, however, the work burgeoned into a general theory of art.

Numerous other writings were devoted to architecture (*Seven Lamps of Architecture*, 1849; *The Stones of Venice*, 1851–1853, – both illustrated by Ruskin himself), to geology, politics, and social issues, the last of which he stroved to place on a more humane basis through utopian social projects inspired by the example of medieval guilds. In 1851 the London *Times* published two letters by Ruskin defending the art of the Pre-Raphaelites. From 1867 he held the post of

SCHADOW Wilhelm von
1788 Berlin – 1862 Düsseldorf
Son of the neoclassical sculptor Gottfried Schadow, Wilhelm entered the painting class of Ferdinand Georg Weitsch at the Berlin Academy in 1808. From 1811 to 1819 he lived in Rome, joining the St. Luke's Brotherhood – the Nazarene group – in 1813 and converting to Catholicism in 1814.

Schadow collaborated on the frescoes in Casa Bartholdy in 1816/17. In 1819 he became professor at the Berlin Academy, and in 1826 assumed a corresponding post in Düsseldorf. Several journeys to Rome served to intensify Schadow's reliance on the model of classical Italian painting. He was nobilitated in 1845.

Illustration:
59 Pietas and Vanitas, 1840/41

SCHINKEL Karl Friedrich
1781 Neuruppin – 1841 Berlin
A pupil of the architect Friedrich Gilly and a student at the Bauakademie, or Building Academy, in Berlin, Schinkel developed a neoclassical architectural style that materially shaped the face of Berlin in the first half of the nineteenth century. A journey to Italy in 1803–1805 took him to Rome, Naples, and Sicily. In Rome he met Wilhelm von Humboldt and the artists Gottlieb Schick and Joseph Anton Koch.

His own landscapes and architectural depictions evinced Schinkel's lasting interest in medieval buildings and romantic scenery, which supplemented his basic neoclassical vocabulary. While serving as chief building supervisor in Berlin from 1815, he made a crucial contribution to the field of maintenance of public and national monuments.
Illustrations:
51 Set Design for "The Magic Flute:" Starry Sky for the Queen of the Night, 1815
51 Gothic Cathedral by the Waterside, c. 1813/14

SCHNORR VON CAROLSFELD Julius
1794 Leipzig – 1872 Dresden
Schnorr received first instruction from his father, Veit Schnorr, who was then director of the Leipzig Art Academy. In 1811 he studied at the Vienna Academy with Heinrich Friedrich Füger, but oriented him-

self more to the work of Ferdinand Olivier and Joseph Anton Koch, which brought him in contact with the Romantics. After joining the St. Luke's Brotherhood in 1817, he travelled to Italy. Associating with the Nazarenes, especially Overbeck and Cornelius, Schnorr collaborated on their fresco decorations in Casino Massimo.

In 1827 King Ludwig of Bavaria called him to the Munich Academy and commissioned him to decorate the Residence with frescoes from the sagas of the Nibelungen and scenes from the lives of Charlemagne, Friedrich Barbarossa, und Rudolf von Habsburg – a project that would extend over four decades. In 1846 the artist became director of the Gallery of Painting and professor at the Academy in Dresden. Schnorr's style represents the Nazarene approach in perhaps its purest form.
Illustration:
53 Portrait of Clara Bianca von Quandt, c. 1820

SCHWIND Moritz von
1804 Vienna – 1871 Niederpöcking (on Starnberger See)
The son of a high court official in Vienna, von Schwind studied philosophy there until 1821, then spent two years at the Vienna Academy, where he was influenced particularly by Schnorr von Carolsfeld. He also was a friend of the Olivier brothers and frequented the musical circle around Franz Schubert. After meeting Peter von Cornelius in Munich in 1827, he moved to that city the following year, and in 1832 was entrusted with the decoration of the Tieck Room in the Royal Residence. After an Italian journey in 1835, von Schwind devoted himself to fresco designs for Hohenschwangau Castle.

In 1840 he moved to Karlsruhe, then resettled in 1844 in Frankfurt am Main. A professorship at the Munich Academy followed in 1847. A commission from the Weimar Court for frescoes in the Wartburg

occupied him from 1853 to 1855, and from 1863 to 1867 he was involved in the decoration of the Vienna Opera. Von Schwind can be characterized as a typical representative of literary oriented late Romanticism in Germany.
Illustrations:
66 Fairy Dance in the Alder Grove, c. 1844
66 A Hermit Leading Horses to the Trough, c. 1845

SCOTT David
1806 Edinburgh – 1849 Edinburgh
David Scott was the son of a copper engraver, and his brother, William Bell Scott, likewise occupied himself with painting, though he became better known as a poet and friend of Dante Gabriel Rossetti. After training in graphic art, David turned to painting in about 1826, and in 1829 was accepted into the Scottish Academy. In 1832 he went to Italy, spending over a year in Rome before returning to Edinburgh in 1834. One his most important sources of inspiration was the work of William Blake, but Scott was also cognizant of the latest developments in Europe. He admired the French neoclassicist Jacques-Louis David and was influenced in Rome by the German Nazarenes. His submission of fresco designs to a competition for the Houses of Parliament in 1845 met with no success. Four years later Scott died in Edinburgh after a long illness.
Illustration:
82 Russians Burying their Dead, 1831/32

SONNTAG William Louis
1822 near Pittsburgh – 1900 New York
Sonntag grew up in Cincinnati and, after largely teaching himself painting, remained active as a landscapist there until 1853. An initial Euro-

pean trip in 1853/54, undertaken with another native of Cincinnati, the black painter Robert S. Duncanson, probably included a stay in Italy. A visit to Florence followed two years later. A further, unconfirmed Italian journey may have followed in 1860/61, but in 1862 Sonntag was definitely active in Florence, for the last time.

In addition to his European travels, the artist undertook numerous excursions from New York, where he resided from 1854 onwards, to the mountains of Maryland, Virginia, Vermont, und New Hampshire. In 1861 he became a member of the National Academy of Design. His œuvre of over 400 paintings comprises romantically tinged American landscapes and a few classical landscapes with Italian motifs, influenced by Claude Lorrain.
Illustration:
129 Classical Italian Landscape with Temple of Venus, c. 1858

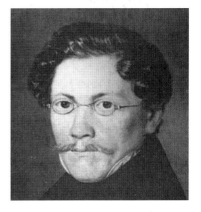

SPITZWEG Carl
1808 Munich – 1885 Munich
Spitzweg is still one of the most popular German artists of the nineteenth century. An apothecary by profession, he began to teach himself painting in the 1820s. Most of his pictures have a humorous side, evoking the yearnings for higher things of people with rather limited horizons, whether mental or financial. Thus Spitzweg's aspiring poet in his leaky garret, or the portly, elderly widower ogling a passing young girl. In 1851 Spitzweg travelled with his Munich artist friends to Paris and then London, where John Constable and the works of the Barbizon School left a lasting impression on him. He began increasingly to concentrate on landscapes, exploring the open brushwork technique developed in Barbizon. From then on his figures tended to become incidental, mere witty asides rather than the main focus of the composition.

Illustration:
67 The Poor Poet, 1839

STANFIELD Clarkson
1793 Sunderland – 1867 London
Stanfield was employed as a seaman
before becoming a theater set
painter in 1818. In about 1823 he
began to concentrate on fine art,
specializing in marine pieces and
coastal scenes. In 1829 and 1839 he
travelled through Europe, spending
much of his time on the coasts of
Holland and Belgium, but going
to Naples and Venice as well. Such
travel impressions were also the
source of a portfolio of lithographs
published in 1838 under the title
*Sketches on the Moselle, the Rhine
and the Meuse*, in which typically
Romantic motifs played the prime
role.
Illustration:
76 Burg Eltz, 1838

TURNER William
(Joseph Mallord William Turner)
1775 London – 1851 London
Turner was only fourteen years old
when he was admitted to the Royal
Academy Schools. He started his
career by painting watercolors and
producing mezzotints under the
strong influence of John Robert
Cozens's work. Then, in 1796, he
launched into oil painting, working
in the neoclassical manner of
Richard Wilson and Nicolas
Poussin, with results that found

wide acclaim. One of the most pro-
lific painters of his time, Turner
travelled extensively in England,
Scotland and Ireland, and also on
the Continent (France, Belgium,
Holland, Germany, Italy).
 The year 1802 saw his first visit
to Paris, where he studied the Old
Masters in the Louvre, above all
Dutch seascapes and Claude Lor-
rain's compositions, which lastingly
influenced him. Turner's first pri-
vate showing, at his own house, fol-
lowed in 1804. During this period,
thanks to an increasing concentra-
tion on the atmospheric effects of
light, his original style began to
evolve, a process that culminated
during trips to Italy in 1819 and
1829.
 Like the works of Constable,
Turner's seemingly effortless water-
colors and oil sketches were based
on impressions of nature, as for
example the series of landscapes
painted from a boat on the Thames
in 1807. But his perception of the
world differed vastly from Con-
stable's. Turner's pictures transcend
ordinary appearances, conveying a
visionary sense of the forces at work
in the universe.
 In his atmospheric depictions of
shipwrecks and natural disasters,
perhaps inspired by such works as
The Battle of Trafalgar by Philippe
Jacques de Loutherbourg, who lived
in Turner's neighborhood, reality
and fantasy merge, and color is used
to metaphorically evoke the power
of natural phenomena. By abandon-
ing form or merely adumbrating it,
Turner lent color autonomy and en-
dowed it with a puissance of its
own. This achievement was to prove
especially influential on twentieth-
century art.
Illustrations:
13 Venetian Festival, c. 1845
78 Snowstorm – Steam-Boat off
 a Harbour's Mouth Making
 Signals in Shallow Water, and
 Going by the Lead. The Au-
 thor was in this Storm in the
 Night the Ariel left Harwich,
 1842
78 Peace – Burial at Sea, 1842
79 The Fighting Temeraire
 Tugged to her Last Berth to
 be Broken up, 1838
80 Snowstorm. Hannibal and his
 Army Crossing the Alps,
 c. 1810–1812
80 Rain, Steam and Speed – The
 Great Western Railway, 1844
81 Light and Colour (Goethe's
 Theory) – The Morning after
 the Deluge – Moses Writing
 the Book of Genesis,
 1843
81 Shadows and Darkness –
 The Evening of the Deluge,
 1843

VEIT Philipp
1793 Dresden – 1877 Dresden
Together with his brother, Johan-
nes, Philipp Veit began his art
training in 1809–1811, with
Johann Friedrich Matthaei in
Dresden. At the home of his step-
father, Friedrich Schlegel, he made
the acquaintance of Joseph Anton
Koch and a number of Romantic
artists.
 In 1815 he journeyed to Rome
and a year later was accepted into
the St. Luke's Brotherhood. With
other Nazarene artists he was in-
volved in fresco work at Casa
Bartholdy in 1816/17, and in the
decoration of Casino Massimo in
1818–1824. In 1830 Veit became
director of the Städelsches Kunst-
institut (Municipal Art Institute)
in Frankfurt am Main, for whose
new building he designed a fresco
cycle. In 1854 he was named direc-
tor of the City Gallery of Mainz.
Illustrations:
56 Italia: Introduction of the
 Arts through Christianity,
 completed 1833
56 Germania, 1848

**VENEZIANOV Alexei
Gavrilovitch**
1780 Moscow – 1847 Poddubye,
Gouvernement Twer (now Oblast
Kalinin)
After moving to St. Petersburg in
1802, Venezianov was employed as
an engineer and city official, and
painted in his spare time. It was not
until his retirement in 1819 that he

was able to devote himself exclu-
sively to art. While his portraits
from the first two decades of the
nineteenth century were marked by
a sentimental neoclassicism, the
concurrent drawings tended more
towards a sober and straight-
forward realism. In 1808
Venezianov founded a satirical
magazine, *Journal of Caricature*,
which was soon banned by the cen-
sors, and in 1812/13 he published
a series of etchings on political
subjects.
 In 1819 he left St. Petersburg
to settle at his country estate,
Safonkovo. The following two
decades saw the emergence of his
major works – primarily genre
scenes that made Venezianov the
first Russian artist to take an inter-
est in the life of the serfs, and that
prepared the ground for the heyday
of Russian Realism in the latter
half of the century. Especially out-
standing were portraits of peasants,
redolent of dignity and self-confi-
dence. The artist established a
painting and drawing school in
Safonkovo whose students came
from the region and in many cases
had first to be redeemed from serf-
dom by Venezianov before they
could attend.
Illustration:
114 Sleeping Shepherd Boy,
 1824

VERNET Claude-Joseph
1714 Avignon – 1789 Paris
Claude-Joseph Vernet was the most
outstanding marine painter of the
eighteenth century. After a modest
artistic training with his father and
with a second-rate painter in Aix, at
the age of twenty he went to Rome,
where he lived until 1753, becom-
ing in 1743 a member of the Ac-
cademia di San Luca and in 1753 a
member of the French Academy in
Rome. During this initial successful
period he married the daughter of a
British officer working as an agent
for English buyers, travelled to
Naples, and returned home on two
occasions.
 After finally settling in France in
1753, he travelled the country to
paint a series of large-format views
of fifteen harbor towns. In 1762 he
took up long-term residence in
Paris, where his celebrity brought
him entry into the most illustrious
circles of the day. His patrons in-
cluded English aristocrats, French
diplomats, and the international
nobility.
 Vernet's œuvre comprises far
more than a thousand oils and great
numbers of drawings. Many repre-
sent imaginary Neapolitan coastal

scenes illuminated by a rising or setting sun, nocturnal landscapes, and shipwrecks. There are also imaginary landscapes and mountain panoramas inspired by the environs of Rome and Tivoli, and topographical views of Naples, Rome, Tivoli, and regions of France. Claude-Joseph's style, frequently compared by his contemporaries to that of the great Claude Lorrain, was adopted by scores of pupils and imitators.

Illustration:

15 A Seastorm, 1752

VERNET Horace

1789 Paris – 1863 Paris

Horace Vernet was instructed in art by his father Carle, son of the renowned landscape and marine painter Claude-Joseph Vernet, and also studied with his maternal grandfather Jean Michel Moreau and with François André Vincent. After an Italian journey in 1820, he became an instructor of history painting in 1826 at the Académie des Beaux-Arts. From 1829 to 1835 he served as director of the French Academy in Rome. In the years after 1830 he enjoyed the favor of the new Paris regime and became the most popular artist in France. In this phase there emerged military and battle paintings – which brought him wide public acclaim under Louis Philippe, but which many critics rejected due to their hollow pathos – as well as portraits, oriental genre scenes, and satirical drawings. His illustrations to *Histoire de Napoléon* by Laurent l'Ardèches, published in 1839, became the model for Franz Kugler's *Geschichte Friedrichs des Großen* of 1840, illustrated by Adolph Menzel.

Illustration:

93 Mazeppa, 1826

WAGNER Carl

1796 Rossdorf an der Rhön – 1867 Meiningen

After studying forestry in Tharandt, Wagner took up painting and attended the Dresden Academy from 1817 to 1820. Though he frequented the circle of artists around Johan Christian Clausen Dahl, the work of Caspar David Friedrich did not remain without influence on him.

In 1821 he travelled to Switzerland, then spent the years 1822–1825 in Tyrol and Italy. After returning home Wagner became court painter and inspector of galleries in Meiningen.

Illustration:

50 Moonrise, 1821

WALDMÜLLER Ferdinand Georg

1793 Vienna – 1865 Hinterbrühl (near Vienna)

Waldmüller was the most important Viennese representative of the Biedermeier style. His main subjects were portraits and landscape, later supplemented by genre scenes. From 1807 he studied at the Vienna Academy, of whose gallery he would become curator in 1829, followed by a professorship. Though he was aware of the difficulty of surviving as a freelance artist – his wife, an actress, had previously supported him – in the 1840s he jeopardized the financial security of his academic position.

A dedicated realist, he attacked

the idealist doctrines of his colleagues in two polemical papers of 1846 and 1849. This resulted in his salary and pension being reduced, forcing Waldmüller to live in restricted circumstances in later years. Despite recognition outside Austria, he was not rehabilitated until 1864. Like his friend Franz Steinfeld, he was interested in the way daylight affected the perception of color. His landscapes are marked by a realism of almost photographic precision in which the effects of bright, direct sunlight play a key role.

Illustration:

67 The Emergency Sale (The Last Calf), 1857

WARD James

1769 London – 1859 London

After an apprenticeship with the engraver John Raphael Smith, Ward worked until 1791 with his brother William in a print publishing firm and developed into an outstanding mezzotint engraver, as which he was employed by the Prince of Wales. In about 1790, encouraged by his brother-in-law, the artist George Morland, he made his first essays in painting and soon developed an original style. Inspiration came from the work of George Stubbs and William Gilpin, but above all from the technique of Rubens, which Ward admired above all and began to study in 1803.

In 1792 he began to exhibit at the Royal Academy, whose member extraordinary he became in 1807, followed by full membership in 1811. Initially concentrating almost entirely on depictions of animals such as cattle and sheep, aimed at potential buyers among the landed gentry, Ward began to expand his repertoire in 1805 to include religious subjects, portraits of famous horses and their owners, and landscapes, most famously his enormous canvas depicting Gordale Scar. In later years he devoted himself largely to history paintings. The most ambitious of

these, the monumental *Triumph of Wellington*, was done for a British Institution competition and displayed in 1821 in the Egyptian Hall, but drew scathing criticism from both public and press. Ward died embittered and impoverished, dependent on a Royal Academy pension.

Illustration:

76 Gordale Scar, Yorkshire, 1811–1815

WIERTZ Antoine

1806 Dinant – 1865 Brussels

When his precocious drawing talent became apparent, Wiertz's father, a tailor, sent him as a boy to classes in drawing, music, and grammar. Accepted into the Antwerp Academy in 1820, he spent the years 1829 to 1832 in Paris, and the latter year was awarded the Grand Prix de Rome. In 1834 to 1836 followed a sojourn in Italy, where at the Académie de France in Rome he copied Old Masters under the supervision of Horace Vernet. In 1838 Wiertz exhibited his *Patrocles* in Paris. The resulting negative reviews injured him so deeply that he relinquished his French citizenship.

In 1850 the Belgian government financed a studio building for him, based on the Greek Temple of Paestum. Wiertz's works combine echoes of medieval art with imitations of Peter Paul Rubens, and possess humanitarian, even revolutionary undertones, all staged with vivid imagination and frequently laden with erotic symbolism. His masterpiece, *The Lovely Rosine*, occupies a place between Baroque *vanitas* depictions and a secular meditation reminiscent of Charles Baudelaire.

Illustration:

113 The Lovely Rosine (Nude with Skeleton), 1843

WILSON Richard
1714 Penegoes (Wales) –
1782 Colommendy (Wales)
Wilson was a pupil of Thomas
Wright in London and, like his
mentor, initially specialized in
portraiture. A journey to Italy from
1750 to 1758 took him first to
Venice, then to Rome. The experi-
ence prompted him to abandon por-
trait painting for landscape, of
which Wilson subsequently became
the first great British master. The
principal sources of his inspiration
were Nicolas Poussin, Claude
Lorrain and Claude-Joseph Vernet,
and he also owed something to
Dutch landscape painting of the
late seventeenth century. Among
his finest works are the English
landscapes and Welsh mountain
scenes, in which topographical ac-
curacy, highly skilled composition,
and finely graded palette combine
marvellously to convey the expanse
and peace of the lakes and hills.
Illustration:

25 Snowdon, c. 1770

WRIGHT OF DERBY Joseph
1734 Derby – 1797 Derby
Wright studied under Thomas
Hudson in London. In 1771 he be-
came a member of the Society of
Art and in 1784 of the Royal Acad-
emy. On a trip to Italy, 1773–1775,
he had the opportunity to study the
Old Masters. Especially Caravaggio
and his followers seem to have in-
trigued Wright, judging by the
dramatic chiaroscuro in the work
of his later period. On returning to
England he briefly tried his hand at
commercial portraiture in Bath, but
then went back to Derby, where he
settled.

Although primarily a portraitist,
Wright also concentrated on devel-
oping a discovery of his, the "scien-
tific genre painting," in which the
effects of illumination were refined
in an attempt to infuse an objective
ambience with emotion. This inno-
vative employment of light sources
was apparent in Wright's landscapes
as well.
Illustration:

26 The Experiment with the
 Airpump, 1768

ZIEM Félix
1821 Beaune – 1911 Paris
The son of a Croatian father and
French mother, Ziem initially stud-
ied architecture in Dijon, where his
family had settled in 1831, before
turning to painting in 1839. After
periods in Marseille and Nice there
followed, in 1842, a first Italian
journey and extensive travels
throughout Europe and in North
Africa. While in Berlin in 1869, he
opened a school of watercolor paint-
ing. A friend of Théophile Gautier
and Frédéric Chopin, Ziem resided
in Paris, spent the winters in Nice,
and by 1897 had visited Venice
over twenty times. He achieved
rapid fame and his works – by the
end over 1,600 oils and approxi-
mately 10,000 watercolors and
drawings – drew top prices.
In 1910 he became the first living
artist to be represented in the
Louvre. Unconventional, not
belonging to any school, Ziem
produced still lifes and portraits but
primarily shimmering, colorful,
light-suffused Mediterranean views
that put him in an intermediate
position between Romanticism and
Impressionism.
Illustration:

112 Venice with Doges' Palace at
 Sunrise, c. 1885

BIBLIOGRAPHY

Addison, A.: *Romanticism and the Gothic Revival.* New York, 1938

Adhemar, J. and W. Hofmann: *Les Lithographies romantiques: Le paysage en France au XIX^e siècle.* Paris, 1997

Ahnung und Gegenwart. Drawings and Watercolours of the German Romanticism from the Berlin Kupferstichkabinett. Exhibition catalogue. Berlin, 1995

Alazard, J.: *L'Orient et la peinture française au XIX^e siècle. D'Eugène Delacroix à Auguste Rodin.* Paris, 1930

American Paradise – The World of the Hudson River School. Exhibition catalogue. New York, 1987

Andrews, K.: *The Nazarenes. A Brotherhood of German Painters in Rome.* Oxford, 1964. – *Die Nazarener.* Munich, 1974

Les Années romantiques: la peinture française de 1815 à 1850. Exhibition catalogue. Musée des Beaux-Arts de Nantes. Paris, 1996

Arcangeli, F.: *Des Romantiques aux impressionnistes.* Paris, 1996

Ariel, D. and J. Isabelle: *L'Art romantique.* Paris, 1996

Aubert, A.: *Die nordische Landschaftsmalerei und Johan Christian Clausen Dahl.* Berlin, 1947

Barnes, R.: *The Pre-Raphaelites and Their World.* London, 1998

Baudelaire, C.: *Curiosités esthétiques. L'art romantique.* Paris, 1962

Baudelaire, C.: *L'Art romantique.* Paris, 1990

Baumgart, F.: *Vom Klassizismus zur Romantik 1750 bis 1832.* Cologne, 1974

Baumgärtel, B. and M. Sitt: *Angesichts der Natur.* Cologne, 1995

Baur, J. I. H.: *American Painting in the Nineteenth Century: Main Trends and Movements.* New York, 1953

Baur, C.: *Landschaftsmalerei der Romantik.* Munich, 1979

Barr, A. H.: *Three American Romantic Painters.* London, 1974

Berlin, I.: *The Origins of Romanticism.* Washington, 1965

Bernhard, M. (Ed.): *Deutsche Romantik, Handzeichnungen.* 2 vols. Munich, 1974

Bialostocki, J.: *Romantyzm.* Warsaw, 1967

Boime, A.: *The Academy and French Painting in the Nineteenth Century.* New York, 1971

Boase, T. S. R.: *English Art 1800–1870.* Oxford, 1959

Börsch-Supan, H.: *Deutsche Romantiker. Deutsche Maler zwischen 1800 und 1850.* Munich et al., 1972

Börsch-Supan, H.: *Die Deutsche Malerei von Anton Graff bis Hans von Marées 1760–1870.* Munich, 1988

Börsch-Supan, H. (Ed.): *Gli artisti romantici tedeschi del primo Ottocento a Olevano Romano.* Museo-Centro Studi sulla Pittura di Paesaggio del Lazio. Exhibition catalogue. Villa De Pisa Olevano Romano. Milan, 1997

Brinkman, R. (Ed.): *Romantik in Deutschland.* Stuttgart, 1978

Brion, M.: *Peinture romantique.* Paris, 1957. – *Die Kunst der Romantik.* Munich and Zurich, 1960

Bryson, N.: *Tradition and Desire: From David to Delacroix.* Cambridge et al., 1984

Cardinal, R.: *German Romanticists in Context.* London, 1975

Cecchi, E.: *Pittura italiana dell'ottocento.* Milan, 1946

Charlton, D. G. (Ed.): *The French Romantics.* Cambridge, 1984

Christian, J. (Ed.): *The last Romantics: The Romantic Tradition in British Art; Burne-Jones to Stanley Spencer.* Exhibition catalogue. Barbican Art Gallery. London, 1989

Clark, K.: *The Gothic Revival.* London, 1950

Clark, K.: *The Romantic Rebellion. Romantic versus Classic Art.* London and New York, 1973

Clay, J.: *Le Romantisme.* Paris, 1985

Cogniat, R.: *Die Malerei der Romantik.* Weltgeschichte der Malerei, vol. 15. Lausanne, 1967

Colin, P.: *La Peinture belge depuis 1830.* Brussels, 1930

Colin, P.: *Le Romantisme.* Brussels and Paris, 1935

Cornell, H.: *Den svenska konstens historia under 1800-talet.* Stockholm, 1946

Courthion, P.: *Le Romantisme.* Geneva, 1961. – *Malerei der Romantik.* Geneva, 1961

De Angelis, E. (Ed.): *Deutsche und italienische Romantik.* Pisa, 1989

Denis, A. and J. Isabelle: *L'Art romantique.* Paris, 1996

Deusch, W. R.: *Malerei der deutschen Romantiker und ihrer Zeitgenossen.* Berlin, 1937

Deutsche Romantiker in Italien. Exhibition catalogue. Städtische Galerie München. Munich, 1980

Deutsche Romantiker. Bildthemen der Zeit von 1800 bis 1850. Exhibition catalogue. Kunsthalle der Hypo-Kulturstiftung. Munich, 1985

The Splendor of Dresden. Five Centuries of Art Collecting. Exhibition catalogue from the Staatliche Kunstsammlung Dresden in the Metropolitan Museum of Art. New York, 1979

Duncan, C.: *The Pursuit of Pleasure: The Rococo Revival in French Romantic Art.* New York, 1976

Einem, H. v.: *Deutsche Malerei des Klassizismus und der Romantik.* Munich, 1978

Eitner, L.: *Neoclassicism and Romanticism,* 2 vols. Englewood Cliffs, 1970

Eschenburg, B. and I. Güssow: *Romantik und Realismus: Von Friedrich bis Courbet.* Edited by I. F. Walther. Museum der Malerei, vol. 7. Herrsching, 1985

Escholier, R.: *La Peinture française. XIXe siècle,* vol. 2. Paris, 1943

Faniel, St.: *Le XIX^e siècle français.* Paris, 1957

Fiorillo J. D.: *Kunstgeschichte und die romantische Bewegung um 1800.* Göttingen, 1997

Focillon, H.: *La Peinture au XIX^e siècle. Le retour à l'antique – le romantisme.* Paris, 1927

Fontainas, A.: *Histoire de la peinture française au XIX^e siècle (1801–1900).* Paris, 1906

Ford, B.: *The Romantic Age in Britain.* Cambridge, 1992

Foucart, B.: *Le Renouveau de la peinture religieuse en France (1800–1860).* Paris, 1987

Fredeman, W. E.: *Pre-Raphaelitism. A Bibliocritical study.* Cambridge (MA), 1965

Friedlaender, W.: *Hauptströmungen der französischen Romantik von David bis Cézanne.* Leipzig, 1930

Friedlaender, W.: *From David to Delacroix.* Cambridge (MA), 1952. – *Hauptströmungen der französischen Romantik von David bis Delacroix.* Cologne, 1977

Gallwitz, K. (Ed.): *Die Nazarener in Rom. Ein deutscher Künstlerbund der Romantik.* German edition of the exhibition catalogue "I Nazareni a Roma" in the Galleria Nazionale Moderna, Rome, 1981. Munich, 1981

Gautier, T.: *Histoire du romantisme suivie de notices romantiques.* Paris, 1874

Geismeier, W.: *Die Malerei der deutschen Romantik.* Dresden, 1984

Geller, H.: *Künstler und Werk im Spiegel ihrer Zeit. Bildnisse und Bilder deutscher Maler des neunzehnten Jahrhunderts.* Dresden, 1956

Gemälde der deutschen Romantik in der Nationalgalerie Berlin, Staatliche Museen Preussischer Kulturbesitz: Caspar David Friedrich, Karl Friedrich Schinkel, Carl Blechen. Exhibition catalogue. Berlin, 1985

Gilmore Holt, E. (Ed.): *From the Classicists to the Impressionists: A Documentary History of Art and Architecture in the Nineteenth Century.* New York, 1965

Glaesemer, J. (Ed.): *Traum und Wahrheit.* German Romantic Art from Museums of the German Democratic Republic. Exhibition catalogue. Kunstmuseum Berne. Stuttgart, 1985

Günzel, K.: *Die deutschen Romantiker. 125 Lebensläufe. Ein Personenlexikon.* Zurich, 1995

Günzel, K.: *Romantik in Dresden. Gestalten und Begegnungen.* Frankfurt am Main, 1997

Hartley, K. (Ed.): *The Romantic Spirit in German Art: 1790–1990.* Exhibition catalogue. National Gallery of Modern Art, Edinburgh, 1994, Haus der Kunst, Munich, 1995. Edinburgh and Stuttgart, 1994

Hijmans, H.: *Belgische Kunst des 19. Jahrhunderts.* Leipzig, 1906

Hilton, T.: *The Pre-Raphaelites.* London, 1985

Hofmann, W.: *Das irdische Paradies. Kunst im 19. Jahrhundert.* Munich, 1960. – *The Earthly Paradise: Art in the Nineteenth Century.* London, 1961

Honour, H.: *Romanticism.* London, 1979

Howald, G.: *Malerei 1800 bis um 1900.* Exhibition catalogue. Hessisches Landesmuseum. Darmstadt, 1979

Howat, J. K. and J. Wilmerding: *Nineteenth-Century America: Paintings and Sculpture*. Greenwich (CT), 1970

Hübner, F. M.: *Die Kunst der niederländischen Romantik*. Düsseldorf, 1942

Hübner, F. M.: *Die Malerei der Romantik in Amerika*. Bonn, 1953

Hugler, M. and A. M. Cetto: *Peinture suisse au XIXe siècle*. Basel, 1943

Hütt, W.: *Die Düsseldorfer Malerschule 1819-1869*. Leipzig, 1964

Huyghe, R. and P. Jaccottet: *Le Dessin français au XIXe siècle*. Lausanne, 1848

Ironside, R. and J. Gere: *Pre-Raphaelite Painters*. London, 1948

Zwei Jahrhunderte englische Malerei. Britische Kunst und Europa 1680 bis 1880. Exhibition catalogue. Haus der Kunst. Munich, 1979

Janson, H. W. and R. Rosenblum: *Art of the Nineteenth Century*. London, 1984

Jaspert, R. (Ed.): *Die deutsche Romantik*. Berlin, 1949

Jensen, J. C.: *Die Bildniszeichnung der deutschen Romantik*. Lübeck, 1957

Jensen, J. C.: *Malerei der Romantik in Deutschland*. Cologne, 1985

Jensen, J. C.: *Aquarelle und Zeichnungen der deutschen Romantik*. Munich, 1978, Cologne, 1992

Keisch, C.: *Italia und Germania. Deutsche Klassizisten und Romantiker in Italien*. Exhibition catalogue. Nationalgalerie. Berlin, 1975

Klassizismus und Romantik. Paintings and Drawings from Sammlung Schäfer, Schweinfurt. Exhibition catalogue. Germanisches National-museum. Nuremberg, 1966

Klassizismus – Romantik – Realismus. Painting and Graphic from Saxon Art Collections. Zwickau, 1994

Kleßmann, E.: *Die Welt der Romantik*. Munich, 1969

Kleßmann, E.: *Die deutsche Romantik*. Cologne, 1981

Klingender, F. D.: *Art and Industrial Revolution*. London, 1947

Knoef, J.: *Tussen rococo en romantiek*. The Hague, 1943

Knoef, J.: *Van romantiek tot realisme*. The Hague, 1947

Knuttel, G.: *L'Art hollandais au XIXe et XXe siècle*. 2 vols. Brussels and Paris, n. d.

Kroeber, K.: *British Romantic Art*. Berkeley (CA), 1986

Die Kunst der englischen Romantik: 1750-1850. Exhibition catalogue. Galerie Arnoldi-Livie. Munich, 1985

Kunst erleben – Romantik. Ein multimedialer Wegweiser zur Kunst. CD-Rom. Würzburg, 1998

Lacambre J. and J. Isabelle (Ed.): *Les Années romantiques: La peinture française 1815-1850*. Exhibition catalogue. Galeries Nationales d'Exposition du Grand Palais. Paris, 1996

Lambosse, P.: *Histoire de la peinture et de la sculpture en Belgique 1830-1930*. Brussels, 1930

Lankheit, K.: *Revolution und Restauration 1785-1855*. Cologne, 1988

Laurence, R. et al.: *Les romantiques*. Paris, 1994

Le Bris, M.: *Journal du romantisme*. Geneva, 1981. – *Die Romantik in Wort und Bild*. Geneva, 1981

Leppien, H. R. (Ed.): *Deutsche Malerei des 19. Jahrhunderts*. Exhibition catalogue. Kunsthalle Köln. Cologne, 1971

Leymarie, J.: *Französische Malerei. Das 19. Jahrhundert*. Geneva, 1962

Lindsay, J.: *Death of the Hero: French Painting from David to Delacroix*. London, 1960

Lister, R.: *British Romantic Painting*. London, 1993

Lister, R.: *British Romantic Art*. London, 1973

Lorenz, O. v. (Ed.): *Romantik*. Kirchdorf am Inn, 1995

Maas, J. et al.: *Victorian Fairy Painting*. London, 1997

Malerpoeten. Die romantische Welt des 19. Jahrhunderts. Munich, 1976

McShine, K. (Ed.): *The Natural Paradise: Painting in America 1800-1950*. Exhibition catalogue. The Museum of Modern Art. New York, 1976

Metken, G.: *Die Präraffaeliten*. Cologne, 1974

Meyer L. and C. Sala: *Romantic Landscape (England/Germany): Masters of English Landscape & Caspar David Friedrich*. New York, 1997

Die Nazarener. Exhibition catalogue. Städelsches Kunstinstitut. Frankfurt am Main, 1977

Neidhardt, H. J.: *Die Malerei der Romantik in Dresden*. Leipzig, 1976

Novak, B.: *American Painting of the Nineteenth Century*. New York, 1969

Novotny, F.: *Painting and Sculpture in Europe 1780-1880*. Harmondsworth, 1960

Parris, L. (Ed.): *The Pre-Raphaelites*. Exhibition catalogue. Tate Gallery. London, 1984

Paysage romantique. 2 vols. Paris, 1997

La Peinture allemande à l'époque du Romantisme. Exhibition catalogue. Musée de l'Orangerie. Paris, 1977

Peter, K. (Ed.): *Romantikforschung seit 1945*. Königstein, 1980

Prideaux, T.: *Delacroix et son temps. 1798–1863*. New York, 1966

Quenell, P.: *Romantic England: Writing and Painting, 1717–1851*. London, 1970

Réau, L.: *L'Art romantique*. Paris, 1930

Richardson, E.: *American Romantic Painting*. New York, 1944

Robels, H.: *Sehnsucht nach Italien: Bilder deutscher Romantiker*. Munich, 1974

Romantic Art in Britain. Exhibition catalogue. Detroit Institute of Art and Philadelphia Museum of Art. Detroit and Philadelphia, 1968

The Romantic Movement. Exhibition catalogue. Tate Gallery. London, 1959

Romantik in Österreich. Exhibition catalogue. Residenzgalerie Salzburg, 1959

Rosen, C. and H. Zerner: *Romanticism and Realism: the mythology of 19th-century art*. New York, 1984. – *Romantisme et réalisme, mythes de l'art au XIXe siècle*. Paris, 1986

Rosenberg, P. et al.: *French Painting, 1774–1830: The Age of Revolution*. Exhibition catalogue. Detroit Institute of Arts. Detroit, 1975

Roters, E.: *Malerei im 19. Jahrhundert*. 2 vols. Cologne, 1997

Rosenblum, R.: *Modern Painting in the Northern Romantic Tradition. Friedrich to Rothko*. London, 1975. – *Die moderne Malerei und die Tradition der Romantik. Von C.D. Friedrich zu Mark Rothko*. Munich, 1981

Rosenthal, L.: *Du Romantisme au réalisme: la peinture en France de 1830 à 1848*. Paris, 1987

Rudrauf, L.: *Eugène Delacroix et le problème du romantisme artistique*. Paris, 1942

Russische Malerei der ersten Hälfte des 19. Jahrhunderts. Exhibition catalogue. Kunsthalle Baden-Baden, 1981, Niedersächsisches Landesmuseum Hannover. Hanover, 1982

Sala, C.: *Caspar David Friedrich et l'âme romantique*. Paris, 1993

Schanze, H. (Ed.): *Romantik-Handbuch*. Stuttgart, 1994

Schindler, H.: Nazarener: *Romantischer Geist und christliche Kunst im 19. Jahrhundert*. Regensburg, 1982

Schneider, N.: *Geschichte der Landschaftsmalerei. Vom Spätmittelalter bis zur Romantik*. Munich, 1999

Schulz, G.: *Romantik*. Munich, 1996

Schrade, H.: *Deutsche Malerei der Romantik*. Cologne, 1967

Soby, J. T. and D. C. Miller: *Romantic Painting in America*. Exhibition catalogue. The Museum of Modern Art, New York, 1943

Sommerhage, K.: *Deutsche Romantik: Literatur und Malerei 1797–1830*. Cologne, 1988

Ernste Spiele. Der Geist der Romantik in der deutschen Kunst 1790–1990. Exhibition catalogue. Haus der Kunst. Munich, 1995

Spitzer, G.: *Malerei der Romantik in der Gemäldegalerie Neue Meister Dresden*. Leipzig, 1996

Staley, A.: *The Pre-Raphaelite Landscape*. Oxford, 1973

Steiner, W.: *Pictures of Romance: From Against Context in Painting and Literature*. Chicago, 1991

Auf der Suche nach dem Goldenen Zeitalter: Niederländische Malerei in der Zeit der Romantik. Exhibition catalogue. Österreichische Galerie. Vienna, 1986

Swoboda, K. M.: *Von der Romantik bis zur Moderne*. Geschichte der bildenden Kunst, vol. 9. Vienna and Munich, 1984

Der Symbolismus in England 1860-1910. Exhibition catalogue. Haus der Kunst. Munich, 1998

Treuherz, J.: *Victorian Painting*. London, 1993

Vanzype, G.: *L'Art belge du XIXe siècle*. 2 vols. Brussels and Paris, 1923

Vaughan, W.: *Romantic Art*. London, 1978. – *L'Art romantique*. London and Paris, 1994

Vaughan, W.: *German Romanticism and English Art*. London, 1979

Vaughan, W.: *German Romantic Painting*. New Haven and London, 1980

Vaughan, W.: *Romanticism and Art*. London, 1994

Vaughan W. and F. Zegler: *Caspar David Friedrich to Ferdinand Hodler. A Romantic Tradition: Nineteenth Century Paintings and Drawings from Oskar Reinhart Foundation.* Frankfurt am Main, 1994

Viktorianische Malerei. Von Turner bis Whistler. Exhibition catalogue. Bayerische Staatsgemäldesammlungen. Munich, 1993

Warner, M. et al.: *The Victorians: British Painting, 1837–1901.* New York, 1997

Wat, P.: *Naissance de l'art romantique: Peintures et théories de l'imitation en Allemagne et en Angleterre.* Paris, 1998

Wellek, R.: *Das späte 18. Jahrhundert. Das Zeitalter der Romantik.* Berlin, 1978

Wescher, P.: *Die Romantik in der Schweizer Malerei.* Frauenfeld, 1947

Whitley, M. T.: *Art in England 1821–1837.* Cambridge, 1937

Wilton, A. and A. Lyles: *The Great Age of British Watercolours 1750–1880.* Munich, 1993

Wolf, B. J.: *Romantic Re-vision: Culture and Consciousness in Nineteenth-century American Painting and Literature.* Chicago, 1986

Photo credits

The editor and publisher wish to express their gratitude to the museums, public collections, galleries and private collectors, the archivists and photographers, and all those involved in this work. The editor and publisher have at all times endeavoured to observe the legal regulations on the copyright of artists, their heirs or their representatives, and also to obtain permission to reproduce photographic works and reimburse the copyright holder accordingly. Given the great number of artists involved, this may have resulted in a few oversights despite intensive research. In such a case will the copyright owner or representative please make application to the publisher.

The locations and names of owners of the works are given in the captions to the illustrations unless otherwise requested or unknown to the publisher. Below is a list of archives and copyright holders who have given us their support. Information on any missing or erroneous details will be welcomed by the publisher.

The numbers given refer to the pages of the book, the abbreviations a = above, b = below.
Berlin, Archiv für Kunst und Geschichte: 21, 35 a, 45 b, 47, 49, 51 b, 61 a, 68 a, 90 b, 91 b, 92 b, 108 (E. Lessing), 114 b, 119. – Berlin, Bildarchiv Preußischer Kulturbesitz: 10 (J. P. Anders), 19 (J. P. Anders), 24 (K. Göken), 39 a (J. P. Anders), 46 a (J. P. Anders), 51 a (R. Saczewski, 1993), 53 a (J. P. Anders), 53 b (L. Braun), 57 a (J. P. Anders), 64 b (J. P. Anders), 87 (L. Braun), 97. – Brooklyn (NY), Brooklyn Museum of Art. Dick S. Ramsay Fund, A. Augustus Healy Fund B, Frank L. Babbott Fund, A. Augustus Healy Fund, Ella C. Woodward Memorial Funds, Gift of Daniel M. Kelly, Gift of Charles Simon, Charles Smith Memorial Fund, Caroline Pratt Fund, Frederick Loeser Fund, Augustus Graham School of Design Fund, Bequest of Mrs. William T. Brewster, Gift of Mrs. W. Woodward Phelps, Gift of Seymour Barnard, Charles Stuart Smith Fund, Bequest of Laura L. Barnes, Gift of J. A. H. Bell, John B. Woodward Memorial Fund, Bequest of Mark Finley. 76. 79: 132 b. – Brussels, Musées Royaux des Beaux-Arts de Belgique: 113 a (Speltdoorn). – Budapest, Szépművészeti Múzeum: 72 a (D. Józsa). – Cleveland, © The Cleveland Museum of Art, 1998, Gift of Eugene Victor Thaw, 1965.310: 93 a. – Dresden, Sächsische Landesbibliothek, Staats- und Universitätsbibliothek Dresden, Abteilung Deutsche Fotothek: 45 o (A. Rous), 48 a, 65 (A. Rous), 118 b (A. Rous), 121 a (K.-D. Schumacher). – Ecublens, Archiv André Held: 41, 95 a, 95 b, 96 b. – Florence, INDEX s.a.s., Ricerca Iconografica: 116 b (Saporetti), 122 b (Rapuzzi), 123 (A. Mella). – Frankfurt am Main, Freies Deutsches Hochstift, Frankfurt Goethe-Museum: 69 (R. Lenz). – Glasgow, © Hunterian Art Gallery, University of Glasgow: 82 b. – Hamburg, Elke Walford Fotowerkstatt: 36 b, 48 b, 85 a. – Kassel, Staatliche Museen Kassel: 44 a (Hensmanns, 1995), 44 b (Hensmanns, 1995). – Copenhagen, Hans Petersen: 117 a, 120 a, 120 b. – Cologne, Rheinisches Bildarchiv: 50 a, 58 a, 125. – London/New York, Bridgeman Art Library: 15, 16, 25, 71, 73 b, 75, 76 b, 82 a, 84, 91 a, 132 a. – London, © The British Museum: 14. – London, Tate Gallery: 72 b, 77 b. – London, V&A Picture Library: 17, 70 b. – Madrid, Derechos reservados © Museo del Prado: 126 a, 126 u. – Milan, Gruppo Editoriale Fabbri: 74 a, 74 b, 101 b, 117 b. – Munich, Archiv Alexander Koch: 37, 46 b, 61 b, 62 b, 64 a, 66 a, 67 a, 79, 88 b, 90 a, 110 b. – Oslo, © Nasjonalgalleriet 1998: 121 b (J. Lathion). – Paris, Photographie Giraudon: 109 b. – Paris, Photothèque des Musées de la Ville de Paris: 112 b. – Paris, © Photo RMN: 30 a, 94 (J. G. Berizzi), 109 a (D. Chenot), 110 a (H. Lewandowski), 116 a (J. G. Berizzi). – Peißenberg, Artothek: cover, 2 (J. Blauel), 22 (J. Blauel), 33 (J. S. Martin), 38 a, 40 a, 42, 43 b, 52 b, 55 (J. Blauel), 59 b, 60 (Blauel/Gnamm), 63 a (J. Blauel), 63 b (Blauel/Gnamm), 66 b (J. Blauel), 77 a (G. Westermann), 89 (Christie's), 99 (P. Willi), 115. – Washington, DC, National Museum of American Art / New York, Art Resource: 129 a. – Vienna, Fotostudio Otto: 58 b.

The remaining illustrations used belong to the collections mentioned in the captions or to the editor's archive, and the archive of Benedikt Taschen Verlag, Cologne. The portraits of the artists in the biographical section are reproductions from the archives of the editor and the publisher.

DISCARDED